C3334 86908

D1332970

WITHDRAWN

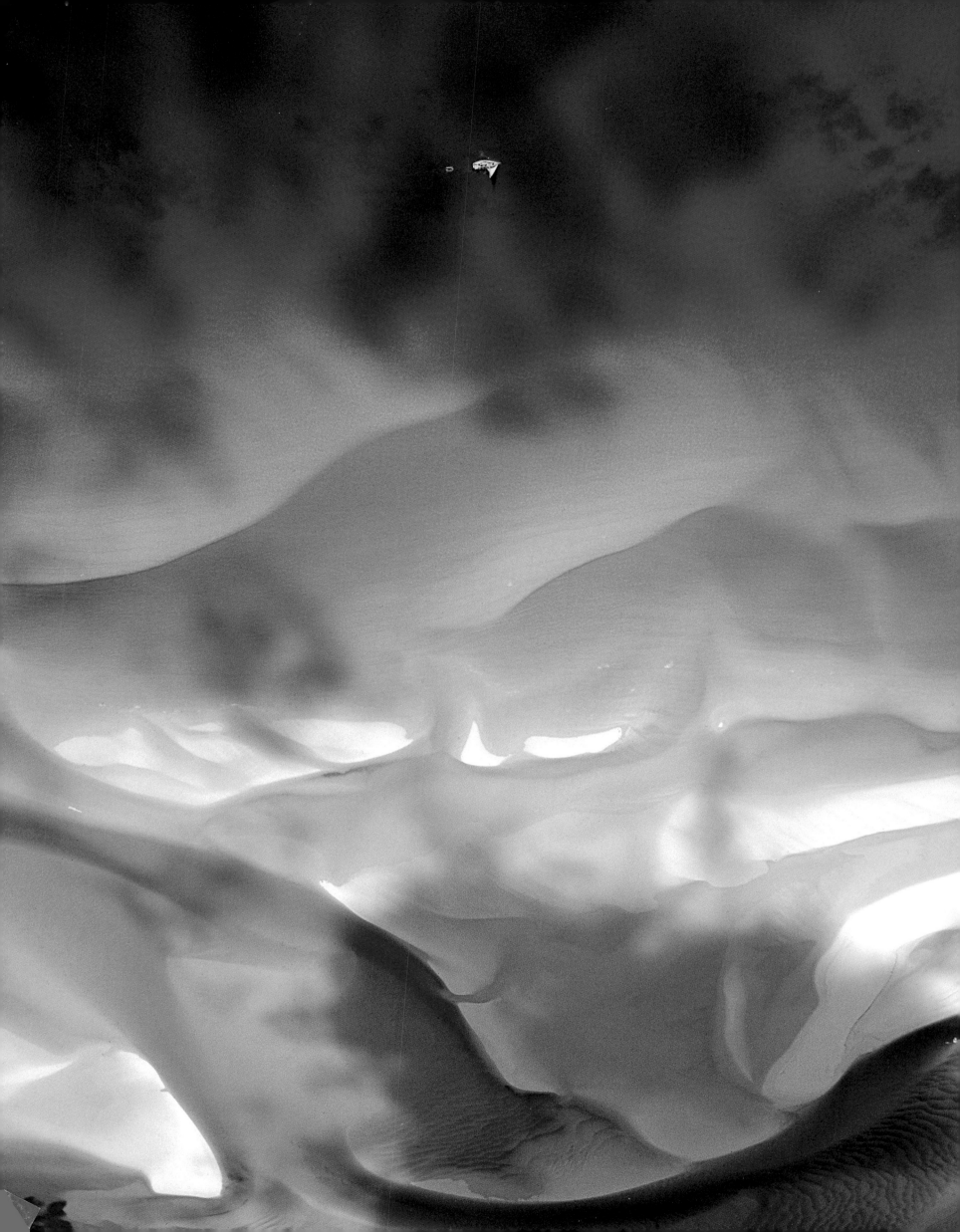

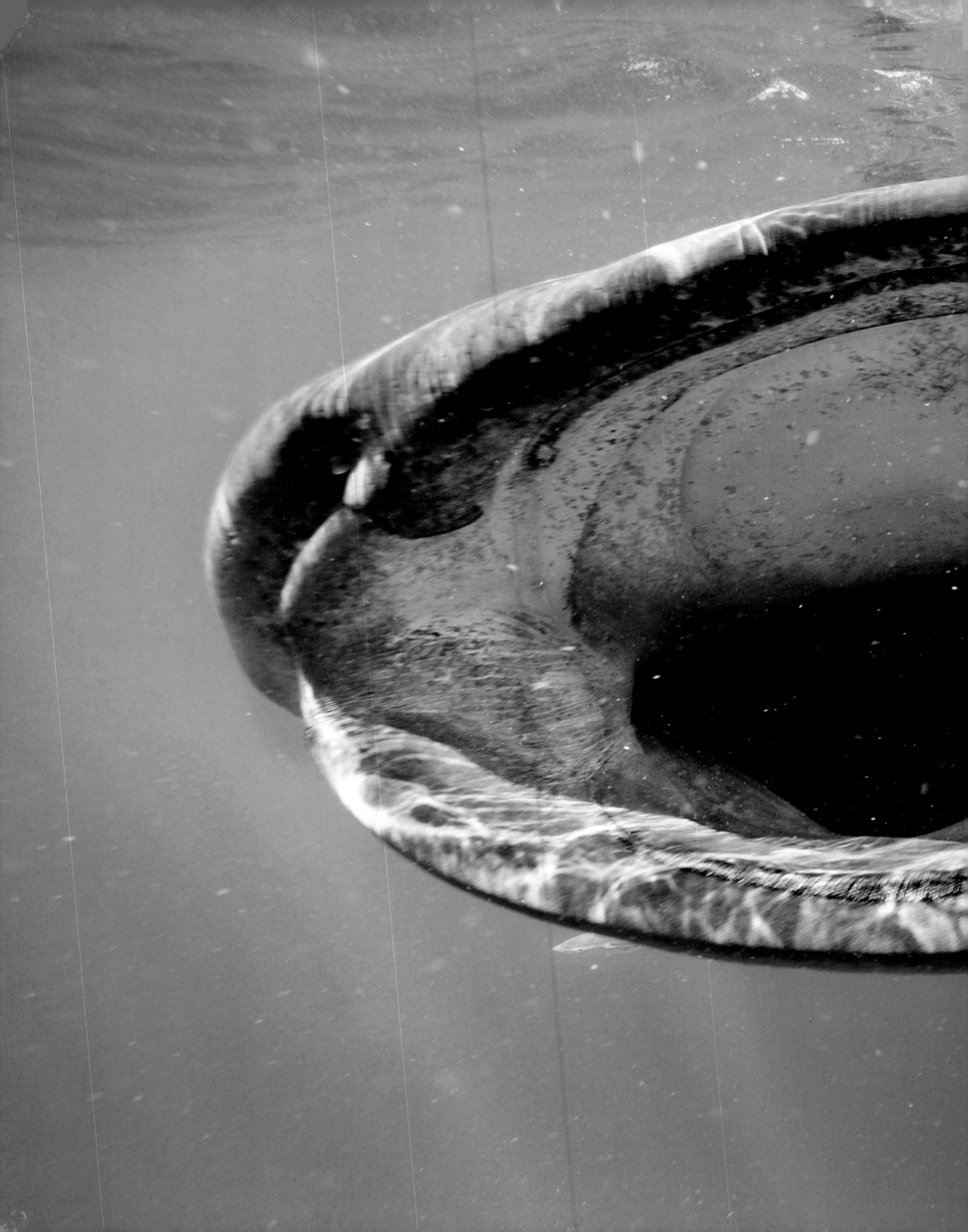

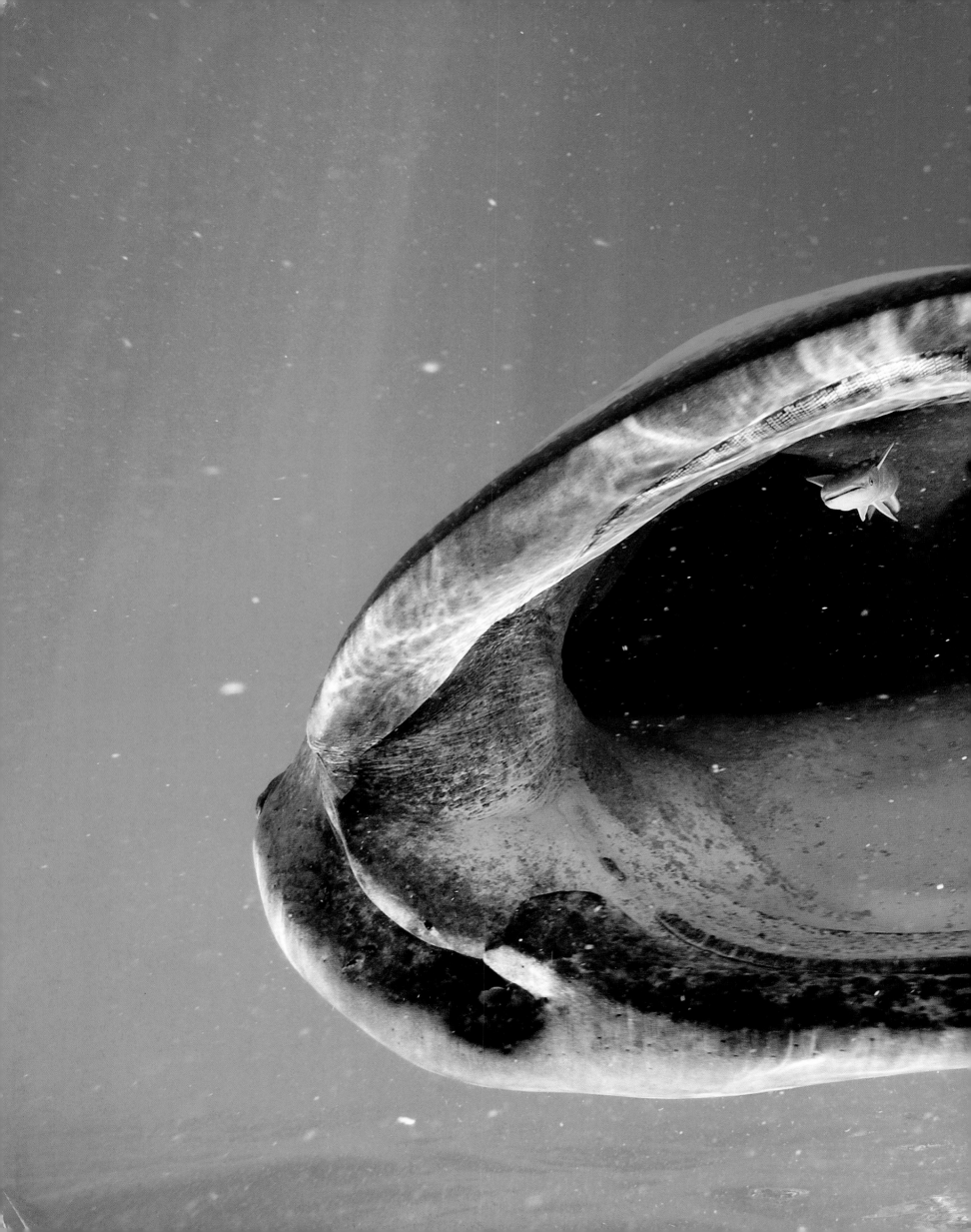

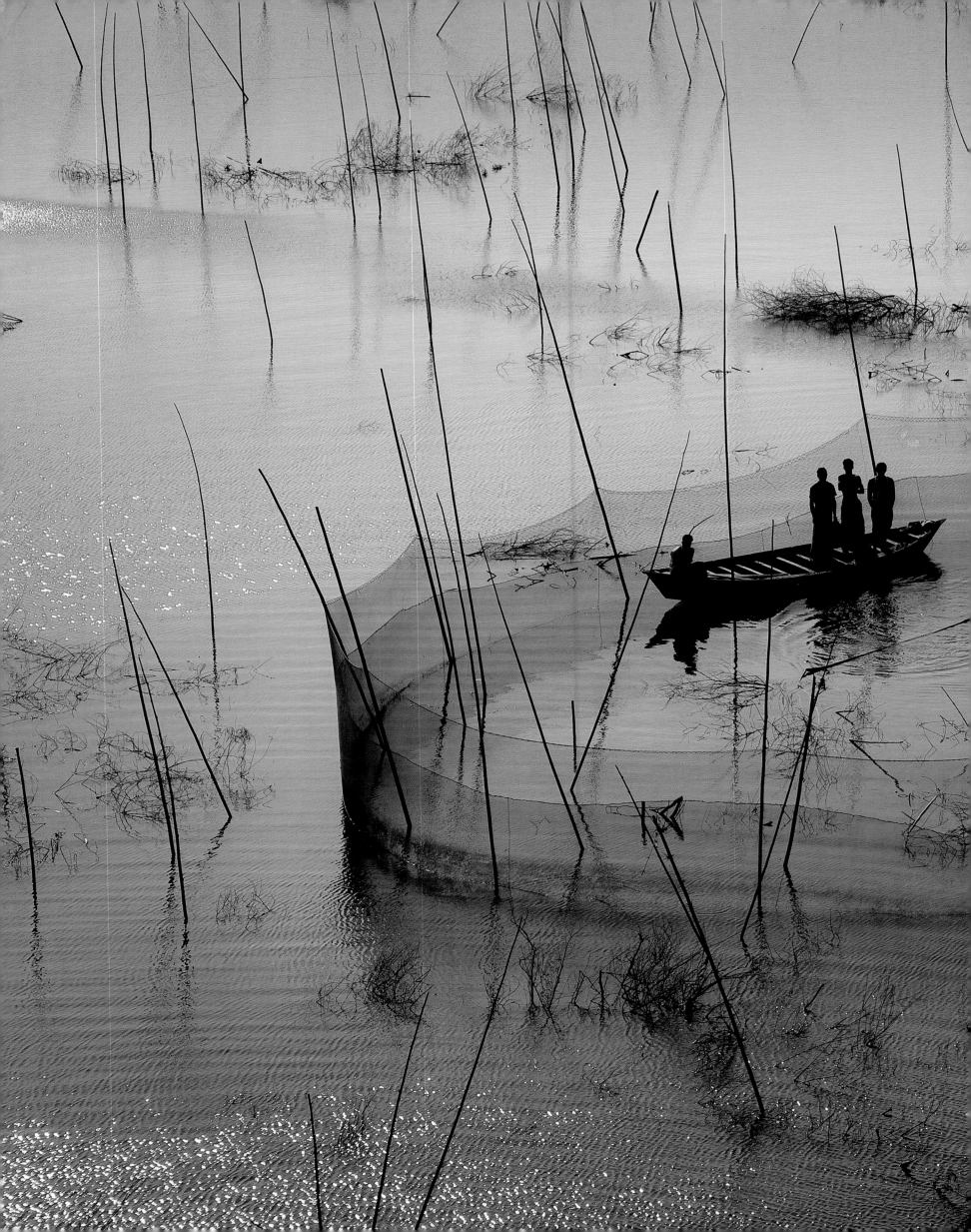

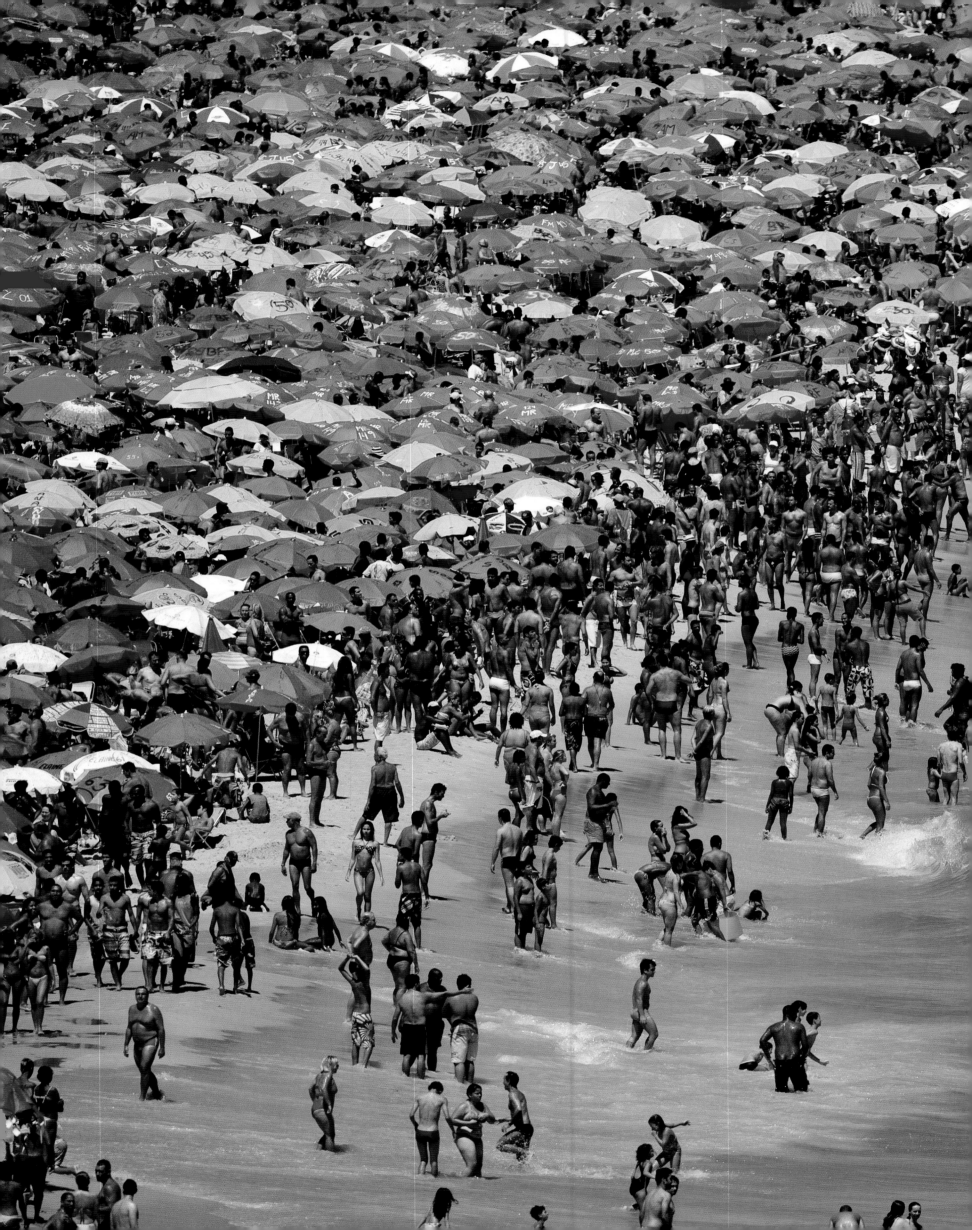

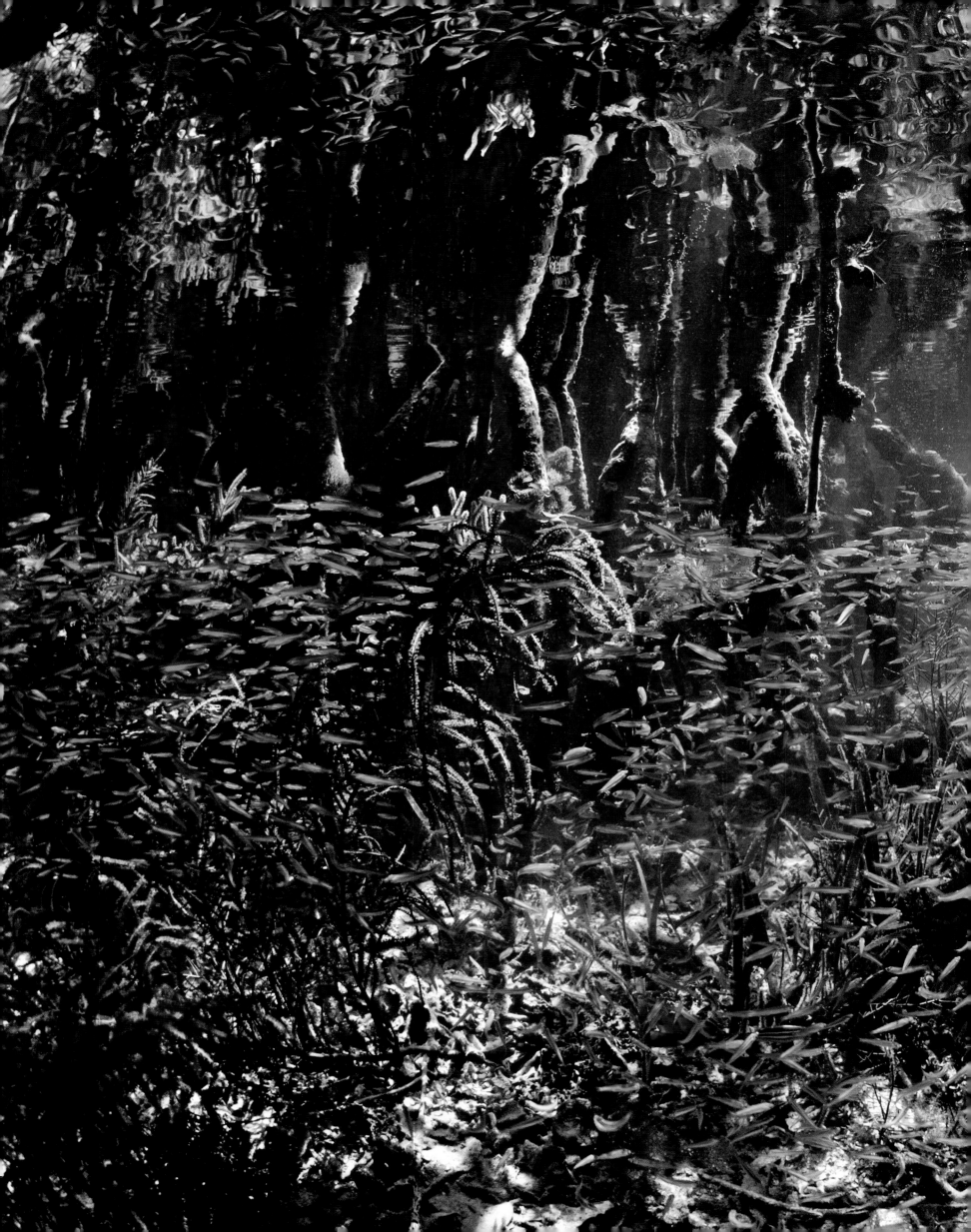

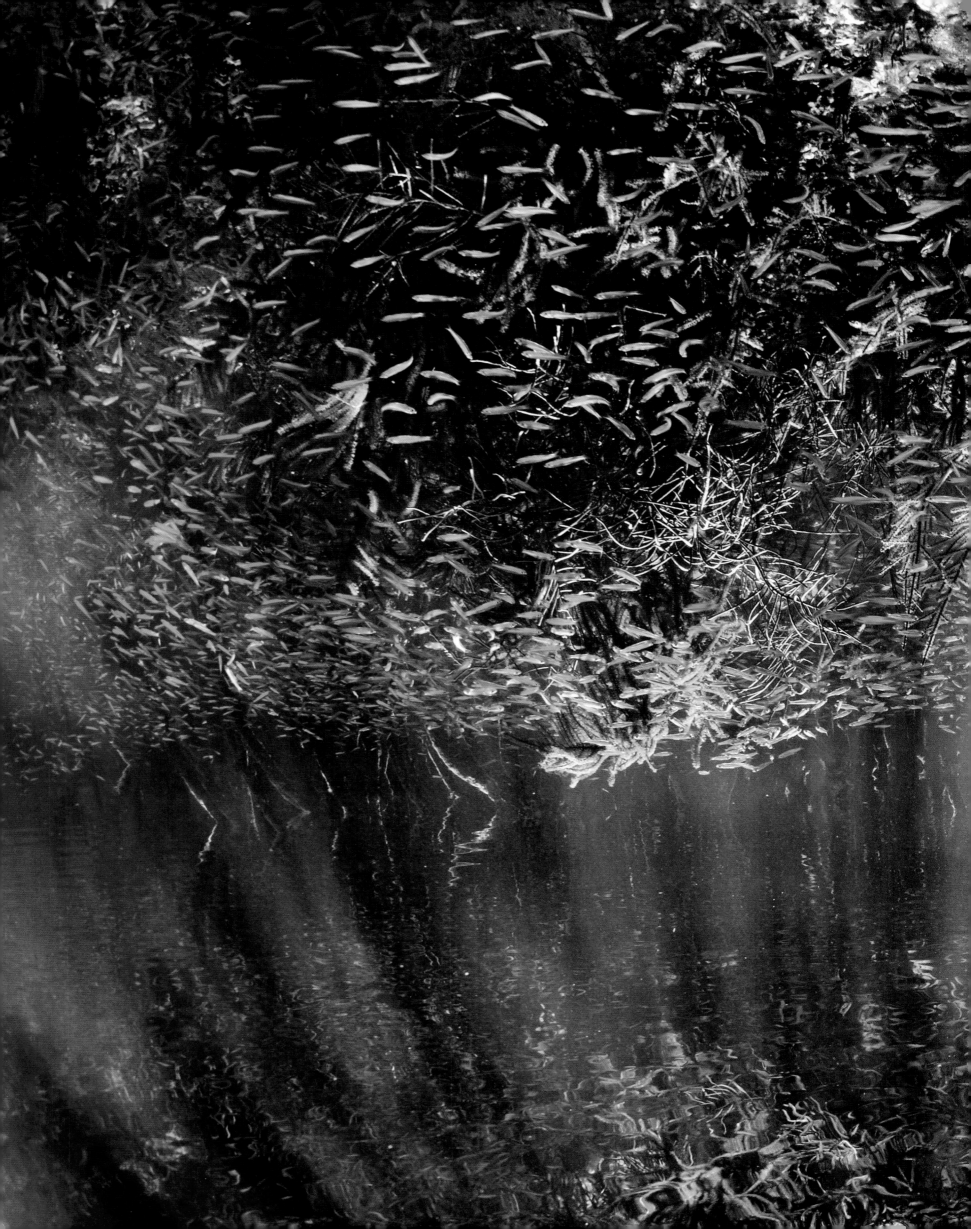

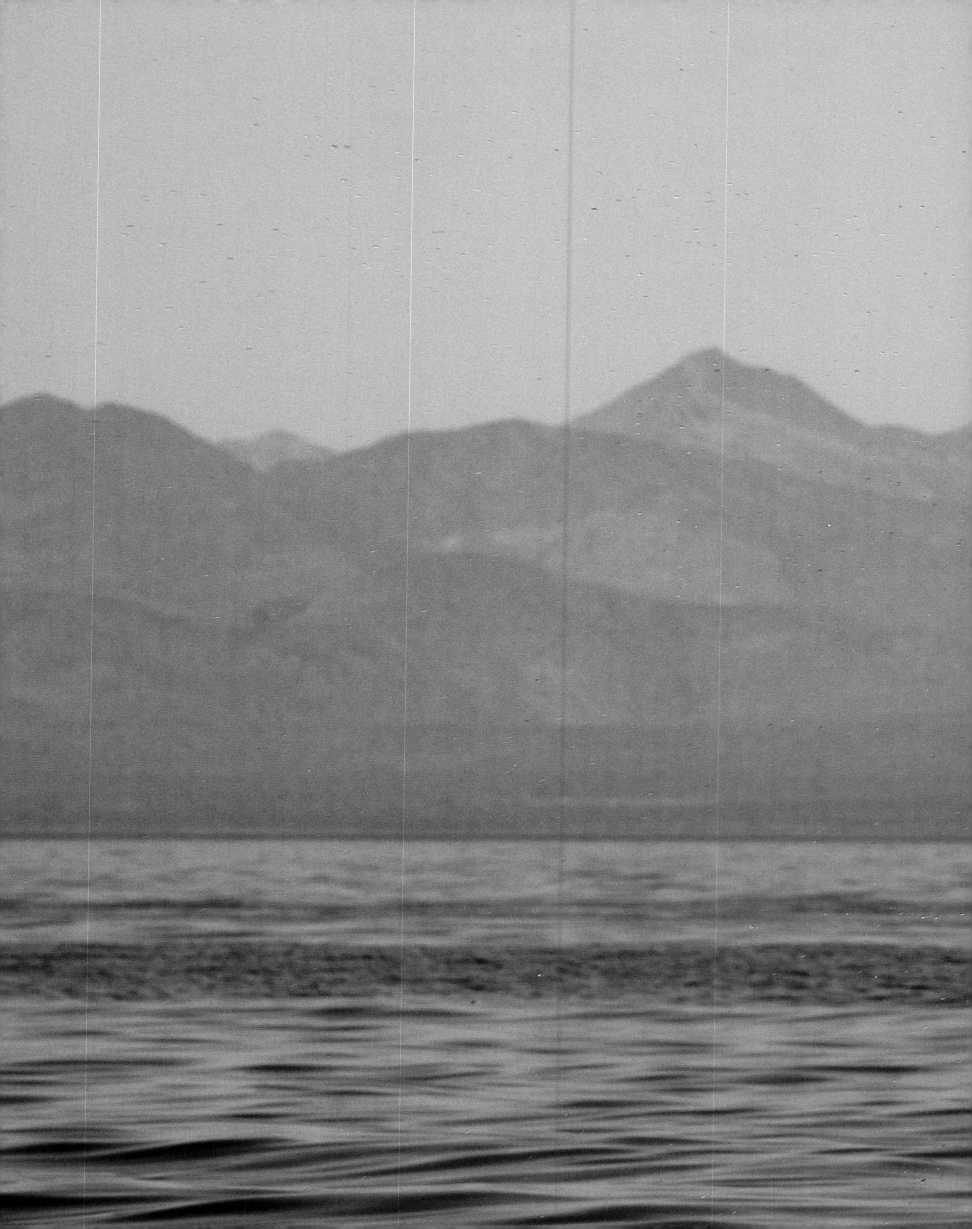

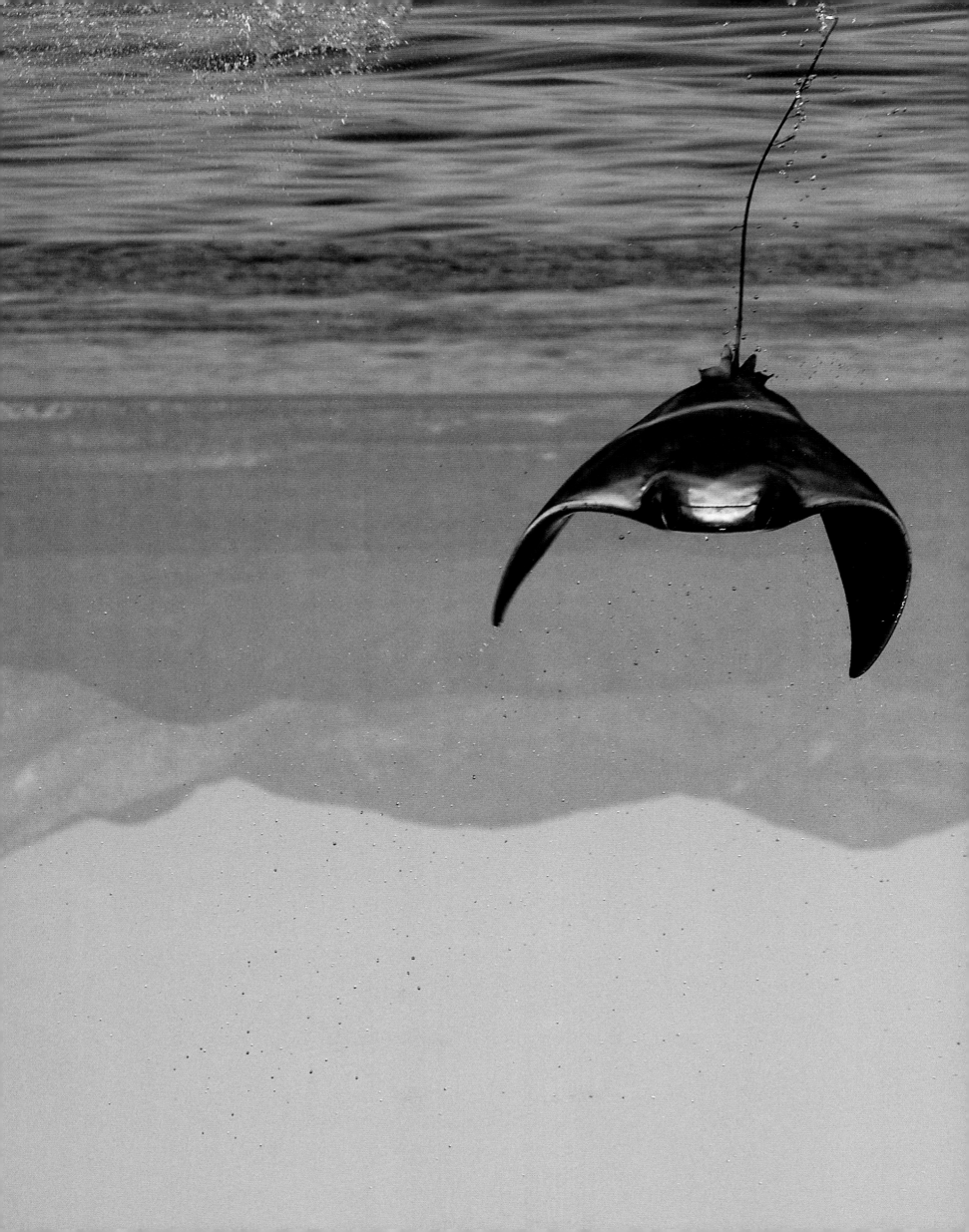

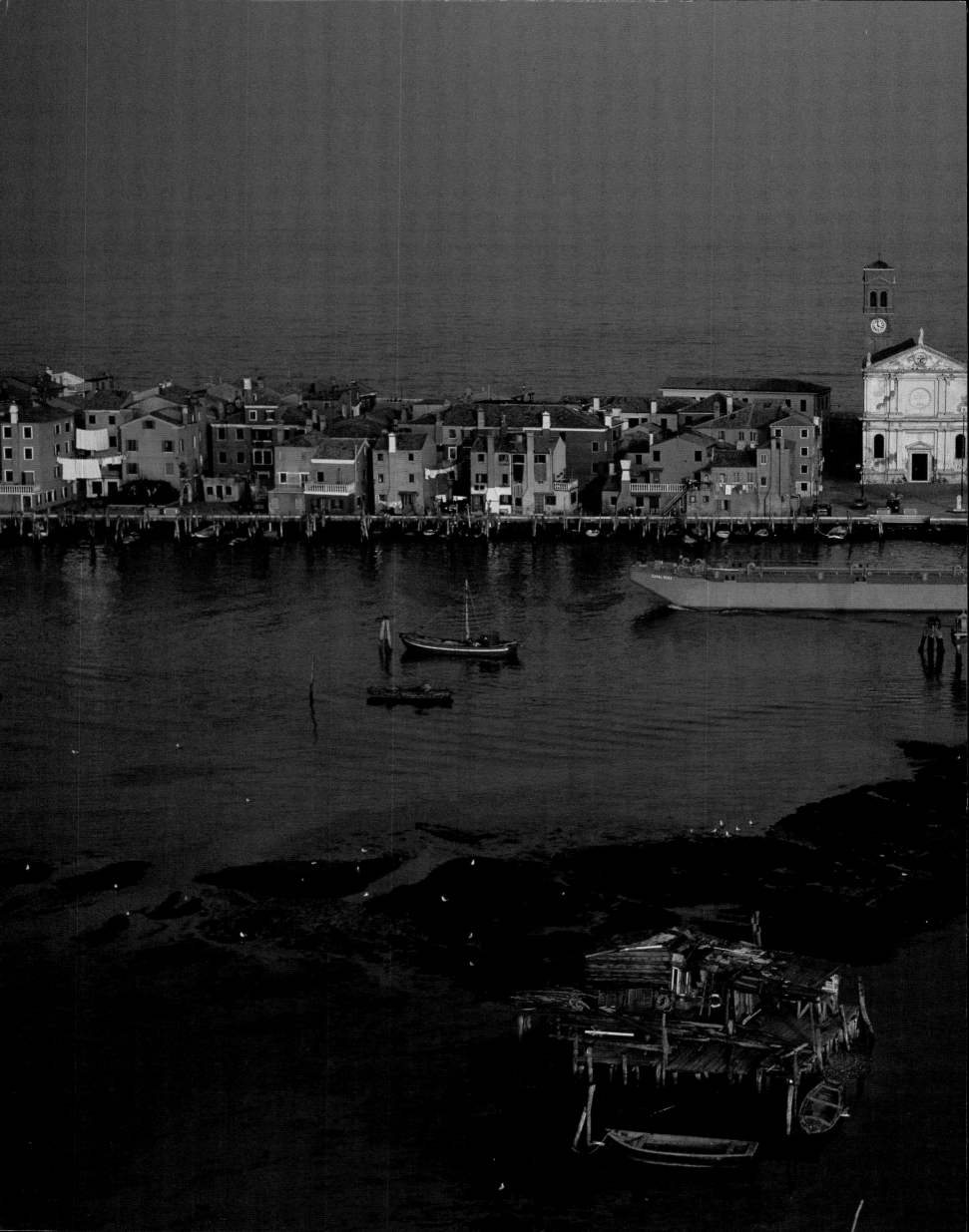

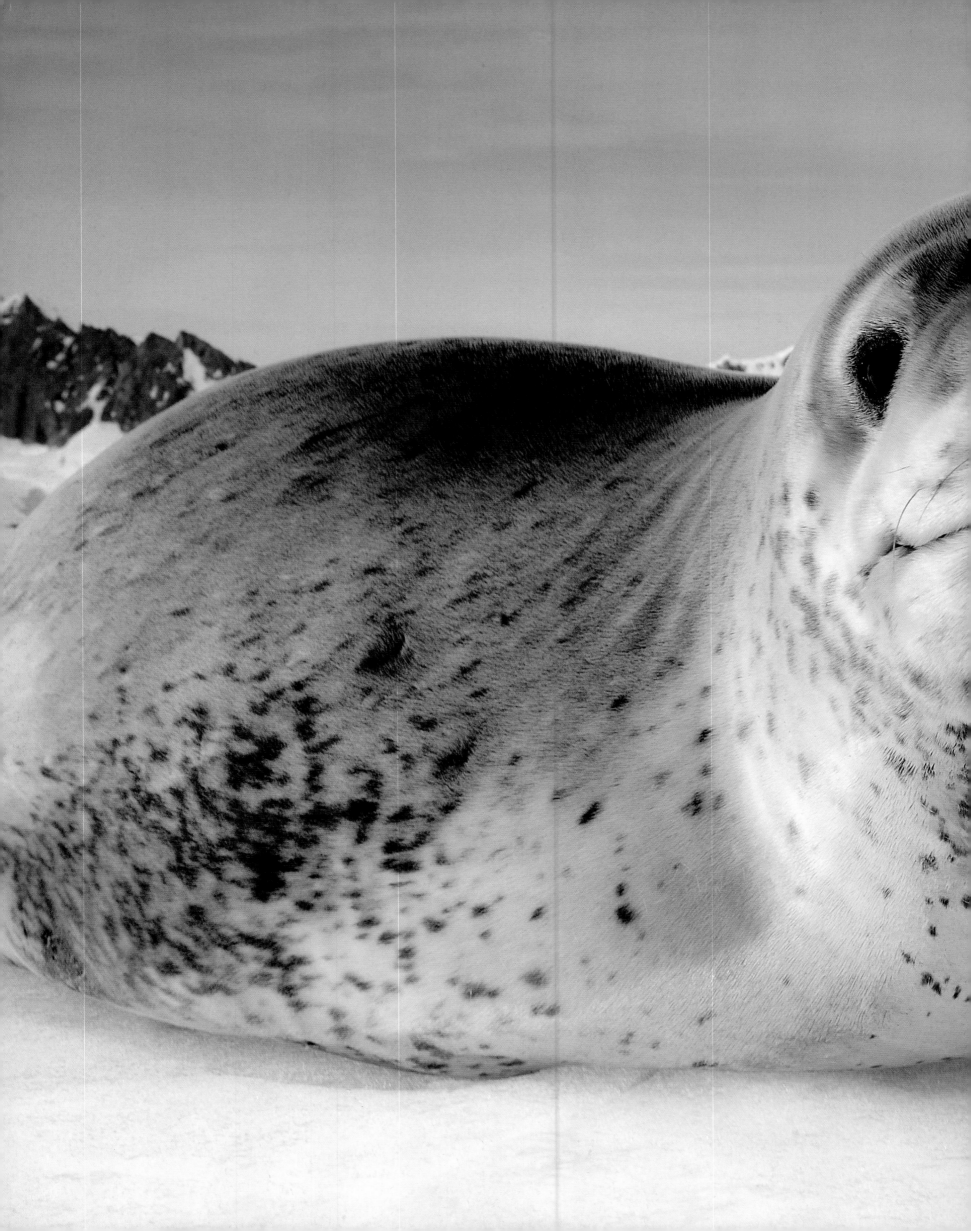

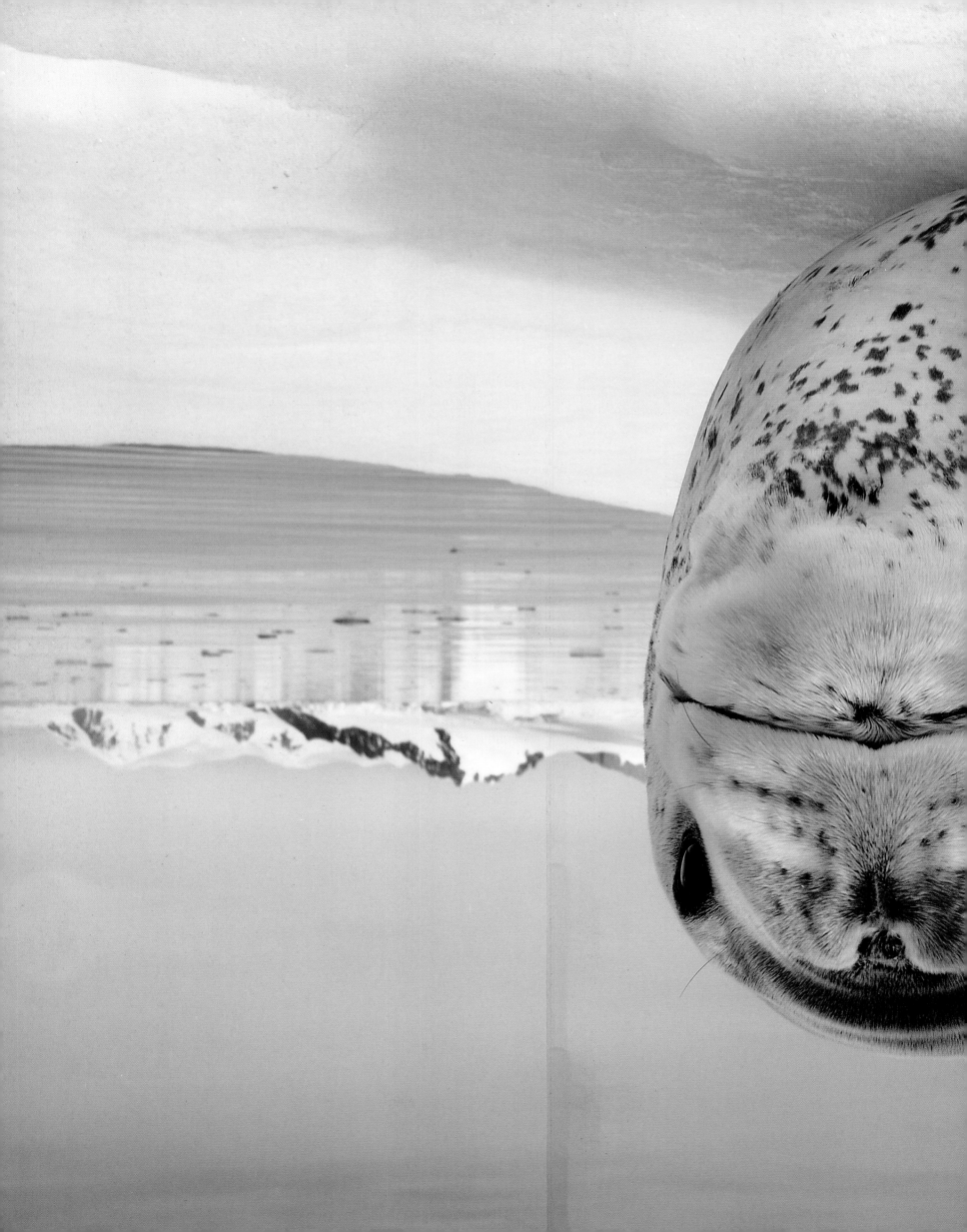

CONTENTS

Thames & Hudson

GOODPLANET
FOUNDATION

YANN ARTHUS-BERTRAND
BRIAN SKERRY

MAN AND THE SEA

FROM ABOVE
AND BELOW

OPPOSITE: **Diver off Lighthouse Reef atoll, Belize District, Belize** (17°16' N, 87°30' W)

PAGE 20: **Southern right whale (*Eubalaena australis*) off the Valdes Peninsula, Argentina** (42°23' S, 64°29' W)

PAGE 21: **Encounter between a diver (Brian Skerry's assistant) and a southern right whale (*Eubalaena australis*), Auckland Islands, New Zealand**

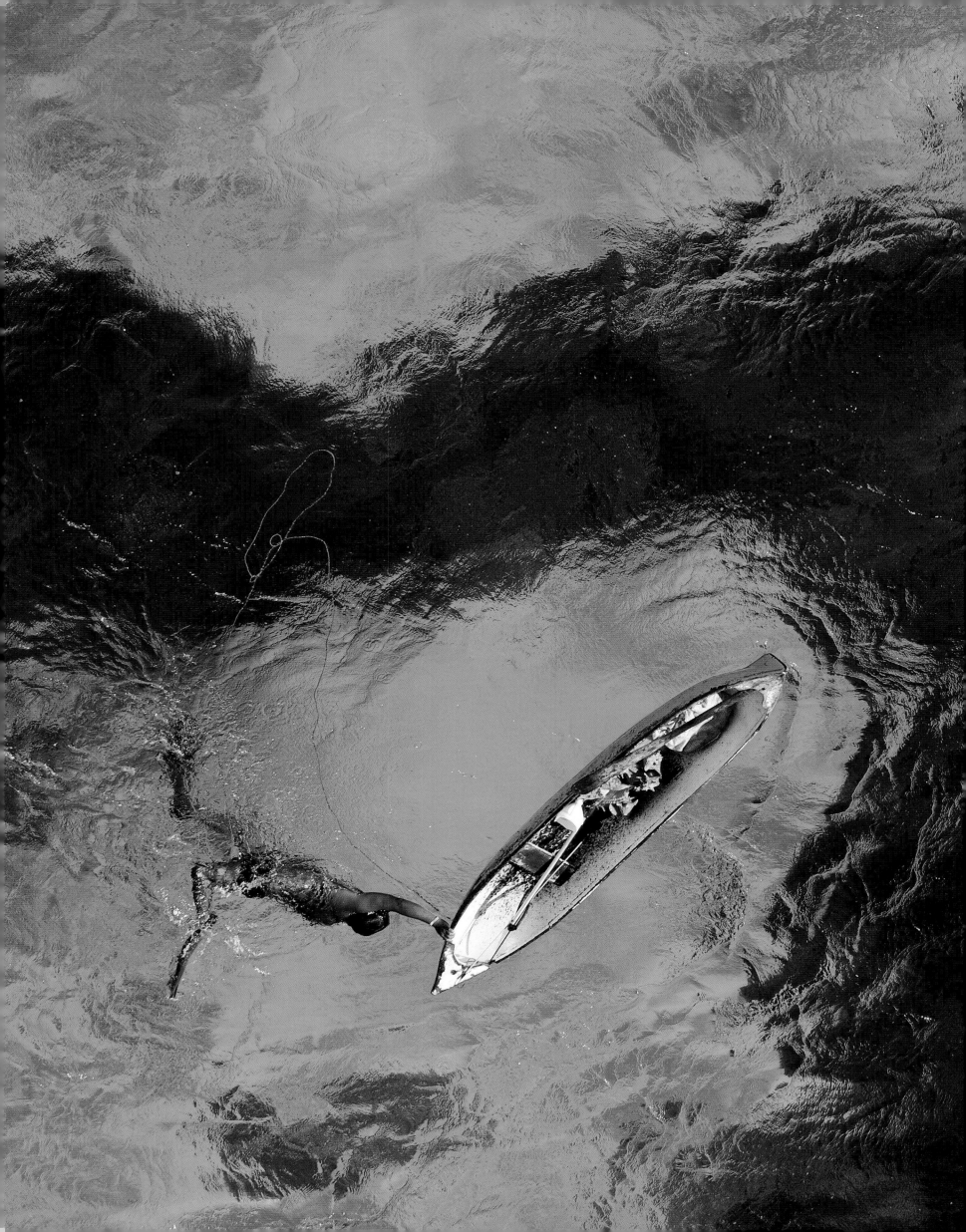

FOREWORD YANN ARTHUS-BERTRAND

Ernest Hemingway's fisherman provides a picture of a past long gone. The feeling of brotherhood the old man painfully establishes with the fish he will kill is far removed from the cold calculation of the crews navigating today's industrial trawlers.

Yet modern man remains deeply connected to the oceans, though he may no longer be conscious of it: Today there is not one stretch of land or sea that does not bear his mark, including marks of destruction. The connection between man and sea is a fundamental relationship. An ambivalent one, too, for man is both the cause and the solution of every problem.

How do we show this ambivalence, how do we allow people to see the beauty of the oceans, their diversity and uses, but also the threats weighing on them today and the solutions that we can provide? How do we make a different kind of book, one that does not only show whales and coral reefs but also man's footprint, and that re-situates the oceans in their relationship with landmasses and our industrious society?

I opted for a dialogue with an exceptional photographer, Brian Skerry. The reasons for my choice will quickly be apparent: His photos are more eloquent than my words could ever be.

Looking from below the waves, and then from the sky, his point of view and mine answer each other and complete each other. And we share a similar approach. We have both seen the beauty of the world, and we have chosen to bear witness to it in order to protect it.

For while the planet has changed, and though multiple threats endanger it, it remains magnificent. And speaking of its beauty might give us the momentum to save it.

In fact, what I am offering here is a three-way dialogue. For this book cannot be solely attributed to Brian and me. It also belongs to a team of journalists and specialists headed by Olivier Blond. Every day they inform and alert us about planetary issues through the GoodPlanet Foundation, which I founded, on its website and in

countless public awareness publications such as this one.

This book is part of a new series of projects I am undertaking through my foundation, which includes a new film, made with Michaël Pitiot, titled *Planet Ocean*; educational posters in schools; exhibitions; and various awareness initiatives for children—all of which are generously supported by the Omega group.

This book is a choral work reflecting the collective efforts and new solidarities that will have to be formed to protect our planet.

**Stay in touch with the planet:
www.goodplanet.org**

Excerpts from the film *Planet Ocean* are accessible on the foundation's site, and these relevant clips can be accessed directly from the QR (Quick Response) codes you will find in each chapter.

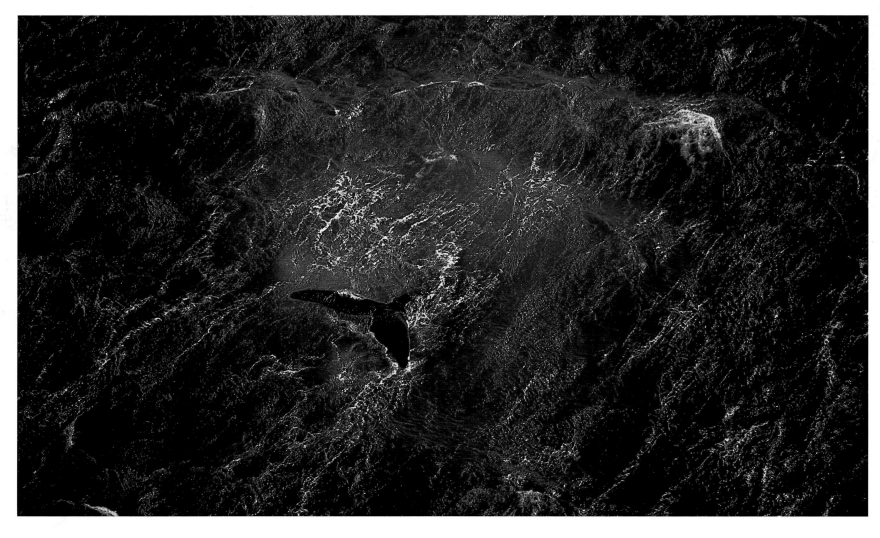

C333486908

FOREWORD BRIAN SKERRY

Once, an interviewer asked me what I thought the most important shot in the history of photography was. Without the slightest hesitation, I answered: "The first photo of the earth from outer space." I am sure I am not the only one who thinks this, but it bears repeating, because this extraordinary view of our planet tells us a great deal about where we live. The first thing you notice is water. We live in a world of water, a world that—as far as we know—is unique. Life was born in earth's primeval waters.

Those of us who love the sea do not need to be convinced that it plays a major part in our lives. Even when you live far from the ocean and do not have a direct connection to it, it remains vitally important to your existence. Most of the oxygen we breathe comes from the sea, as do many of our sources of protein. Many of the goods we consume on a daily basis are brought to us on ships crisscrossing the oceans. Yet despite its crucial importance for human life, we have always treated the sea with stunning contempt. We take everything we want from it and dump everything we don't want into it. And there are no real measures in place to protect and preserve it.

I have been exploring the planet's oceans for thirty-five years. I have seen extraordinary things there. In fact, I sometimes think of my career as a long series of profoundly moving experiences with underwater fauna and flora. But I have also witnessed terrible things in this time, things that take place underwater and probably remain unknown to most people. As a photographer and journalist, I have always felt a kind of responsibility and a sense of urgency, which have pushed me to bear witness both to these negative situations and the dazzling spectacles I have seen. Man is a "visual being," and I think that images touch our deepest core. Photographs of nature have the power to soothe and calm us, to intrigue and inspire us. They can also encourage us to change our behavior and take action.

We've included all kinds of photographs in this book; some are beautiful; others are disturbing. It is a great honor for me to collaborate on this volume with Yann Arthus-Bertrand, an artist I have long admired. I believe that this unique collaboration offers a rarely seen perspective of our "ocean planet." I have always felt that the two most appropriate points of view to look at the sea are from above and from the inside. This book brings the two perspectives together. Yes, we have been causing grievous damage to our oceans for generations, but take heart: It is never too late to do something about it. I am hopeful that interest follows awareness and that preservation measures follow interest, and that with our help the sea can be healed. It belongs to every one of us. It is time that we make it ours and protect what we love.

A WORLD
TO DISCOVER

"Free man, you will forever cherish the sea!" These are the first words of the Baudelaire poem "L'Homme et la mer" (Man and the Sea). Despite the fact that the world has changed a great deal since *Les Fleurs du mal* was published; the sea is no longer that mysterious, untamed force that was a call to adventure. Our century is that of the airplane rather than the transatlantic liner, fish is just another product in the supermarket, and we carelessly pour billions of gallons of waste into the oceans. The sea has largely been forgotten in our speedy urban lives. For centuries, the ocean was unknown; today it is ignored.

Sometimes horrific, sometimes marvelous, the ocean was once a thing of mystery and fantasy. Its gradual exploration—the "disenchantment" of the marine world—has not been completed; to this day, we know the surface of the moon better than the bottom of the oceans. But the tenuous protection the ocean was offered—by the relative lack of interest in the deep sea and the difficulty of reaching it—could be shattered by a combination of new economic interests and technological progress.

For centuries, ships were fragile. People said that only a few boards stood between a sailor's life and his death. Then, compasses gradually spread, and navigation charts—however simplistic—became common. In the fifteenth century, the caravel revolutionized navigation with its high sides and maneuverable sails. It allowed Christopher Columbus to discover America and Magellan to become the first to sail around the world. The oceans were opening up to man.

THE NEW ROAD TO THE INDIES

Yet, as Gaston Bachelard wrote: "Usefulness cannot legitimize the tremendous risk of going to sea. To face navigation, one needs powerful interests." The great Renaissance powers were driven to discover the world not only by scientific curiosity but also by the prospect of opening profitable trade routes. In this case, routes that would bypass the Silk Road, which was slow, unsafe, and controlled by enemies.

The vast fortunes amassed on expeditions around the world by conquistadors and trading company merchants—generally to the detriment of local populations—are legendary. As for Christopher Columbus, he was promised the titles of viceroy and governor-general of the territories he discovered and over a tenth of the riches he brought back.

The nineteenth century inaugurated a new golden age of exploration. The technical means had considerably improved, money was abundant, and explorers became the heroes of a human race that felt it could now dominate nature. Alexander von Humboldt is the emblematic figure of these scientific explorers who roamed the planet, filling herbariums with previously unknown flowers and describing the worlds they discovered with a curious eye. The incredible leaps forward made by science during this period were largely due to explorers: Charles Darwin's American journey, notably his stop in the Galápagos, inspired his theory of evolution.

OPPOSITE: **Shark Bay: sandbanks in L'Haridon Bight, Peron Peninsula, Western Australia** (25°59' S, 113°44' E)
Located at the tip of the Australian continent, Shark Bay looks like no place else on earth. Much of its 9,650 square miles (25,000 square kilometers) are covered in oxide-rich sand, giving the bay its unusual red color. Several spits of land, peninsulas, and islands separate the bay from the waters of the Indian Ocean; restricted water circulation limits its renewal, accounting for the seafloor's unique appearance.

SEAS MAKE UP 70 PERCENT OF THE EARTH'S SURFACE
As a planet primarily covered in water, the earth deserves its nickname "the blue planet." The oceans cover 105.3 million square miles (361.3 million square kilometers) of its surface. The Southern Hemisphere is known as the "marine hemisphere" because its seas occupy a greater area than the Northern Hemisphere's.

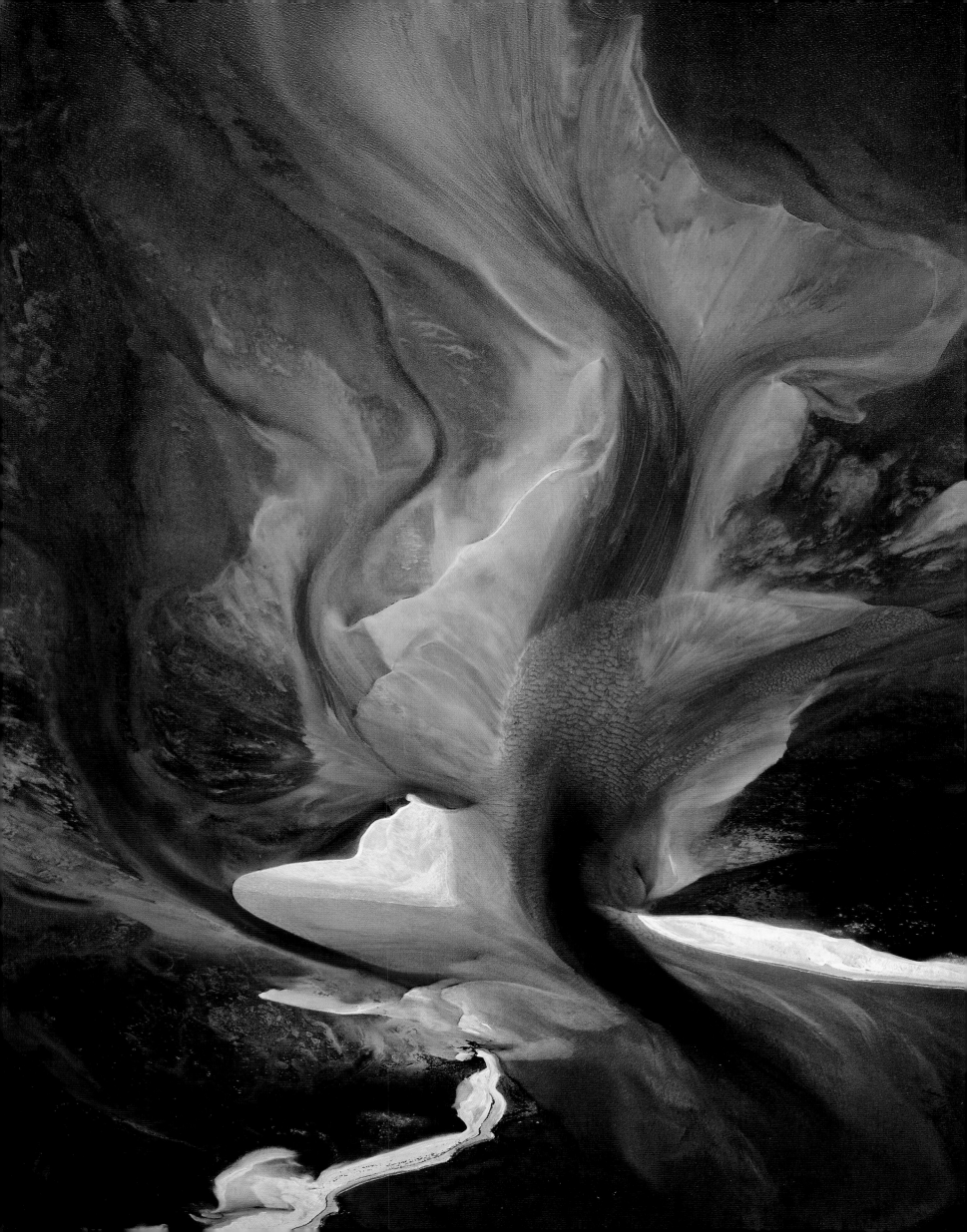

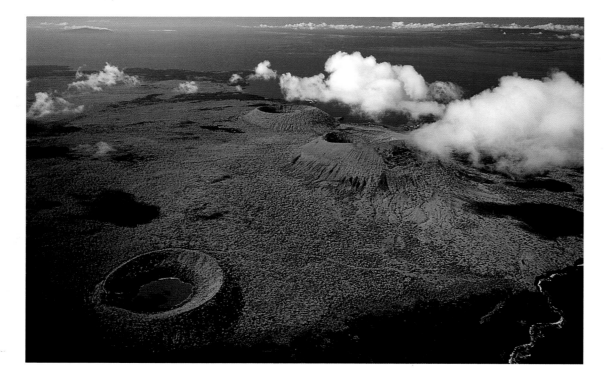

LEFT: **Volcanoes on the Galápagos Islands, Ecuador**
(0°20' S, 90°35' W)
Having emerged from the waters of the Pacific Ocean three to five million years ago, the nineteen volcanic islands forming the Galápagos Archipelago have exceptional biological riches you would not expect from their lunar appearance. The islands are home to the largest colony of marine iguanas in the world and to the giant turtle, or *galápago*, after which they are named. Darwin visited the archipelago during his 1831–36 voyage on the *Beagle* and was inspired to develop his theory of the evolution of species.

THE POLES

All that still resisted man's curiosity were the deep ocean and the poles. As the more easily accessible of the poles, the North Pole was the first to be reached. Several explorers claimed the exploit in 1908 and 1909, but these declarations were much contested. The true pioneers were the Norwegian Roald Amundsen and the Italian Umberto Nobile, who flew over the North Pole together aboard a dirigible on May 12, 1926. Much harder to reach, Antarctica wasn't explored by western sailors until 1820. Amundsen was also the first to set foot on it, in 1911. Many explorers, including Amundsen's rival Robert Falcon Scott and his team, lost their lives there.

Today, global warming has changed everything. With the melting of the ice caps, the vast natural resources buried under the Arctic are coveted by various nations, notably the Russians, who claim a large part of the region. According to the United Nations Convention on the Law of the Sea, nations can extend their sovereignty to the edges of their continental plate. The Russians allege that the Lomonosov Ridge under the Arctic is an extension of the Eurasian continent. This scientific question will largely determine the fundamental geostrategic issue. In late 2007, a Russian expedition made up of a nuclear icebreaker, a research ship, and two mini submarines explored the area and staked their claim by placing a titanium capsule holding the Russian flag 13,800 feet (4,200 meters) beneath the water surface.

Antarctica has been protected in part by an international treaty since 1959, but primarily by its inhospitable climate, with temperatures as low as −123°F (−89°C)! But as the quest for scarce resources continues, this protection may not remain sufficient.

DISCOVERING THE OCEAN FLOORS

Seafloors became crucially important in the nineteenth century. The development of telecommunications required the installation of underwater cables. But where? It became essential to map the seafloor. By observing the movement of waves, Pierre-Simon Laplace estimated the Atlantic was about 13,000 feet (4,000 meters) deep. But at the time the only way to measure depth was with a sounding line: a line marked at intervals to indicate length that is weighted at one end and dropped over the side of a vessel to estimate the depth beneath a ship. Despite obvious difficulties, the first underwater cable connecting France and England was installed in 1850. In 1858, the first transatlantic cable between Ireland and Canada was installed, extending 2,600 miles (4,200 kilometers) and weighing 7,000 tons. By 2012, there were 620,000 miles (one million kilometers) of fiber-optic cable ranging across the bottom of the sea.

DYING AT SEA

According to the International Labour Organization's estimations, at least twenty-four thousand fishermen die at sea each year, by drowning and in shipwrecks, capsizes, or fires. Most victims of the sea fish from frail skiffs off countries in the Southern Hemisphere, but the profession is also dangerous in wealthy countries and on more modern, better-maintained boats. In Norway, the probability of dying at sea is twenty-five times greater for fishermen than people working on offshore oil rigs. Overall, sea workers are twenty-five to thirty times more likely to have a lethal work accident than land workers. As this macabre assessment suggests, security and working conditions at sea remain crucially important. The probability of accidents increases with fatigue, stress, outdated equipment, and lack of training. There is also little supervision at sea, making it easier to disregard labor laws, notably by using forced labor, including children.

Despite the installation of telegraph lines, the world of the deep sea remained largely unknown. It is a hostile world: Pressure increases by about one atmosphere every 30 feet (10 meters), and, of course, one has to find a way to breathe. Diving only became possible after World War II, notably through the work of Captain Jacques-Yves Cousteau, who participated in the invention of the modern Aqua-Lung, supplanting inadequate earlier systems (bells, suits). Cousteau realized the potential importance of showing the underwater realm: *The Silent World* and his other films invited wide audiences to discover this new world. But even with the new equipment, people cannot dive much deeper than 100 feet (30 meters). Submarines allowed us to go deeper, their development spurred by a combination of military interests and the oil industry.

UNDERWATER COLD WAR

The Cold War was fraught with incidents between submarines—incidents of varying significance and degrees of public disclosure. Submarines had been revealed as key vessels by the Nazi military, and now carried atomic missiles. Their nuclear propulsion and oxygen extraction systems gave them practically unlimited range. With the unprecedented interest in hiding in the deep and detecting enemy boats, the underwater war took the exploration of the deep sea to a new level.

Exploration submarines regularly broke depth records. In 1960, Jacques Piccard and Don Walsh reached the bottom of the Mariana Trench, 35,813 feet (10,916 meters) below the surface. The crew was stunned to observe mysterious animals through the portholes, shattering the commonly held belief that the ocean floors were deserted.

Charts of the seafloor, known as bathymetric charts, were improved. The development of a public global chart, the General Bathymetric Chart of the Oceans (GEBCO), begun in 1903, was a particular milestone. These charts are generally based on data from

3 MILLION UNDISCOVERED WRECKS BELIEVED TO LIE ON THE OCEAN FLOORS

Wrecks of boats, warships, and planes are underwater museums. This subaquatic cultural heritage can be preserved for thousands of years in some environments. This is the case of the famous wrecks of the transatlantic liner the *Titanic* and Christopher Columbus's ships.

ABOVE: **Oceanographer Greg Stone in a rest station, *Aquarius* lab, Conch Reef, Florida Keys, Florida, United States**

The *Aquarius* platform is the only underwater lab in the world. Located off the coast of Florida, this lab was previously operated by the American National Oceanic and Atmospheric Administration, which announced in 2012 that it was suspending its funding. Greg Stone is an oceanographer, known for his key part in creating the marine protected area in the Phoenix Islands in Kiribati, one of the largest in the world.

LEFT: **Colony of northern gannets (*Morus bassanus*), Eldey Island, Iceland** (63°44' N, 22°57' W)
Nine miles (14 kilometers) south of the Icelandic coast, Eldey Island, a 230-foot (20-meter) rocky peak classed as a nature reserve, annually welcomes one of the largest colonies of northern gannets in the world, with close to forty thousand individuals. Arriving to nest on the island between January and February, the birds leave in September to winter off the coast of Africa, having given birth to a single chick per pair. During their journey, they must face natural threats (headwinds, predators), as well as human-related dangers (hunting, pollution, lack of fish due to overfishing).

sonar equipment aboard ships, but more recently also on planes. By measuring minute variations in sea levels, satellites can also calculate variations in the seafloor.

OIL EXPLORATION

In the 1940s and '50s, a new technological revolution jump-started seafloor exploration: the exploitation of offshore oil deposits. This stimulated underwater research and financed companies such as Comex (*Compagnie maritime d'expertises*, founded in 1961), which developed essential tools for research.

ROBOTS

But while technological advancements enabled divers to reach greater depths, the deep sea remained resolutely hostile. In 1988, Comex succeeded in sending divers to work 1,751 feet (534 meters) below the surface, but the process remained extremely unpractical. The alternative was to send robots.

While drones play an increasingly significant part in military operations today, they are also becoming indispensable for underwater exploration. Referred to as ROVs (remotely operated vehicles), they are increasingly used and have earned their stripes by locating several world-famous wrecks: the *Titanic*, the black box of Flight AF447 from Rio to Paris, and Antoine de Saint-Exupéry's plane off the coast of Marseille. They were also used to combat the oil slick caused by the explosion on the Deepwater Horizon oil rig in the Gulf of Mexico.

These robots will certainly play an important part in future exploration of the deep sea and the exploitation of its resources. For seafloors do not only hold hydrocarbons, but also diamonds, rare metals, etc. Many companies have their eye on these resources, though we do not yet know how to extract them. Environmentalists are following this research closely because it is more than likely that this will have a considerable impact on the environment.

UNLIKELY UNDERWATER DWELLINGS

Technical means and economic interests have now converged to allow the last unexploited area on the planet to be modified by man, probably to the environment's detriment.

But the ocean remains an inhospitable world. Captain Cousteau worked with several architects throughout his life to realize projects for underwater homes. The desire to live under the sea has always fueled dreams of a new Atlantis. Yet this goal remains far from realizable. As long as landmasses remain even slightly inhabitable, as long as we have not totally destroyed them, it is unlikely that permanent human settlements will be found under the oceans.

OPPOSITE: **Octopus with luminous suction cups (*Stauroteuthis syrtensis*)**
The octopus *Stauroteuthis syrtensis* originated in surface waters. By migrating to the deep sea, it developed the ability to create light with its suction cups. *Stauroteuthis syrtensis* eggs were recently discovered in the branches of a deep coral living 6,500 feet (2,000 meters) beneath the surface.

THERE ARE MORE THAN SEVEN THOUSAND OIL RIGS AROUND THE WORLD

Found in all of the planet's seas, these rigs provide about 25 percent to 30 percent of the world's hydrocarbon supply. Whether floating or anchored to the seabed, they have a life span of twenty to thirty years. As demonstrated by the Deepwater Horizon catastrophe in the Gulf of Mexico, this type of structure is highly vulnerable.

For more information on this subject and a relevant excerpt from the film *Planet Ocean*, go to http://ocean.goodplanet.org/monde-inconnu/?lang=en

ABYSSES LIFE WITHOUT LIGHT

The deep sea appears to be a hostile environment. Nonetheless, nearly all the phyla of the living world are present here, and species have developed original strategies for adapting to this environment's conditions. Beyond a depth of 650 feet (200 meters), there is a twilight zone where light is rare; at about 3,200 feet (1,000 meters), it is a world of darkest night. In the absence of light, photosynthesis is impossible and, without lighting, the animals that populate the deep sea cannot rely on sight to move, eat, or reproduce. Certain animals create their own light through bioluminescence. These creatures belong to varied groups including bacteria, jellyfish, tunicates, cephalopods, and fish. Their luminous organs vary widely and can serve different purposes, from lighting their way to serving as bait for potential prey. The humpback anglerfish (*Melanocetus johnsonii*) has a luminous lure, which it waves in front of its mouth. This luminescence, produced by symbiotic bacteria, also serves as a means

of communication or of camouflage and protection from predators: In the twilight zone, animals illuminate their bottom side, thereby blending in with light from the surface, when seen from below.

Outside of hydrothermal sources, food is not produced in the deep sea and principally comes from the surface. Food is rare at these depths, and animal species have had to develop strategies adapted to scarcity. The fangtooth (*Anoplogaster cornuta*) has the biggest teeth proportional to its size in the entire animal kingdom; combined with extraordinary swiftness, the fangtooth's jaw ensures that it rarely misses the small number of prey it encounters.

Organisms that populate the deep sea must also withstand cold temperatures ranging from 35°F to 39°F (2°C to 4°C) at the greatest depths. The temperature's extreme variability is even more striking than how low they are. Fluids from black smokers, hydrothermal sea vents (see page 72), can reach temperatures of 662°F (350°C); a few

feet away, the water is 35°F (2°C). Species are distributed around these vents according to their capacity to tolerate high temperatures. Bacteria, which develop at the vent's exit, are found at the highest temperatures: These organisms are known as "hyperthermophiles" or "extremophiles."

These organisms must also withstand tremendous pressure: At a depth of 32,000 feet (10,000 meters), the water pressure is one ton per 0.1 square inch (one square centimeter)! Bacteria have adapted, notably by modifying the composition of their membranes in order to make them pressure-resistant. Deep-sea fish do not have swim bladders—small air-filled organs that ensure bony fish's stability—and their buoyancy is ensured by liquid and gelatinous tissues and organs whose texture is less dense than water; they are therefore not compressed by the high pressure.

While apparently hostile, the deep sea is far from deserted. It is home to a diversity of life whose full extent remains unknown to us.

DISCOVERING THE DEEP SEA

INTERVIEW WITH DANIEL DESBRUYÈRES

DANIEL DESBRUYÈRES is the former director of Ifremer's department of deep-sea ecosystem studies. He has headed numerous manned submersible sea expeditions (including in the *Cyana* and *Nautile*) to study the deep hydrothermal springs in the eastern and western Pacific and in the Atlantic, southwest of the Azores. He has participated in dozens of dives aboard research submersibles, descending to depths greater than 3,280 feet (1,000 meters).

You are a pioneer of deep-sea exploration. How did it feel to be among the first to discover these ecosystems?

I was certainly aware of my luck at being among the few people to dive into the deepest reaches of the sea. I was, both literally and figuratively, in my bubble. In those exceptional moments, the challenge is to control your mind, because you are in awe, your eyes are as wide as saucers, and you nearly forget the reason for the dive! Over the years, I have been lucky enough to dive aboard the French submarines *Cyana* and *Nautile* and the American submarine *Alvin*. I have also had the opportunity to work with ROVs, a kind of remote-controlled submarine that is stunningly good at replicating the sensations of the dive . . . except that you can step out for a hot chocolate!

What did these deep-sea dives change?

In the early 1970s, our work was based on the description of species that we brought up from the deep sea. We used dredges and trawls, without any visibility, and we described this new diversity of life. An American team's discovery of the first hydrothermal spring in 1977 was a tremendous stroke of luck. Everything we thought about deep-sea environments was called into question: It turned out that life proliferated on the ocean floor. At first, no one really believed it. But it was the beginning of a long series of explorations and a beautiful scientific adventure.

> "It was a real revolution: an ecosystem that could live without photosynthesis!"

How was the disovery of the deep-sea oases of hydrothermal springs a revolution?

We had known there was life in the deep sea since the nineteenth century. In 1950, the *Galathée* expedition showed there was life at the bottom of the Mariana Trench, at a depth of 36,000 feet [11,000 meters]. But people were convinced that there was less life the deeper you got. We believed this because we thought that all food in the deep sea came from the surface and was increasingly scarce the deeper you went. At the time, we imagined a quasi desert with a few animals here and there. But by the mid-sixties, we knew that bait placed on the seafloor would be completely consumed in less than twenty-four hours, which proved that there is significant biomass in the deep sea. Then came the 1977 discovery of hydrothermal springs, which shelter rich, abundant ecosystems that are not dependent on the surface. On the surface, plants, which use the sun as an energy source, develop thanks to photosynthesis. But in the deep sea there is no light and organisms develop through a process called chemosynthesis. Microorganisms in these ecosystems are able to make their organic matter from the chemical compounds of the hydrothermal springs. They are able to burn these compounds for energy like we burn coal.

It was a real revolution: an ecosystem that could live without photosynthesis! Three years later, we discovered that this type of phenomenon does not only take place on ocean ridges and in hot springs, but also close to cold springs along the continental edges.

Does chemosynthesis explain the abundance of underwater life?

Actually there are two reasons. The first is that the microbes responsible for the chemosynthesis in these ecosystems are the equivalent of plants in other ecosystems and are therefore the base of the food chain. The second reason was revealed by studying a giant worm called *Riftia pachyptila*. This worm does not have a digestive tube and is therefore unable to ingest chemosynthetic bacteria. Yet it is found in abundance close to hydrothermal vents. It turns out chemosynthetic bacteria live in the very interior of these tissues: These worms live in symbiosis with microorganisms. Following this initial discovery, the phenomenon was discovered to be present among most hydrothermal animals. The symbiosis is so effective that it leads to an abundance of incredible animals.

It is fascinating to observe that a great number of animals live in such extreme conditions of temperature, darkness, pressure, and even radioactivity.

Can a connection be made between these discoveries and the appearance of life on earth?

That's subject to major debate! Initially, American researchers stated that hydrothermal springs could explain the origins of life. But since then things have gotten more complicated, and today the question is being debated—which isn't always straightforward, given that the question of the origin of life is obscured by all sorts of nonscientific arguments, including the most fallacious ones. In any case, we know that certain molecules that are synthesized in these ecosystems can be considered prebiotic. This means that they are the first building blocks of the living world. This is particularly true when the environments are rich in hydrogen and methane, conditions close to those in primeval times. But we are still a long way from the formation of cells and of life itself.

Could these original molecules be a reserve of future molecules for mankind?

We shouldn't kid ourselves about that. I deeply believe in what these compounds and their derivatives can and will bring us, but for the time being magic formulas do not exist. Yet the components of the organisms living in the deep sea have properties that can have applications in the field of biotechnologies. For example, mechanisms for repairing DNA are being closely studied, particularly in the field of cancer research.

With advances in underwater exploration, is it still accurate to say that the deep sea is less known to us than the moon?

That's a hard question. It's true that if you compare the explored surface to the total surface, we only know a few thousandths of it. But I think that today we have quite a precise idea of the main phenomena governing life on the seafloor—barring any unexpected major discovery, of course! If there's any area of the ocean that remains practically unexplored, it's open water. This environment requires complex technology, because we are dealing with animals that can be big and gelatinous and therefore fragile. There will probably still be major discoveries in the field.

Do we still have explorers in the historical sense of the term?

Yes! Exploration and explorers still exist, and oceans lend themselves to exploration. In fact, today's explorers are very similar to those of centuries past. They face the same problems encountered in earlier eras. Whether in the nineteenth century or early twentieth century or today, the primary difficulty was and remains to convince people and find the funding required for an expedition: The great discoveries are dependent on money and technological developments. The general public remains as fascinated by exploration as it always was, but the institutional world remains overly cautious. Exploration in and of itself has very little support from the scientific world.

"Today's explorers are very similar to those of centuries past."

Yet many view the deep sea as an el dorado. What do you think of the race for deep sea resources? Are the ocean floors in danger?

This is a huge subject, with several kinds of resources to consider: mineral, energy, and biological resources. It is only natural to try and exploit this vast territory, but it has to be done in a reasonable and sustainable manner. In exclusive economic zones, states are in a position to apply the rule of law within their territorial waters. Most of the water, oil, and gas resources are currently exploited within these zones. Which doesn't resolve all of the problems, but at least someone is accountable. Yet if you take France as an example, it has over 3 million square miles [11 million square kilometers]. What is it doing to identify and preserve these resources? Today the principal operations are for minerals; there is a real rush on them, particularly for the polymetallic sulfides that can be found around hydrothermal springs. The value of these minerals follows the price of oil. Thus they are increasingly sought after. There is also oil, gas, and clathrates—which are frozen methane.

What is your most beautiful exploration memory?

One in particular comes back to me: It was at the end of a dive on the *Alvin*, right when the crew at the surface was encouraging us to come back up and those of us on the bottom wanted nothing more than to stay. But we were starting to get headaches, so we got away from the hydrothermal spring to drop the submarine's ballasts. Suddenly, I saw a pink carpet covering several thousand square feet, entirely composed of gelatinous animals—stationary jellyfish. These strange, unknown animals hovered in a lustrous atmosphere, like a heat mirage. The colors and the way they moved in the lukewarm water made for a dreamlike vision.

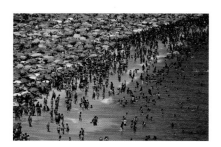

Sandbank on the coast of Whitsunday Island, Whitsunday Islands archipelago, Queensland, Australia (20°15' S, 149°01' E)

As can be seen on this Whitehaven beach, the coasts of the Whitsunday Islands are characterized by the exceptional whiteness of the sand, which is primarily composed of grains of quartz. This site belongs to the Great Barrier Reef Marine Park, which welcomes more than 2 million visitors a year. Tourism is well regulated and only has a moderate impact on this sensitive environment, unlike pollution from land and repeated invasions of crown-of-thorns starfish, which have damaged close to 20 percent of the coral reefs in the last thirty years.

Whale shark (*Rhincodon typus*), Mexico

The whale shark is considered the biggest fish on earth. While this sea giant can be up to 65 feet long (20 meters) and weigh more than 10 tons, it is totally harmless. Like its namesake the whale, it slowly travels along the water's surface, its 6-foot-wide (2-meters-wide) mouth open, feeding on plankton and small fish, which it placidly swallows by filtering seawater. Easily recognizable by the checked pattern on its back—which researchers use to identify individuals—the whale shark is found in warm and tropical waters. It can live more than one hundred years.

Fishing net near Dhaka, Bangladesh (23°43' N, 90°20' E)

Bangladesh is rich in rivers, lakes, ponds, estuaries, and natural hollows, all suitable surfaces for fishing and particularly aquaculture—a thriving field today. The country ranks sixth globally for its aquacultural production and second for freshwater aquaculture. About 1.4 million people work in the fishing field, largely for subsistence fishing and often seasonally, and 3 million in aquaculture.

Ipanema Beach, Rio de Janeiro, Brazil (22°59' S, 43°12' W)

The city of Rio has 22 miles (36 kilometers) of beaches, the most famous of which are Copacabana and Ipanema. These are social hubs for the Cariocas (inhabitants of Rio), who meet there after work or on holidays. The population of Brazil grew from 150 million inhabitants in 1990 to more than 200 million in 2011. Over the same period, the country experienced significant economic expansion and became the sixth largest global economy.

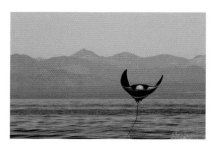

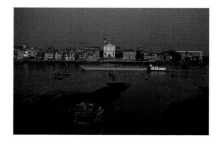

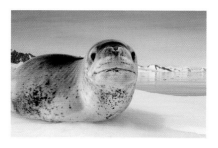

Sunlight on the mangrove, Belize

The emblematic species of this lush ecosystem is the mangrove tree. The tree survives in this unusual salty and marshy environment thanks to a network of aerial roots that anchor it to the ground but also draw oxygen from outside the airless, dense mud. Some species produce pneumatophores—vertical roots that literally come out of the ground to ensure the species can breathe. The mangrove tree reproduces by releasing sprouted plantlets, which are capable of taking root in the mud.

Manta ray (*Manta birostris*) leaping out of the ocean, Mexico

Also known as the "devil of the seas," the manta ray gets its name from the Spanish *manta*, which means "blanket." With its impressive span of 10 to 20 feet (3 to 6 meters), it is the biggest ray. It lives in small groups in tropical waters, often around coral reefs, where it finds plankton and small fish to feed on. The manta ray is not heavily fished, but is a tourist asset for countries where visitors can dive in its company. The motion of the manta ray's large fins when it is swimming make it look like it is "flying" underwater, and it sometimes even leaps out of the ocean. To this day, scientists have been unable to explain this behavior, though it might relate to a form of courtship display.

Pellestrina fishing village, Venetian Lagoon, Venice, Italy (45°15' N, 12°18' E)

The Venetian Lagoon is separated from the Adriatic by a barrier beach, a chain of narrow islands including Pellestrina Island and its fishing village. Like all lagoons, the Venetian Lagoon lives off the fragile balance of freshwater and salt water: The barrier beach that separates it from the sea only includes three passageways. The historic city of Venice, which is composed of 118 islands, was founded fifteen centuries ago.

Leopard seal (*Hydrurga leptonyx*), Antarctica

While it appears to be cuddly, the leopard seal—with its predator's teeth and spotted fur—fully deserves its name. Feeding on krill, fish, and young seals, it is also the terror of penguins on the ice caps. Yet it is one of the favorite preys of killer whales and sharks. More at ease in the water than on the ice, the leopard seal, sometimes known as the "sea leopard," lives in the cold waters of the Antarctic.

Uluru, Northern Territory, Australia
(25°20'40.82" S, 131°1'49.07" E)
Standing 1,141 feet (348 meters), Uluru, also known as Ayers Rock, is a sandstone rock in the Australian desert. Included on the UNESCO World Heritage List, this monolith is a sacred place for Aborigines, who forbid visitors from photographing certain parts of the site. The rock is composed of marine sediments that rose up and were then eaten away by erosion.

Young Caribbean reef squid (*Sepioteuthis sepioidea*) in a mangrove, Belize
Like octopuses, squid are highly intelligent invertebrates, which adopt advanced cooperative behavior to hunt a school of fish as a group. But before becoming an avid predator armed with long tentacles, the young squid feeds on zooplankton in a well-sheltered area. Mangroves are therefore natural nurseries for many marine species, which find all the food they need to develop in these oases of life shielded from the currents.

Estuarine crocodile (*Crocodylus porosus*), Buccaneer Archipelago, Kimberley, Western Australia
(16°16' S, 123°45' E)
The estuarine crocodile is the distinguished guest of the Buccaneer Archipelago northwest of Australia. This formidable carnivore is born in freshwater. Once it is chased away by more aggressive adult males, it moves to saltier waters, where it can survive due to its salt glands—a relatively rare feat among reptiles. Particularly sought after for the quality of its leather, this crocodile is nonetheless flourishing in Australia, where the preservation of wild habitats is combined with breeding farms.

American crocodile (*Crocodylus acutus*), Mexico
Generally from 6.5 to 13 feet (2 to 4 meters) long and weighing about 11,000 pounds (500 kilos), the American crocodile is one of the most imposing crocodile species. As its name suggests, this indigenous species lives in areas from the south of Florida to the north of South America. It prefers freshwater but can tolerate saltier waters, such as estuaries and mangroves, and can therefore live along coastal zones. While it primarily feeds on fish, the American crocodile will also attack and drag underwater any prey that comes within its reach.

Koh Pannyi village, Phang Nga Bay, Thailand
(8°20' N, 98°30' E)
Having become a marine park in 1981, the bay shelters the "floating village" of Koh Pannyi, which was built on stilts two centuries ago by Muslim fishermen from Malaysia. Tourism now supplements the traditional activity of fishing. The southwest coast of Thailand on the Andaman Sea has a succession of bays lined by numerous islands, including the touristy Phuket. In 2011, Thailand welcomed 19.1 million foreign tourists, or nearly twice the number that visited a decade earlier.

Pollack (*Pollachius virens*) swimming among sea pens (*Ptilosarcus gurneyi*) in the shallow waters of Long Sound, Fiordland National Park, New Zealand
Sea pens look like eccentric colored feathers but are actually animals. Anchored to the ground by their foot, they belong to the same zoological branch as jellyfish. Very beautiful at first glance, their tentacles are actually fearsome devices for preying on plankton, sea worms, and even crabs and fish. The dark color of the water here is due to the presence of a massive amount of freshwater from rain and rivers, not to its depth: The difference in salinity rates literally separates deep waters from surface waters.

Hutt Lagoon: salt lake and algae farming, Gregory, Western Australia
(28°10' S, 114°15' E)
Located in an arid region, 8.6 miles (14 kilometers) long and 1.2 miles (2 kilometers) wide, the Hutt Lagoon salt lake extends along Australia's northern coast. Its red color is due to the presence of a microalgae called *Dunaliella salina*. This algae is green in waters with limited salt levels, but turns pink and red when salinity increases. It is cultivated and harvested for the extraction of carotene, a pigment turned into paste, notably for food coloring.

Seal hunting ship, Gulf of Saint Lawrence, Canada
In the spring of 2012, the Canadian government granted hunters an annual quota of four hundred thousand seals in Greenland, while its own research departments recommended a quota of 300,000 to ensure the proper management of this declining species. This quota was set amidst controversy, in spite of the fact that Russia, which is the principal market for Canadian seal hunting, had previously decided to ban the import and export of Greenland seal fur.

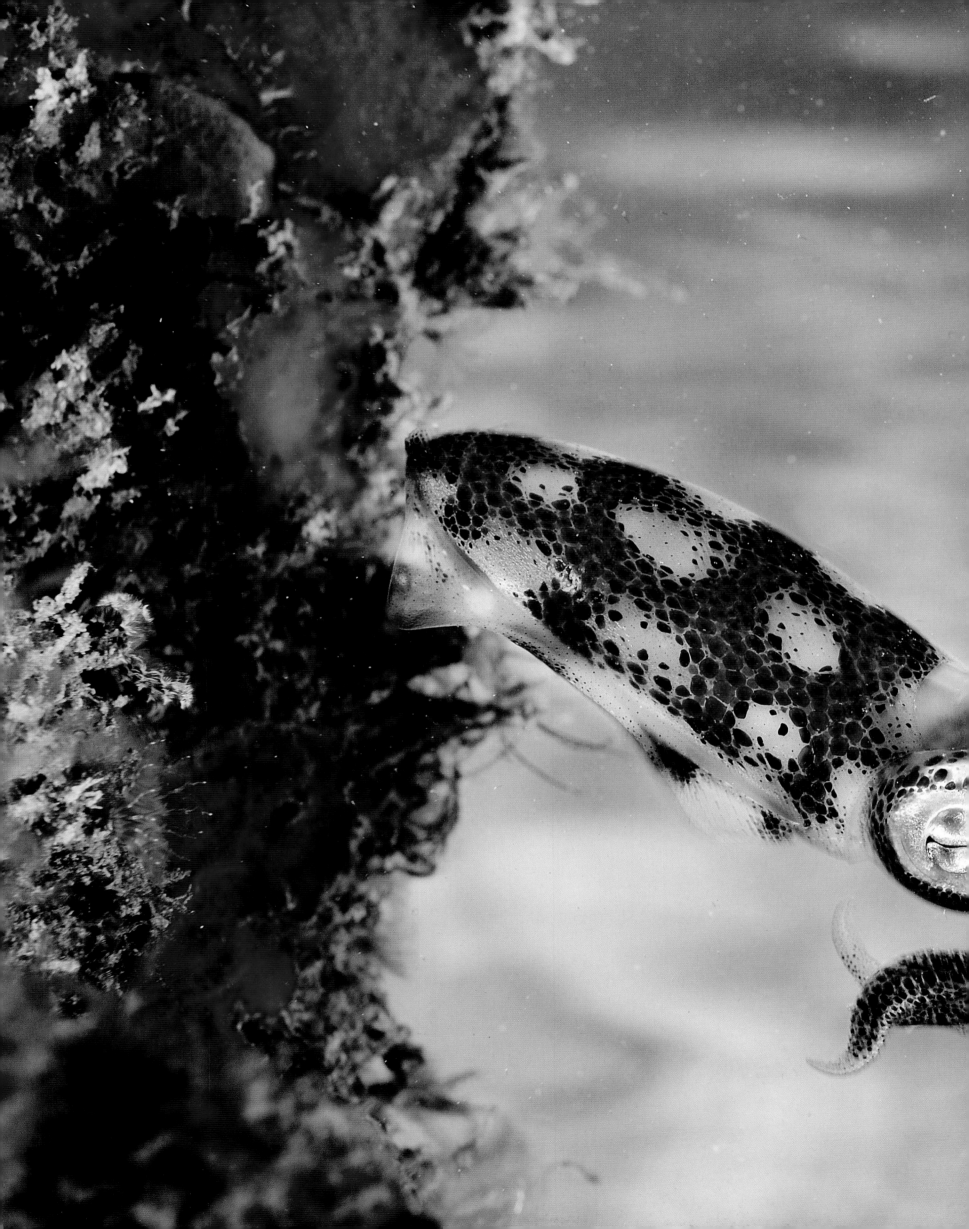

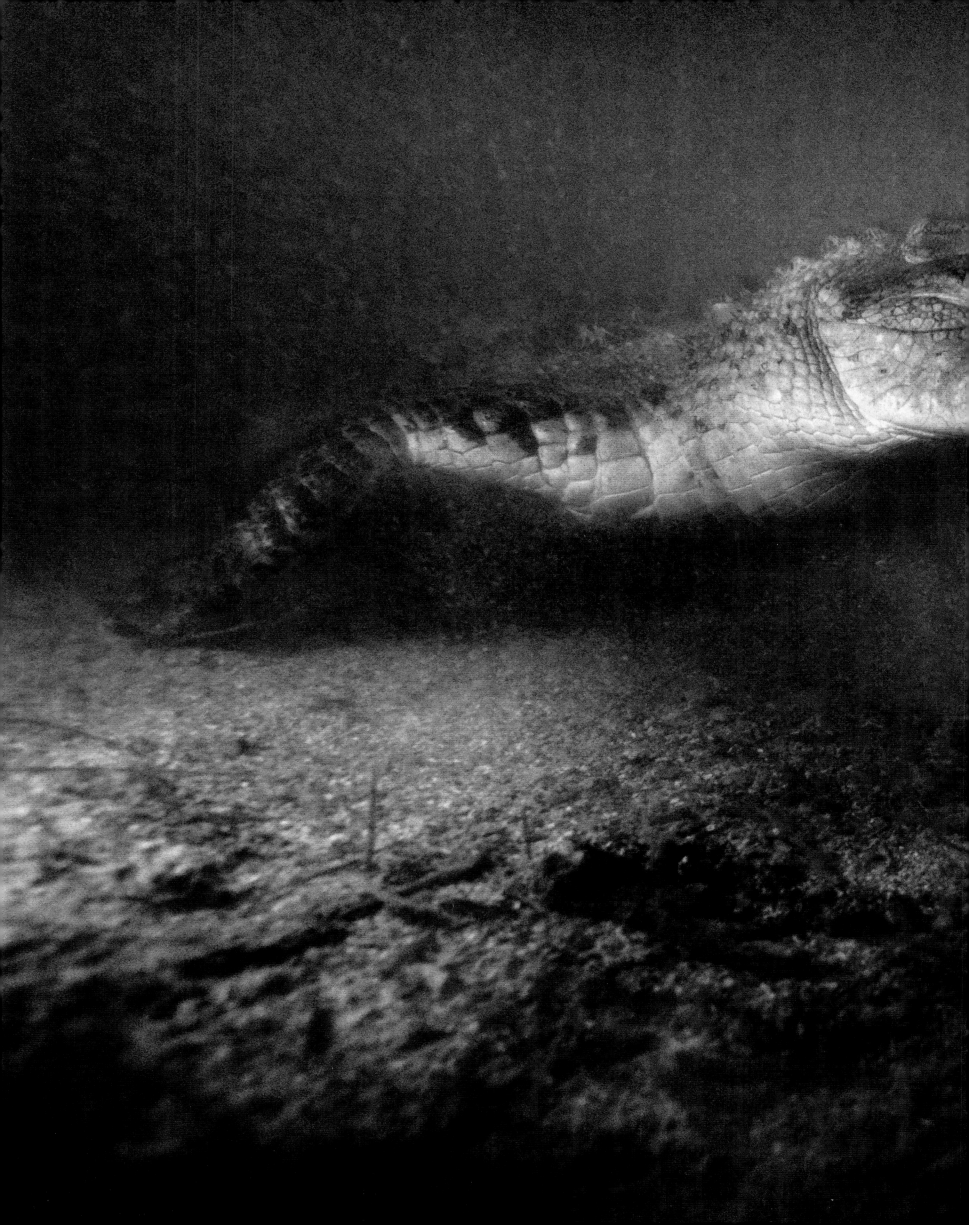

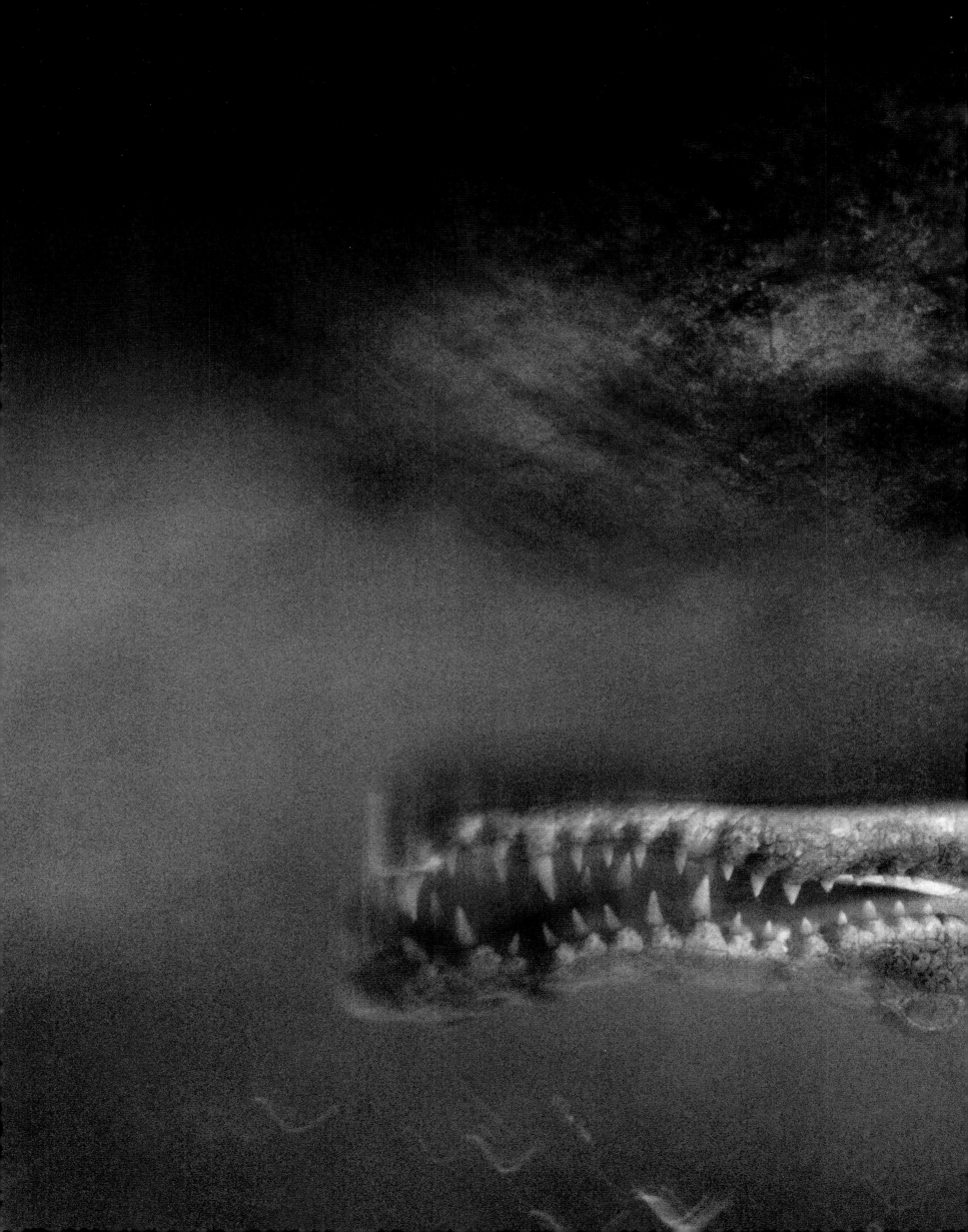

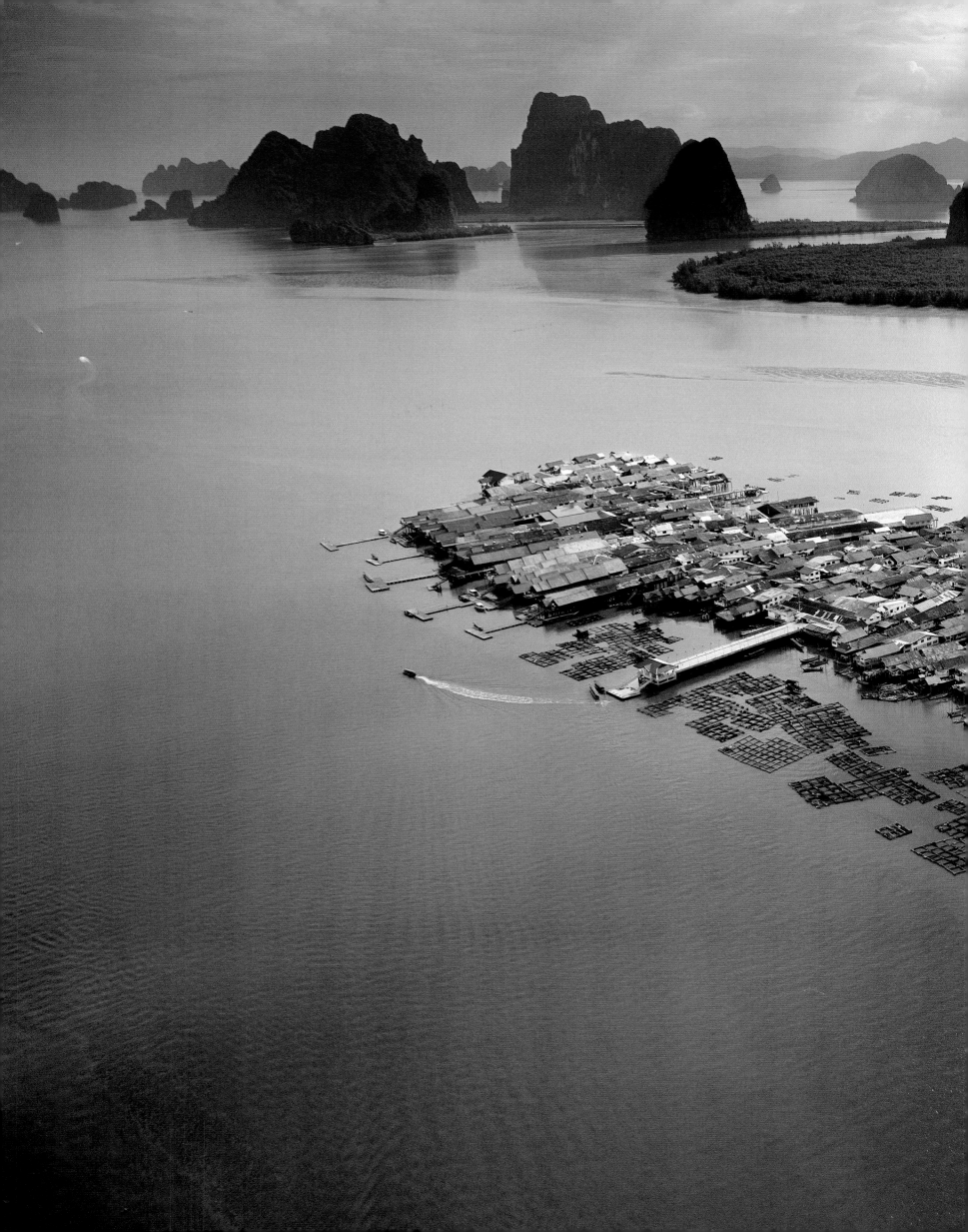

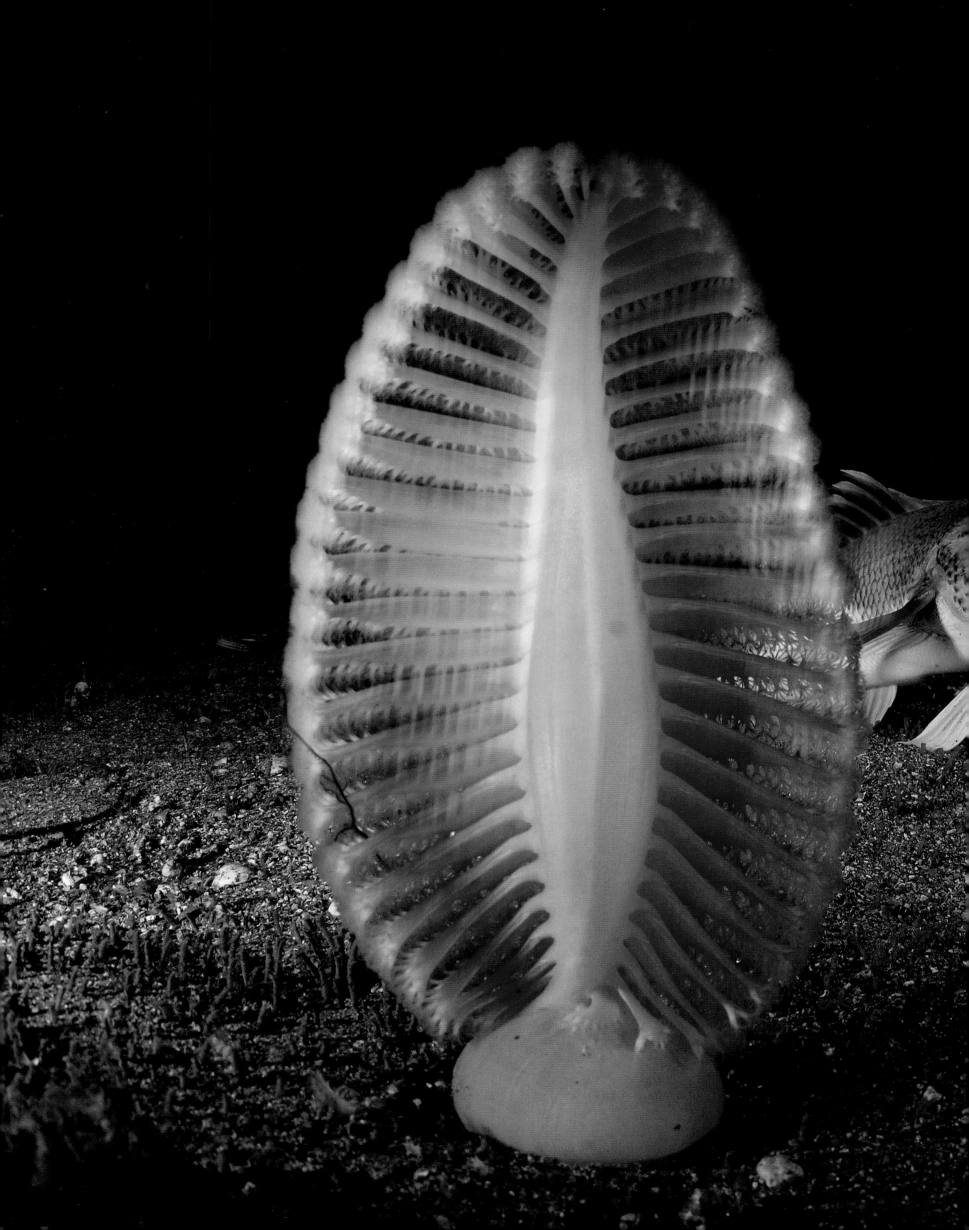

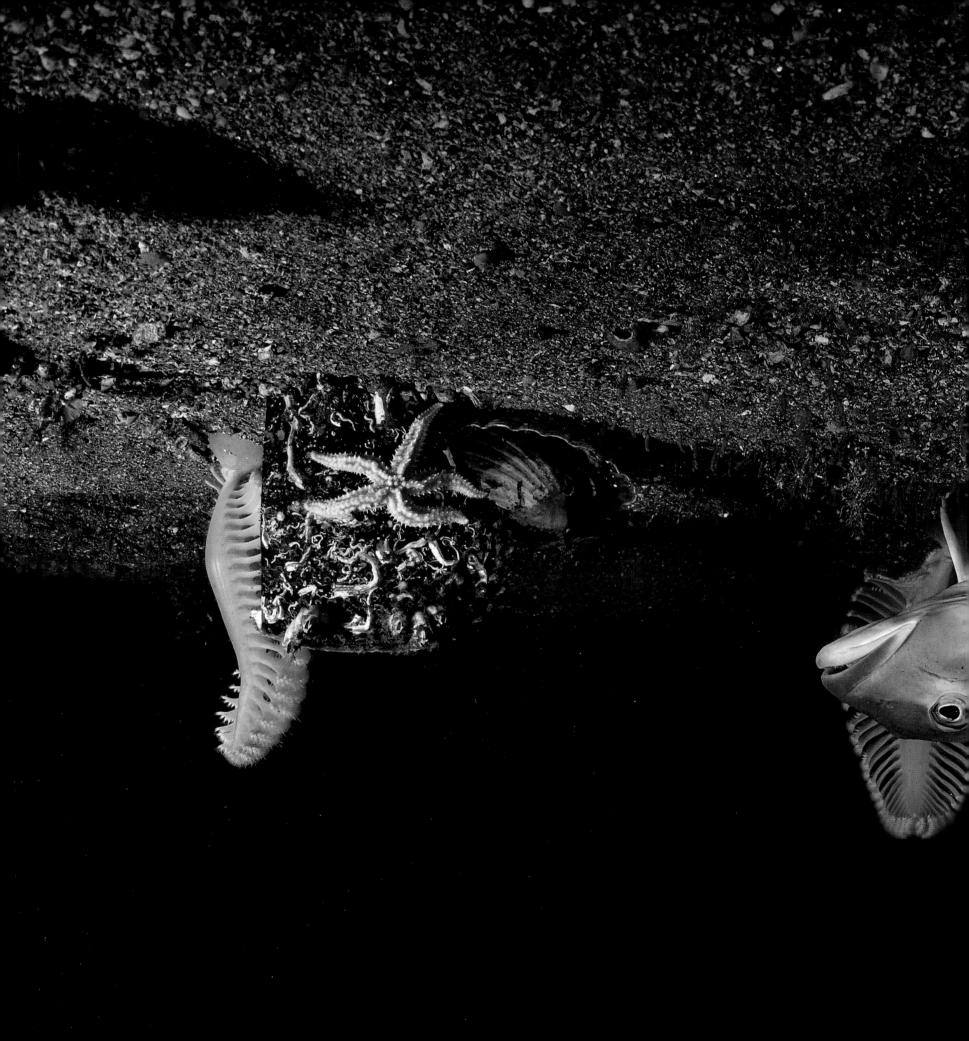

THE ESSENTIAL MOVEMENT OF THE OCEANS

Swells, waves, currents, tides . . . our planet's climate and life owe everything to the constant movement of the seas. But only a fraction of the water's motion is visible on the surface. Far more important currents are at play in the deep sea, over vast distances and in unsuspected proportions. On the surface, the ocean's waters principally move due to the wind and are conditioned by the amount of sunshine the planet receives. Their direction is also influenced by the Coriolis effect caused by the earth's rotation. Because these currents are affected by winds, both their direction and intensity vary according to season and even time of day.

EL NIÑO

Air masses and water currents are closely related, as demonstrated by the El Niño phenomenon. Pressure variations between the eastern and western Pacific follow a cycle called ENSO (El Niño–Southern Oscillation): When the Easter Island Anticyclone in the middle of the Pacific weakens, the wind system can even change directions; surface currents then lose their driving force and begin to change. One of the El Niño phenomenon's most famous consequences is the appearance of a current along South American coastlines, disrupting the local ecosystem and climate. We know that on average this phenomenon takes place two or three times per decade, but we do not know its exact causes.

However, the winds have little or no impact on deep currents. As the name indicates, these currents flow hundreds of feet below the surface. Thus they are also far more stable or constant. These currents' driving force is the temperature and salinity differences between water masses—beneath their apparent uniformity, the oceans are actually a collection of widely different waters in perpetual motion, with unique properties determined by their place of origin. Due to the high temperature and high rate of evaporation, water formed in the tropics is warm and salty. On the contrary, Antarctic water is cold and less salty due to the massive amount of freshwater it contains from the frozen continent. Each of these water masses forms, flows, and slowly dilutes over the course of a journey around the world that can last from five hundred to one thousand years.

The principal underwater currents form a cycle called thermohaline circulation, which plays a major part in an ocean's life. The journey begins in the tropics, where the trade winds push warm waters heated by sunlight on the surface toward the northern Atlantic Ocean. Collected in two major currents, the North Atlantic Drift and the Gulf Stream, these waters can reach a rate of flow of one billion cubic feet per second (30 million cubic meters per second) off the coast of Florida. Once they reach the seas of Greenland, Norway, Iceland, and Labrador, Canada, the surface waters cool as they come in contact with cold dry air from the Arctic.

OPPOSITE: **Squid, Sea of Okhotsk, Rausu, Hokkaido, Japan**
The name "squid" refers to more than three hundred species, from the most common ones, consumed by man, to mysterious giant species, which feed sperm whales and the imaginations of readers of *Twenty Thousand Leagues Under the Sea*. Science has long been interested in squid, whose intelligence fascinates researchers. In the 1950s, the electric nature of nerve messages was explained by experiments on the squid's giant axon. Squid are also very good pollution indicators: Scientists use them to study the effects of pollutants, such as those in heavy metals, tracing them throughout the food chain.

FIFTY THOUSAND DEATHS ATTRIBUTED TO THE 1997–98 EL NIÑO EPISODE

The list of catastrophes is long: Hurricane Mitch in Honduras and Nicaragua, leaving more than seventeen thousand dead and 3 million homeless; floods in Venezuela causing the deaths of thirty thousand people; droughts and forest fires in Indonesia; tornadoes reaching speeds of up to 250 miles (400 kilometers) per hour in Florida; record-breaking floods and snowstorms in the United States, etc. In financial terms, El Niño led to losses evaluated at 30 to 96 billion dollars by the United Nations.

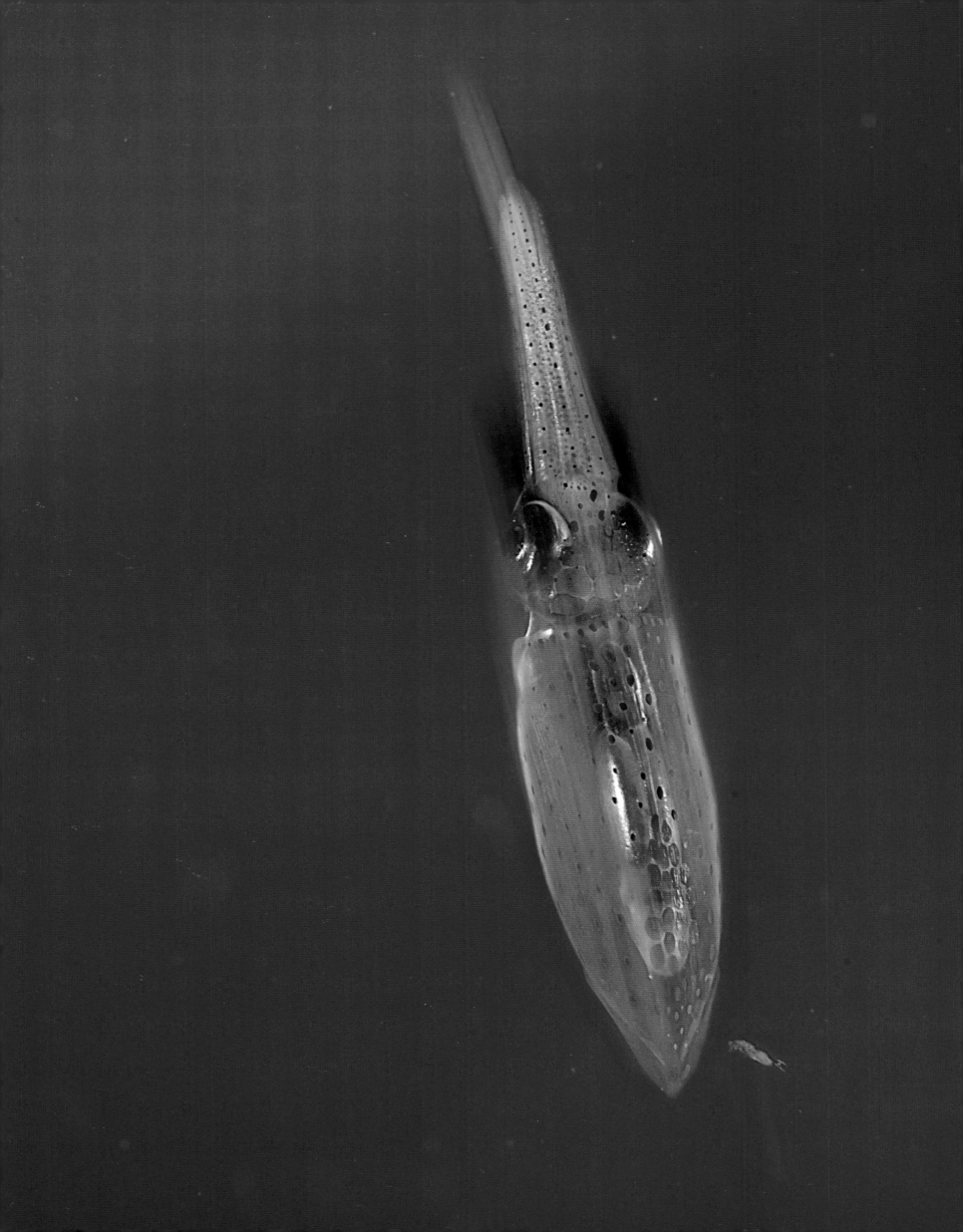

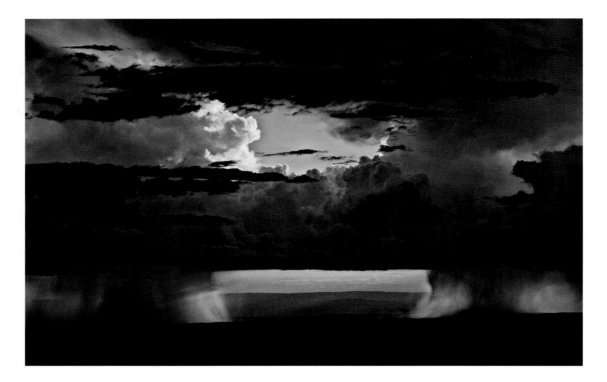

LEFT: **Storm over the Loita Hills, Kenya**
(1°50' N, 35°80' E)
Kenya has erratic precipitation, with long rainy periods from April to June and brief showers from November to mid-December. Often violent, the rain is accompanied by awe-inspiring storms, such as this one over the hills of Loita, which appear to be tied to the sky by terrifying columns of water. Yet long periods of drought are frequent in Kenya, one of the eight African countries most affected by these episodes, particularly in recent years. Temperature and water exchanges between sea and sky are determining climate factors.

As they cool down, the waters become denser and plunge down into the deep sea, pulled by their own weight. At the same time, they begin to flow south at a rate of 529 to 706 million cubic feet per second (15 to 20 million cubic meters per second).

The oceans' deep layers are thus reoxygenated by the massive contribution of oxygen-rich surface waters. Their descent to the south continues until they encounter the Antarctic Circumpolar Current, which allows these deep waters to reach the Indian Ocean and the Pacific.

These water masses' journey continues with a return to the north. By mixing with tropical waters, the deep waters return to the surface. The pattern comes full circle with the waters' return to the Atlantic via Cape Horn and the Cape of Good Hope. And a new cycle around the world begins.

These currents play an important part in the mixing of water, and influence the ocean's major biogeochemical cycles. Additionally, they form a kind of moving sidewalk, a genuine transportation method for migratory species or species unable to travel autonomously, such as microalgae and jellyfish. Surface currents also favor the scattering of eggs and larvae, thereby ensuring the maintenance and propagation of species.

UPWELLING

Ocean currents also contribute to the appearance and survival of life in the oceans in another way. When plankton and other marine organisms die, they sink to the bottom and are decomposed into nutrients, which is why waters flowing in the deep ocean are rich with mineral elements essential to life. When they rise back to the surface—a phenomenon called upwelling—they are enriched with oxygen and encounter the sunlight. At that moment, the conditions are ideal for the development of phytoplankton, which multiply rapidly through a phenomenon called a bloom. Billions and billions of microscopic plant organisms appear. These organisms display an incredible diversity of shapes and sizes. For instance, diatoms—round protective shells made of fine, light silica—provide them with improved buoyancy. Other genera, such as the dinoflagellate *Ceratium*, develop horn-shaped outgrowths or gather in colonies to improve their buoyancy.

This phenomenon is essential because phytoplankton are the first link in nearly all marine ecosystem food chains: zooplankton, small crustaceans, filtering mollusks, marine worms, and small fish all feed on these microorganisms. The phytoplankton's dynamics are essential to every trophic level up to the great predators, including man.

5 BILLION CUBIC FEET (150 MILLION CUBIC METERS) PER SECOND

This is the volume of water moved by the Antarctic Circumpolar Current. One hundred and fifty times the amount of water carried by all the rivers in the world put together! It is the most powerful current in the world. It flows around Antarctica from west to east and is well known to sailors, who also call it the "West Wind Drift."

Maritime resources are therefore directly connected to marine currents and the most prolific fishing zones are located in areas enriched by rising deep waters. Along the coasts of Chile, Peru, and Ecuador, southern winds chase the warm surface waters away and allow deep waters to rise again. Here, deep waters favor the proliferation of plankton in unmatched proportions, making the west coast of South America one of the most fish-rich regions in the world: With less than one percent of global ocean surface, this upwelling zone provides between 15 percent and 20 percent of global catches, or close to 20 million tons per year in Peru and Chile combined—the most heavily fished species on the earth's surface is the Peruvian anchovy, which alone represents 10 percent of global catches. The fact that upwelling is closely dependent on currents is particularly perceptible when the El Niño phenomenon is in force: This wide-scale weather anomaly directly threatens fishing because the El Niño current causes fish to leave the coastlines, making resources collapse and ruining the fishing trade.

OCEAN AND CLIMATE

The global ocean's movements do not only control nutrient dynamics; they also enable the exchanges between ocean and atmosphere, which are responsible for our climate. The oceans' large thermal capacity allows them to collect vast quantities of heat and redistribute it, thereby tempering the climate's effects. One of the best-known examples is the Gulf Stream's effect on the European climate: When it flows back north, the Gulf Stream gets closer to European coastlines, and western winds warmed by this hot current make the continent's winter season more temperate. Thanks to the Gulf Stream, Europe has a far gentler climate than North America's east coast, though they are on the same latitude. In winter, the temperature in Paris can be up to 18°F (10°C) higher than in Montreal, and sometimes even more, despite the fact that the French capital is more northerly than the city in Quebec.

The ocean can absorb our atmosphere's carbon dioxide (CO_2) and limit its accumulation: Due to pressure differences between the atmosphere and the ocean, CO_2 is

ABOVE: **Chart of surface currents in the Indian Ocean**

This chart of currents prepared by NASA is based on satellite data allowing visualization of ice floes and the ocean's movements. This document only shows surface currents, those primarily driven by the wind. The south of the African continent appears as a zone of particularly intense currents: The Agulhas Current flows down South Africa's east coast and splits in two, with one part of the Indian Ocean's waters being carried to the Atlantic, while the other returns to the Indian Ocean by mixing into the Circumpolar Current.

naturally sucked up by the surface. This purely physical suction is maximal in cold waters, while on the contrary warm waters tend to release part of the carbon accumulated.

This physical pump is supplemented by a "biological" pump, whose principal agent is phytoplankton. Like terrestrial plants, phytoplankton can absorb CO_2 by photosynthesis and produce oxygen. Algae, the organisms that consume it, and the waste produced by these organisms are all carbon-rich organic matter that sediments to the ocean floor. The net annual balance (including the impact of both the physical and biological pump) is 2.2 gigatons of carbon absorbed by our oceans. Only a small part of this carbon will be held durably, in mineral form, in marine sediments. Ninety percent of the carbon is recycled at the surface. And of the 10 percent that sinks into the deep sea, only one percent will be permanently stored in mineral form. Nonetheless, the ocean is considered the planet's major carbon sink, since it absorbs nearly a third of atmospheric CO_2. At the same time, phytoplankton produces oxygen, which is released into the atmosphere. Contrary to popular belief, forests are not the planet's lungs: The ocean is its principal reservoir of oxygen. It is also the principal producer of oxygen, generating between 50 percent and 70 percent of the oxygen we breathe.

BLUE ENERGY

The oceans carry tremendous energy. Yet this energy, which has been studied for its environmental and climate impact, remains significantly underexploited if you consider that the oceans' energy potential is estimated at 120,000 terawatt hours per year, or more than six times global electricity consumption (about 18,000 terawatt hours per year). Several types of technology exist to capture this energy, but have not yet been developed on a large scale. Tidal energy, for example, uses the ebb and flow of the tides: Two to four times a day, the water enters a reservoir and activates turbines, which then produce electricity; on a global scale, the potential production is of 22,000 terawatt hours. Some tidal factories are operational, notably in France, where the La Rance Tidal Power Plant produces 540 gigawatt hours per year, or the equivalent of Rennes', a city with a population of more than 200,000 people, consumption. Tidal energy turbines have nearly as much potential. Similar to how wind turbines capture the energy of air movement, tidal energy turbines use the energy of marine currents. Several projects have already been realized and others are in development, notably in the United Kingdom and at the mouth of the East and Hudson rivers in New York. Other forms of blue energy are currently being studied, such as wave energy, which uses the energy of waves and swells, or the seas' thermal energy, which uses temperature differences between surface and deep waters in intertropical zones—both of which have vast potential. Given the importance of energy issues for our planet, the domestication of this energy would open exciting possibilities for sustainable development.

GENOMICS

The introduction of molar biology—techniques based on the study of DNA—has revolutionized our vision of marine microbe biodiversity in the last twenty years. For example, the classification of diatoms, the dominant phytoplanktonic organisms, was formerly based on the particularly challenging examination of the patterns formed by their silica shells. Additionally, many of these organisms are impossible to isolate, far less cultivate, in a laboratory. Genetics allow us to identify them based on their DNA, even leading to the identification of new, previously unknown or inaccessible species. An entire class of plankton, the picoplankton, was discovered: It includes organisms whose sizes range from 0.2 to 2 micrometers. With the most modern genetics techniques—a discipline referred to as "genomics"—the massive and rapid sequencing of plankton's DNA has begun, in hopes of better understanding these organisms, but also of finding new pharmaceuticals or molecules with industrial uses.

OPPOSITE: **Planktonic dinoflagellates of the _Ceratium_ genus**

Dinoflagellates are among the most important types of phytoplankton; there are about two thousand species in existence. These microorganisms consist of a single cell and a rigid cellulose shell. As the name implies, they have a small filament, the flagellate, which allows them to move. Some of these organisms can also exist in symbiosis with other organisms. This is the case with zooxanthellae, algae which have a mutualistic relationship with coral.

For more information on this subject and a relevant excerpt from the film _Planet Ocean_, go to http://ocean.goodplanet.org/climat/?lang=en

PHYTOPLANKTON SMALL BUT SIGNIFICANT

Plankton include all the small organisms that float freely in the water column. Even when mobile, these organisms are unable to go against the power of the currents and therefore drift with them. Thus, plankton are defined in relation to their ecological niche rather than a particular biological group, and the term refers to an extremely wide variety of living beings. Phytoplankton differ from zooplankton, which are not able to grow thanks to light and photosynthesis. Plankton can also be distinguished according to size: nanoplankton (2 to 20 micrometers) or microplankton (20 to 200 micrometers), for example.

Scientists have identified some five thousand species of phytoplankton in marine environments. These play an absolutely essential role as a group. Though each individual consists only of a single cell less than 0.2 millimeters, taken together phytoplankton represents 98 percent of the oceans' biomass. Phytoplankton is at the base of the marine food chain. Absorbing 30 percent of our CO_2 emissions and producing between 50 percent and 70 percent of the oxygen we breathe, it also serves as the earth's lungs. As with terrestrial plants, its efflorescence is a seasonal phenomenon depending on light, temperature, and the provision of nutrients. When phytoplankton suddenly develops in a massive, rapid way in spring or summer, it is referred to as a bloom. High concentrations of phytoplankton, up to several million cells per milliliter, turn the water a green, blue, brown, or red color visible from outer space. Good phytoplankton growth is also essential to aquaculture: Because mussels and oysters feed on phytoplankton, their breeding depends on its abundance.

Plankton composition is also significant. This is why health authorities suspend the consumption of shellfish when plankton comes in contact with toxin-bearing microalgae such as *Dinophysis* or *Alexandrium*. The appearance of these toxic species is precipitated by massive contributions of nitrates and phosphates from the land and therefore is essentially caused by intensive agricultural practices.

With the advent of biotechnologies, phytoplankton is now considered a resource of the future. Spirulina, for instance, is cultivated and sold as a dietary supplement. But the principal field of research is in the production of biofuels: Because their growth rate and yield are greater than terrestrial plants, microalgae are good candidates for the production of fuels. Additionally, microalgae do not take up arable land, which is beginning to be in short supply and can therefore be reserved for producing food. However, industrial processes do not yet allow the production of microalgae at a large scale or at a reasonable cost.

Meanwhile, water acidification, which is related to climate change, is a threat to phytoplankton, and the growth of certain algae that produce shells or calcareous structures may be stunted in more acidic waters.

LIVING AND DYING FORTY-FIVE TIMES A YEAR

INTERVIEW WITH PAUL FALKOWSKI

PAUL FALKOWSKI is a specialist in phytoplankton and marine photosynthesis. He teaches at the Institute of Marine and Coastal Sciences at Rutgers (New Jersey). He is part of the scientific advisory board for the Tara Oceans expedition.

The oceans have tremendous biodiversity, particularly on a microscopic level. How important is that?

The vast majority of the oceans' biodiversity is microscopic. But like many things that are invisible, its importance was long neglected. Phytoplankton was only discovered in the last century, and our understanding of its role is very recent. The appellation "phytoplankton" includes two types of single-cell organisms: cyanobacteria and microalgae, which share the ability to carry out photosynthesis, the production of organic matter from nutrients and sun. Thousands of these organisms live and proliferate in a single drop of water. Through various methods, biologists have estimated that about one billion tons of phytoplankton is permanently found in the oceans. Which is huge. At the same time, this only accounts for about one percent of the biomass of photosynthetic organisms on our planet, which largely consists of terrestrial plants.

But phytoplankton plays an essential part in our atmosphere?

It certainly does. It is responsible for nearly 50 percent of photosynthesis. To evaluate its importance, you must understand that, more than the biomass itself, the important thing is the speed at which it renews itself, which is to say the speed at which new living matter is created and carbon is captured and oxygen released. Terrestrial plants have a biomass of 500 billion tons, essentially in the form of wood, but their renewal is slow; it is estimated that it occurs about every ten years. On the contrary, a phytoplankton cell only lives five days and renews its biomass forty-five times a year! Therefore, there are 45 billion tons of new phytoplankton each year. This high activity is what allows phytoplankton to be so productive.

What is phytoplankton's impact on the atmosphere's composition?

Twenty-one percent of the air we breathe is composed of oxygen, and the oceans produce half this oxygen. So yes, in one way, we should be grateful for phytoplankton. But not only: We should also be grateful for the oceans' ability to store carbon on the seafloor. This requires the entire ecosystem to function. In the forest, trees are not being constantly or totally eaten, while phytoplankton is devoured in large quantities by a whole range of organisms. This explains why the carbon it produces efficiently moves through the entire food chain. Part of this carbon-rich matter—bodies, feces—will slowly fall toward the deep sea. It will carpet the ocean floor or be carried in the slow circulation of the deep ocean, from which it will only emerge several hundreds of years later. This process is called a biological pump. Without plankton, greenhouse gas concentration would be much higher than it already is.

> "Without plankton, greenhouse gas concentration would be much higher."

How is phytoplankton distributed? Which are the most productive zones in the ocean?

Phytoplankton needs light—it proliferates in the first 330 feet [100 meters] of the water column—and nutrients. Consequently, coastal zones and continental margins are the ideal places for its development. There are very productive zones along American coasts, in the North Sea, but also in Antarctica. Winds also play an essential part in the production of phytoplankton. In certain areas of the ocean, winds drive nutrient-rich deep waters back to the surface; this is upwelling. Today the most productive zone in the ocean is probably the area of the Benguela Current (named after a city in Angola), which flows up the western coast of Africa from South Africa. The western coasts of South America are also particularly rich due to the Peru upwelling.

Do coastal zones sometimes become too nutrient rich?

Everything we use and throw away on land is likely to wind up in our coastal waters one day. The rivers carry impressive quantities of nutrients such as nitrogen—principally in the form of nitrate—particularly when they cross densely populated areas or areas of intensive agricultural activity. Under the influence of these additional nutrients, algae develop in excess, which leads to what we call eutrophication.

This phenomenon is now well documented. Unfortunately, it is widespread along our coasts. For instance, the Gulf of Mexico (because of the Mississippi), the Black Sea (because of the Danube), and even France (because of the Rhône) are areas where an increased level of nutrients is a real danger to the ecosystem.

Does eutrophication lead to the formation of dead zones?

When the quantities of nutrients are too high and phytoplankton develops to excess, we encounter the phenomenon of dead zones. When these algae die, bacteria break them down, using up the oxygen in that environment in the process. As the oxygen disappears, the entire ecosystem suffocates—eventually, no other life form is possible. This happened in the Adriatic Sea, the Gulf of Mexico, and the China Sea.

Is this irreversible?

No, it isn't irreversible. The oceans have a natural ability to evacuate excess nitrates. But the quantities are such that the ecosystems cannot compensate for the increased level of nutrients fast enough. The only real solution is to reduce the level of nutrients.

Leatherback turtle (*Dermochelys coriacea*) and its remoras (*Remora remora*), Kai Kecil Island, Maluku Archipelago, Indonesia

The leatherback is the biggest sea turtle. It can be as long as 6.5 feet (2 meters) and weigh up to a ton. It also holds the diving record for reptiles: It can reach depths of 4,265 feet (1,300 meters). Leatherback turtles lay their eggs on beaches but mate in the sea. Yet no scientist has ever succeeded in observing their coupling, which remains a mystery. Males never return to their place of birth.

Algae harvest, Bali, Indonesia
(8°17' S, 115°06' E)

About thirty thousand species of algae are known around the world, of which only a few dozen are exploited commercially. Some are cultivated to be consumed untransformed; others are used as raw material in the agribusiness, pharmaceutical, and cosmetics industries. This activity requires unpolluted waters and does not destroy the marine environment. Today the United Nations' Food and Agriculture Organization (FAO) encourages algae farming, which is considered an efficient means of battling food scarcity and poverty.

Biologist discovering an old coral formation on Kingman Reef, Pacific Ocean, United States

Kingman Reef is a lagoon close to Hawaii. Located only 3 feet (1 meter) above sea level, it is often flooded and remains uninhabited. It was named a national wildlife refuge in 2001. In 2009, the reef was included in the Pacific Remote Islands Marine National Monument, composed of a group of uninhabited American islands in the Pacific, far from the continent and home to numerous endemic species, including corals, birds, plants, and marine mammals.

Mouth of the Markarfljót River, near Mýrdalsjökull, Iceland
(63°32' N, 20°05' W)

Fed by Mýrdalsjökull, a 300-square-mile (800-square-kilometer) glacier in the south of the island, the Markarfljót River skirts around the small Eyjafjallajökull to the north, following a hesitant path over a large plain of basaltic sediments before opening onto a black-sand beach on the Atlantic. Like all glacial streams, the Markarfljót spreads over a glacial evacuation plain in a dense network of braided channels. Its course varies constantly and reaches its maximum rate of flow in July and August, when the ice is at its peak melting rate. Climate change could perturb this natural seasonal rhythm.

Whiting swimming between the tentacles of a *Pelagia noctiluca* jellyfish, Mediterranean

Pelagia noctiluca, the most venomous jellyfish in the Mediterranean, is well known to vacationers on the Côte d'Azur who fear the sting of its purplish tentacles. These jellyfish live in depths of up to 1,300 feet (400 meters) and return to the surface at night. When currents drag them to shallow waters, they can migrate and die washed up on the beach. By overfishing, man is gradually eliminating the natural predators of jellyfish, which are proliferating as never before, precipitating the ecosystem's decline and creating a nuisance to swimmers.

Cultivating nori seaweed in the Ariake Sea, Kyushu, Japan
(33°08' N, 130°13' E)

Thanks to nori, a seaweed particularly appreciated for its taste and nutritional properties, Japan has the most valuable harvest of aquaculture algae (nearly 1.3 billion dollars); the industry employs about thirty-five thousand people. Seaweed cuttings are fixed to ropes immersed in water and extended between wood posts, following the principal current. The plant develops rapidly: It only takes forty-five days for it to grow from being sowed to the first harvest. Of the approximately thirty thousand algae species known to man, only a few dozen are exploited commercially.

Whale shark (*Rhincodon typus*), Mexico

The solitary, peaceful whale shark's only predators are the killer whale, man, and a few other sharks. But overfishing is threatening the species. While the whale shark's great mobility makes the total population difficult to evaluate, the International Union for Conservation of Nature (IUCN) considers the species vulnerable. In February 2012, an unconscious 39-foot (12-meter) specimen was brought in to the port of Karachi, Pakistan; four cranes were needed to get it out of the water. It was sold for 14,000 Euros.

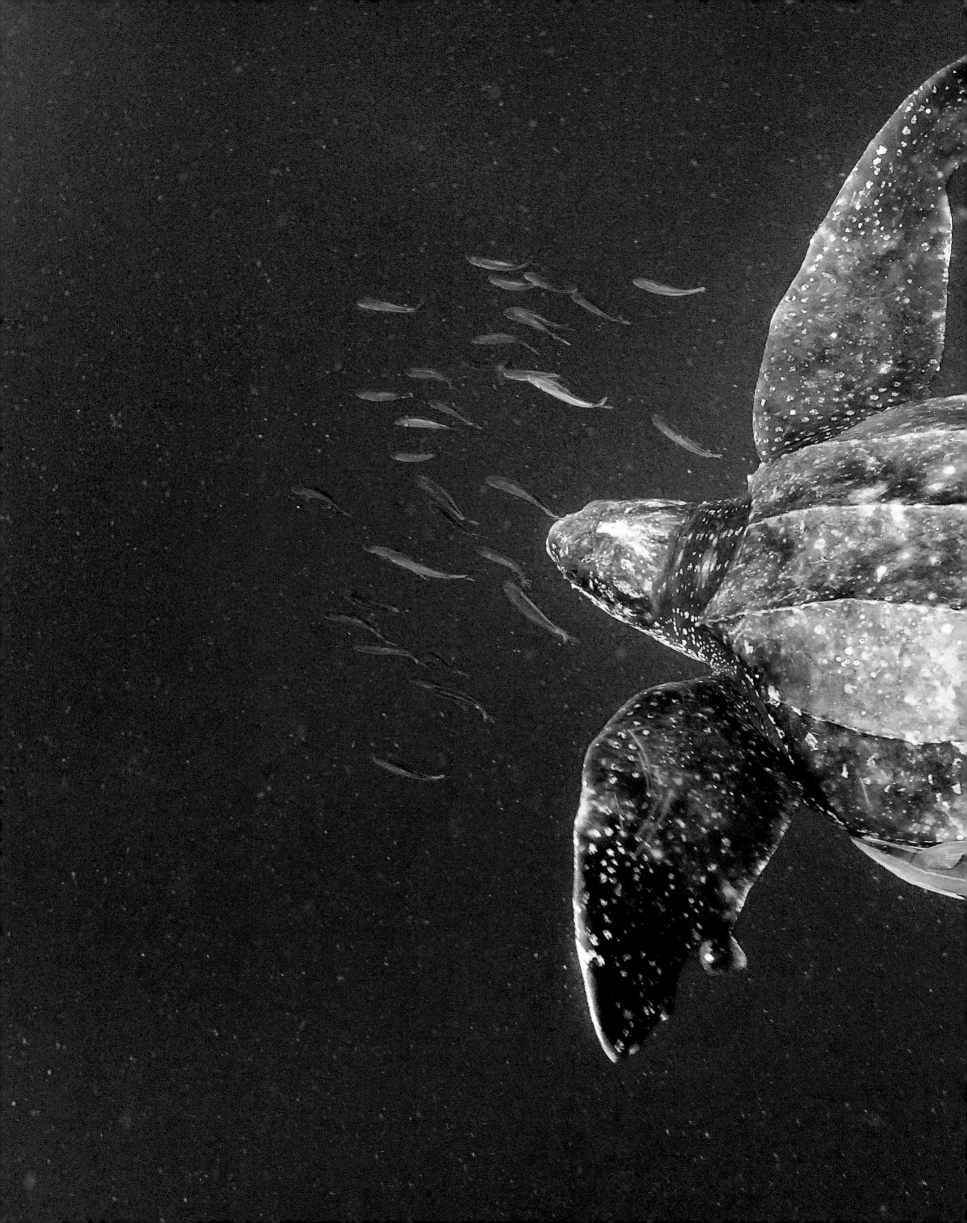

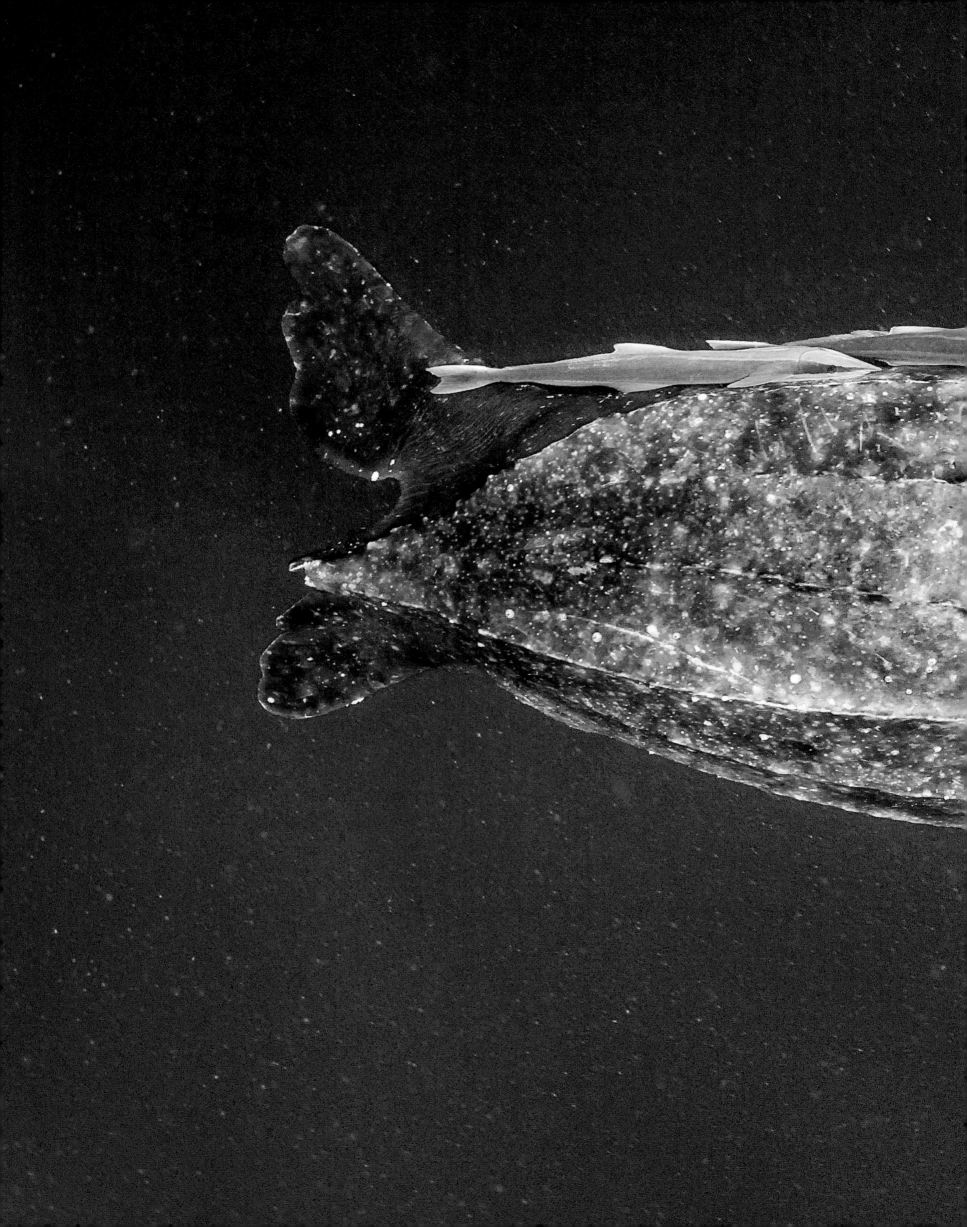

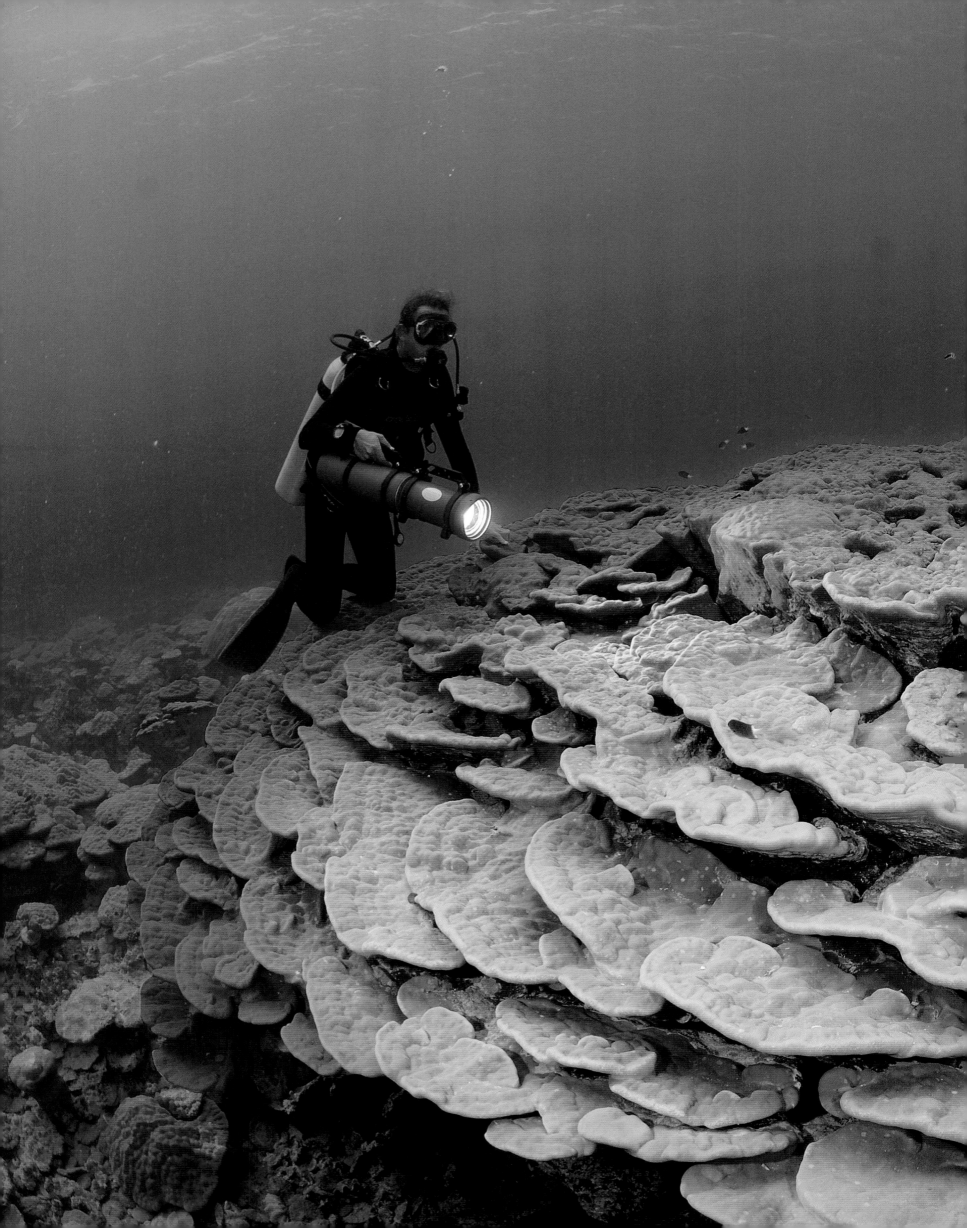

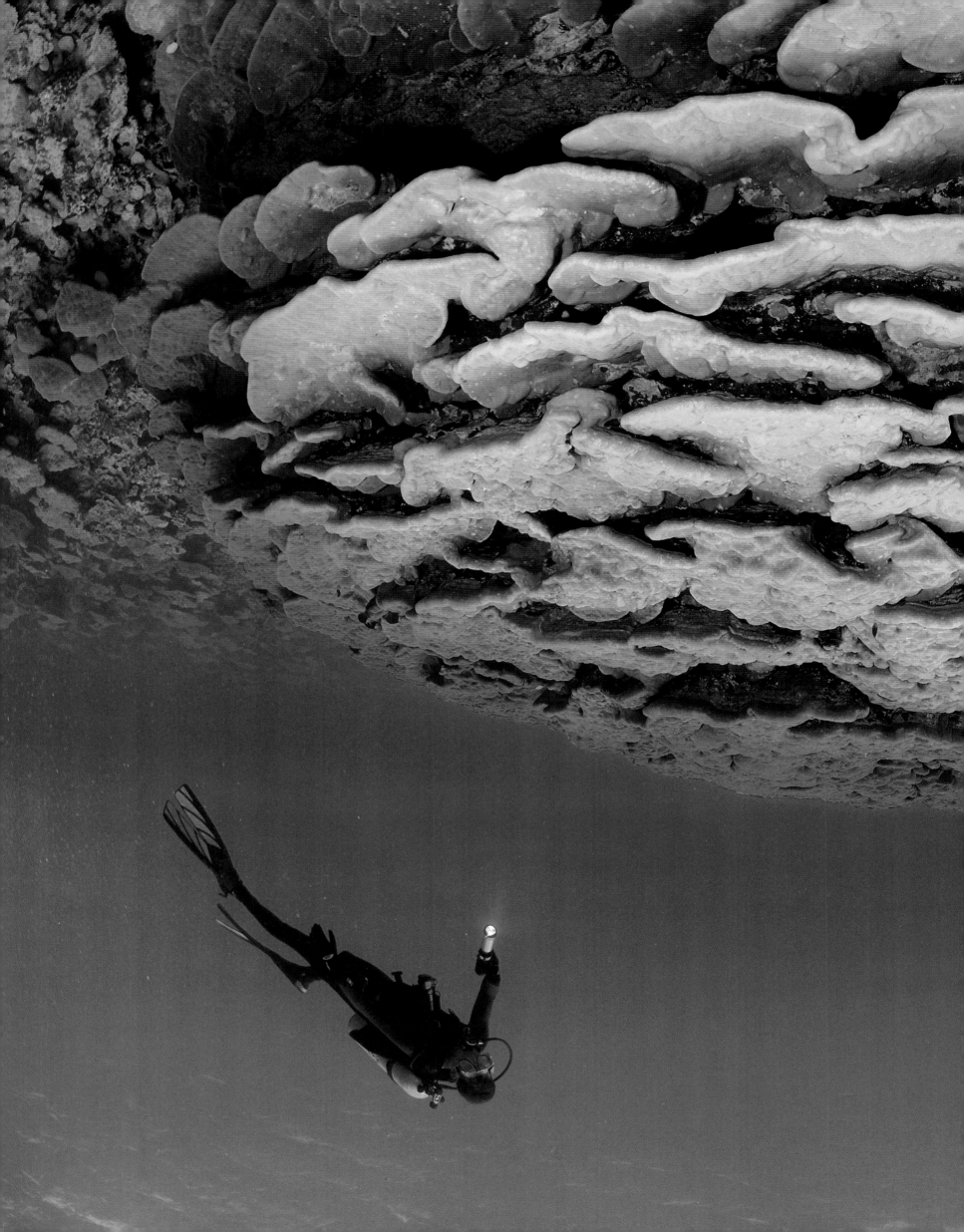

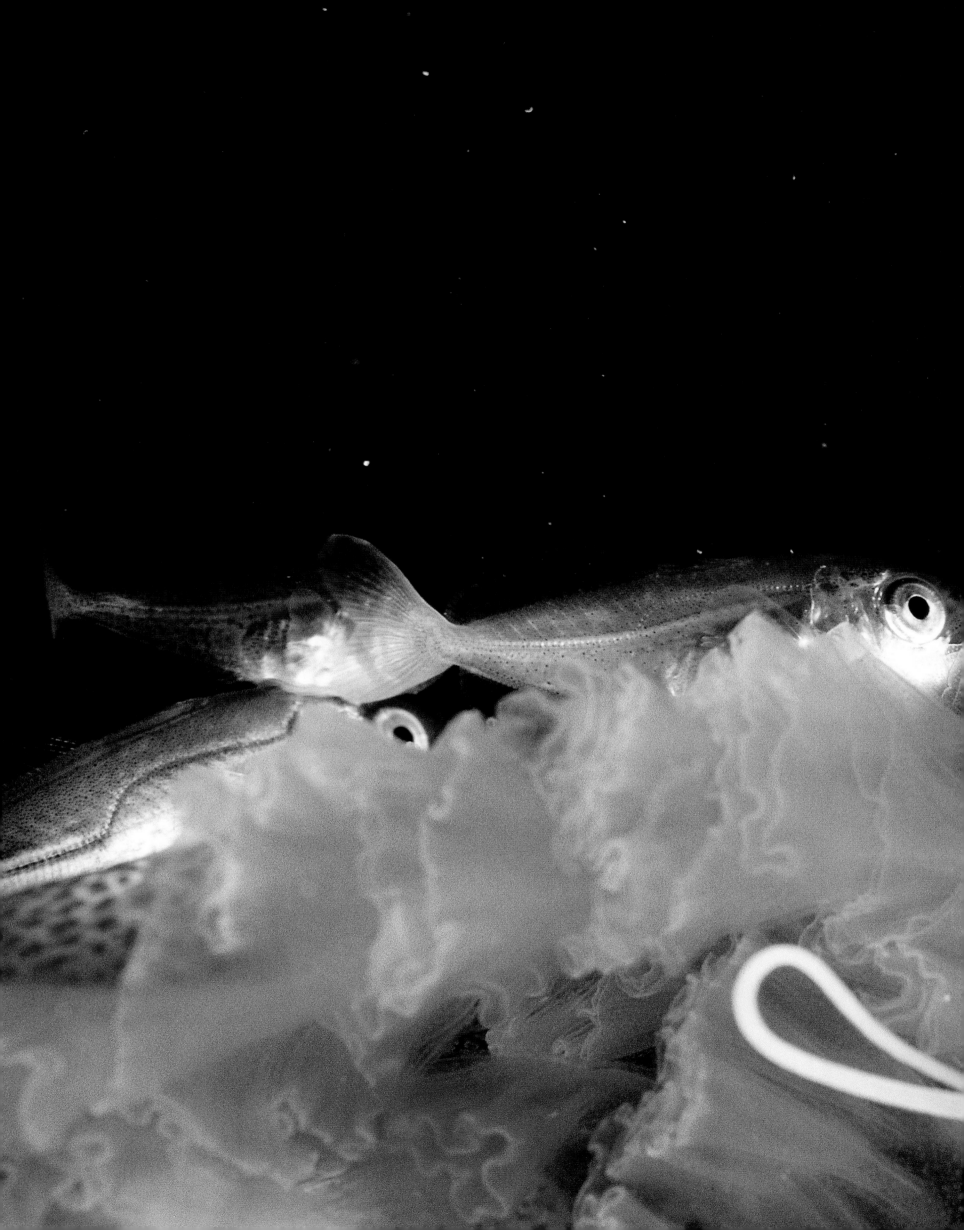

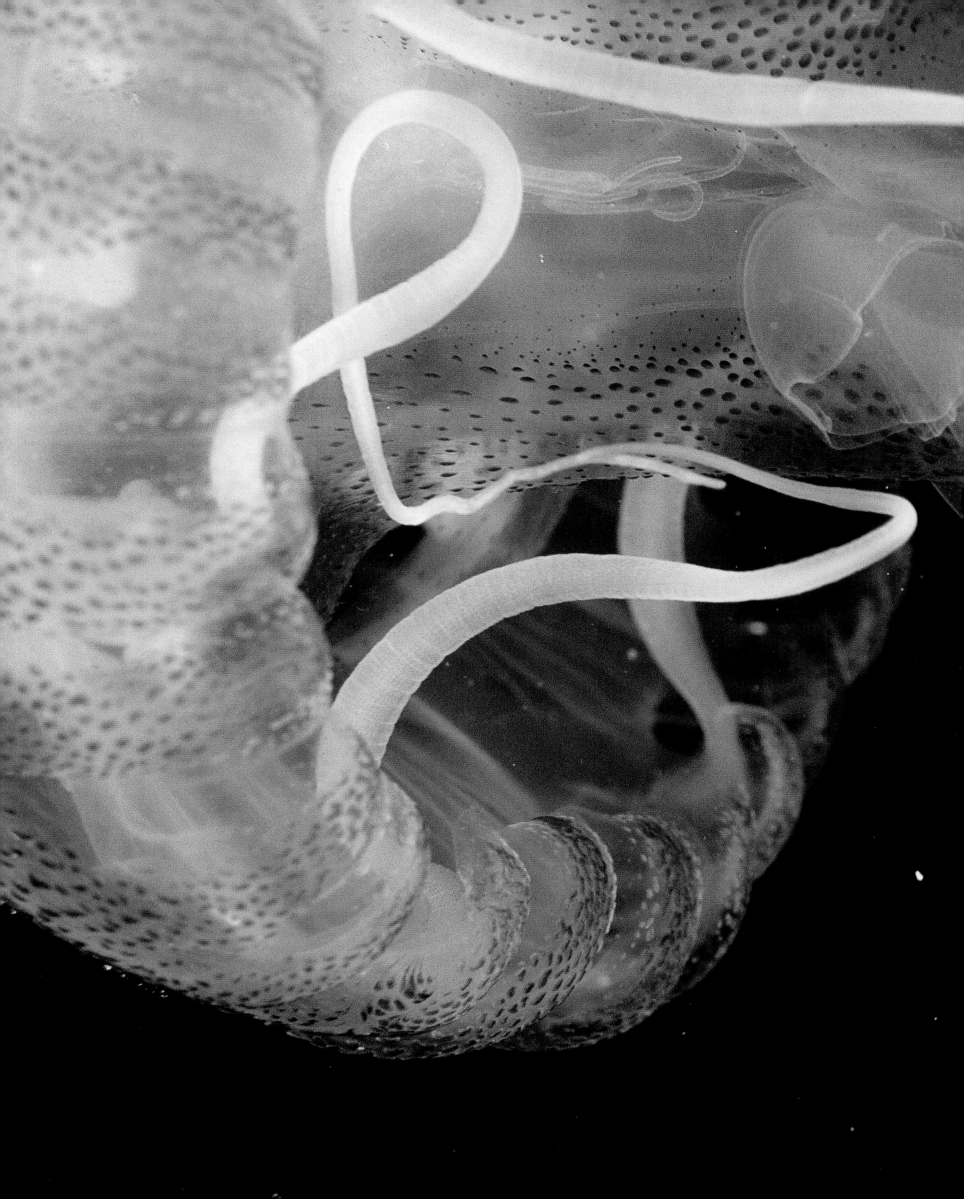

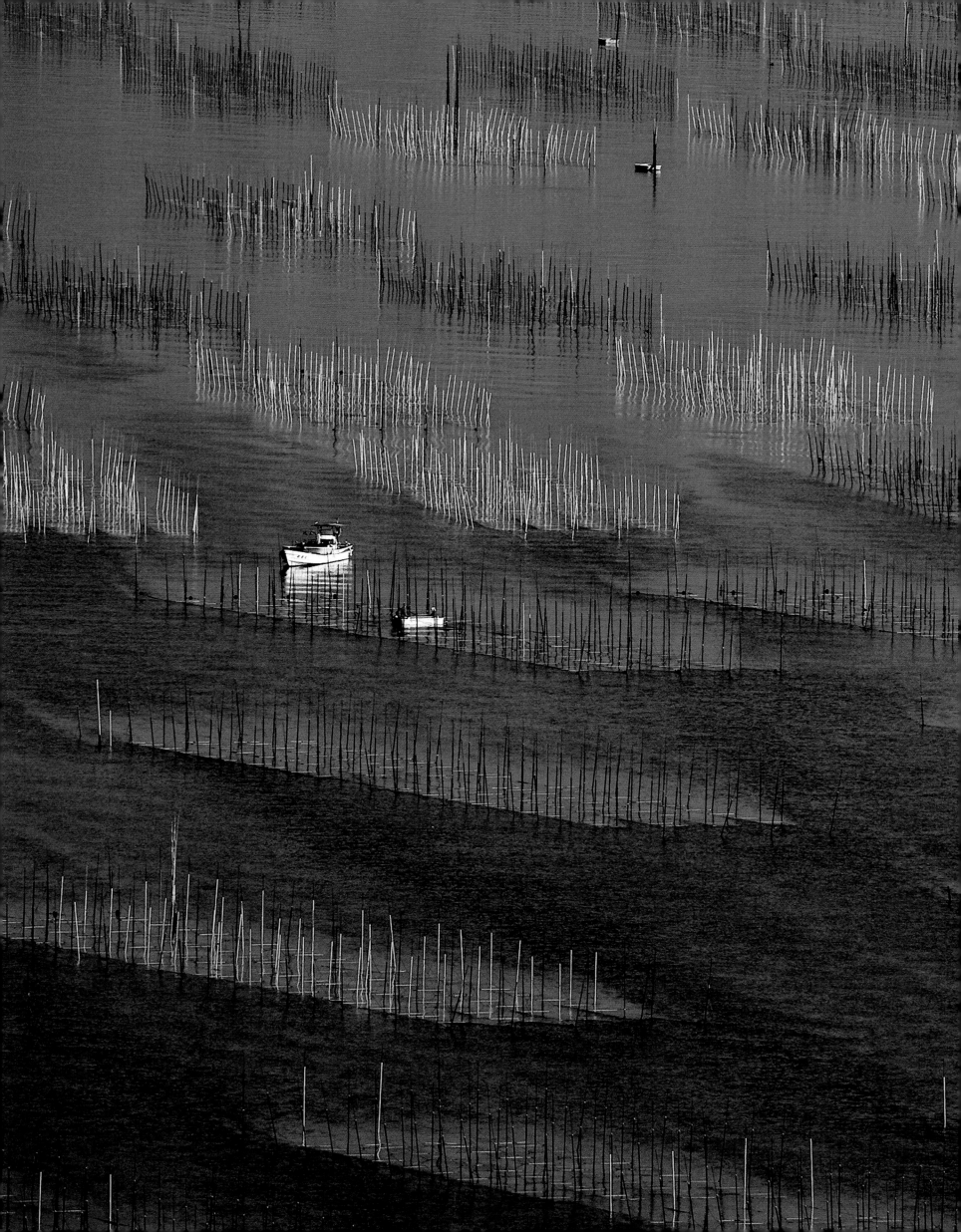

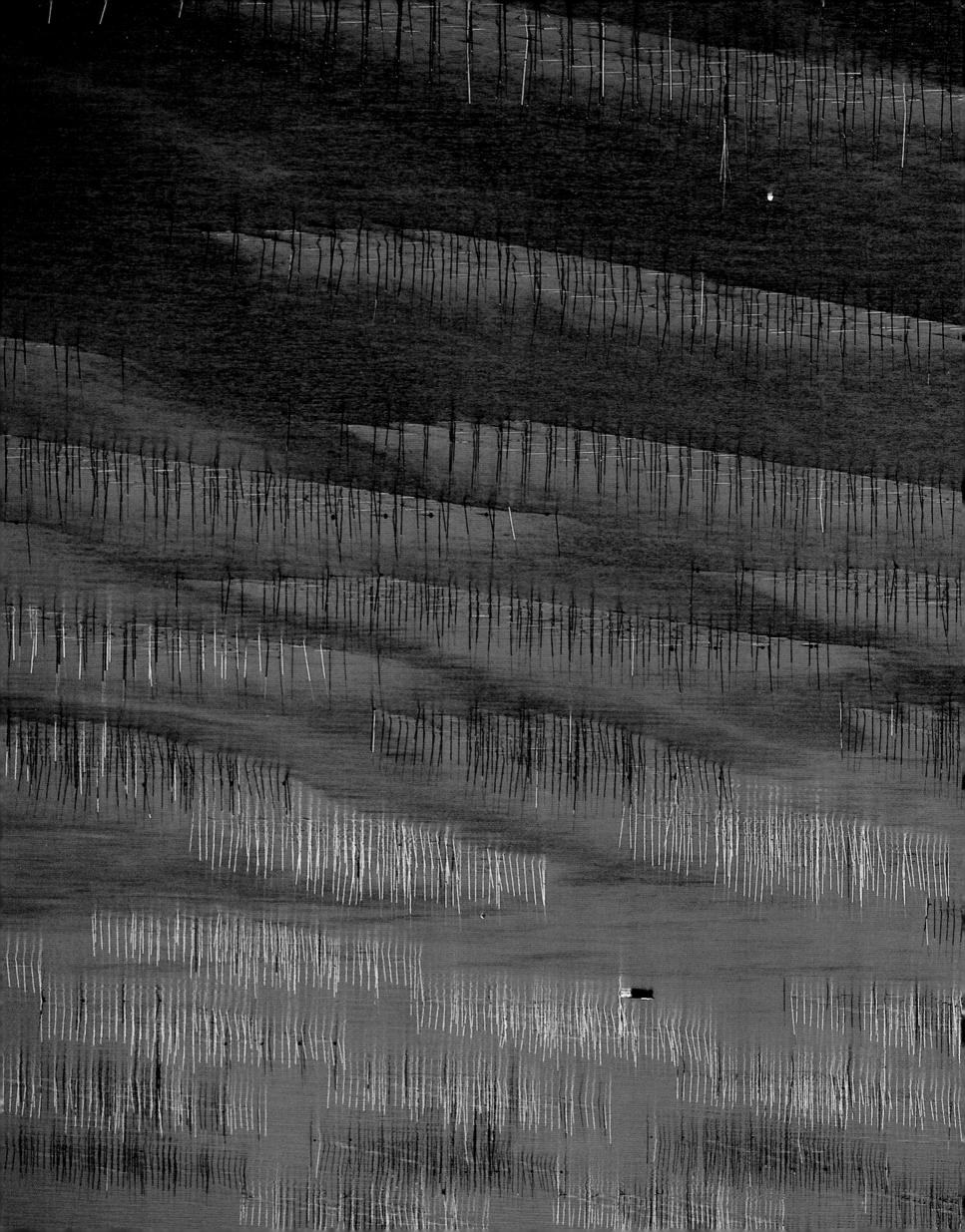

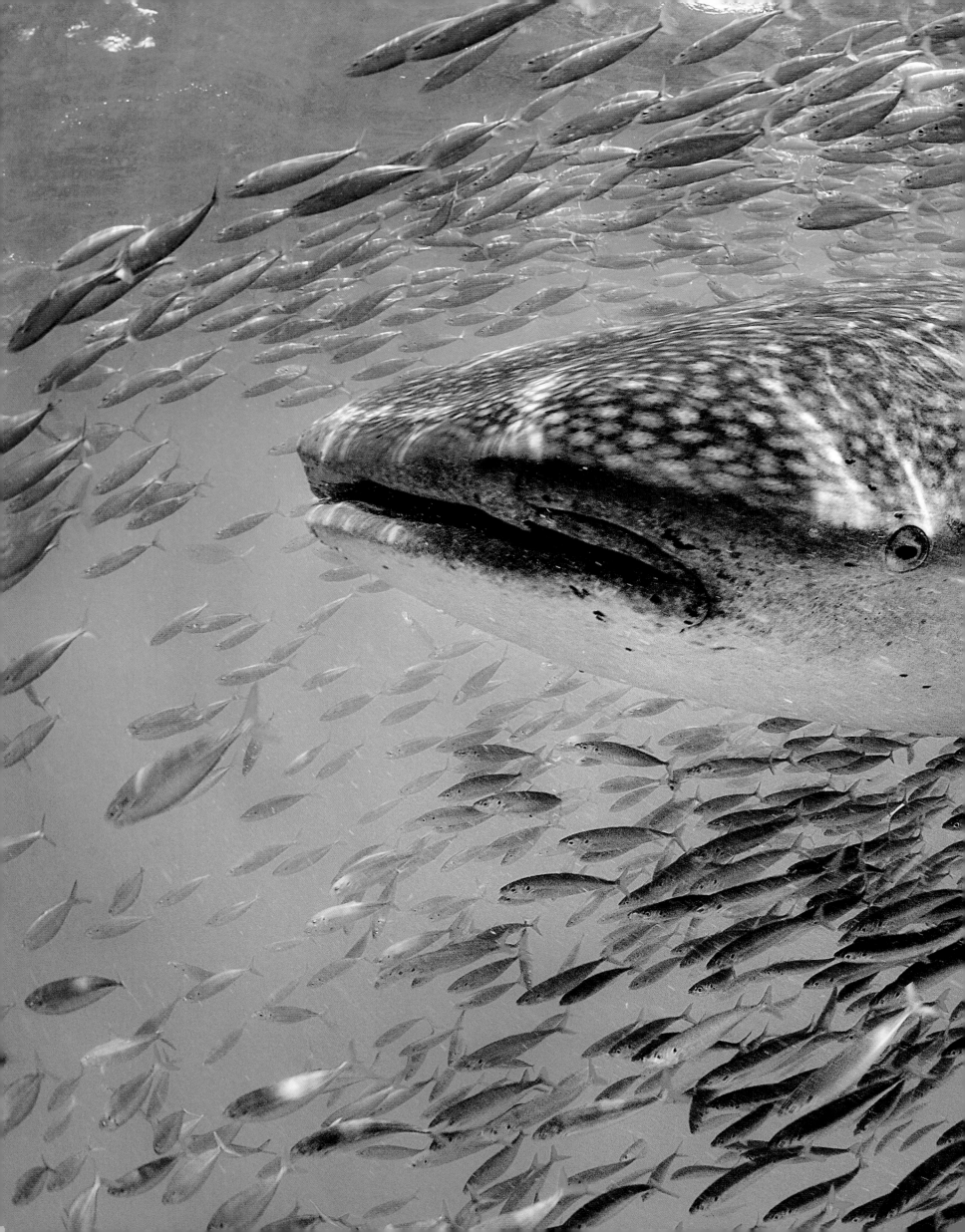

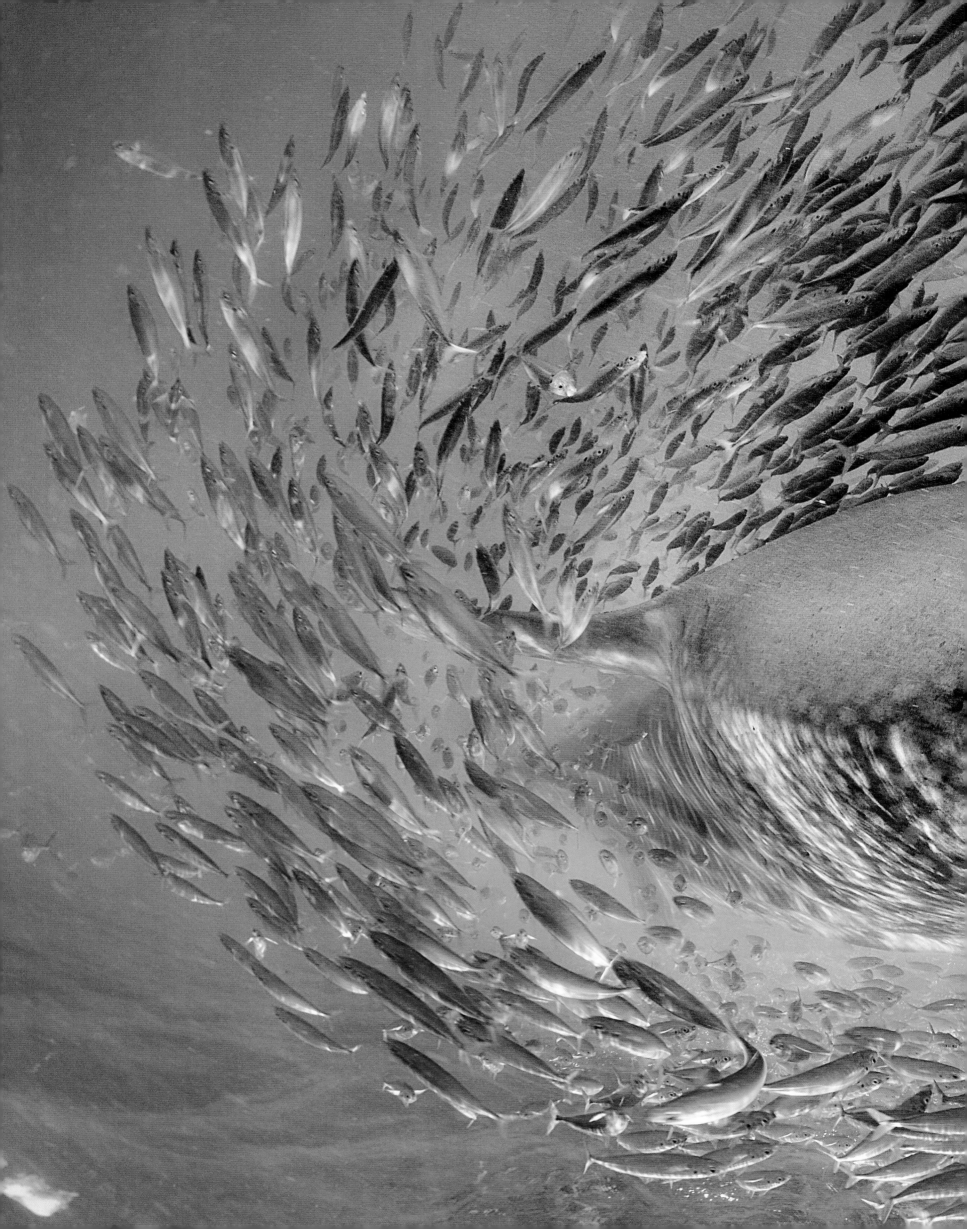

AN ABUNDANT WORLD

Life first appeared in the oceans. The oceans' evolving history is therefore much longer than that of landmasses, and due to these billions of years of evolution, nearly every branch of the tree of life is represented there: Of the thirty-four major divisions—the phyla—of the animal kingdom, thirty-two can be found in the marine environment and fourteen are specific to it. Echinoderms, which include starfish, sea urchins, and sea cucumbers, are part of these strictly marine phyla. In 2010, other strictly marine organisms, loricifera, were discovered on the Mediterranean seafloor. These are the first metazoans known to be able to live in the total and constant absence of oxygen.

MICROSCOPIC DIVERSITY

The oceans' biodiversity remains as full of unknowns as that of landmasses, starting with the controversial subject of the number of species it includes: Without including microorganisms, it is estimated that 200,000 to 250,000 animal and plant species populate the oceans, figures that represent approximately 15 percent of the total number of the planet's described species. Yet various studies evaluate the planet's total biodiversity to hold between 2 to 100 million species, which is indicative of the lack of data we have at our disposal.

While the most emblematic animals are large ones such as whales, seals, sharks, and turtles, nearly all of biodiversity is invisible to the naked eye. Indeed, microorganisms—algae, bacteria, and viruses—include several millions of species; for example, there are up to 160 prokaryotic species (bacteria) in a single drop of seawater, and between 229 and 381 eukaryotic species (organisms with a cell nucleus) in a single liter.

Phytoplankton—all single-cell organisms able to carry out photosynthesis—represents 98 percent of the oceans' biomass. These microorganisms, none of which are larger than one millimeter, produce resources for the entire ecosystem and recycle waste. They also produce most of the oxygen we breathe.

From the smallest to the largest—from the phytoplankton to the blue whale that feeds on it (and that can be up to 100 feet [30 meters] long and weigh up to 170 tons)—all marine organisms are connected.

CORALS

Another miniscule organism, the polyp forms colonies that can become as gigantic as they are indispensable. Corals are colonies of polyps, small gelatinous animals able to produce a calcareous skeleton. The reef's colors are due to microscopic algae living symbiotically with the polyps in their tissues. By day, the coral draws the nutritive substances it needs from the algae by using the sun's energy. By night, each polyp in the coral transforms into a formidable predator that captures its prey with sticky, toxic tentacles.

Coral reefs attract many organisms: crustaceans, mollusks, thousands of fish, and numerous shark species that take advantage of the potential abundance of prey.

OPPOSITE: **Jewel anemones (*Corynactis viridis*), Ireland**

One thousand species of anemones populate the planet's oceans, from coastal zones to the deep ocean (32,800 feet/10,000 meters). This type of animal, similar to corals and jellyfish, does not produce a calcareous skeleton. *Corynactis viridis* is a small anemone that can live in isolation or a dense group. Its bright colors vary widely: The jewel anemone can be green, violet, red, orange, pink, yellow, whitish, or brown.

86 MILLION ACRES (35 MILLION HECTARES) OF CORAL

The Great Barrier Reef, northeast of the Australian coast, is the largest living structure on earth. Composed of nearly 2,900 coral reefs, it is visible from space. Its 86 million acres (35 million hectares) are on the UNESCO World Heritage List. The Great Barrier, which is composed of four hundred coral species, is home to 1,500 fish species and 4,000 mollusk species; it is also the habitat of endangered species such as the dugong and the great green turtle.

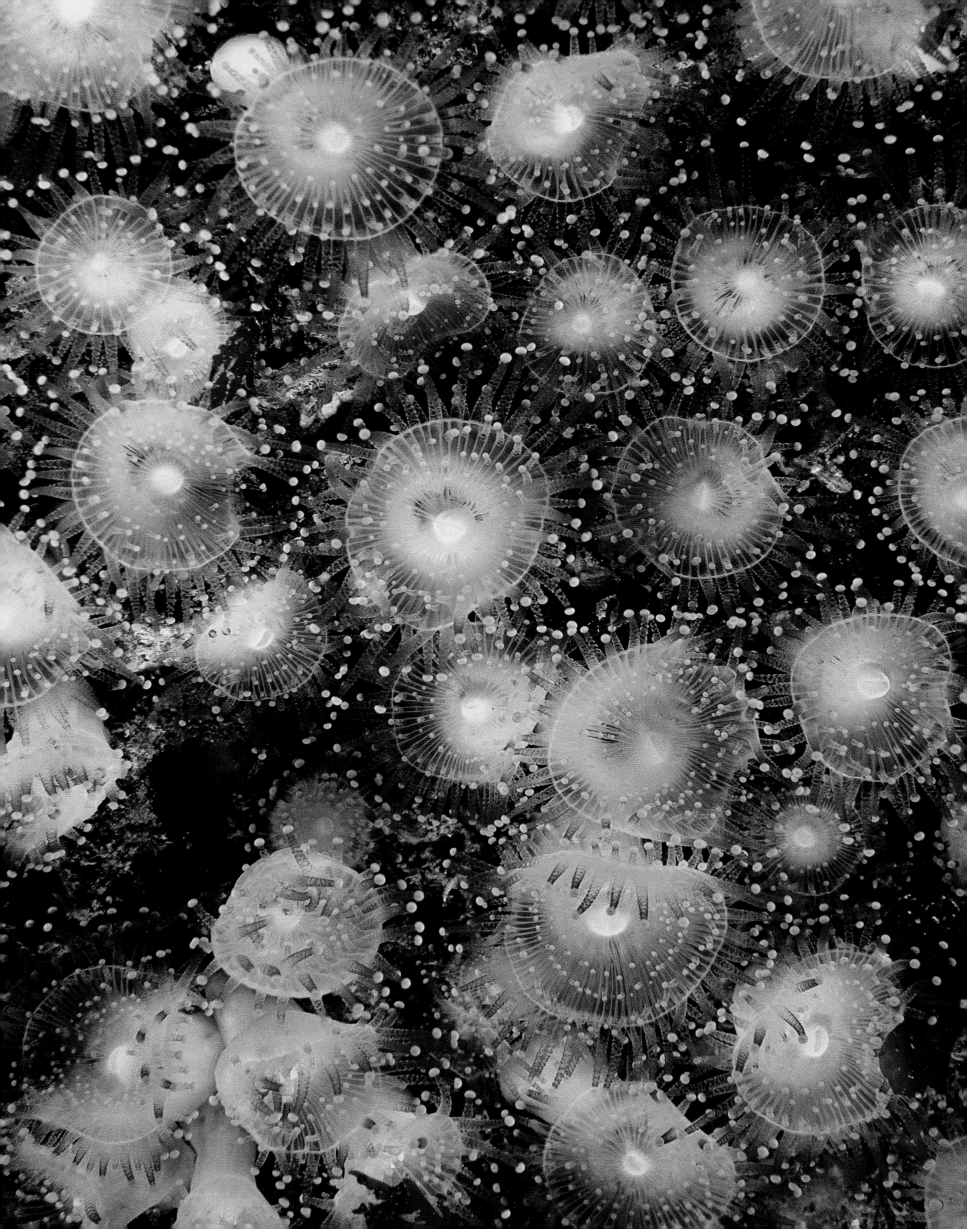

Along with the top of the equatorial forests, coral reefs make up the richest and most complex ecosystems on the planet. Though they occupy less than 0.1 percent of the aquatic environment, they might be home to one to nine million species, of which only 10 percent are known. Nearly five thousand species of fish—more than a quarter of all marine fish species—have been identified there. On a mere 10 square feet (one square meter) of coral reef, the number of animal and plant species is more than one hundred times greater than that found in the open water. Coral reefs are veritable oases of life in the heart of the ocean.

BLACK SMOKERS

As near tropical corals, life also abounds in the depths of the ocean, particularly around the hydrothermal vents that form along ocean ridges at depths of 1,600 to 13,000 feet (500 to 4,000 meters). Here, volcanic activity releases a cloud of black material after which black smokers are named. The liquid released by these vents can reach temperatures of 662°F (350°C); it contains a very high concentration of chemical compounds such as iron, zinc, manganese, hydrogen sulfide, and carbon dioxide. Despite the total lack of light, along with major pressure (between one hundred and five hundred bars), vast local temperature variations (from 662°F to 35°F [350°C to 2°C] in a few feet), and waters full of metallic compounds toxic for most species, life develops and even abounds: Concentrations of animals around the vents can be up to 10 pounds per square foot (50 kilos per square meter).

Life forms adapt and develop novel strategies. For example, the Pompeii worm (*Alvinella pompejana*) is known for being the macroscopic organism able to withstand

ABOVE: **Sea cucumber (*Holothurioidea*) passing food from its tentacles to its mouth, Gulf of Maine, United States**

Like sea urchins and starfish, sea cucumbers are echinoderms, a branch of the tree of life exclusive to the marine environment. Holothurian species have a soft body covered in a hard skin that serves as a skeleton. Many are psammivores: They feed themselves by recovering particles in the sand. Others capture food particles suspended in the water with a crown of tentacles surrounding their mouth. In case of stress, certain holothurian species expel gluey filaments known as tubules of Cuvier to defend themselves. In the Indo-Pacific, holothurian species are used in soups and stews.

SHARK BAY A BIODIVERSITY RESERVE

Located at the tip of the Australian continent, Shark Bay looks like no place else on earth. Much of its 9,650 square miles (25,000 square kilometers) is covered in oxide-rich sand, accounting for the bay's unusual red color.

Several spits of land, peninsulas, and islands separate the bay from the waters of the Indian Ocean; restricted water circulation limits its renewal and increases salinity, which is two times higher here than the global ocean average, allowing for the existence of rare biological structures called stromatolites.

These stromatolites are born of the activity of bacteria capable of carrying out photosynthesis: cyanobacteria, which lead to the formation of calcareous crust by capturing CO_2 and producing oxygen. Some 3.5 billion years ago, stromatolites colonized a majority of coastal waters around the world and contributed to the creation of our atmosphere. They were long considered fossils, but in the 1950s, the first living stromatolites, identical to those

that populated the primeval ocean, were discovered in Shark Bay.

The waters of Shark Bay are also home to the biggest and most diverse sea grasses in the world. Aside from protection from erosion, these plants provide a habitat and food for numerous animal species, and notably shelter the largest colony of dugongs on the planet: Thirteen thousand of these threatened herbivorous mammals live there (or 87 percent of the individuals in western Australia).

Sea grasses also attract many green turtles and loggerhead sea turtles, which come to graze on the aquatic plants' shoots or to lay eggs in the bay. Other big animals, such as the Indian Ocean's large dolphins, humpback whales, and whale sharks, also take advantage of the bay's riches.

Shark Bay also includes a multitude of islands and isles. Fifteen of its forty-two islands are nature reserves. They are genuine sanctuaries for the fifteen bird species that come to nest there and feed in the bay's fish-abundant waters. The pelican, the

crested stern, and the osprey—which builds nests up to 6½ feet (2 meters) tall—are among the most important species that colonize most of these islands. In 1997, close to 1,500 cormorant nests and two hundred wedge-tailed shearwater shelters were recorded on Freycinet Island alone. The avifauna is so abundant that guano exploitation was one of the first industries to be established in Shark Bay. Back when this nitrogen and phosphorus source was fully exploited in the late nineteenth century, cormorants alone produced 80 tons of guano a year.

For all of the above reasons, Shark Bay was added to the UNESCO World Heritage List in 1991. It includes a marine reserve that has become a symbol both of the stunning richness of the oceans' biodiversity and our ability to protect it—when we decide to do so.

WE DISCOVER NEW SPECIES EVERY DAY

INTERVIEW WITH PHILIPPE BOUCHET

PHILIPPE BOUCHET is a professor at the Paris National Museum of Natural History, where he is director of the taxonomy and collections unit. A member of the International Commission on Zoological Nomenclature (ICZN), he has headed some thirty expeditions and personally described between 500 and 550 new species.

You led the Santo expedition in 2006, which is considered the biggest scientific expedition on biodiversity ever undertaken. What conclusions were drawn?

With 150 scientists in the field for a period of five months, the 2006 Santo expedition to Vanuatu in the southwest Pacific was a large-scale undertaking, which allowed proportionally vast results. We often refer to coral reefs as the principal reservoirs of marine species, and the numbers are truly extraordinary.

On Santo, there are more species in a couple of square miles than in all of the Mediterranean—even in all the seas of Europe.

> "On Santo, there are more species in a couple of square miles than in all of the Mediterranean."

Was it the most important of your missions?

I'm not really prouder of any mission than any other, though Santo was a turning point in the way the public at large perceives this kind of expedition. While it is the most famous, it is probably not the most extraordinary one for me.

I always remember a mission to the Salomon Islands in 2004, on a small research ship called *Alis*: no infrastructure, islands still entirely covered in forests. In those days, we had a real sense of the frontier, of the edge of the world.

How do you mount this kind of mission?

A few years ago, it was much easier to mount large oceanographic missions. Today it is an enormous financial risk. You really have to exert yourself to find the means. One of the tricks to pulling off these missions is to use unconventional methods. I prefer to charter old commercial shrimp boats and sail with high-level amateurs and fishing captains I know, rather than struggle to get big institutional oceanographic boats for a certain period. That allows me to go snoop around in places where no research ships get to.

Thanks to these methods, I can mount an average of one major mission per year, while most of my colleagues are only able to mount a few—at best—throughout their entire career.

How many species are in the oceans?

There are currently probably about 230,000 described species in our oceans. I say "probably," because since 2008, the scientific community has tried to consolidate these descriptions in a database: descriptions made by scientists in many countries and listed in books and articles stocked in libraries throughout the world. When the database was launched, we thought we would get to 240,000 species. But in reality, we're currently stuck at around 213,000 because of duplicates, errors, etc. About two thousand new marine species are described each year, a figure that has markedly increased from the rate of discoveries twenty years ago. There have never been as many species described as there are today.

So it isn't rare to describe new species?

We discover new species every day! Unfortunately, the public at large is often only informed about spectacular discoveries—those involving mammals or strange-looking animals. Most of the discoveries concern "ordinary" biodiversity. Yet there are taxonomic groups that we know better than others. Fish, for example, are among the best-known groups. We estimate there are about seventeen thousand known fish species in the oceans and that there are about five thousand more to be discovered. And then there are groups such as the free-living nematodes, where we have no idea how many species exist. A single researcher initially estimated the figure at 100 million species, then revised it to less than one million species a decade later! That range reflects our ignorance.

And yet it is estimated that 80 percent of biodiversity remains to be discovered. Where do we get this percentage?

This estimation is based on calculations researchers used for the terrestrial world, particularly the tropical forest. Knowing the number of insect species specific to a tree species and multiplying it by the number of tree species, you get an estimate of the diversity of forest insects. However, this multiplicative formula does not exist in the oceans. So I had some "fun" by making these kinds of estimations using crabs, a group relatively well-known throughout the world. In European seas, overall diversity is well characterized and it is therefore possible to know the proportion of crab species to the total number of species. If we consider that this ratio is the same in all the world's seas, we come to a figure of 1.5 million species total. But other authors make different estimates, and just last year two different figures were published: 300,000 and 2.2 million species. Once again, the range is really wide.

Why try to describe every species?

There are several reasons. First, when a species has no name, it is impossible for scientists to communicate and exchange data about its properties and attributes. More broadly, something without a name cannot be referred to in regulatory texts; for example, in the case of fishing, you cannot regulate stocks of a nameless species. Finally, and this may be the most human reason, there is curiosity. It is in our nature to describe the world that surrounds us and to give things names.

You say that more and more species are discovered, and yet we speak of the erosion of biodiversity?

The erosion or threats weighing on biodiversity do not necessarily mean a decrease in the number of species and the extinction of species. There is what we call local extractions, which means that locally a species will disappear, essentially due to overexploitation or the destruction of a habitat. But we cannot speak of extinction plain and simple, for in the marine environment, areas of distribution are vast and there are "spare" populations elsewhere. On the contrary, in freshwater the areas of distribution are smaller, and about one hundred species of fish are extinct as opposed to a single one in the marine environment (and the alleged cause of the marine extinction is due to that species passing into freshwater during part of its life cycle). Yet this does not mean that all is well in the oceans, far from it. It only means that the number of species listed as extinct is not a good way of assessing the oceans' health.

So you make a distinction between extinction and a decline in stocks?

When overexploited, a species' stock can decline dramatically, to a point that it becomes so rare in the nets that it will be considered "commercially extinct." But in fact, the species as such is not biologically extinguished. But I am not optimistic, because today all of biodiversity's warning lights are flashing. The problem is to isolate the causes and define and put in place effective measures to take action, like what could have been done for the ozone layer, for example.

> "Today, all of biodiversity's warning lights are flashing."

Are marine protected areas among these effective measures?

Of course, and any initiative geared toward protection and diversity is a good one. What worries me is that for the time being it is relatively easy to create marine protected areas in places where they don't bother anyone. But once these zones are protected, will we be able to create new protected areas in places that are troublesome, where the economic stakes are higher, but the conservation stakes are the highest? We must also ban deep-sea trawling and overfishing practices, which are currently the primary instruments of destruction of our oceans' biodiversity.

What is the oceans' future?

Today as before, the oceans are facing what is commonly known as "the Four Horsemen of the Apocalypse": fragmentation and disappearance of habitats, invasive species, excessive fishing, and extinctions. I fear that new concerns such as acidification might make us forget these "Horsemen," which I consider far more dangerous. I feel like biodiversity has had cancer for a long time, and adding a sore throat to the diagnosis does not change the cancer's impact. Of course, the sore throat could degenerate into pneumonia, but I think it will be the Horsemen of the Apocalypse that kill biodiversity. Is anyone currently talking about the massive fishing of sea horses for aquariums and Chinese medicine? No. My only shred of optimism is that we still have a "primitive" vision of the ocean, meaning that we all dream of preserving a free and wild ocean populated by big animals.

We have lost this vision of the terrestrial world. Does anyone still dream of a wild Europe covered in forests and prairies populated with buffalo? Sadly, we are in the process of losing our free ocean. We may even have already lost it. And there is no way to reverse the process.

Is this why you archive this diversity in the museum's collections? To remember it?

I think that the collections and the archives play an essential role in the duty we have to remember the diversity surrounding us. But most of the time, museums are rigid structures obsessed with the lack of room! Where will we put all this? The work of remembering is necessary, and yet increasingly difficult to carry out. I don't think that institutions have realized the importance of these data banks, at the very time when biodiversity is clearly in danger.

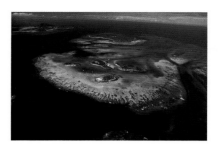

Platax orbicularis in the waters of the Chichi Islands (Chichi-jima), Ogasawara Archipelago, Japan

Platax is a genus of herbivorous fish that plays an essential ecological role in the coral reef: Like the parrot fish, it controls the proliferation of algae by grazing. _Platax_ species are also particularly appreciated by people who keep aquariums. Their increasing rarity in certain lagoons and growing economic value has led to the development of _Platax_ aquaculture. _Platax_ are farmed in Thailand and Taiwan to supply the aquarium market.

Makoko shantytown, Lagos Lagoon, Nigeria (6°29' N, 3°23' E)

Located on the edge of the Atlantic Ocean and a lagoon, Lagos is the biggest city in Nigeria and the country's principal commercial and industrial center. In Makoko, which is inhabited by more than a hundred thousand people, there is no running water, electricity, or sewage system. With one of the largest demographic growth rates on the continent, the city is experiencing uncontrolled urbanization, which is leading to problems like large amounts of untreated wastewater being dumped in the lagoon.

Clown goby (_Gobiodon citrinus_) at the window of its shelter (a rusty soda can), Izu Peninsula, Honshu, Japan

The smallest vertebrate in the world belongs to the goby family. This particular clown goby has taken shelter in the carcass of an old soda can, just as it might do in a rock crevice. The seafloor is littered with garbage ranging from soda cans to shipwrecks, which is gradually colonized by marine fauna and flora. In some places, people immerse large concrete blocks in the water to help form a reef, providing the foundation of a new ecosystem.

Tobago Cays islets, near Union Island, Saint Vincent and the Grenadines, Lesser Antilles (13°15' N, 61°12' W)

Four miles (7 kilometers) east of Union Island, the southernmost island of the Saint Vincent and the Grenadines, four deserted, rocky isles and a few reefs are known as the Tobago Cays. Protected from the Atlantic Ocean by a coral barrier, the cays, their coves, and their palm-lined white sand beaches attract amateur sailors, while the diverse riches of their marine floors have given them a reputation as the most beautiful diving spot in the Caribbean.

Common octopus (_Octopus vulgaris_) hiding in its den, Poor Knights Islands, New Zealand

Octopuses belong to the class of mollusks (_Cephalopoda_) whose "foot" is under their "head," like cuttlefish and squid. These animals have eight arms with suction cups, and a soft body that allows them to squeeze into small holes, to protect themselves from potential predators. They are also known for their unusual intelligence and their ability to learn and memorize.

Barracuda Keys, Florida Keys, United States (24°43' N, 81°38' W)

The tropical Keys archipelago extends in a long string of coral islands to the southwest of the tip of Florida and toward Cuba. Its southern part, the Barracuda Keys, consists of uninhabited, mangrove-covered islets preserved in their wild state since 1938, as part of the Great White Heron National Wildlife Refuge, a habitat for white herons, dolphins, lobsters, leatherback and green turtles.

School of young catfish (_Siluriformes_), Suruga Bay, Honshu, Japan

Catfish owe their name to the barbels around their mouths, which vary in length and resemble a cat's whiskers—though not all types of catfish have them. Catfish belong to the order _Siluriformes_ and often live in freshwater or, according to the species, in coastal marine waters. The catfish is an important commercial resource in Asia, for instance in Japan and Vietnam. Several species have been introduced in Europe and North America, notably for sportfishing, yet these catfish have become invasive and now decimate local species.

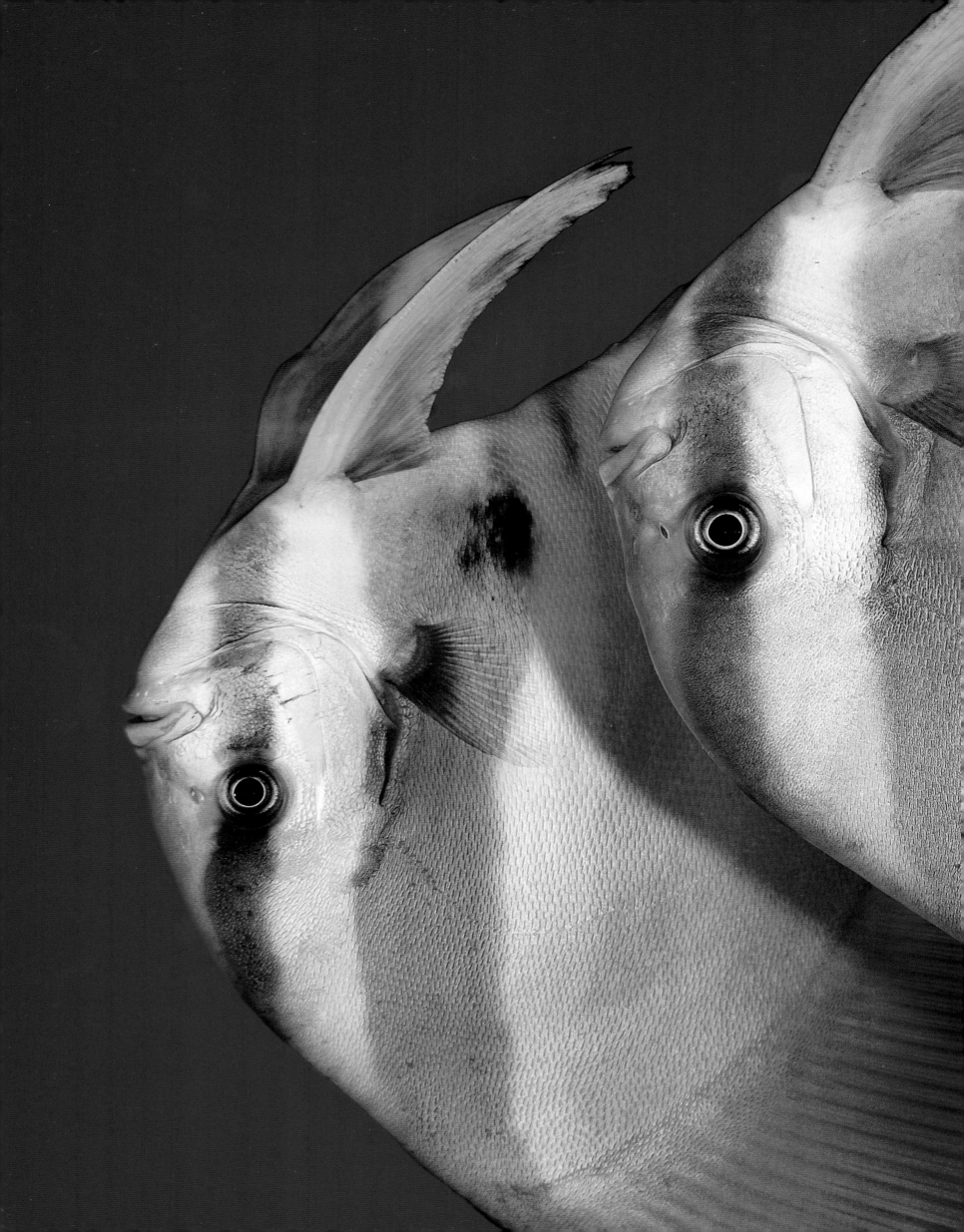

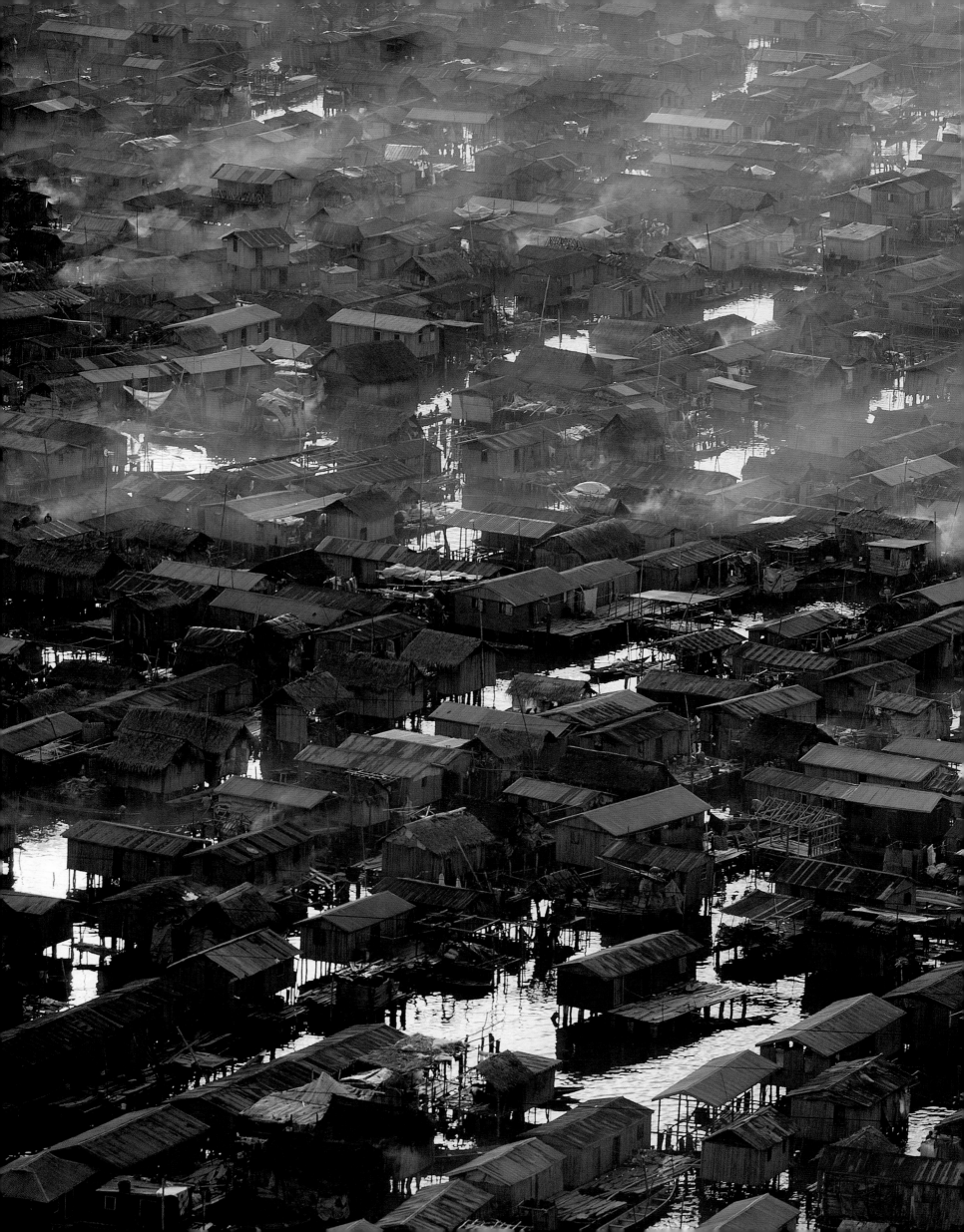

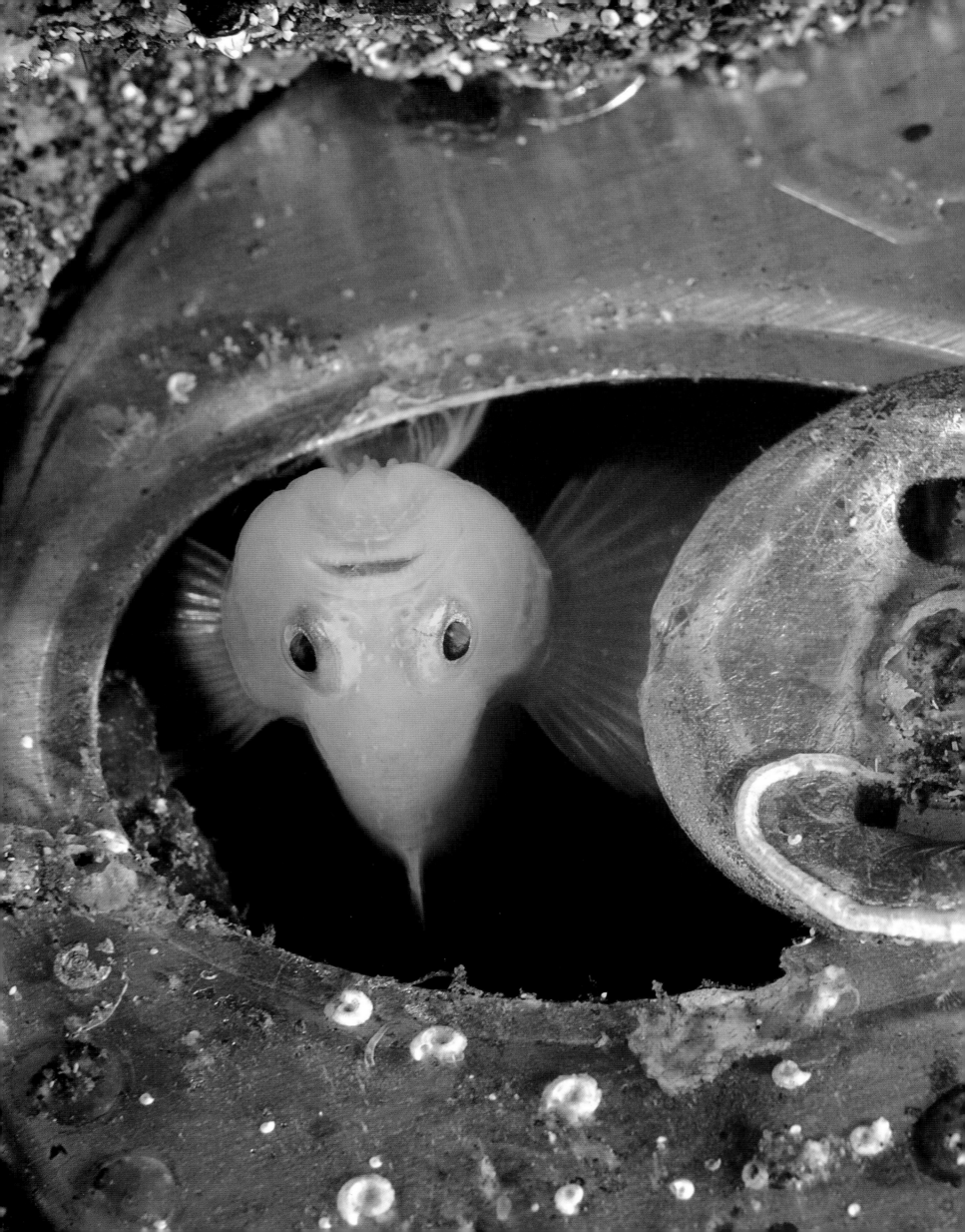

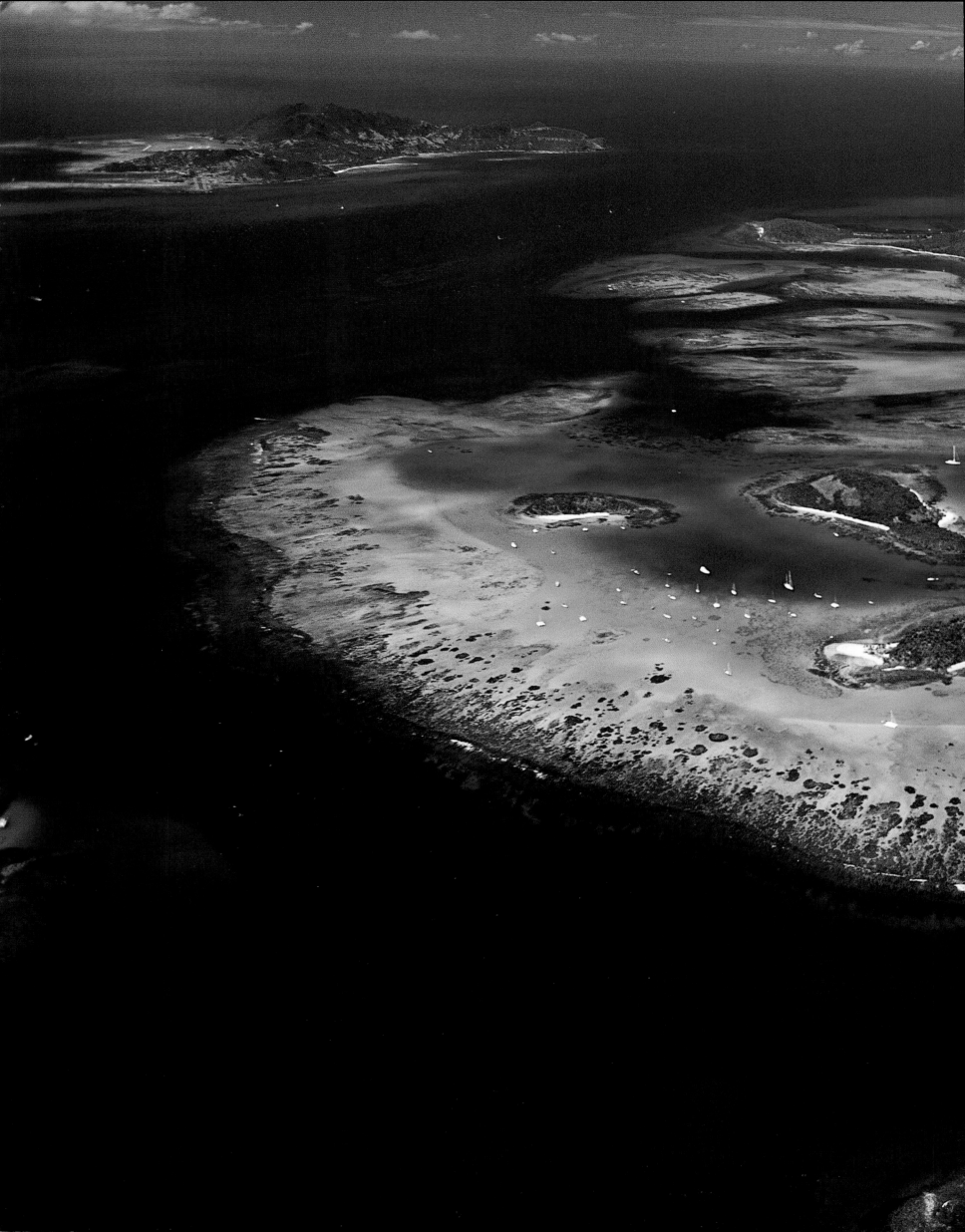

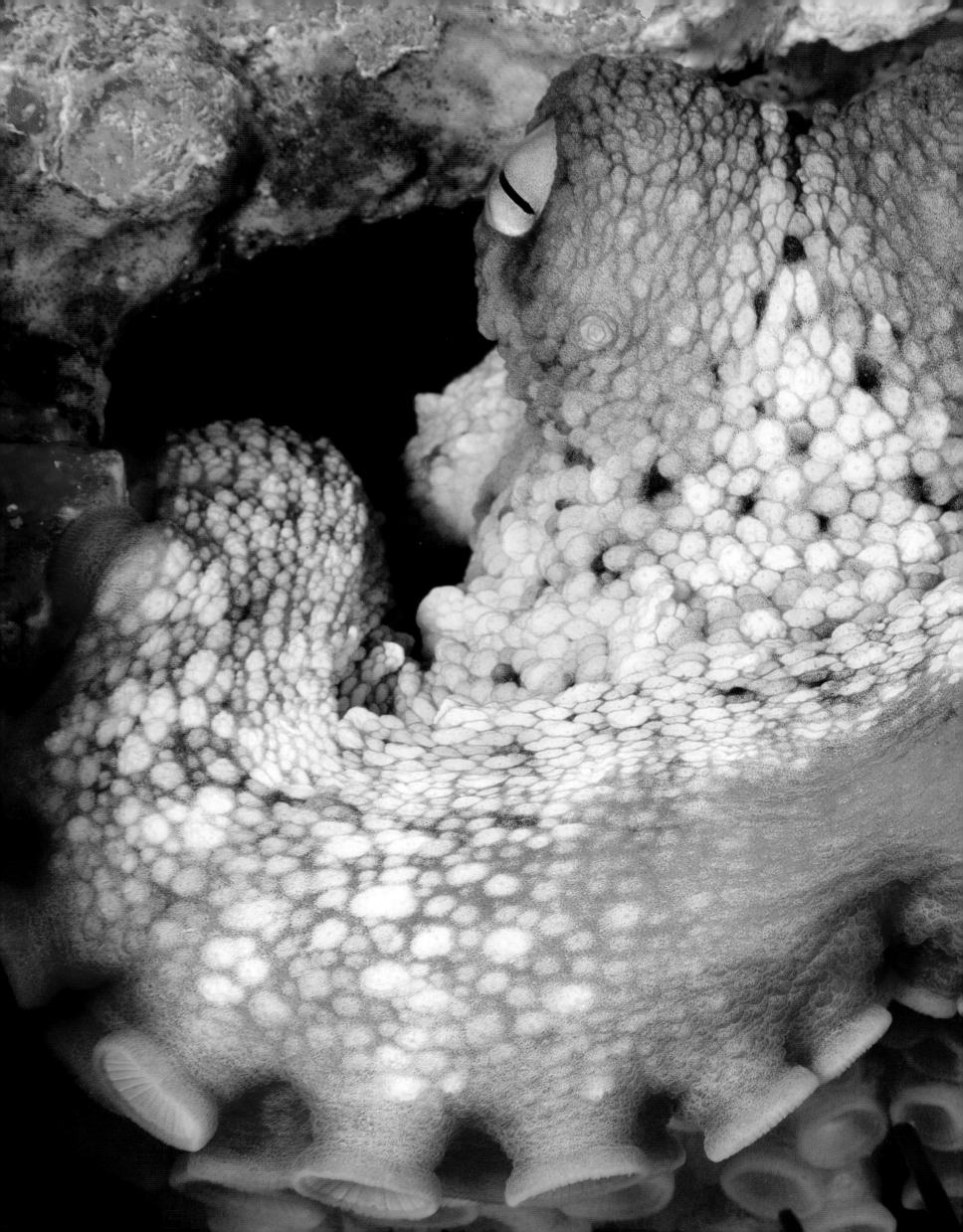

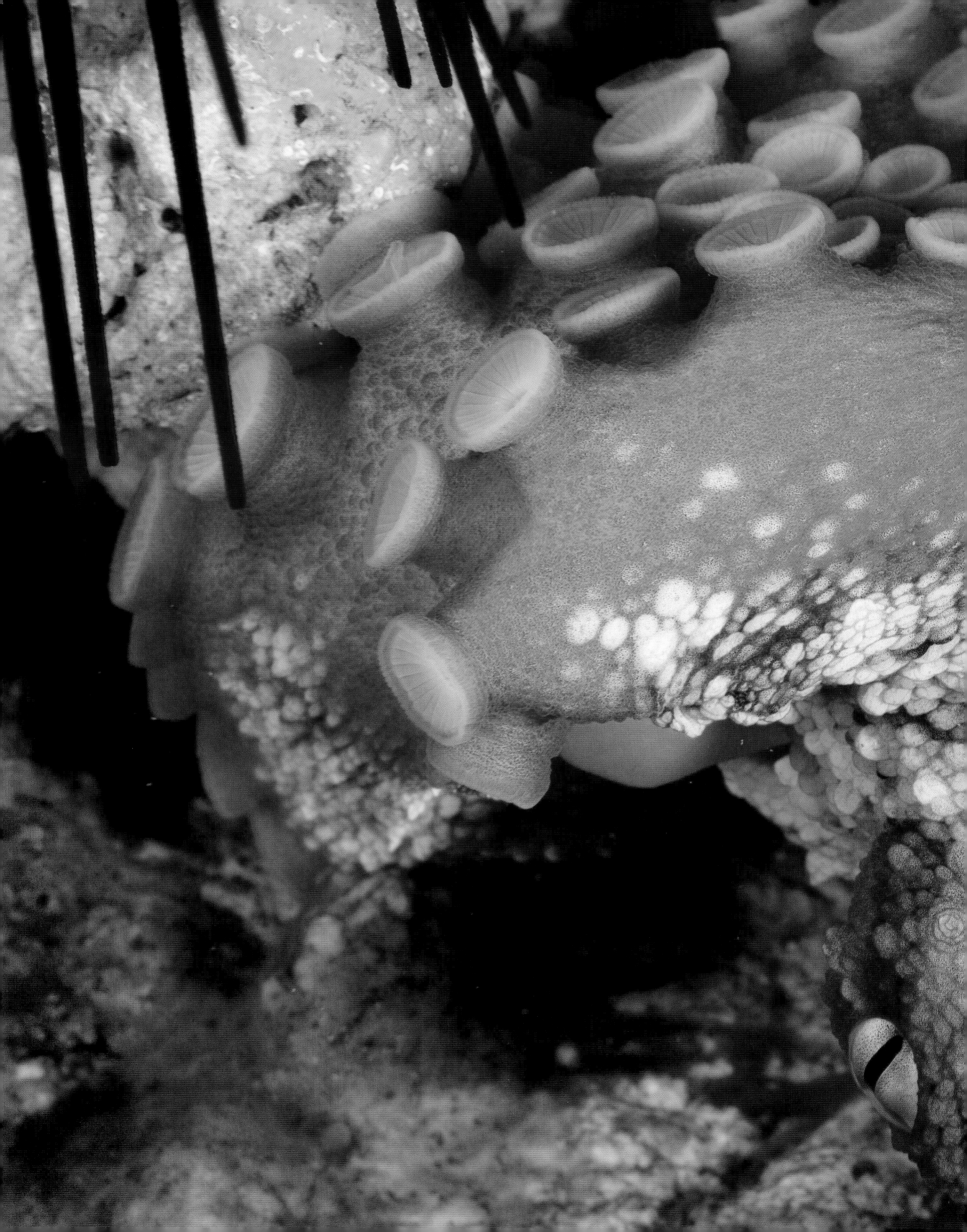

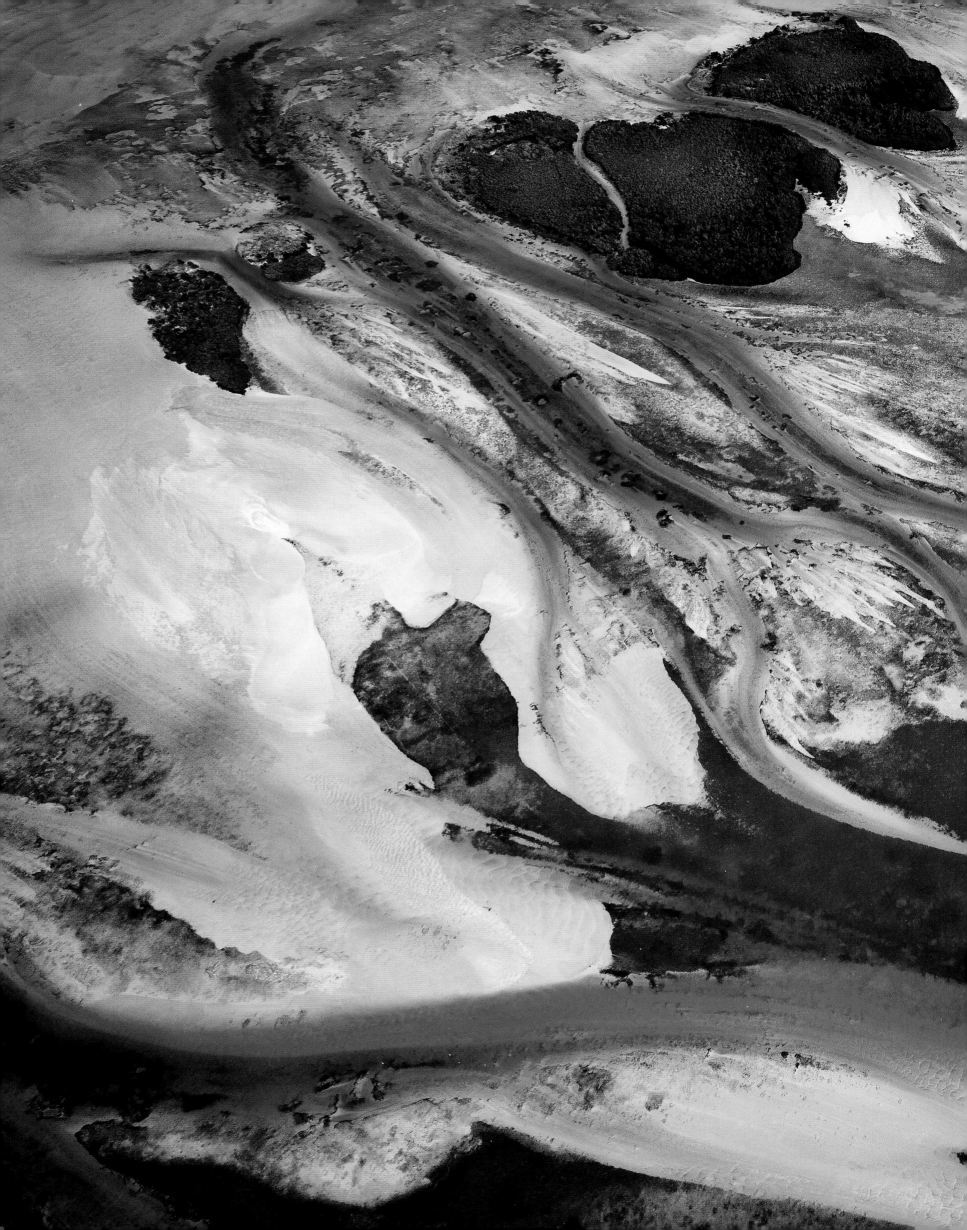

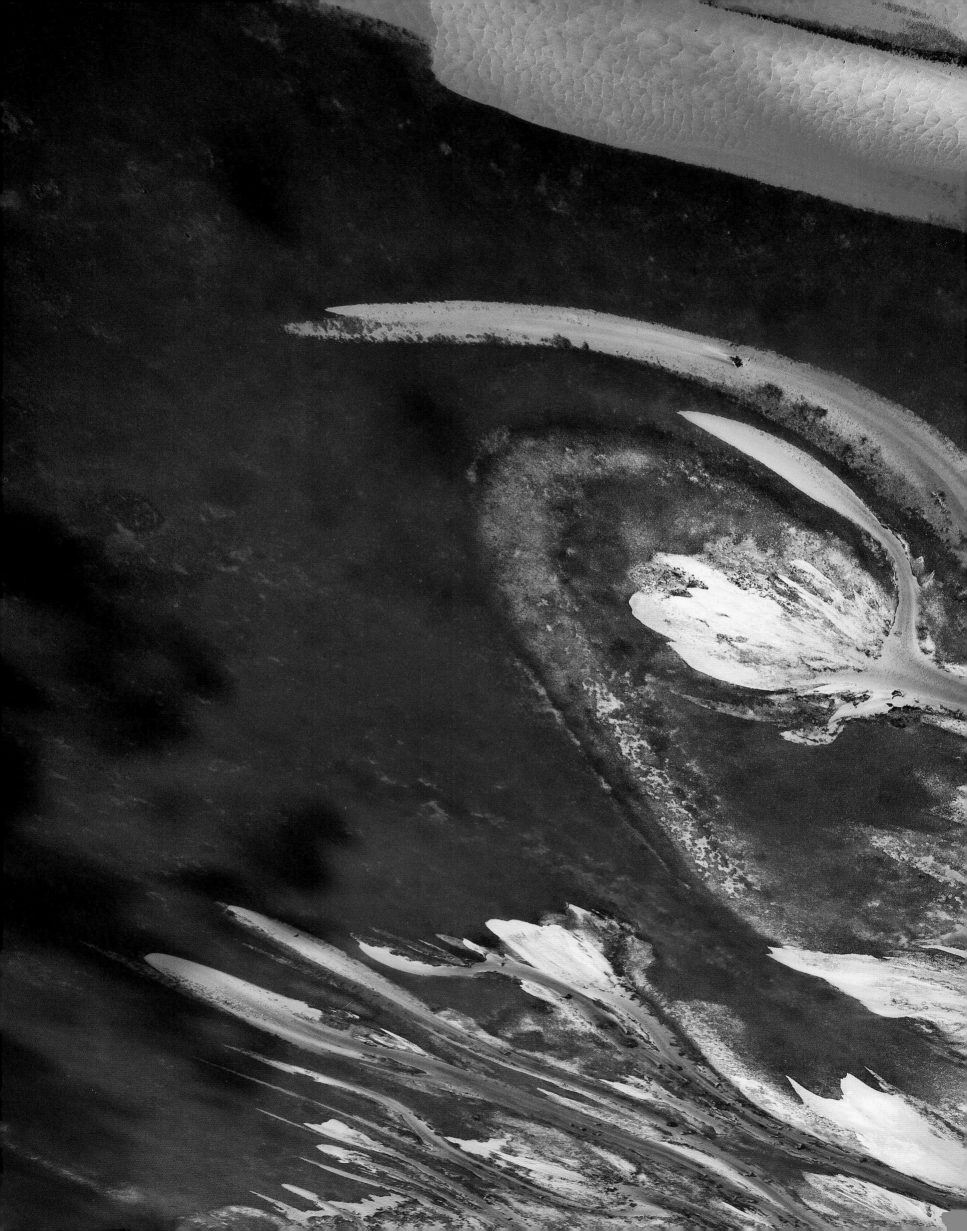

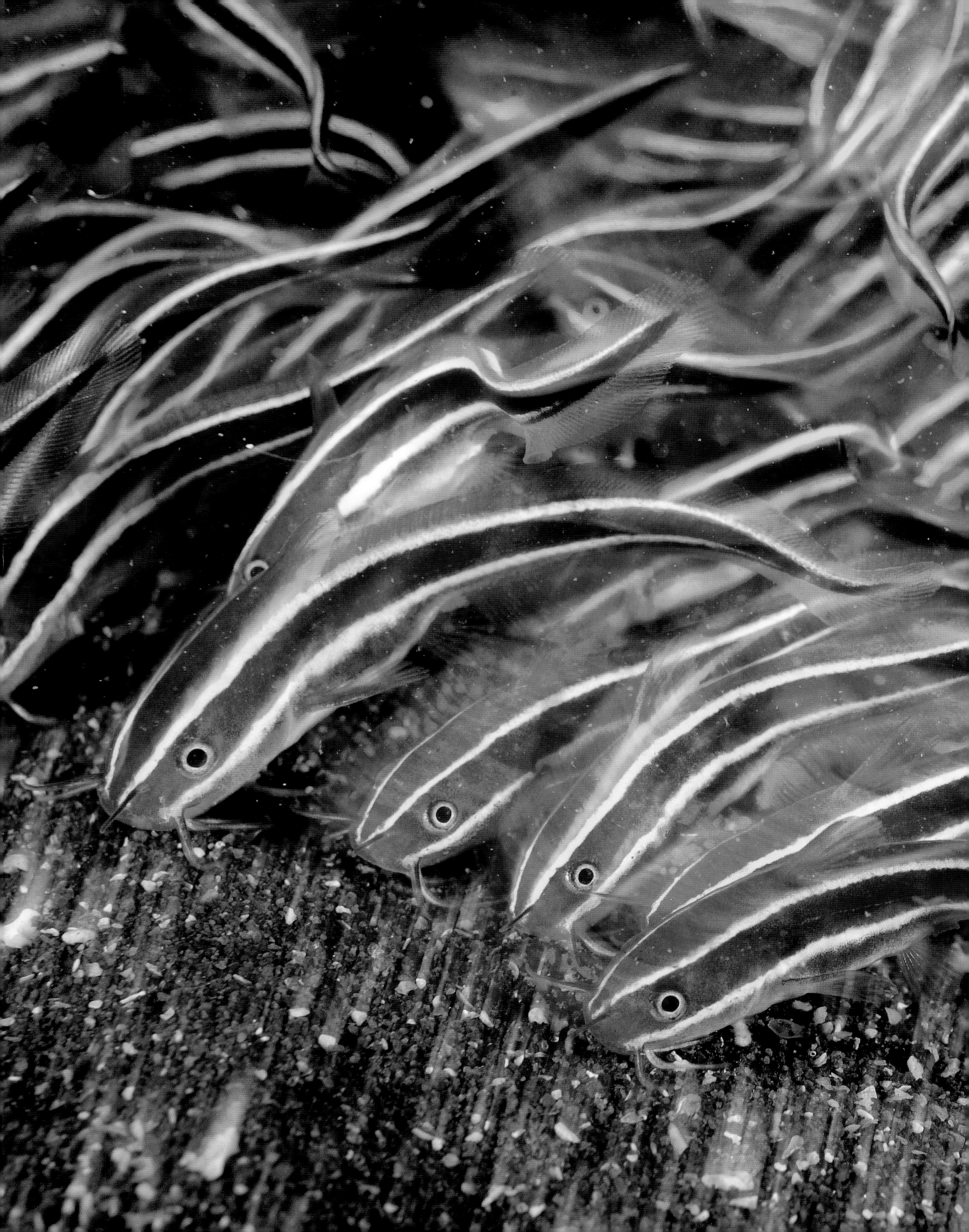

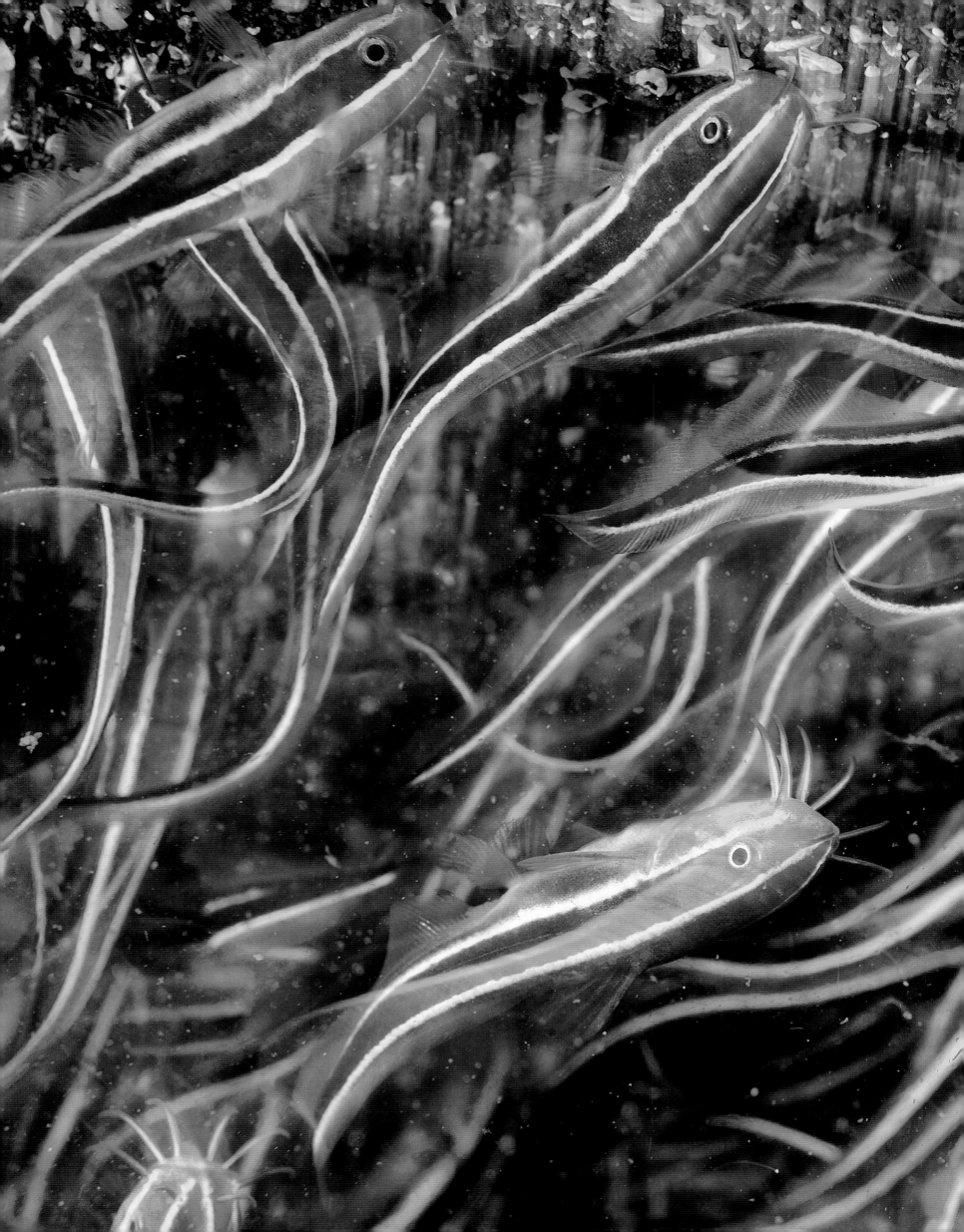

COASTS: LIVING WITH THE SEA

Today more than 50 percent of the world's population lives less than 60 miles (100 kilometers) from a coast. By 2035, this could rise to 75 percent. The human concentration on the edge of the sea indicates the special relationship we have crafted with the ocean. But it also causes tremendous pressure on the environment.

ATTRACTIVE COASTLINES

A growing number of people are settling along coasts. While the socioeconomic mechanisms vary, the trend is general. It is not recent, either. Coastal population spans the centuries, as evidenced by the Mediterranean cities of Antiquity (Athens, Rome, Carthage) and of the Classical age (Venice, London, Constantinople/Istanbul, and Seville, among others). In America, Asia, and Africa, colonization led to the development of large coastal cities; New York, Hong Kong, and Cape Town, for instance, are relatively recent cities. Today Asia's economic development has propelled Chinese, Korean, and Japanese coastal cities to the top tier of global metropolises. In France, coastal towns are home to approximately one in ten people but only cover 4 percent of the territory, and the density there (453 inhabitants per square mile [281 inhabitants per square kilometer]) is two and a half times greater than the national average. In the United States, more than half the population lives in coastal areas, with a density three times the national average (483 inhabitants per square mile [300 inhabitants per square kilometer]), and coastal populations increased by 28 percent from 1980 to 2003, for a total of 33 million additional people. The great deltas of the Nile, Mekong, and Ganges are among the most densely populated areas in the world.

There are multiple reasons for this concentration. History is a determining factor, of course, but not the only one. Today as in the past, access to the ocean allows for fishing and facilitates trading. In some cases, it encourages offshore activities. In others, the coast is used for military installations. More and more, coasts attract tourists and amateur sailors. All these activities ensure jobs, revenue, or simply the population's subsistence. But that is not all. Coastlines are attractive because of the lifestyle their inhabitants enjoy, and opinion polls show that coastal dwellers are happier and in better health than those living inland, a statistic for which it is hard to pinpoint a specific cause.

GAINING GROUND

Demand is high and room is lacking. So certain countries have reclaimed land from the sea. It is not a recent idea; as early as the seventeenth century the Netherlands created polders by draining water and building protective dikes. Most of the country is now located below sea level. In Western Europe, 5,800 square miles (15,000 square kilometers) of polders have been claimed from the sea. Today many countries use these techniques: Dubai, Singapore, Japan, among others.

OPPOSITE: **Fish market in Man, Dix-Huit Montagnes region, Ivory Coast** (7°24' N, 7°33' W)
The Ivory Coast has experienced significant population growth over the last decades. While the country barely had 2.5 million inhabitants in 1950, its population today is close to 20 million. People in the Ivory Coast consume an average of 35 pounds (16 kilos) of fish per year. While it has direct access to the sea, the country only produces 30 percent of the fish it consumes.

MORE THAN 70 PERCENT OF MEGACITIES AROUND THE WORLD ARE ON COASTLINES
With industrialization and globalization, coastal cities have grown exponentially. Today many megacities are also major ports, such as Singapore, Shanghai, Osaka-Kobe, New York, and Rotterdam. Additionally, half the cities with more than one million inhabitants are on or close to an estuary. This is the case with London and Seoul, for example.

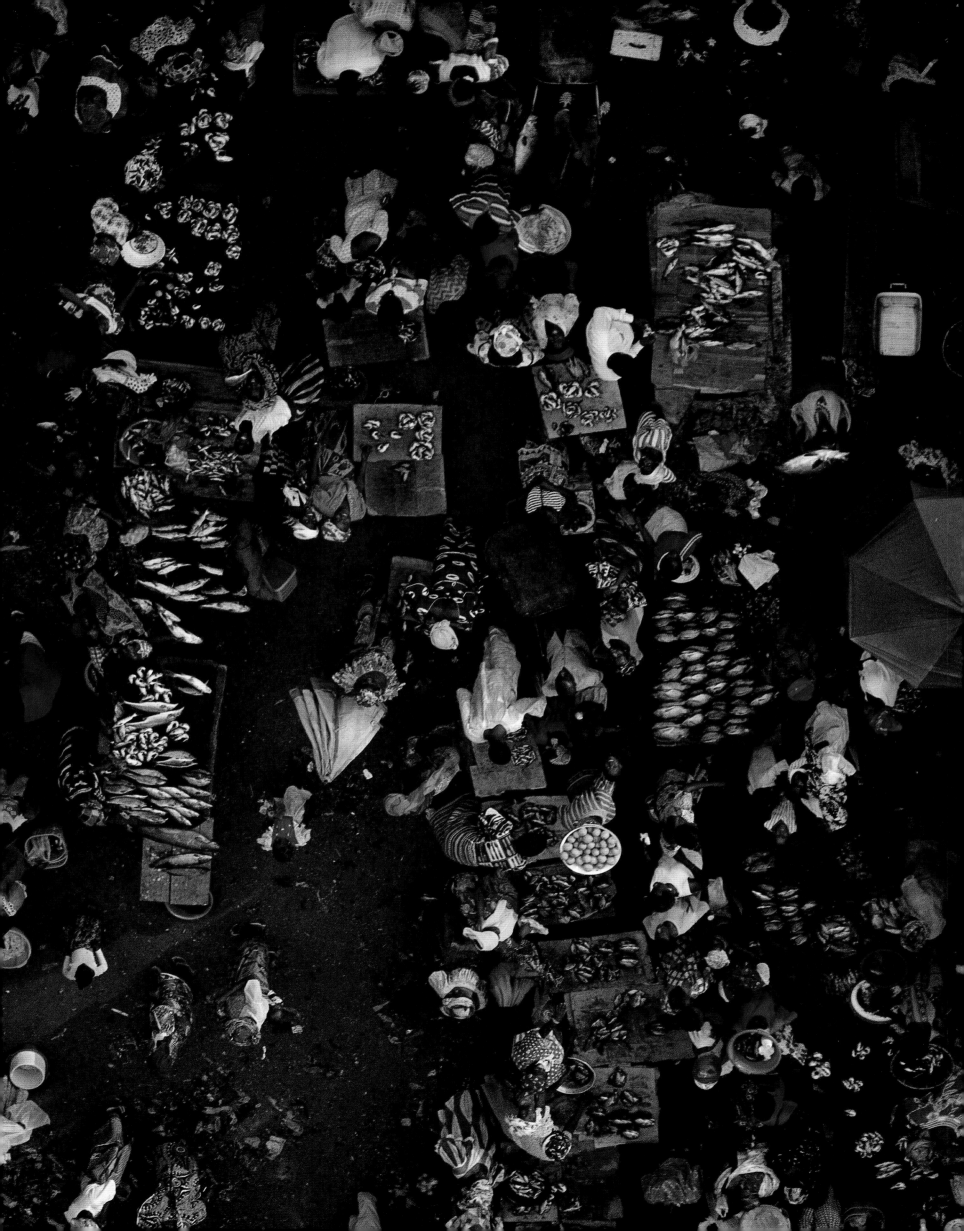

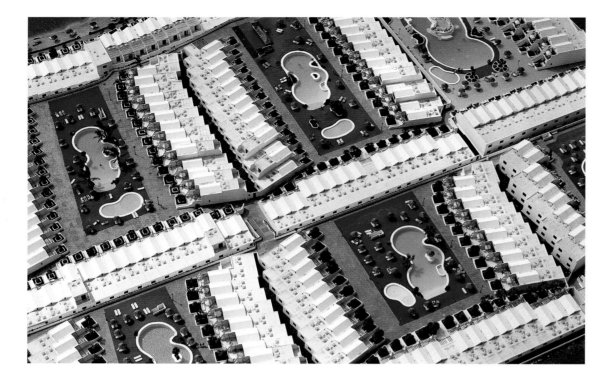

LEFT: **Residential hotel near Arrecife, Lanzarote, Canary Islands, Spain** (29°00' N, 13°28' W)
The Spanish island of Lanzarote is off the coast of Morocco. It is part of the volcanic archipelago of the sunny Canary Islands, which have drawn tourists since the 1960s. In 2011, Lanzarote, whose year-round population is of 120,000 inhabitants, welcomed 1.7 million tourists, most of them German and English. Its coasts attract summer tourist invasions as well as extended stays, notably for retirees who settle there year-round. The increasing number of visitors has led to massive urbanization.

COASTAL RICHES

The fishing and aquaculture industry obviously depends on being on the coast. It generated 106 billion dollars in 2008 and employed 540 million people. The same year, fish provided 3 billion people with 15 percent of their animal proteins. In some areas, fishing continues to be practiced in an ancestral fashion, using barely modernized traditional boats and techniques.

But industrialized countries have floated genuine factory ships that scour the world's seas over long distances and are responsible for most overfishing. It bears repeating that going to sea is a dangerous activity: Each year, some twenty-four thousand fishermen die at sea.

As for aquaculture, it now provides more than half the fish sold around the world. There are 11 million aquaculture farms, 90 percent of which are in Asia. While most Asian farms are operated in freshwater, marine farms are nearly always coastal—in fact, they are threatening the coasts with pollution. The field experienced 245 percent growth from 1992 to 2009.

INCREASED PRESSURE ON THE ENVIRONMENT

Human expansion is accompanied by growing artificialization of the land. In certain areas, particularly touristic ones, the coastline has been disfigured by construction. This is the case of Costa Blanca, which is the most urbanized section of the Spanish coast, with 96 percent of its coastal strip covered in concrete. The situation is aggravated by the problem of wastewater, which is often poured directly into the sea, and other waste inherent to the tourist onslaught.

The need for land, both for farming and living, is particularly damaging to important but fragile coastal ecosystems: wetlands. The term refers to an entire array of varyingly swampy ecosystems that are extremely precious for biodiversity: mangroves, coastal marshes, dunes, lagoons, and estuaries, among others. In metropolitan France, wetlands are home to 25 percent of biodiversity, but are among the ecosystems that have deteriorated the most in recent years. Their surface area dropped by 67 percent in the twentieth century!

MANGROVES

On a global scale, mangroves—those unusual coastal forests with a rich, abundant ecosystem—are one of the environments that lost the most ground during the twentieth century. A quarter of their surface area, or 8.8 million acres (3.6 million hectares), was

THE ENDANGERED DELTA

The 150-mile-wide (240-kilometer-wide) Nile Delta is among the most densely populated zones on the planet, with 1,612 inhabitants per square mile (1,000 inhabitants per square kilometer), in a country undergoing a genuine demographic explosion; the population of Egypt quadrupled from 1950 to 2010. Like all estuaries, the Nile Delta forms a specific ecosystem, determined by combinations of salt water and freshwater. Today its equilibrium is endangered. Upriver, the Aswan Dam considerably reduced the influx of sediments, the soil is becoming less fertile, and the effects of erosion are beginning to be felt. With the drop in the river's rate of flow, the water's salinity is increasing. Downriver, with global warming and rising water levels, the sea is moving inland, sometimes up to 330 feet (100 meters) a year, and some farmers are importing sand in an attempt to hold back the waves. Since the area is very flat, an 11-inch (30-centimeter) increase in the sea level would flood 80 square miles (200 square kilometers). Combined with bad water management, these upheavals have resulted in a decline in the production of irrigated crops, which threatens the country's already fragile food supply.

that a significant part of the world's population lives on the coasts. Think of the islanders given climate change. This would be catastrophic for many areas and their inhabitants, given reclaim the coastline. With the melting of the ice in Greenland, water levels could increase by 19 to 22 feet (6 to 7 meters) by the end of the twenty-first century—a consequence of

RISING WATERS

While natural disasters are occasional, slow coastal erosion is allowing the sea to gradually

individuals are at risk in the case of disaster.

are not sufficient protection, and growing population concentrations mean that more experienced less damage than other areas during the 2004 tsunami. But these ecosystems devastating effects of tropical storms and tsunamis. Those areas with the most mangroves Coastal ecosystems play a natural protective role. Mangroves, in particular, soften the dead), and the Xynthia storm in France in 2010 have all borne witness to this sinister fact. tsunami in Fukushima (20,000 dead), Hurricane Katrina in New Orleans in 2005 (1,800 December 2004 tsunami in the Indian Ocean (which left 200,000 dead), the March 2011 Threatened by human activity, coastal zones are also heavily exposed to natural risks. The

VITAL PROTECTION

bulldozers over entire acres to make room for aquaculture farms.

because the roots of mangrove trees—the ecosystem's essential tree—are often torn out by expansion of warm-water shrimp farms participates in the destruction of the mangroves, into beaches on which to build hotels. Finally, aquaculture's growth also plays its part. The tropical zones to transform sometimes inhospitable, muddy, and mosquito-ridden areas several causes, beginning with urbanization, then tourism, which incites inhabitants of lost in less than twenty years, principally in Asia. The phenomenon is determined by

ABOVE: Florida manatee (*Trichechus manatus latirostris*) with its calf, Weeki Wachee River, Gulf of Mexico, Florida

Manatees, also known as "sea cows," are the last representatives of the order *Sirenia* along with dugongs. This peaceful animal can live up to sixty years, weigh 1.5 tons, and be up to 16 feet (5 meters) long. Manatees, which cannot survive at temperatures below 68°F (20°C), live around mangroves and the mouths of tropical rivers. Harmless herbivores, they notably feed on mangrove tree plantlets, water hyacinth, and algae. They can eat up to 50 pounds (23 kilos) of plants a day.

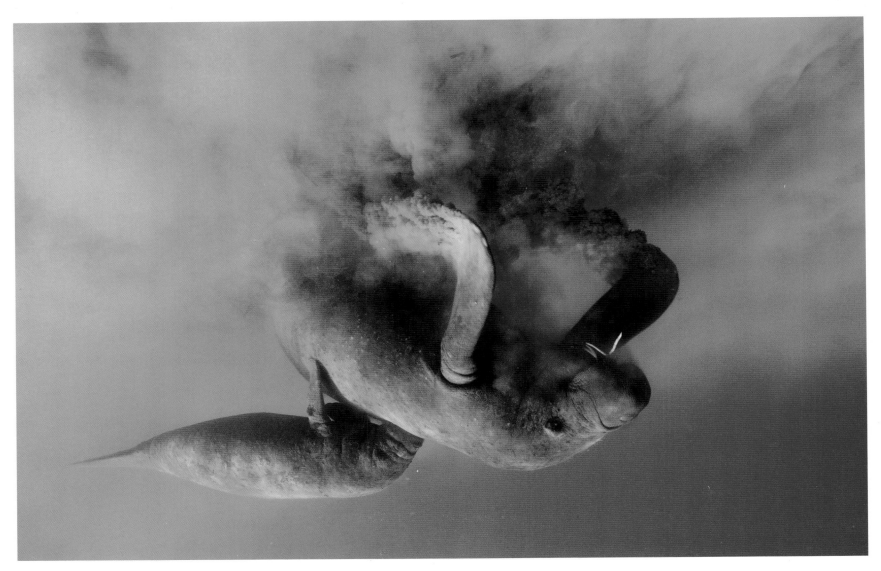

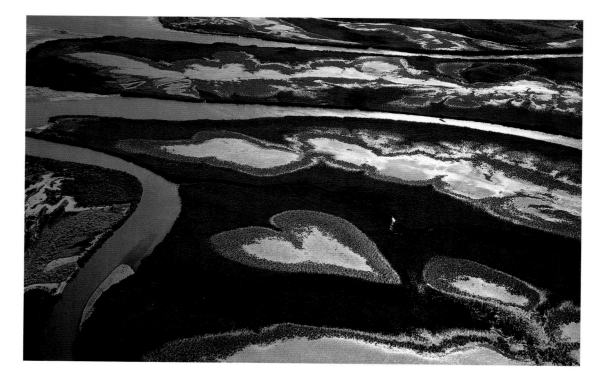

LEFT: **The Heart of Voh, New Caledonia**
(20°56' S, 164°39' E)

On the Pacific island of Grande Terre, where marine water only reaches inland during spring tides, vegetation sometimes gives way to bare and oversalinated stretches called salt marshes, as near the locality of Voh, where nature has drawn this clearing in the shape of a stylized heart. The mangrove, a half-terrestrial, half-aquatic forest, develops on tropical muddy soil exposed to the coming and going of the tides. Consisting of various halophyte plants (adapted to growing in saline conditions), mangroves cover close to a quarter of tropical coasts around the world.

of Pacific microstates, some of which (such as Tuvalu) are immediately at risk, or city dwellers in major metropolises such as New York and Shanghai. In Bangladesh, where half the population lives in zones located lower than 16 feet (5 meters) above sea level, various forecasts predict that about 20 percent of the territory will sink below the waters and that 20 to 40 million inhabitants will be displaced.

As for Africa, the United Nations Framework Convention on Climate Change (UNFCCC) estimates that "close to 30 percent of coastal infrastructures are at risk" and that the number of Africans threatened by floods "will increase from 1 million in 1990 to 70 million in 2080."

TUVALU

The state of Tuvalu is emblematic of this situation. Composed of nine coral atolls, the highest point of which is 16 feet (5 meters) above sea level, and with a population of some ten thousand inhabitants, Tuvalu is threatened by rising water levels. According to experts, the archipelago could disappear by 2050. Tuvalu's representatives have begun to plan for the population to emigrate. They requested visas from Australia, which refused, and New Zealand, which agreed to welcome Tuvaluans under certain conditions. Also in the Pacific, the 1,500 inhabitants of the Carteret Islands (Papua New Guinea) began evacuating in 2009. Other islands are considering displacing their population. According to disputed figures, the number of climate refugees could grow to several hundred million.

AREAS TO PRESERVE

Clearly, coastlines must be protected. In 1975, France created the *Conservatoire national du littoral* (National Coast Conservatory), a public organization charged with acquiring land in order to shield it from real estate pressure and urbanization, and to preserve its natural, wild state. Once acquired, the land becomes inalienable and is managed by local districts or by organizations such as the World Wildlife Fund or the League for the Protection of Birds. Thanks to this initiative, more than 12 percent of French shores are protected or 745 miles (1,200 kilometers) of coastline covering an area of 370,650 acres (150,000 hectares). The long-term objective is to have one third of the coast be "wild" by 2050.

The protection of coastlines is also ensured by international agreements, laws, and government agencies. The Ramsar Convention, which was created in 1971 for the protection of migratory birds, has evolved to protect the specific ecosystems of wetlands.

20 PERCENT OF THE PLANET'S MANGROVES HAVE BEEN DESTROYED

These forests located at the intersection of land and sea are most threatened in Asia and South America, particularly by agriculture and aquaculture. Mangroves, which are among the richest and most productive ecosystems on the planet, play a triple role by protecting, feeding, and serving as a nursery for numerous species.

LEFT: **Devastated mangrove, Casamance, Senegal**
(12°37' N, 16°33' W)
Successive droughts, the development of
roads, and the felling of trees for firewood have
led to the disappearance of part of Senegal's
mangroves. This unusual ecosystem of coastal
forests plays an important part both for its
inhabitants and for the local fauna. The
mangrove is a shelter for fish, reduces soil
salinity, and allows for rice to be cultivated on
nearby land.

More than 1,950 sites are included on the Ramsar Convention's list. These include
coasts whose marine water is no more than 19 feet (6 meters) deep at low tide, peat bogs,
marshes, mangroves, and coral reefs. It currently protects more than 469 million acres
(190 million hectares).

ECOTOURISM

Governments are not the only force that can get involved. The development of ecotourism
is an economic incentive to protect natural areas, notably coasts and coastal zones. To
mention a single example, close to 13 million people went whale and dolphin watching in
2008. This activity brought in close to 2.1 billion dollars and employed thirteen thousand
people around the world. It also encouraged local communities to preserve biodiversity.

CLIMATE CHANGE

Local initiatives can be effective in facing local threats. But these kinds of efforts will
obviously remain powerless to counter rising sea levels. Only global awareness and
drastic reduction of our greenhouse gas emissions can provide a solution. To date, the
international community has not proved ready.

ADAPTING TO THE DAY AFTER

Given our feeble reactions to climate change, a significant rise in sea levels is inevitable.
Additionally, the physical properties of the ocean—which has great thermal inertia—are
such that even if we were to act quickly, the seas would continue to rise for a few decades.
If we cannot prevent climate change (scientists speak of "mitigation"), then we must
prepare to face the consequences (the term is "adaptation"). And the sooner we act, the
easier it will be and the less money and effort it will require. So we must plan ahead. In
general, we have three options: to hold our ground, adapt to rising waters, or simply beat
a retreat. In fact, the three often have to be dealt with at once: building dikes and dams,
moving buildings inland, adapting them, restoring wetlands. But this adaptation also aims
to limit the impact of rising water levels by planning for floodable zones, insurance, and
maintaining the drinking-water supply.

Here, too, these measures will have limited effectiveness if rising water levels take
on excessive proportions—in other words, if we are incapable of attacking the problem's
causes, such as our greenhouse gas emissions.

**46 MILLION PEOPLE ARE AT RISK
FROM A TIDAL WAVE EVERY YEAR**
The Indian and Pacific Oceans, areas of
strong tectonic activity, are most at risk, with
underwater earthquakes capable of setting off
a tsunami that would destroy everything in its
path. In December 2004, Aceh province on the
island of Sumatra was devastated by a tidal
wave that killed 226,000 people; in 2011, the
tsunami that ravaged the east of Japan killed
close to 20,000 people and caused a major
nuclear disaster.

For more information on this subject and
a relevant excerpt from the film *Planet
Ocean*, go to http://ocean.goodplanet.org/
littoral/?lang=en

THE MANGROVE IS THE VILLAGER'S LIFE

INTERVIEW WITH HAÏDAR EL-ALI

HAÏDAR EL-ALI, a lover of the sea, has turned his diving club into an organization for the protection of the environment. He spent several years in the field fighting overfishing and convincing Senegalese villagers to preserve the mangrove. Thanks to him, several million trees have been replanted. In 2012, the activist was appointed Senegal's Minister of Ecology and the Environment, a position which ensures his initiatives have a greater impact.

A few years ago, you and your organization Oceanium began replanting the mangroves which were disappearing from the Casamance and Sine-Saloum deltas. Why?
Mangroves help limit the salinity of coastal soils; they are therefore essential for maintaining the land's fertility and enabling rice cultivation. Mangrove trees provide firewood to local inhabitants.

Bees like their flowers; the mangrove produces honey. As a nursery for fish, it is directly responsible for part of the villagers' diet. Buds and bark are used to make medicine. The mangrove is a source of natural riches and on a wider scale, it protects the coasts from erosion and captures CO_2. The mangrove is the villager's life. Yet in a few decades, Senegal has lost close to 40 percent of its mangrove surface.

What caused the disappearance of mangroves in Senegal?
Mangroves initially suffered from the droughts of the 1970s and '80s. With rivers drying out, increased salinity levels killed the trees. Then they were damaged throughout the 1980s and '90s when many roads were built to make isolated villages accessible, and roadwork cut off seawater circulation in certain areas of the Casamance River Delta. But many mangroves are also cut down by villagers, who use the wood to cook and heat their homes.

"In a few decades, Senegal has lost close to 40 percent of its mangrove surface."

How did you protect the mangrove?
We started the reforestation in a single village in 2006. With three hundred people, we planted sixty-five thousand mangrove trees.

The mangrove came back to life. News of our success spread and the experiment was expanded. The next year, sixteen other villages joined the movement and we planted five hundred thousand mangrove trees. In 2008, we decided to plant ten times more trees and we reached our goal: More than 6 million propagules were planted from September to October 2008, with the support of the Yves Rocher Foundation. In 2010, the Danone group began supporting us financially, allowing us to operate on an even larger scale. This year, we mobilized seventy thousand people to plant close to 70 million mangrove trees. That's how enthusiastic people have gotten!

"Today the watchword is action; we have to stop talking."

How did you get so many people involved?
For years, I traveled the country with my organization Oceanium, using a movie-theater truck to explain to villagers the essential role played by mangroves and to convince them to replant mangrove trees with us. I always have the same approach: talking with populations to find applicable solutions. You have to speak the language of the heart, the language of truth.

What we say must not stray from concrete realities. You do not win over the people of Casamance, of Senegal, or of Africa in general by talking abstractly about global warming, but by speaking about things that are close to them and will be directly beneficial to them . . . By explaining that the sea is not eternal, that a lack of fish can lead to famine and unemployment, and that we have to save this planet for ourselves. Not for the birds, the trees, or the butterflies. For us!

What is the current status of the projects for restoring and replanting the mangroves?

Every citizen, every Senegalese person must understand how urgent it is to act to protect our environment. All it takes is to plant a tree. If we start there, we will win this battle. Today the watchword is action; we have to stop talking.

Mangroves play an essential role in the reproduction of marine populations. Is this why you also created a marine protected area?

In the Sine-Saloum estuary [a delta formed by the Sine and Saloum rivers, 80 miles (130 kilometers) south of Dakar] in the south of the country, we closed the Bamboung bolong [small saltwater channel] in 2002 and created a marine protected area. It is managed by representatives of the fourteen neighboring villages, who meet every three months to discuss the initiatives required. Thanks to this marine area, some twenty species that had vanished from the region have reappeared. And thanks to spillover, these fish also enrich peripheral fishing zones. The reserve therefore benefits nearby fishermen. The reserve has also allowed women to relaunch oyster cultivation, which provides them with additional revenue. This marine protected area has changed the lives of many people here. They make enough money to support their entire families and protect the environment at the same time!

When you became a minister, what was the state of fishing resources?

A lot remains to be done in the field of fishing; a lot of bad practices have to be changed. The marine protected areas' management is charged with creating new preservation zones. It must work in consensus with local fishermen.

I believe marine spaces must be divided into three major categories: One-third must be authorized for sea fishing, one-third must be reserved for small-scale fishing or fishing from the shore, and the last third must consist of marine protected areas. The last third will allow for the other two-thirds' resources to be maintained.

Once the fish's habitat is restored, the animals multiply. Yet creating marine protected areas is not enough in the face of the destruction from industrial fishing. I should mention that for several years, resources were managed by mafiosi and corrupt individuals. Those people pillaged and ruined the country's fishing resources.

The Chinese and the Europeans came to our waters aboard huge trawlers and helped themselves, jeopardizing the country's precious resources. [According to Pape Diouf, Senegalese Minister of Fisheries, the sector accounts for 32 percent of the country's exports and seven hundred thousand permanent and temporary jobs.]

> "We have to save this planet for ourselves. Not for the birds, the trees, or the butterflies. For us!"

Is this why you requested fishing authorizations for foreign trawlers to be canceled in May 2012?

As soon as it came to power, the new government denounced these agreements [made by the previous government through a completely opaque process in contradiction with national regulations]. We helped small-scale fishing professionals. [According to Greenpeace, the twenty-nine trawlers involved were single-handedly fishing 60 percent of what the roughly ten thousand pirogues of small-scale Senegalese fishermen catch.] Local fishermen soon saw its beneficial effects, because the sardinella reappeared. Yet this is not enough. For there are two kinds of fish. Those that reproduce quickly, like the sardinella, which lives a year and a half. For small pelagic fish like the sardinella, sardine, and horse mackerel, solutions remain: We need to close certain fishing zones to allow individuals to mature and replenish the stocks. But for fish that live longer and whose reproductive cycle is slower—such as the grouper, which lives eighty years—I fear that we have reached a point of no return.

What has your appointment as Minister of Ecology and the Environment changed?

My appointment changed the scale of my initiatives. Previously, I was active locally, in villages. This local action proved its effectiveness, showed results. Now it can be continued at a national level with the support of the state and the administration, and the Water and Forests departments. This is obviously very important, for as an NGO [a nongovernmental organziation] you make decisions on a local level, while as minister, my plan of action is national, even international. But I want to return to the question of fishing, which is very important, notably for the young, who are tempted to escape to Spain. Obviously, when they see that European countries come to corrupt our ministers, sign phony agreements, take all our fish and enrich themselves, they want their piece of the pie! But from now on things are changing.

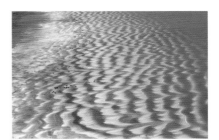

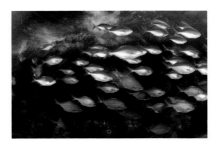

Traditional fishing method, between Abidjan and Grand-Bassam, Ivory Coast (5°13' N, 3°53' W)

Every day, fishermen in the Ivory Coast take considerable risks to cross the "bar," a highly dangerous zone where enormous breakers crash down in rapid succession. Experience teaches them to anticipate the moment when the waves subside to take their pirogues out to sea. This natural obstacle found along the entire Gulf of Guinea isolated the countries bordering it from the rest of the world until the nineteenth century. Today the Gulf of Guinea is on the verge of becoming a crucial geostrategic site on the international scene, particularly with the development of Nigeria (the leading African oil producer) and Angola, which is also rich in hydrocarbons.

Giant clam (*Tridacna gigas*) mantle, Kingman Reef, United States

The giant clam is the biggest shellfish in the world: It can be as long as a record-breaking 4.9 feet (1.5 meters), and the heaviest giant clam ever weighed was 734 pounds (333 kilos). The blue of the mantle sticking out of the shell is due to the presence of an algae living symbiotically in the tissue, a zooxanthella similar to those found in corals. The pressure exerted by the valves when the shell closes is a genuine trap—and a lethal one for divers who might slip their foot into it. Long used as decorative or religious objects, or even as food, these animals are now protected.

Herd of cattle in the Mirim Lagoon, near Punta Magro, Rocha Department, Uruguay (34°07' S, 53°44' W)

A vast freshwater lake covering an area of about 1,550 square miles (4,000 square kilometers), Mirim Lagoon is located along South America's Atlantic coast in a temperate subtropical zone. Its western half covers 18 percent of Uruguay, with the other half in Brazil. Between prairie and marsh, this area of pastureland shelters numerous species of migratory birds. The marshes of the Mirim Lagoon are among the fifteen principal migratory paths on the planet.

School of blue maomao (*Scorpis violacea*) in protected waters, Poor Knights Islands, New Zealand

The Poor Knights Islands are located north of New Zealand. Since 1981, the water around these islands is protected by a reserve extending 2,600 feet (800 meters) from the coasts. Navigation and mooring are strictly regulated. Only scientists can be authorized to disembark on the islands. These islands are sanctuaries for numerous bird species, particularly the two hundred thousand pairs of shearwaters recorded.

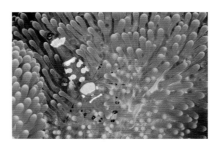

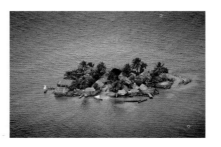

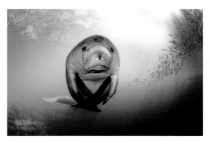

Mouth of the Kalou wadi in Lake Assal, Djibouti (11°37' N, 42°23' E)

At 508 feet (155 meters) below sea level, the Assal salt sea is the lowest point in Africa. Subject to extremely high temperatures, the Lake Assal depression is a furnace, which accelerates evaporation. Once or twice a year, heavy rains lasting only a few dozen hours replenish the wadis, which rush into the lake. They carry detrital sediments (pebbles, sand, and clay) and mineral salts, which crystallize on the basalt riverbed under the effect of heavy evaporation, leaving a trace of the rushing water's passage.

Shrimp (*Periclimenes*) living inside a sea anemone, Kingman Reef, United States

This shrimp's translucent body allows it to hide among sea anemones. Several types of relationships exist between species in the animal kingdom. The association between the shrimp and anemone is known as commensalism, a term referring to the relationship between two species from which one benefits and the other derives no benefit and no harm. This shrimp benefits from the anemone by protecting itself and diverting part of its food, but the anemone does not noticeably benefit from the shrimp.

Homes of the Guna Amerindians, Robeson Islands, San Blas Islands, Panama (9°31' N, 79°03' W)

The Gunas are the native people of Panama. These approximately forty thousand inhabitants of the indigenous region of Guna Yala live on the Caribbean coast and on some forty coral islands in the San Blas Islands, which consist of 365 islands. For the last hundred years, the Gunas have enjoyed semiautonomous status and refused any foreign investments. Nonetheless, part of their revenue is due to tourism.

Florida manatee (*Trichechus manatus latirostris*) in a school of snappers, Weeki Wachee River, Gulf of Mexico, Florida

Like Caribbean manatees in general, Florida manatees are a particularly threatened species. These animals are categorized as "vulnerable" on the IUCN Red List of Threatened Species. While human coastal activities have considerably reduced their habitat, swallowing abandoned fishing nets and collisions with ships have also reduced their numbers. But one of their greatest enemies is temperature. In extreme cold, manatees get hypothermia, are stressed, and die by the hundreds.

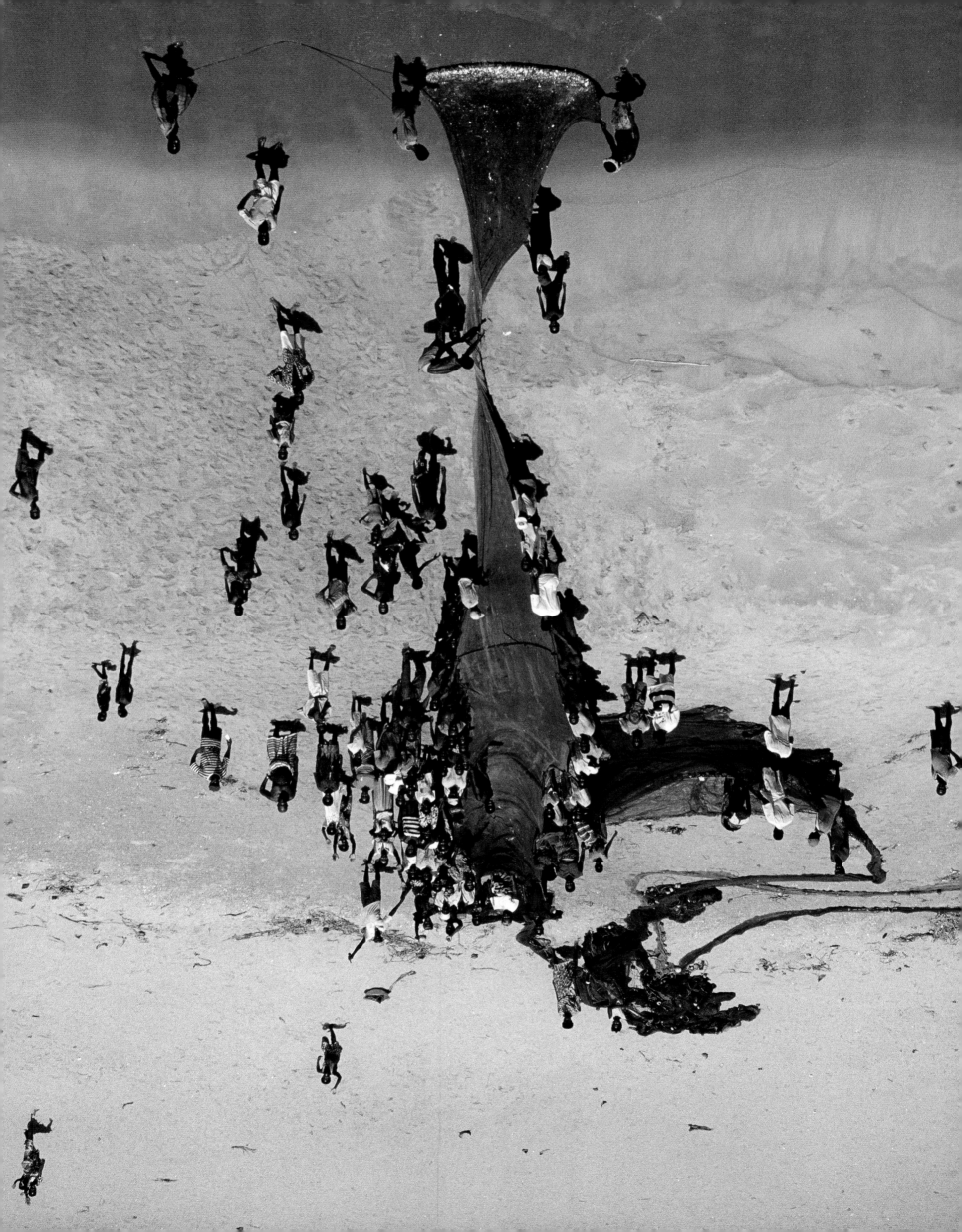

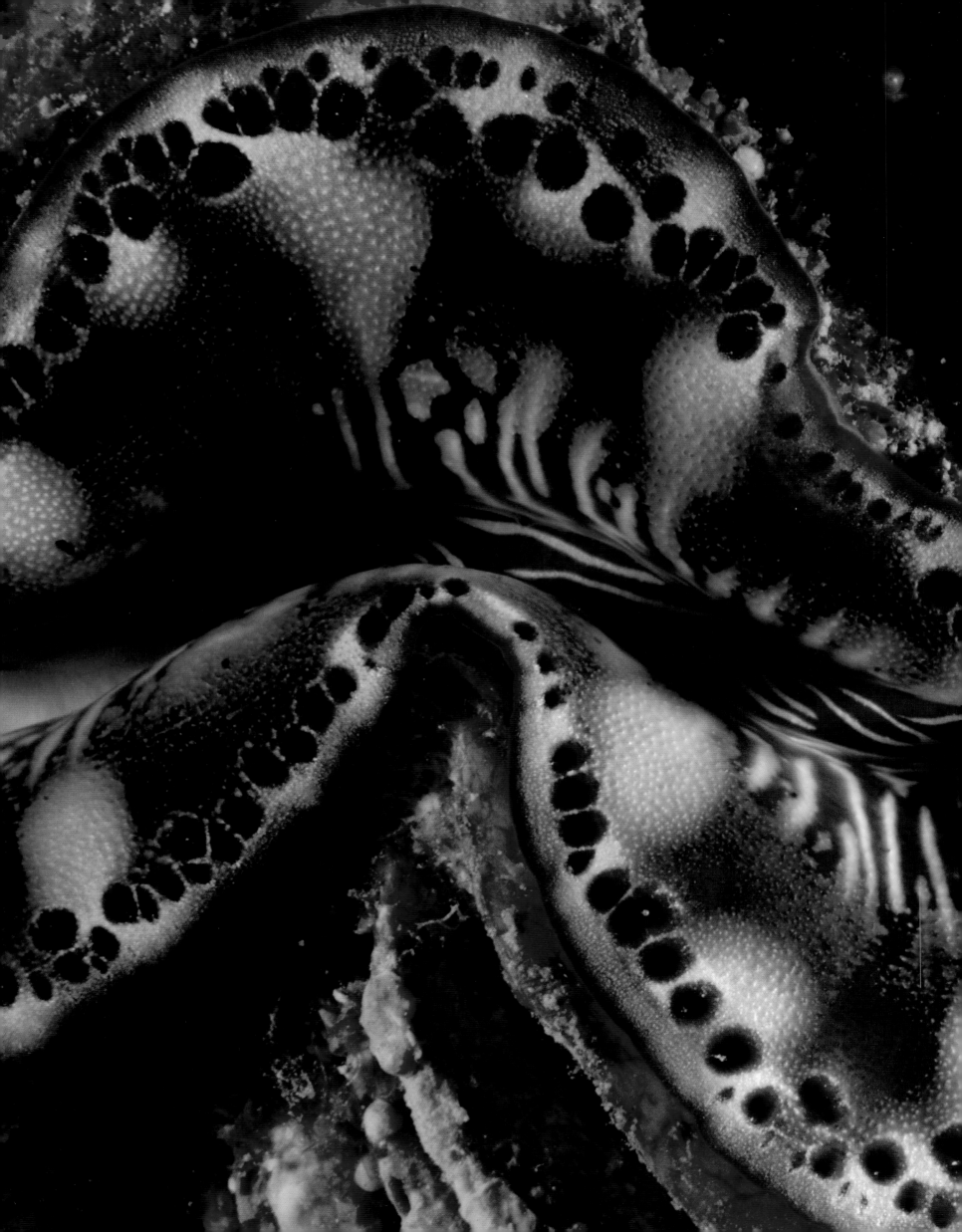

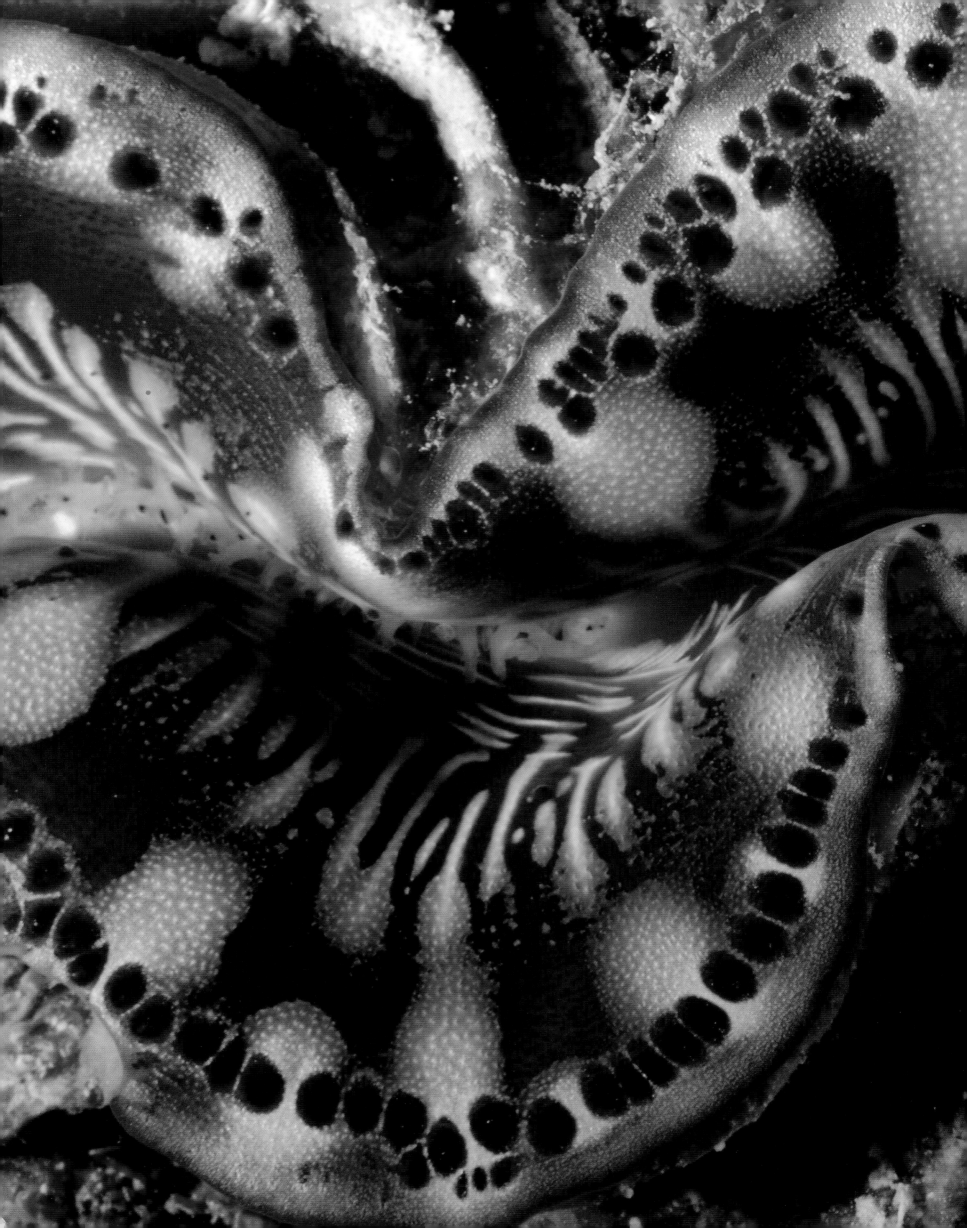

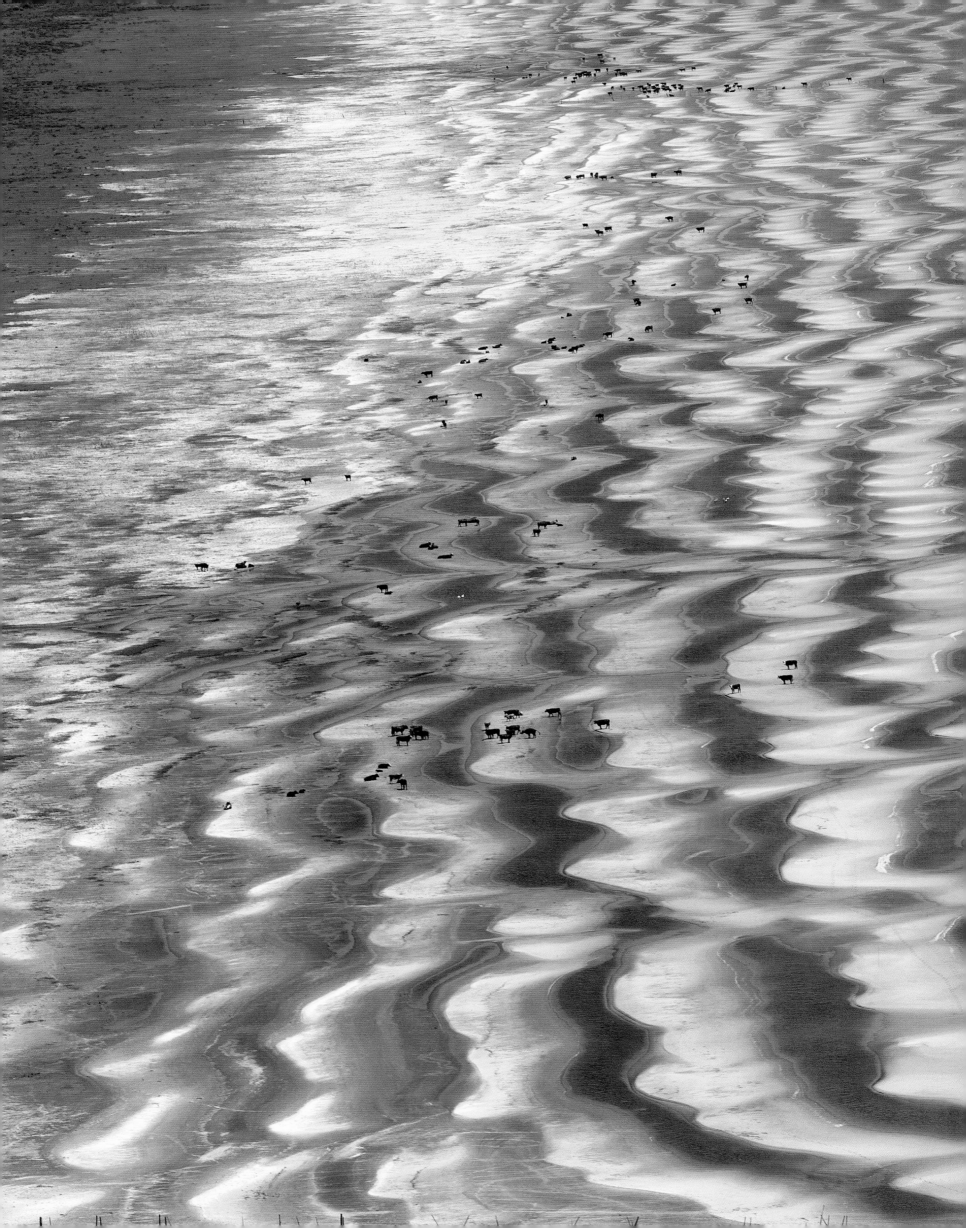

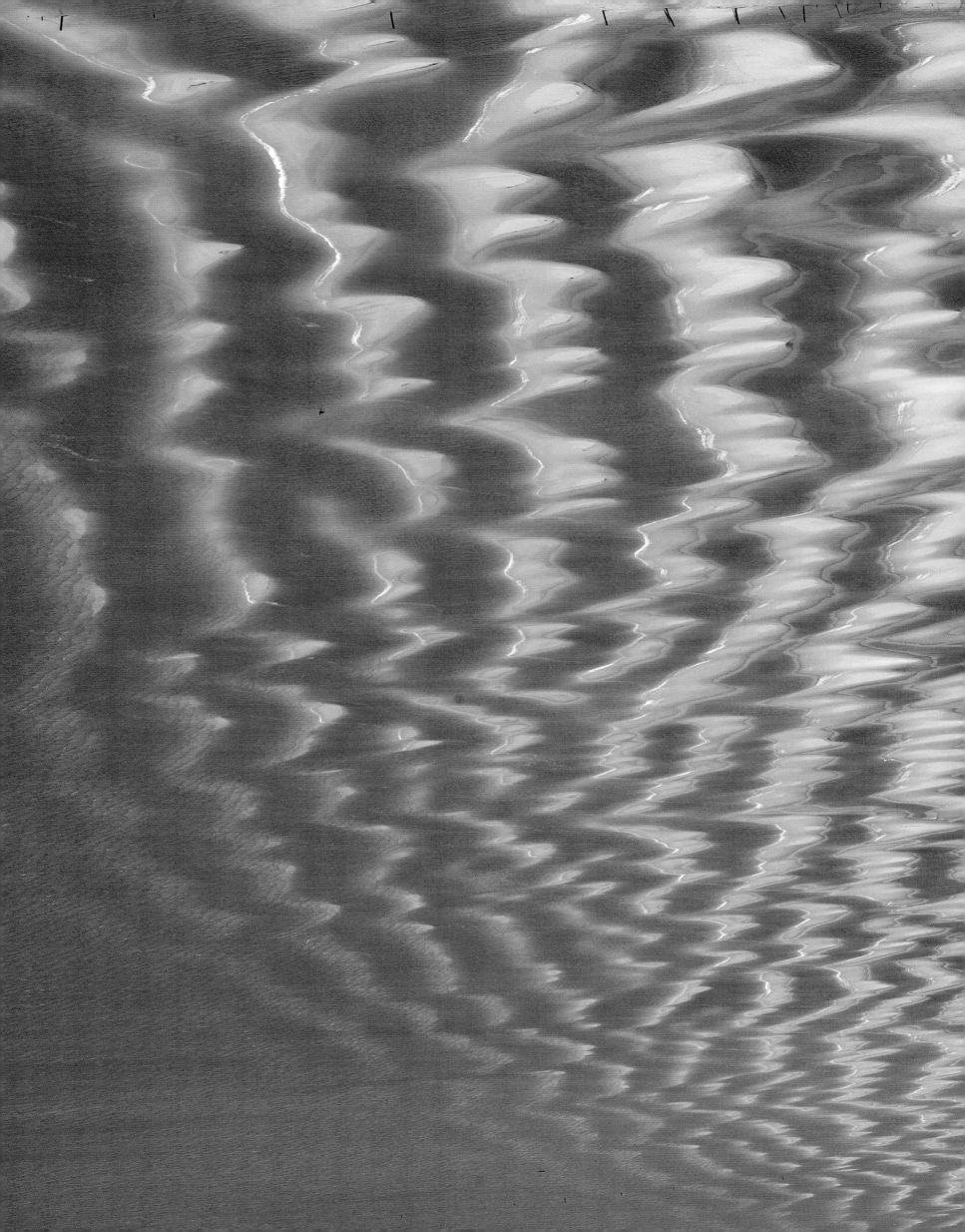

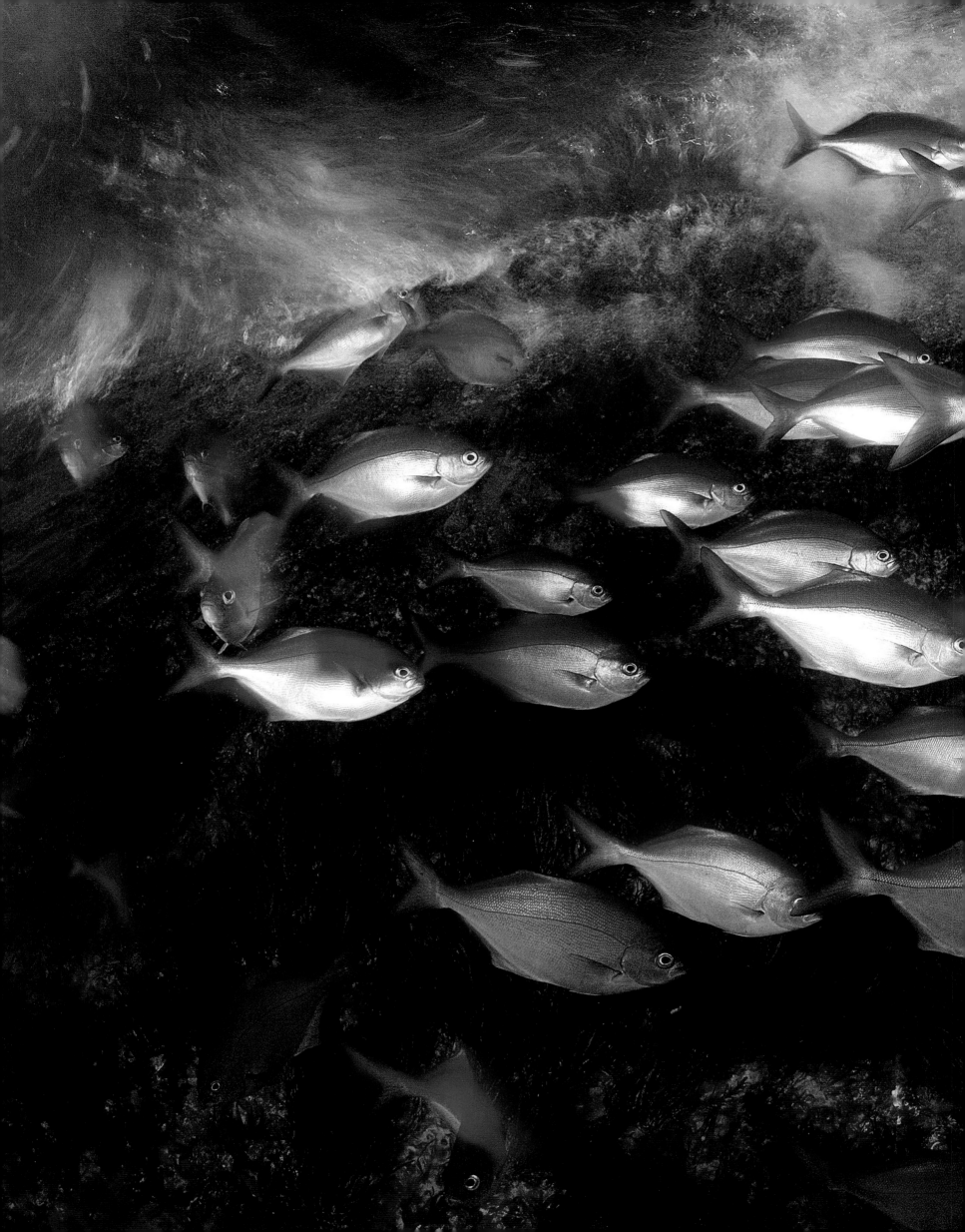

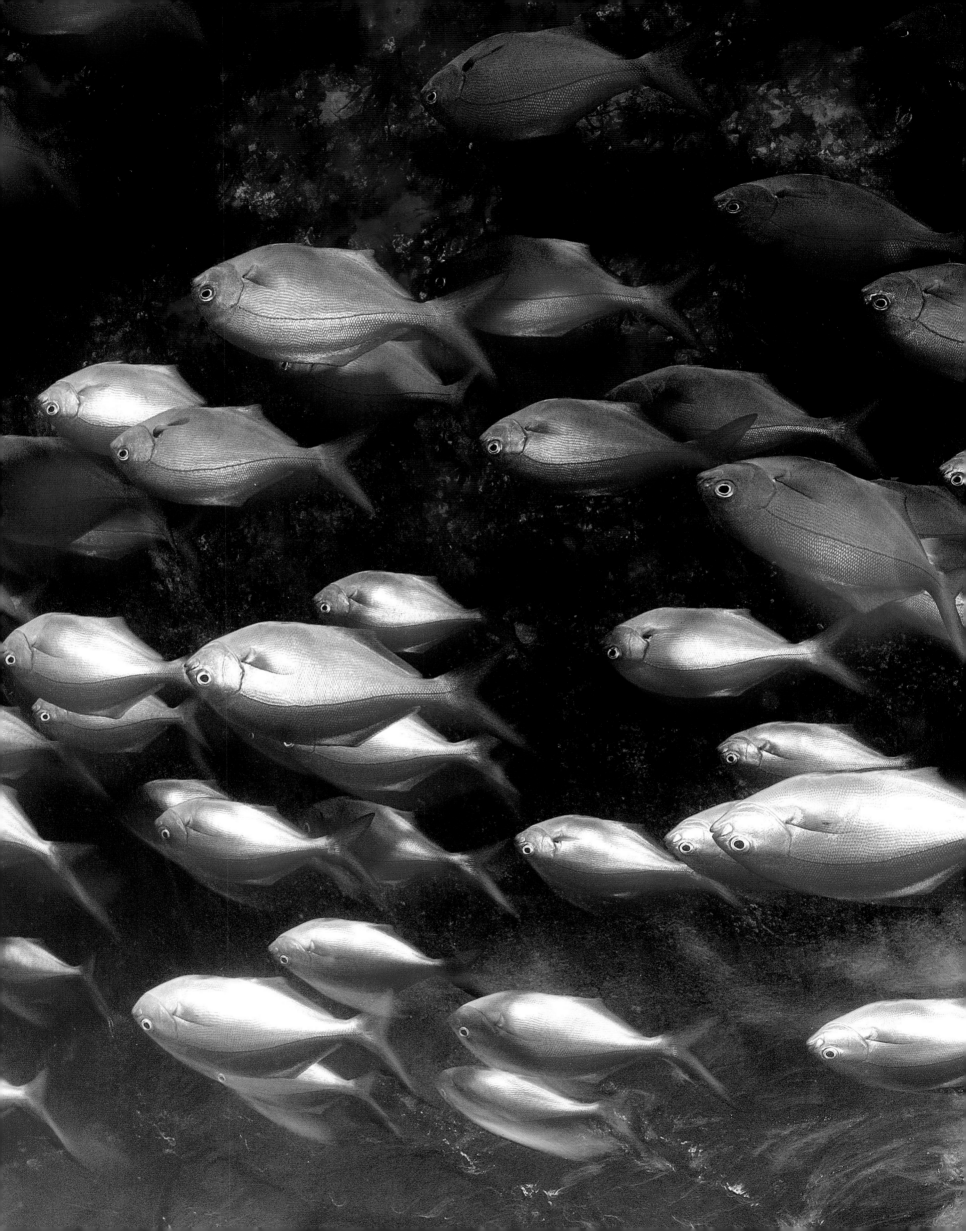

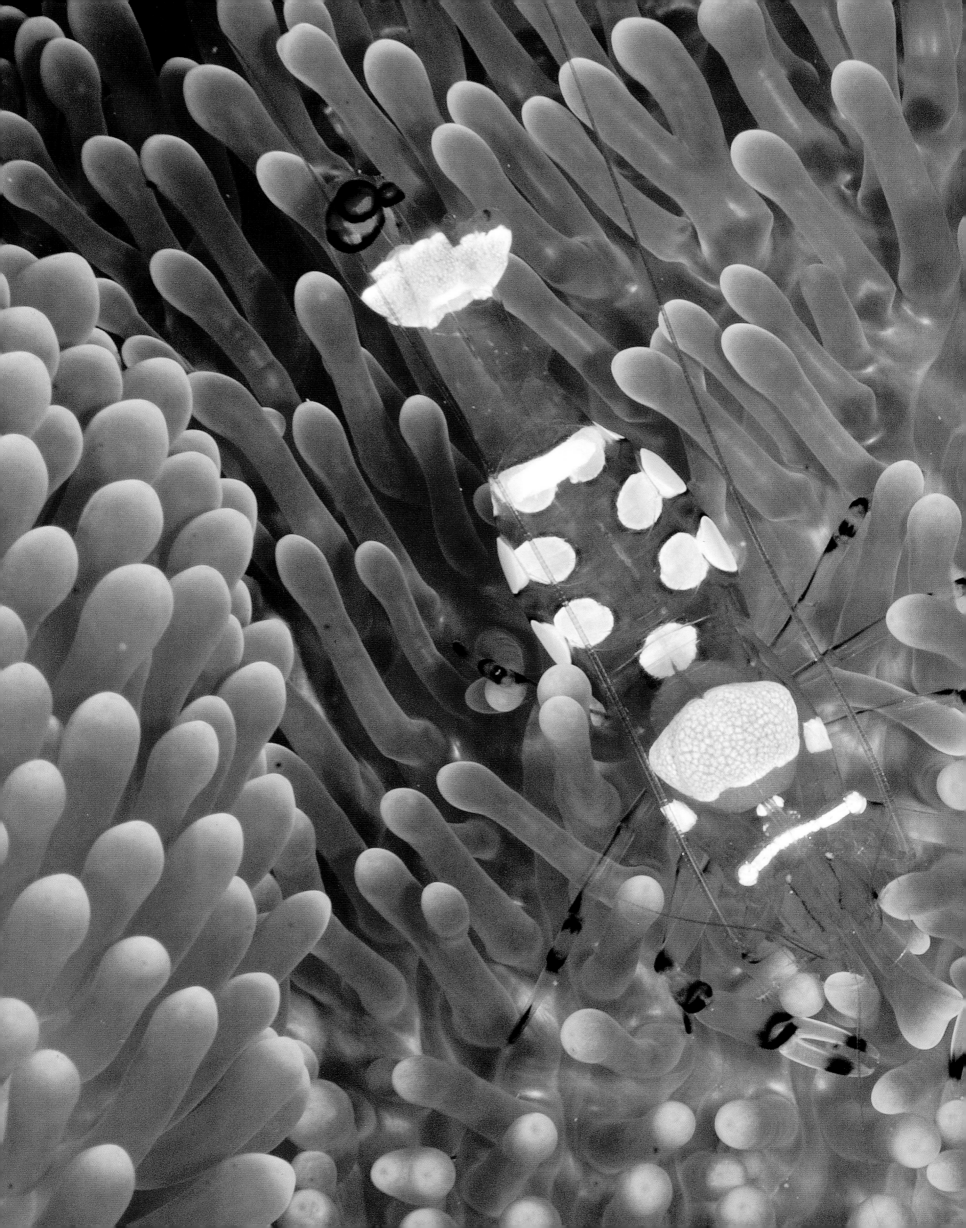

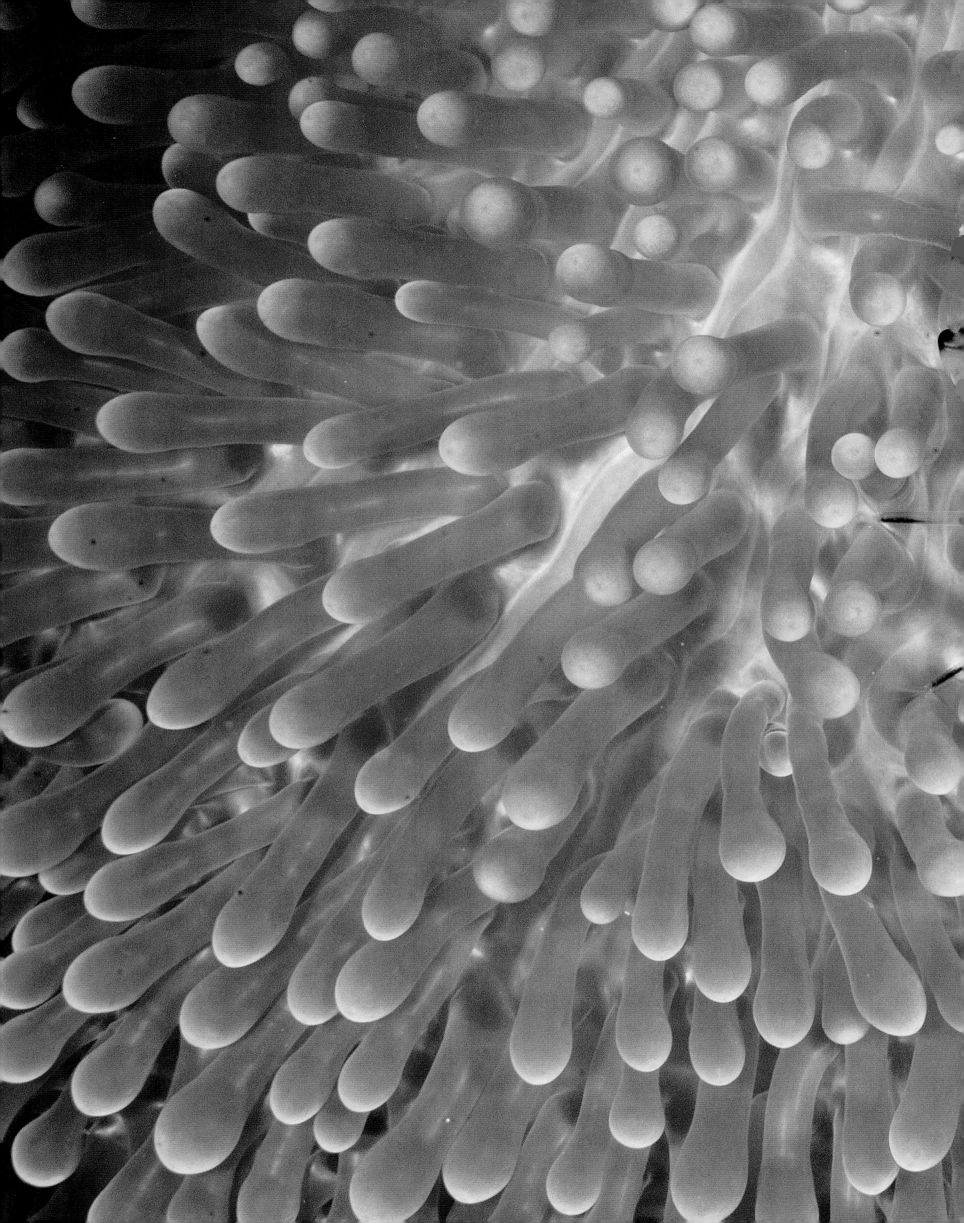

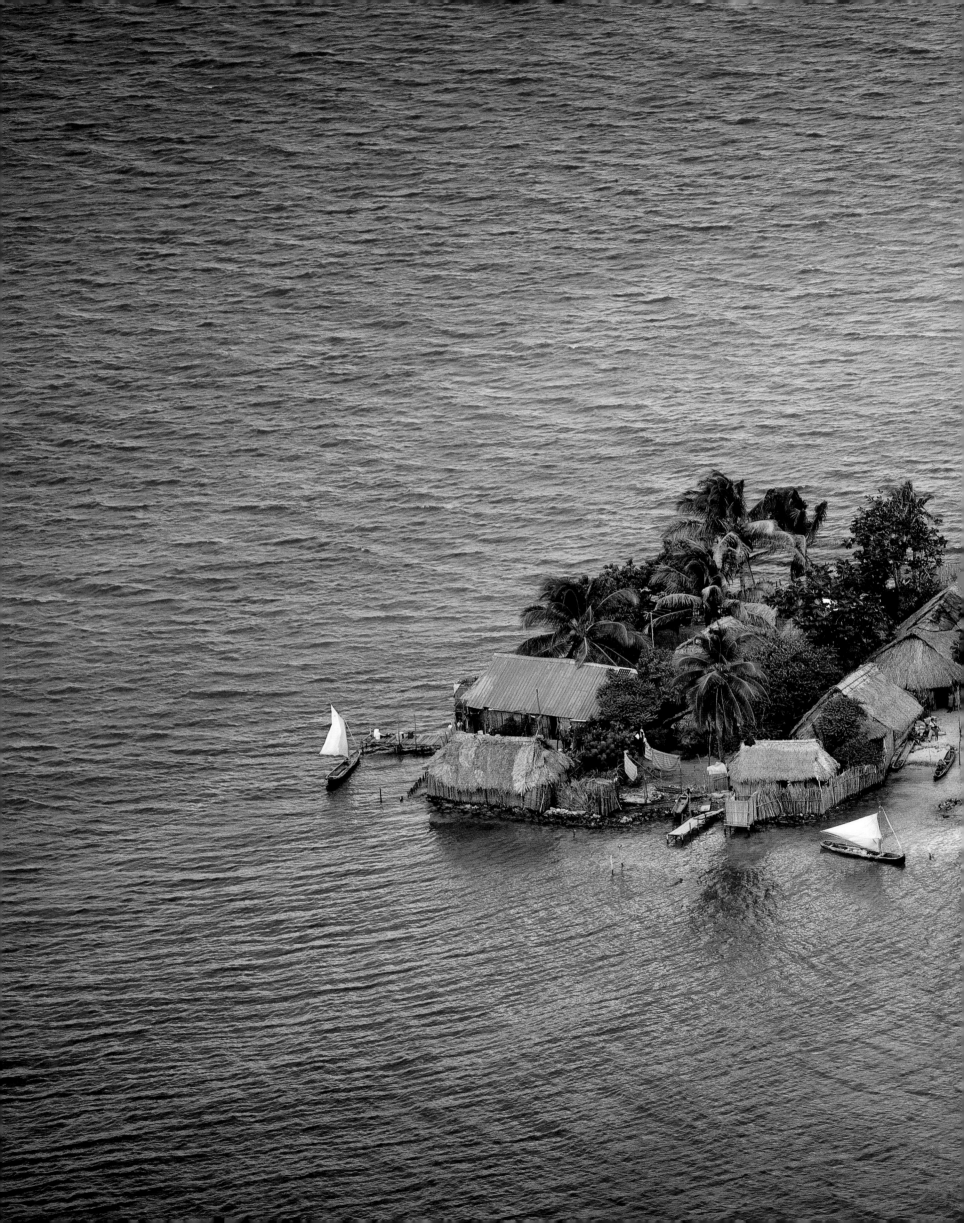

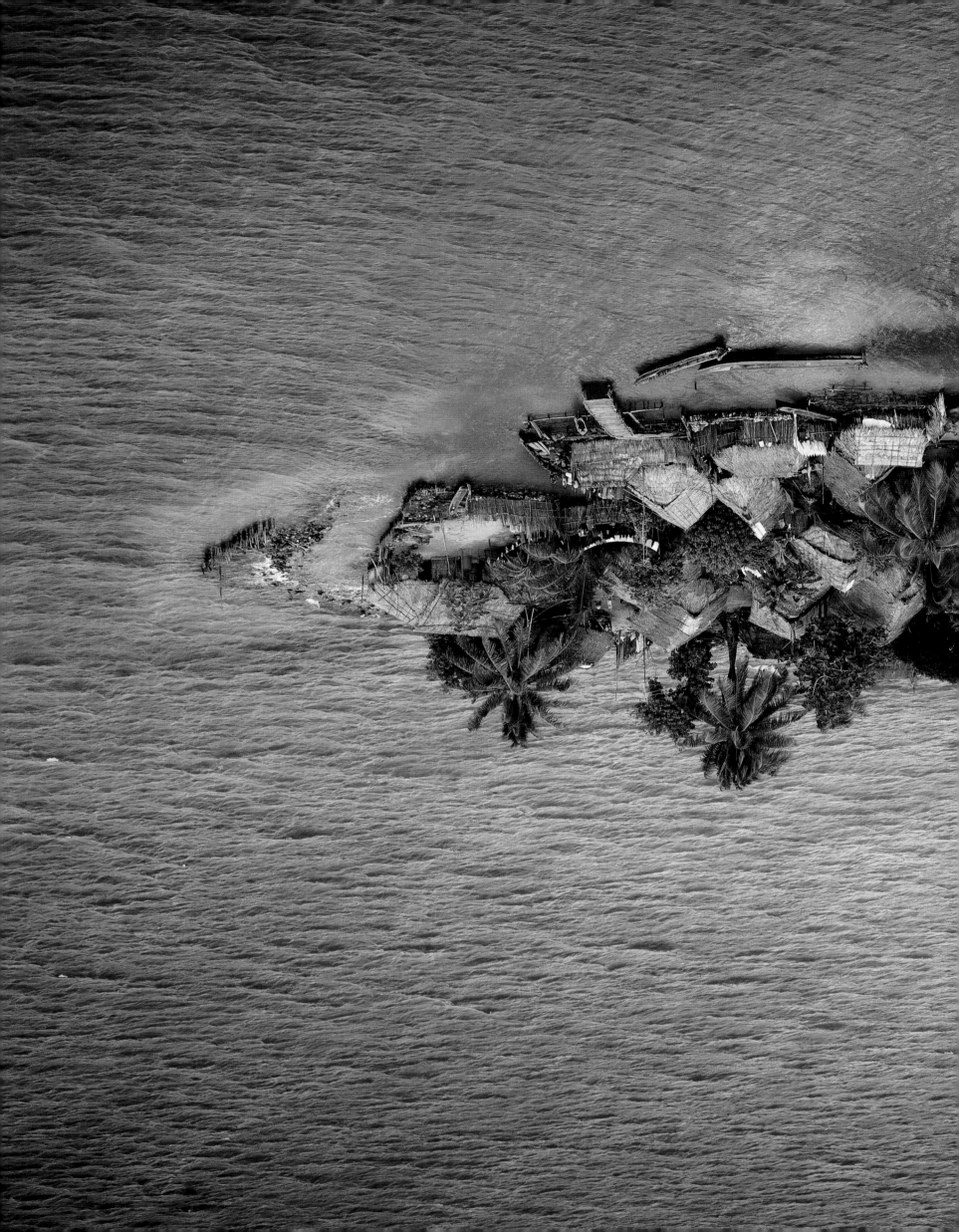

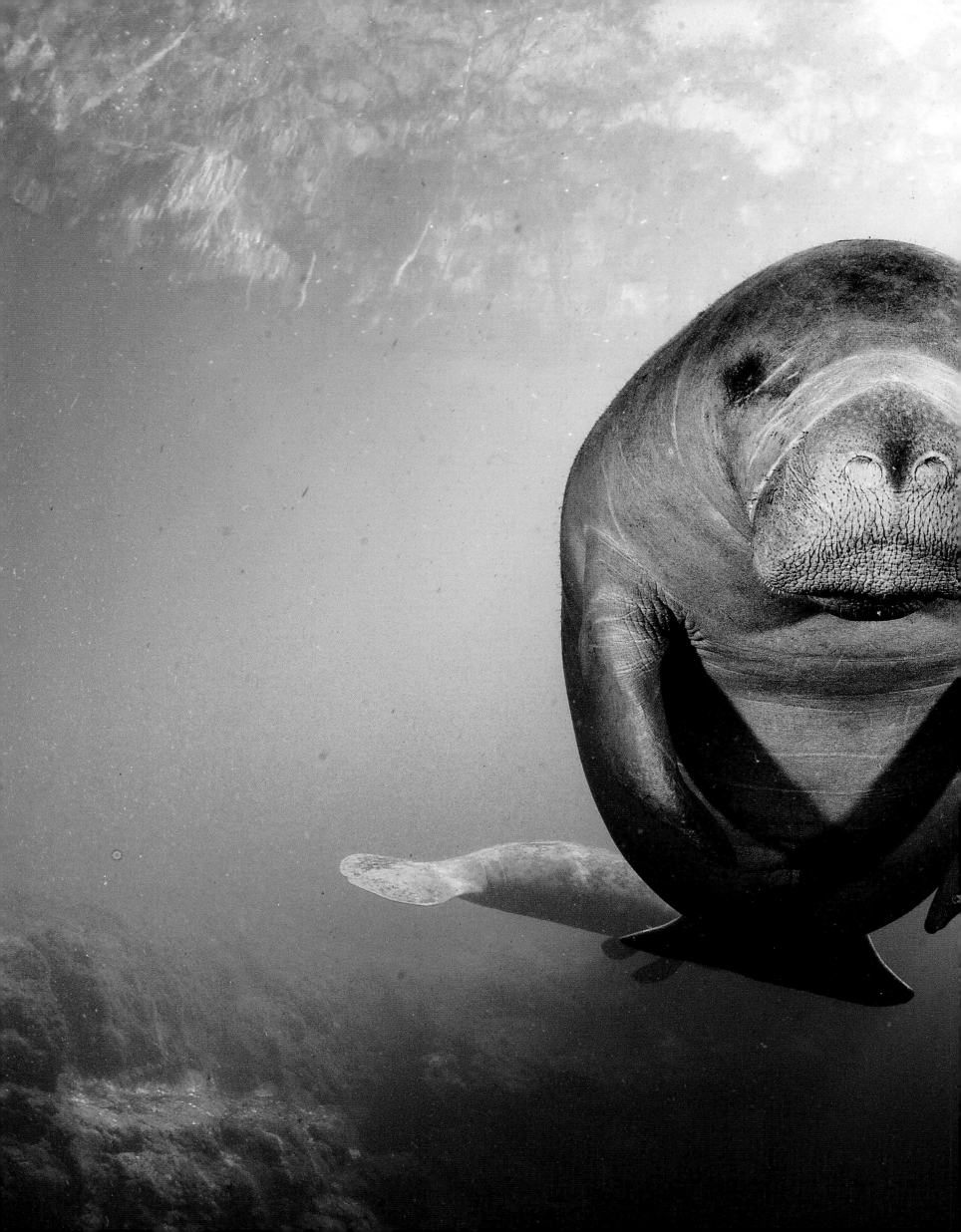

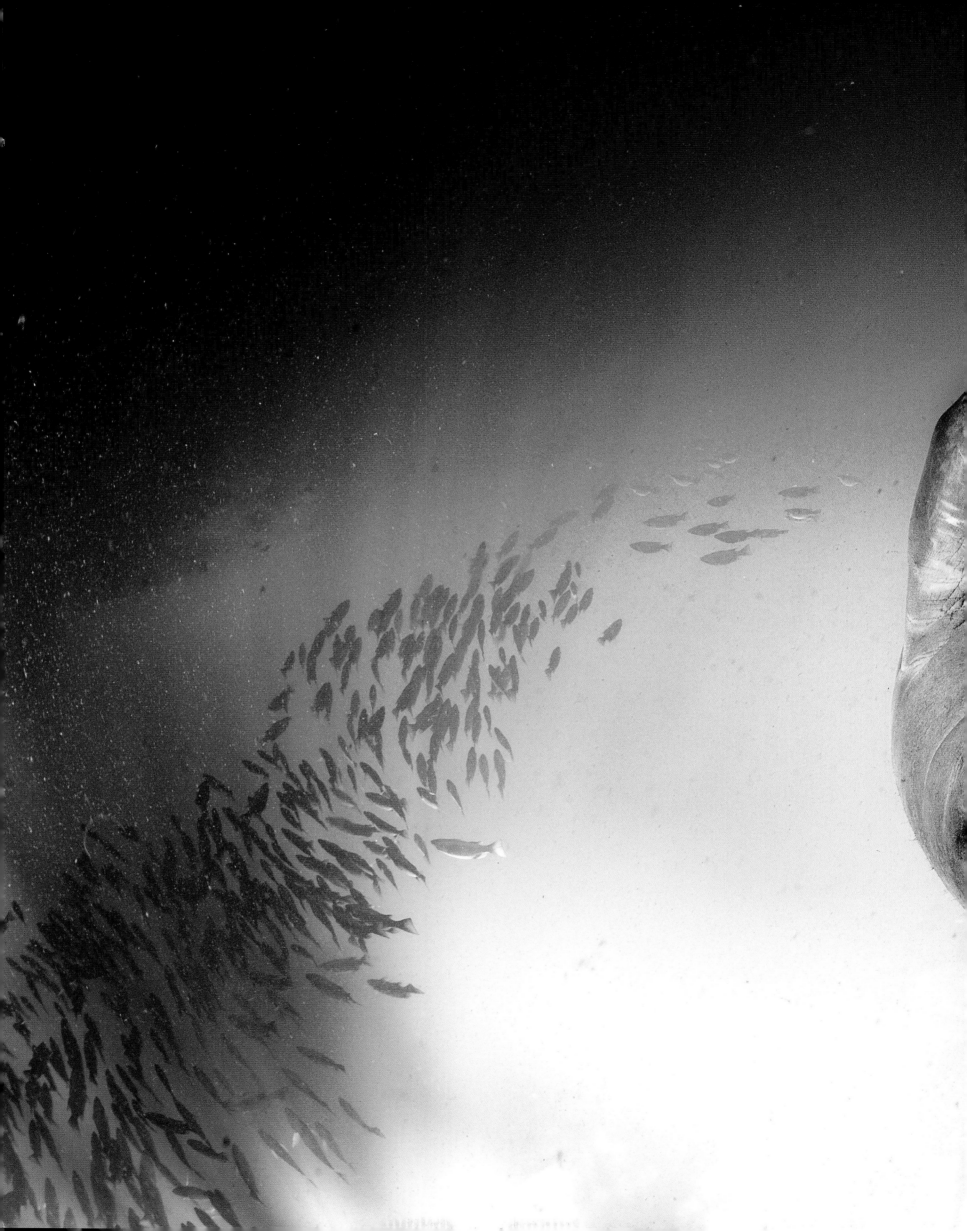

THE WORLD'S GARBAGE DUMP

On April 20, 2010, the Deepwater Horizon drilling rig exploded; it sank two days later off of Louisiana, setting off the worst environmental catastrophe in American history and the second-biggest oil spill ever recorded. For close to three months, hundreds of millions of liters of crude oil spread through the Gulf of Mexico.

Torrey Canyon, Amoco Cadiz, Exxon Valdez, Erika, Prestige . . . like Deepwater Horizon, these names evoke images of soiled coasts and oil-covered birds. Yet oil slicks only make up for 10 percent of hydrocarbon discharge due to maritime transport and oil rigs on the oceans. The remaining 90 percent is due to operational discharge from ships, often known as "degassing" or "deballasting." Large volumes of water containing hydrocarbon residue are clandestinely released when the ships' tanks and ballasts are cleaned, most often with complete impunity, which makes the phenomenon difficult to evaluate. A 2003 WWF study estimated the annual amount of hydrocarbons discharged in the Mediterranean through degassing at 0.7 to 1.2 million tons, or close to fifty times the *Erika* oil slick! Yet even this discharge only accounts for a third of the volume of hydrocarbons in the oceans. The other two-thirds are due to terrestrial activities. Leaks and sabotage at oil facilities in Nigeria annually discharge the equivalent of the *Exxon Valdez* oil spill into the Niger Delta—or close to 11 million gallons (42 million liters) of oil—making it one of the most polluted areas on the planet.

For the last few years, the number of oil spills has been decreasing, notably thanks to the adoption of international regulations, requiring that oil tankers and other tankers have a double hull, among other things. However, hydrocarbon pollution only represents a tiny part of the waste that spills into the oceans. The oceans are the final receptacle of most inland pollution and waste produced.

AGRICULTURE SUFFOCATES THE MARINE ENVIRONMENT

While oil spills are becoming rarer, green tides are becoming increasingly frequent. This is the case not only in France, where they are spoiling the coasts of Brittany, but also in China, the Baltic Sea, and Latin America. The cause of this phenomenon is not only intensive livestock farming and animal waste, but also massive use of nitrogenous manure in agriculture, which infiltrates the soil, enters watercourses, and flows to the sea. These organic and mineral fertilizers add excess nutriments to the marine environment—a phenomenon known as eutrophication. Combined with other factors such as sunshine, increasing temperatures, or a confined geographic position, they favor the proliferation of green algae. Though only dangerous for living beings when they begin to decompose, these algae spoil beaches and landscapes. And this is only one form of eutrophication.

In other cases, excess microscopic algae are decomposed by other microorganisms, which proliferate until they have consumed most of the oxygen available. A dead zone subsequently appears, in which other forms of life—fish, crustaceans, and marine mammals—cannot survive because they are asphyxiated.

OPPOSITE: **Southwest tip of Manhattan, New York, United States** (40°72' N, 74°02' W)
The city of New York has 8 million inhabitants and its greater metropolitan area has 19 million. Each day, New Yorkers produce over one billion gallons (5 million liters) of wastewater and 35,000 tons of garbage. For decades, the city stockpiled its waste in the Fresh Kills Landfill, which was bigger than the Egyptian pyramids and 82 feet (25 meters) taller than the Statue of Liberty when it was closed in 2001.

14 BILLION POUNDS (6 BILLION KILOS) OF PLASTIC WASTE ANNUALLY DUMPED IN THE OCEANS
It takes one hundred to one thousand years for plastic to decompose. Plastic waste transported from the gutter to the rivers and then to the sea is invading the ocean at an alarming rate. While a great majority of the waste sinks, a significant amount floats and forms a "plastic soup," and even a "plastic continent" in the Pacific five times the size of France. These plastics poison the oceans and threaten the survival of marine species.

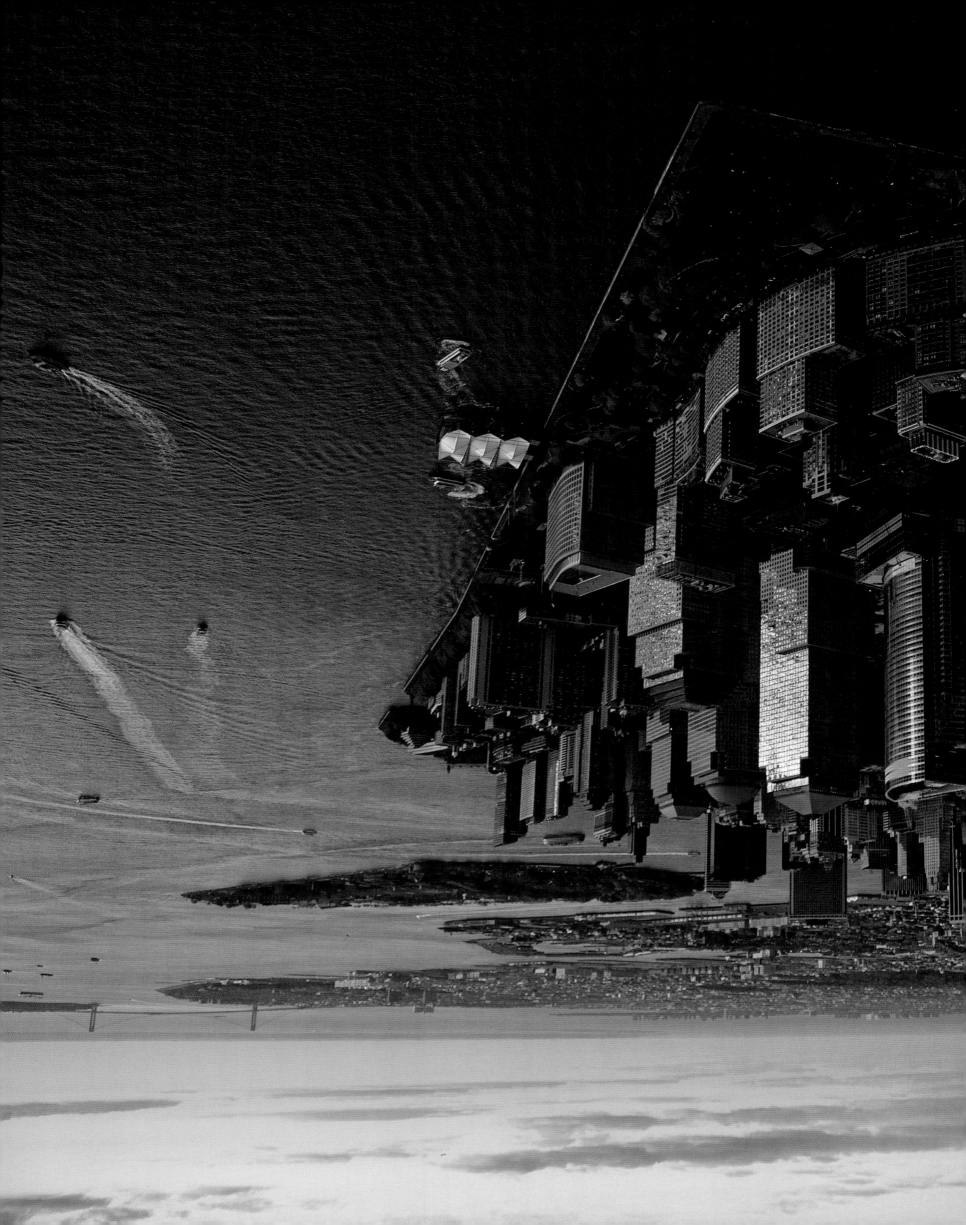

LEFT: **A doe roams free in a rapeseed field, Yvelines, France** (48°50' N, 1°47' E)
Close to 80,000 tons of pesticides or related substances were sold in France in 2008. While the tonnage is tending to drop, France—the leading European agricultural producer—remains the top consumer of pesticides in Europe and the fourth globally, after the United States, Brazil, and Japan. A large part of these pesticides is evacuated through runoff: They are found in most of the country's watercourses, to such a point that health authorities have been led to restrict the use of tap water in certain areas. Finally, residues from pesticides—as well as fertilizers and other agricultural substances—are released into the sea.

The size and number of these dead zones varies according to the influx of nutriments, weather conditions, and currents. According to certain estimations, there are over four hundred dead zones in the world, a figure that has doubled every decade since 1960. One of the largest ones is between the Gulf of Mexico and the Mississippi Delta. The legendary river, which is bordered by numerous farms and vast cornfields, carries more than one million tons of nitrogen and potassium into the gulf, where the dead zone can cover an area of up to 7,700 square miles (20,000 square kilometers). This dead zone has had disastrous effects on the local economy, which largely depends on fishing and has already suffered from Hurricane Katrina and the BP oil slick. The authorities have tried to find a solution to this problem, but the growth of corn farming has only aggravated the situation.

PLASTIC WASTE

Agriculture is not the only sector that dumps pollutants in the sea. Most activities carried out on land can cause marine pollution, beginning with our consumer habits. Glass and plastic bottles, tin cans, shoes, abandoned fishing nets, cigarette butts, Q-Tips, lighters, and so on; the list of garbage that winds up on the world's beaches is long. According to the United Nations Environment Programme (UNEP), 80 percent of waste in the oceans come from inland, the remaining 20 percent having been left on beaches or thrown directly into the sea.

According to the UNEP, 60 percent to 90 percent of "aquatic waste," as it is called, consists of plastics. Every year, 14 billion pounds (6.5 billion kilos) of plastic waste is dumped in the oceans, or 446 pounds (206 kilos) per second! Some is carried by the currents to form concentrations, such as the Great Pacific Garbage Patch (see page 121), nicknamed the "plastic continent," which stretches over an area of 1.32 million square miles (3.43 million square kilometers) between California and Hawaii, or a third the size of Europe!

Eventually, 70 percent of the waste dumped in the ocean sinks. It settles on the ocean floor, where it sometimes forms a kind of carpet that prevents exchanges between water and sediments, thereby asphyxiating these environments where much of marine biodiversity is concentrated.

INVISIBLE POLLUTION

In many developing countries, 80 percent to 90 percent of wastewater is released directly into the ocean, and even in developed countries, sewage treatment systems do not always

NUCLEAR TESTING

Many nuclear tests have been carried out at sea. Beginning in 1946, the United States conducted nuclear tests on Bikini Atoll, particularly to measure the effect of these weapons on its fleet. In 1971, Greenpeace's first action protested American tests on Amchitka, an island in Alaska, and succeeded in stopping them. France first held its nuclear tests in the Algerian Sahara, then carried out 193 tests in Polynesia, Mururoa, and Fangataufa. This decision was opposed by environmentalists, which led to the sabotage of the *Rainbow Warrior* by the French secret service in 1985 and the subsequent death of a Greenpeace activist. Before ratifying the treaty for the total ban of nuclear tests, France carried out a final and highly controversial series of nuclear tests in the Pacific. The damaging effects of these tests on the environment and the health of servicemen and local populations are still unknown and poorly evaluated, though France has compensated certain victims.

prevent bacteria and chemical products from reaching the marine environment. Toxic sludge, solvents, heavy metals, hydrocarbons, various acids, and all sorts of residues: Every year, hundreds of tons of industrial toxic waste wind up in the oceans after having been dumped in the wild by industrialists. This waste is difficult to quantify because it is often generated outside of any supervision or legal framework, but it can have severe consequences on the marine environment and human health. This is true of lead and of mercury, which is increasingly found in certain fish species intended for human consumption. Mercury can have severe toxic effects on nervous, digestive, and immune systems, and on the lungs, kidneys, skin, and eyes. In the 1950s, several thousand people in the small coastal village of Minamata, Japan, died of a previously unknown disease. It took years to discover that all the fish and shellfish in the bay, which had been the local population's chief means of subsistence, had been contaminated by methylmercury chloride from a neighboring factory.

Bacteriological pollution is principally due to human and animal waste, which, once it's in the ocean, exposes swimmers to gastroenteritis, hepatitis, etc. In the United States alone, close to 3.5 million people a year contract a disease due to polluted swimming water, and in Europe, beaches are increasingly being closed for poor water quality, despite the presence of water purification stations.

Thousands of tons of radioactive water used to cool the reactors of the Fukushima nuclear power plant in 2011 were released into the ocean off the coast of Japan, spreading numerous radioactive elements. Sadly, these doses of radioactivity are not the first that the oceans have had to absorb, aside from their own natural radioactivity. They follow the fallout from nuclear tests, legal dumping of radioactive waste until the 1980s, the Chernobyl cloud, and the wrecks of nuclear submarines such as the USS *Scorpion* and the *Kursk*, still lying on the seafloor.

ABOVE: **Green algae in the bay of Saint-Brieuc, Côtes-d'Armor, France** (48°32' N, 2°41' W)
In Brittany, the proliferation of green algae is due to the use of synthetic fertilizers on farms, to animal waste on pastures, and even more so to the release of effluent from industrial livestock farming (pig manure and poultry droppings), which are spread on the land in excessive quantities. Washed out by the rains and carried by the rivers, the nitrates wind up in the sea, where they cause the proliferation of algae. When they wash up on the beaches, these *Ulva armoricana* algae, whose common name is sea lettuce, form thick deposits and begin to putrefy. Their fermentation releases a toxic gas, hydrogen sulfide (H_2S), which smells like rotten gas, and can kill large animals like boars, horses, and even human beings, when inhaled.

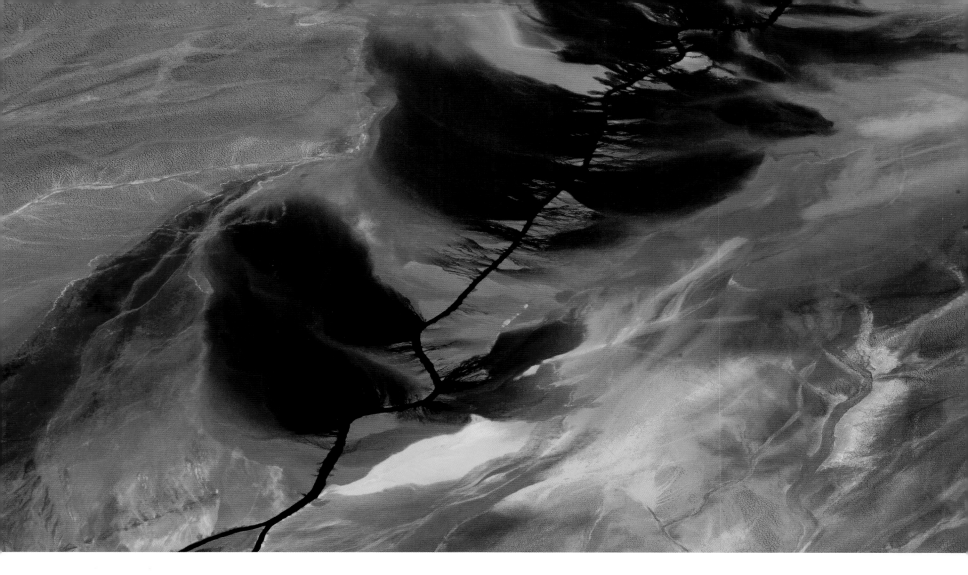

PUBLIC HEALTH

Chemical pollution from industrial centers as well the disposal of everyday products—pharmaceuticals, cosmetics, washing powders, detergents, paint, etc.—affects not only the marine environment but also human health. For instance, some pollutants are powerful endocrine disruptors, which can lead to reproductive disorders (interfering with sexual maturation, reducing fertility, leading to malformed reproductive organs and an increase in the frequency of certain cancers, etc.), cause behavioral problems, and alter the immune system. Studies carried out on certain fish populations particularly exposed to endocrine disruptors—from the urine of women who take contraceptives—have even shown that these molecules could eventually lead to a change of gender among fish. Found in water and carried by currents, molecules such as heavy metals and persistent organic pollutants (POPs) can endure in the environment for several years, even several decades, before being entirely degraded. They accumulate along the food chain, severely contaminating seals and marine mammals in the Arctic, which endangers the health of the native people who eat them. Though the closest factories are thousands of miles away, the immaculate white of the ice is deceptive: The ocean has become a garbage dump.

ABOVE: **Settling tank in a phosphate processing plant near Udaipur, Rajasthan, India**
(24°36' N, 73°49' E)

In Rajasthan, marble, lignite, cadmium, and phosphate are extracted from mines, most of which are open pit, and processed on site. The city of Udaipur is not only one of the most beautiful cities in India, world famous for its marble palaces, but is also next to the only natural phosphate mine in the country and its processing plant. Phosphate is used to produce fertilizers, which are carried by water and most often end up in the sea, where they cause eutrophication.

For more information on this subject and a relevant excerpt from the film *Planet Ocean*, go to http://ocean.goodplanet.org/pollution/?lang=en

THE PLASTIC CONTINENT

INTERVIEW WITH CHARLES MOORE

CHARLES MOORE is a sailor and oceanologist. He founded the Algalita Marine Research Foundation. In 1997, while returning from a sailing race, he crossed a relatively little-known part of the Pacific and encountered an unusual quantity of plastic debris; he had just discovered the "plastic continent."

When you founded Algalita in 1994, its mission did not concern plastic, correct?
When I founded the Algalita Marine Research Foundation, its initial mission had nothing to do with the plastic in the oceans, but the preservation of kelp forests—ecosystems consisting of very large algae, several dozen feet long—which are like the equivalent of terrestrial tropical forests. They populate temperate coastal zones and are therefore subject to the impact of inland pollution. Initially, Algalita aimed to preserve these ecosystems by trying to improve water quality, especially along the California coast.

Then you discovered pollution by plastics?
I discovered the notorious plastic continent in 1997. Starting then, I began researching this kind of pollution with Algalita. We returned there in 1999 with better means and more equipment. The extent of the phenomenon was greater than we imagined, and since then, Algalita has permanently changed its mission to devote itself to the battle against the pollution of oceans by plastics. This pollution does not only consist of visible trash—there are also microparticles of plastic invisible to the naked eye. Plastic is everywhere in the ocean, at every latitude, from the Arctic to the Antarctic.

What is this plastic continent exactly?
It is a zone where plastic trash, debris of every size, and microparticles accumulate under the effect of the currents. The most famous accumulation zone, and the one we study the most, is located in the northern Pacific. Under the effect of the currents, surrounding trash is directed toward the center of this gyre, or vortex. The most concentrated part of the plastic cap covers an area of 3,860 square miles [10,000 square kilometers].

Why are there no pictures of the plastic continent?
Because of waves, the ocean's surface is not smooth, and it reflects light. Consequently, photographs of the ocean only show reflections rather than what is just beneath the surface. Without pictures, it is difficult to estimate the quantity of plastic and the continent's surface area. But to give you an idea, we encounter about ten pieces of trash per minute when we are sailing in that area. Scientists estimate that there is about twenty-five times more trash in the water column than what you can observe on the surface. Which means that the bottom of our oceans store large quantities of plastic. No photo or satellite image could show us that.

Where does the plastic come from?
Like the vast majority of marine pollutants, the trash caught in the gyre comes from the land, and in this case, principally from the eastern shores of Asia, notably Japan, and the west coast of America. On the high seas, 50 percent of the plastic comes from fishing activities and 50 percent from land. In coastal zones, however, the terrestrial share is as high as 80 percent, or even 90 percent in certain areas. Anyhow, plastic is always produced on land, in factories, which are therefore the primary source. Last year we published a study concerning the two principal rivers draining the city of Los Angeles. In three days, we estimated the number of plastic trash items that would be released into the oceans at 2.3 billion units, or 30,000 tons!

What happens to the plastic?
Plastic is everywhere. Living beings trap or ingest large-sized trash. Fish and marine birds die because their stomachs are too full of these plastics for them to feed themselves.

But plastic trash deteriorates into smaller particles, principally due to the effect of light. The finer particles are disseminated and are so abundant in certain zones that they become actual components of the food chain. This way they contaminate all the animals in the oceans. During our studies in the North Pacific, we found that 35 percent of the fish caught contained plastic particles they had ingested. Then these little fish are consumed by bigger fish. This is a serious threat to the ecosystem, because the design and textile industries are producing plastics that other pollutants attach to. The latter become concentrated and accumulate, then become real poisons for organisms at the end of the food chain, such as fish, dolphins, and whales.

What are the risks for human beings who consume this fish?
We do think seafood consumers are at risk, but for the time being no scientific study really shows as much. This is one of the subjects on which Algalita is currently working. While we're waiting for precise data, should certain species be avoided? The most contaminated animals are the large ones that have had the time to accumulate large quantities of pollutants. But if we consume large quantities of small fish, we also run the risk of becoming bioaccumulators. So I would say the best thing is to favor small and not too much.

> "We need plastics that can really biodegrade in the environment."

Plastic is everywhere in our daily life. How can we limit our trash?
Obviously we need plastics that can really biodegrade in the environment, and particularly in marine environments. But especially, we need to give plastic value again, and to ensure that all the plastic produced is recycled. We have to be sure that our plastic is either kept, or reused, and ensure that it is not burned or disposed of in the environment. Because once it is in the oceans, it's too late.

Islet on the Baltic Sea, Porkkala, Finland (60°00' N, 24°20' E)
The Baltic is one of the most polluted seas in the world. In this sea practically sealed off by the Danish straits, it takes more than thirty years to renew the entire aquatic mass; additionally, the water's low temperature considerably slows the biodegradation of pollutants. Today the fish are so contaminated (dioxins, PCB) that they could be declared toxic and banned from European Union markets. Since the creation of the Council of the Baltic Sea States in 1992, the preservation of this fragile environment has become a priority. In 2004, the Baltic was given special status by the International Maritime Organization, which authorizes bordering countries to impose navigation norms for oil transport.

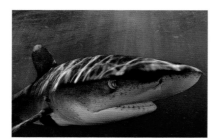

Oceanic whitetip shark (*Carcharhinus longimanus*) Bahamas, Greater Antilles
The name *Carcharhinus longimanus* is apt: *Carcharhinus* is derived from the Greek words *karcharos* and *rhinos*, which mean "sharp nose." And *longimanus*, "long fingers," refers to the shark's large, thin pectoral fins. Easily recognizable by its pectoral fins and the white spot on its dorsal fin, the oceanic shark is widely distributed throughout the world's tropical and subtropical oceans.

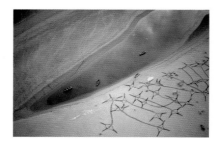

Fishing net on the sand, Moulay Bousselham, Morocco (34°53' N, 6°18' W)
To face the increasing scarcity of fish resources in their waters, developed countries have adopted a strict regulation of catches, but try to stock up farther away. The European Union has made some thirty agreements to access the fishing zones of countries outside the Union. Despite the compensations, currency contributions, and fees paid, these arrangements deprive poor countries' inhabitants of protein resources.

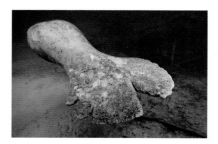

Florida manatee (*Trichechus manatus latirostris*) wounded by a boat propeller, Florida, United States
Florida manatees are among the species most affected by collisions with motorized boats. A 1995 study concluded that 97 percent of the Florida manatees studied displayed scars due to boat propellers. Collisions are responsible for 25 percent of Florida manatee mortality and are thus the principal threat weighing on them. The creation of protected zones must take into account human practices and the paths of major navigation channels.

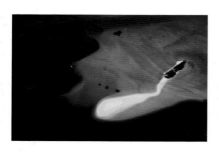

Isle in the middle of the lagoon on Nokanhui Atoll, south of Île des Pins, New Caledonia (22°43' S, 167°30' E)
New Caledonia often seems like heaven on earth. But it was once also hell: In 1863, France turned several of its isles into penal colonies, where twenty-two thousand people were transported, including partisans of the Paris Commune, such as Louise Michel in 1871. Until the *Code de l'indigénat* was repealed in 1946, convicts and settlers had more rights than the natives, the Kanaks. Today the Kanaks have gained more autonomy, but tensions remain. Since the Nouméa Accord signed in 1998, the Kanaks share sovereignty with the French government through the New Caledonia collectivity.

School of yellow surgeonfish (*Acanthurus xanthopterus*), Nikumaroro Island, Pacific Ocean, Kiribati
The Phoenix Islands Protected Area (PIPA) consists of marine and terrestrial habitats covering an area of 157,626 square miles (408,250 square kilometers) in the South Pacific—one of the largest marine protected areas in the world. This area, which includes the Phoenix Islands—one of the three archipelagos making up the state of Kiribati—is home to about eight hundred known fauna species, including close to two hundred coral species, five hundred fish species, eighteen marine mammals, and forty-four bird species.

Traditional fishing boat near Shanghai, China (31°12' N, 121°30' E)
With over 11,000 miles (18,000 kilometers) of continental coastline, China has the largest fishing fleet in the world, with close to 280,000 motorized fishing boats. The fishing sector supports some 8 million people in China, of whom 3.32 million are fishermen. From 1990 to 2010, the quantity of fish caught by China grew from 35 million tons to 48 million tons.

Hermit crab (*Paguroidea*) in an abandoned marine wormhole, Japan
Hermit crabs are crustaceans with the peculiarity of not having a shell over their abdomens. This unusual trait forces them to seek shelter in empty shells, marine wormholes, and sponges, which serve to protect them. While they are growing, hermit crabs must change shells, making them particularly vulnerable to predation and leading to brutal competition among their fellow creatures. Certain species live in association with anemones, which develop on their borrowed shells and protect them.

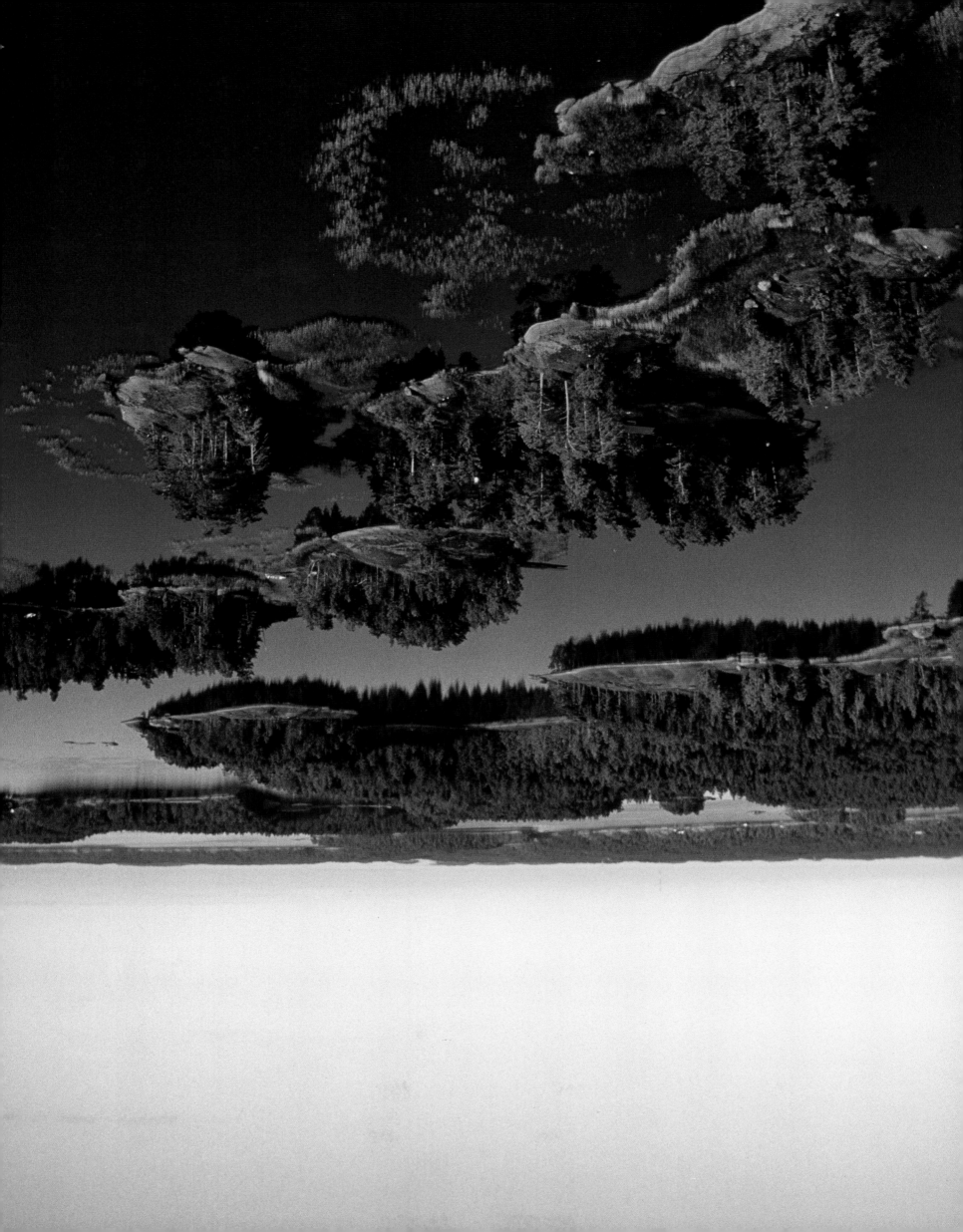

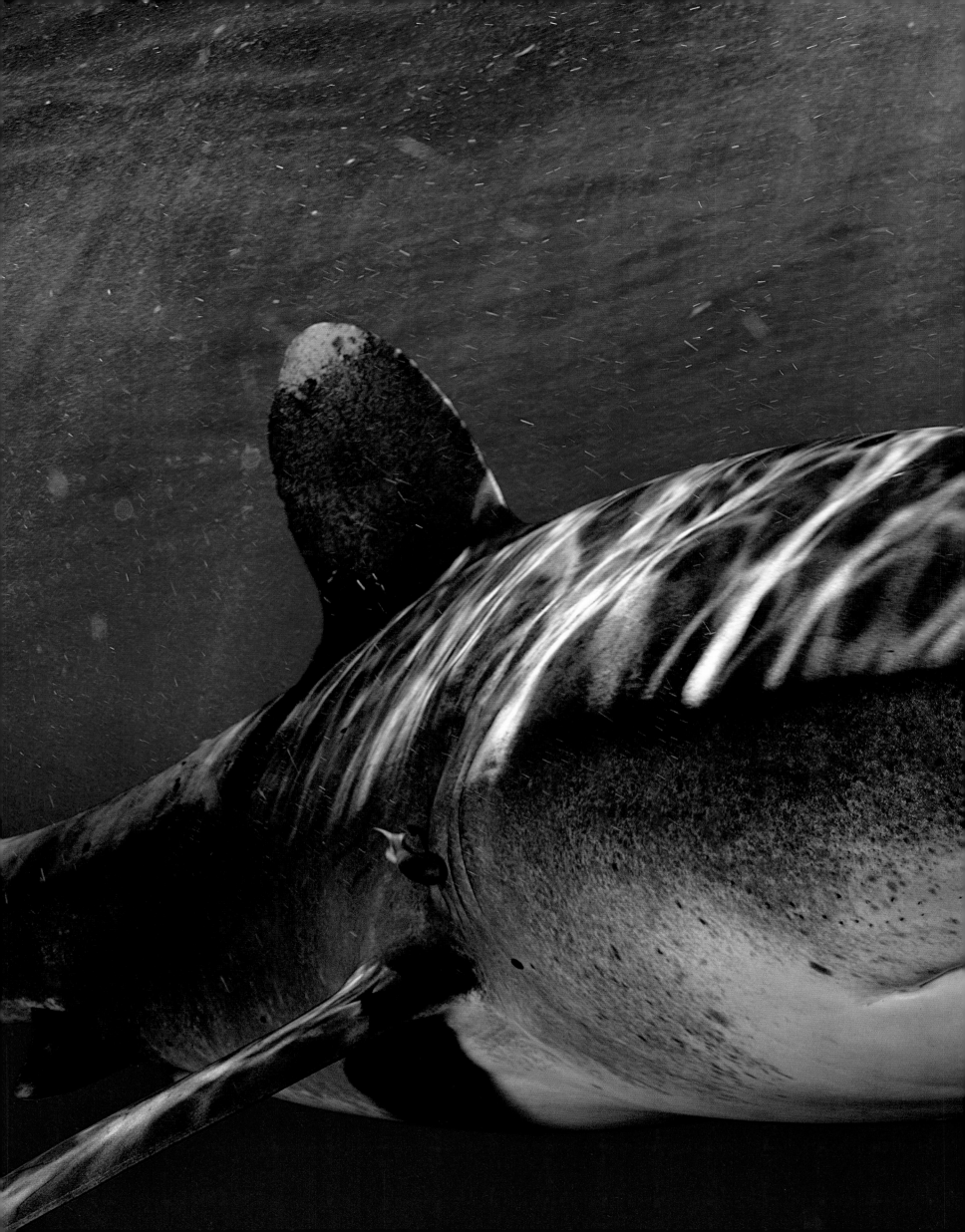

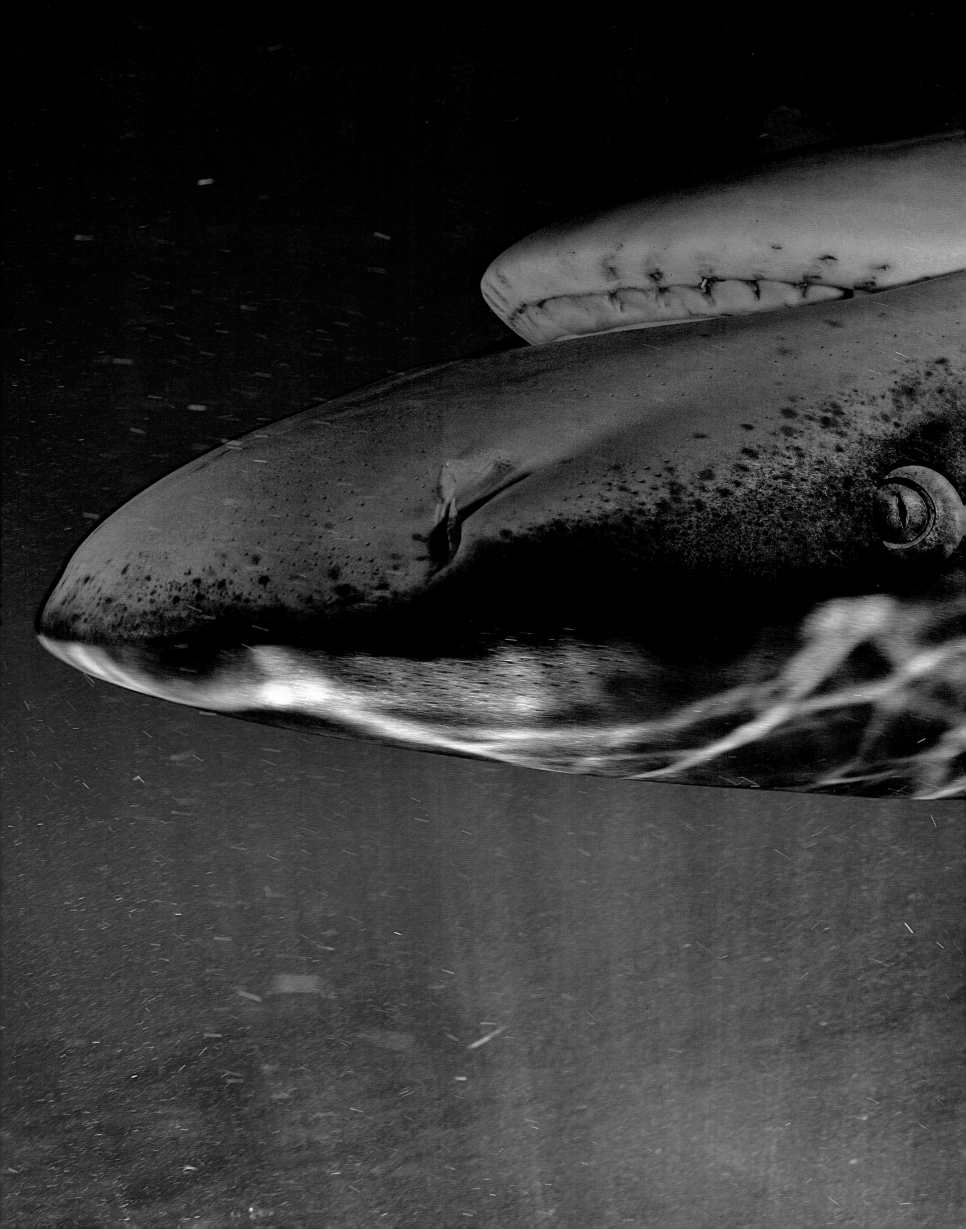

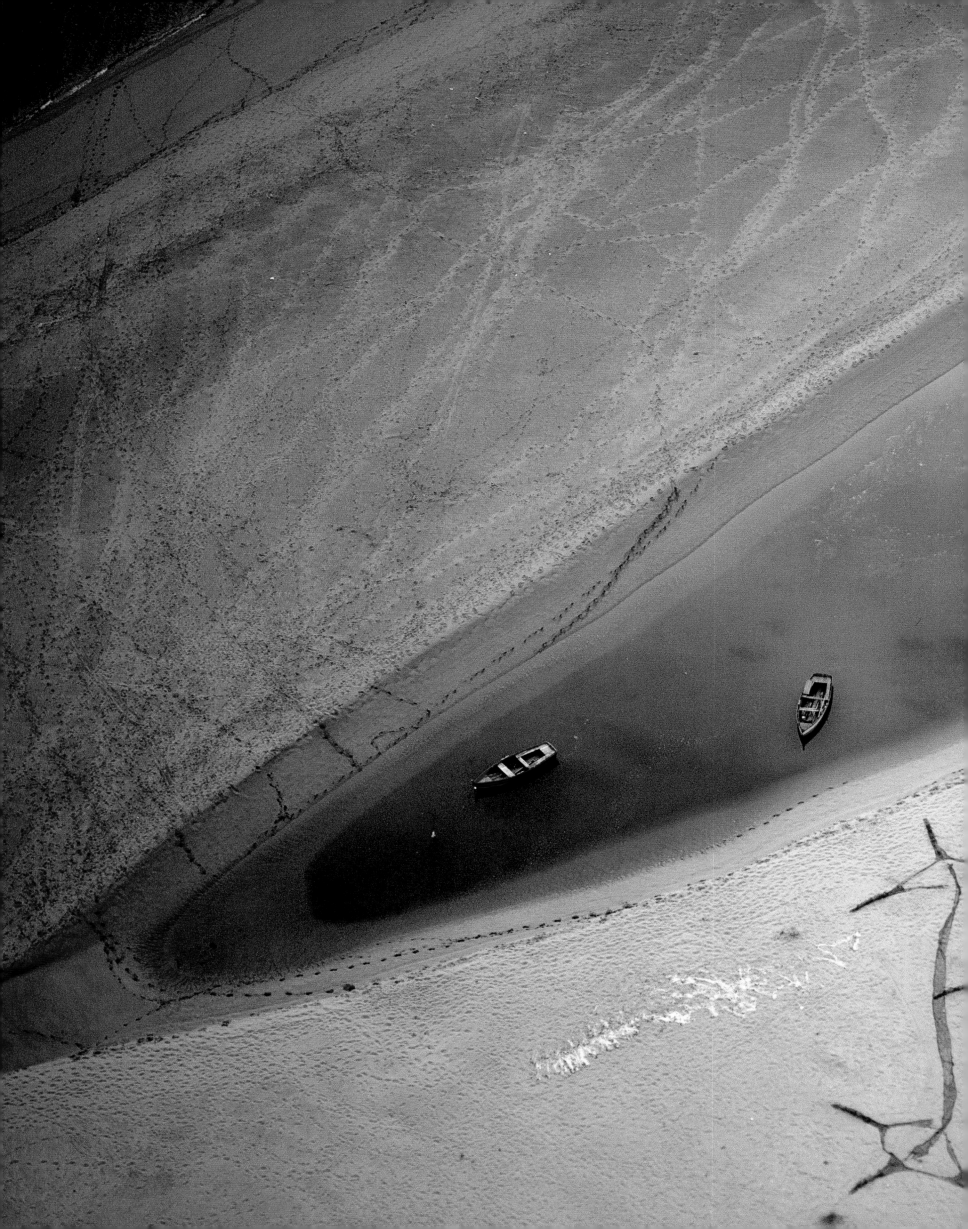

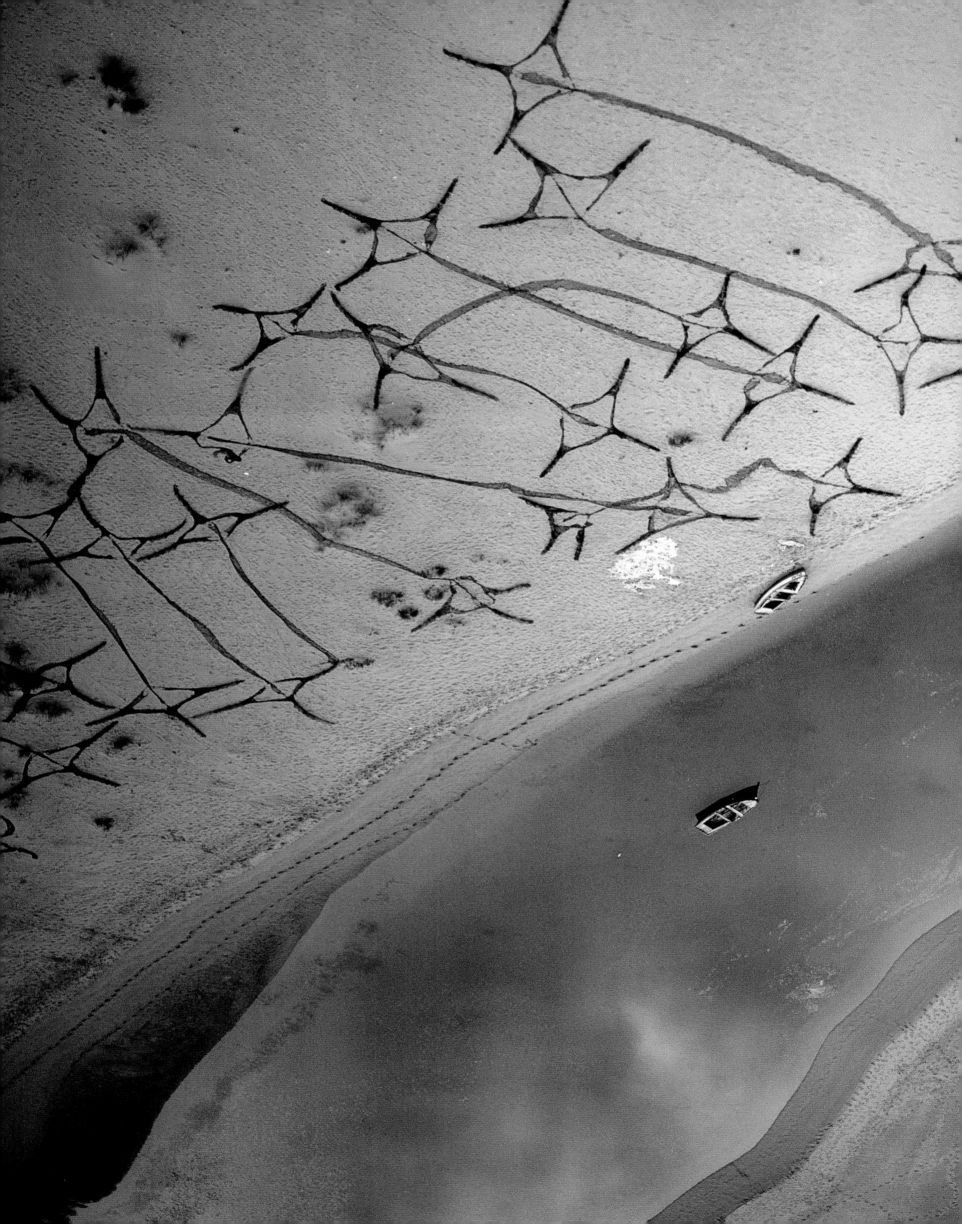

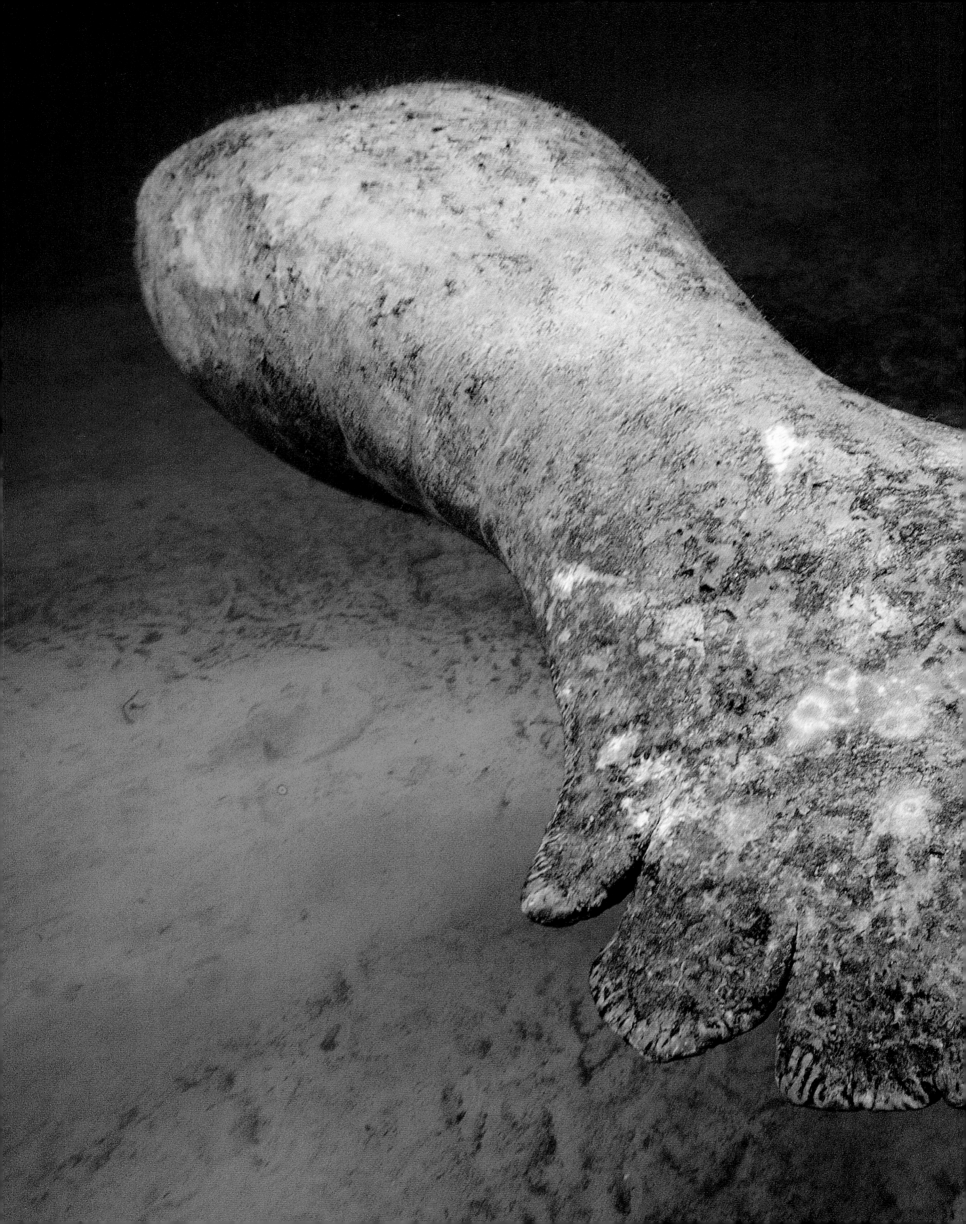

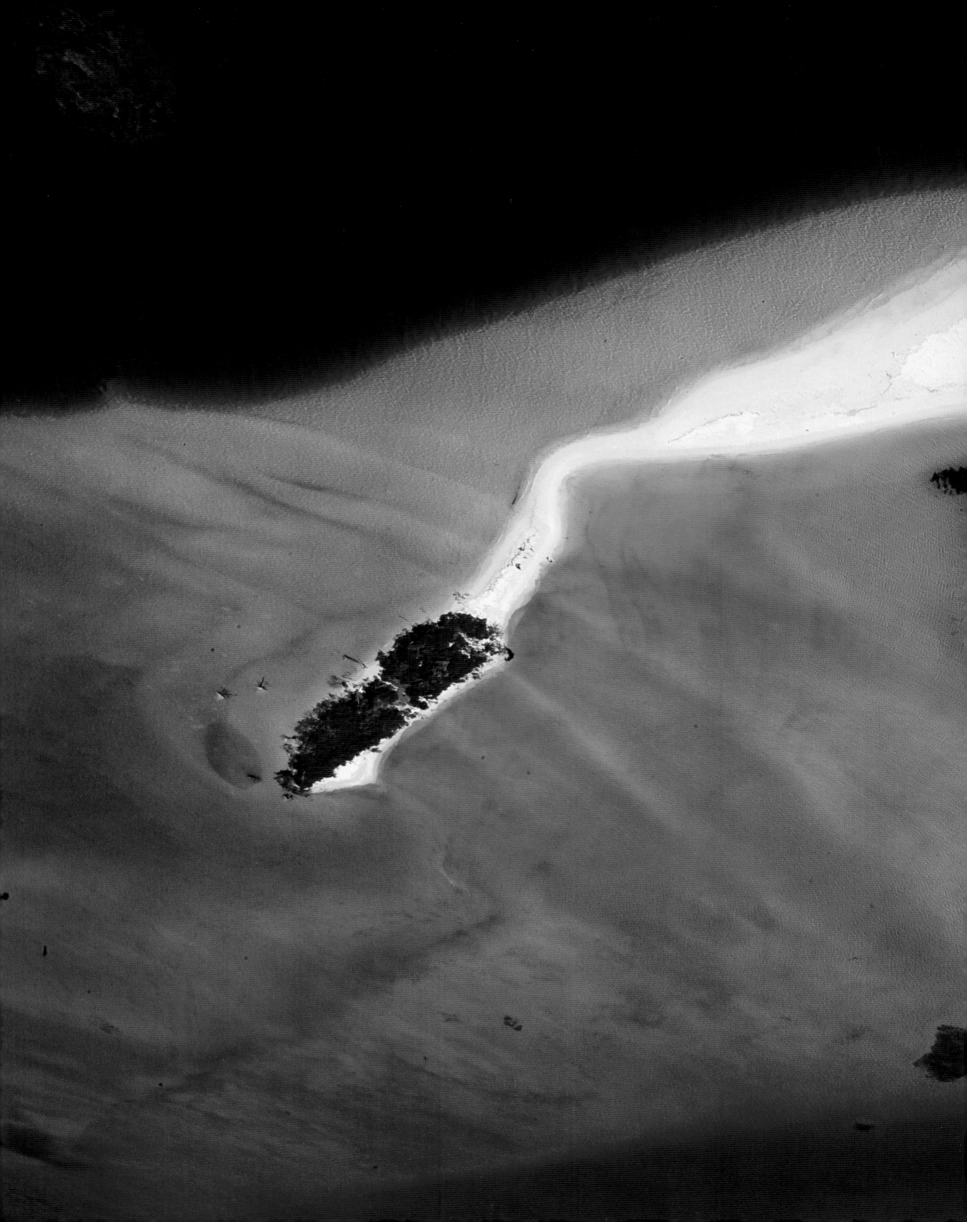

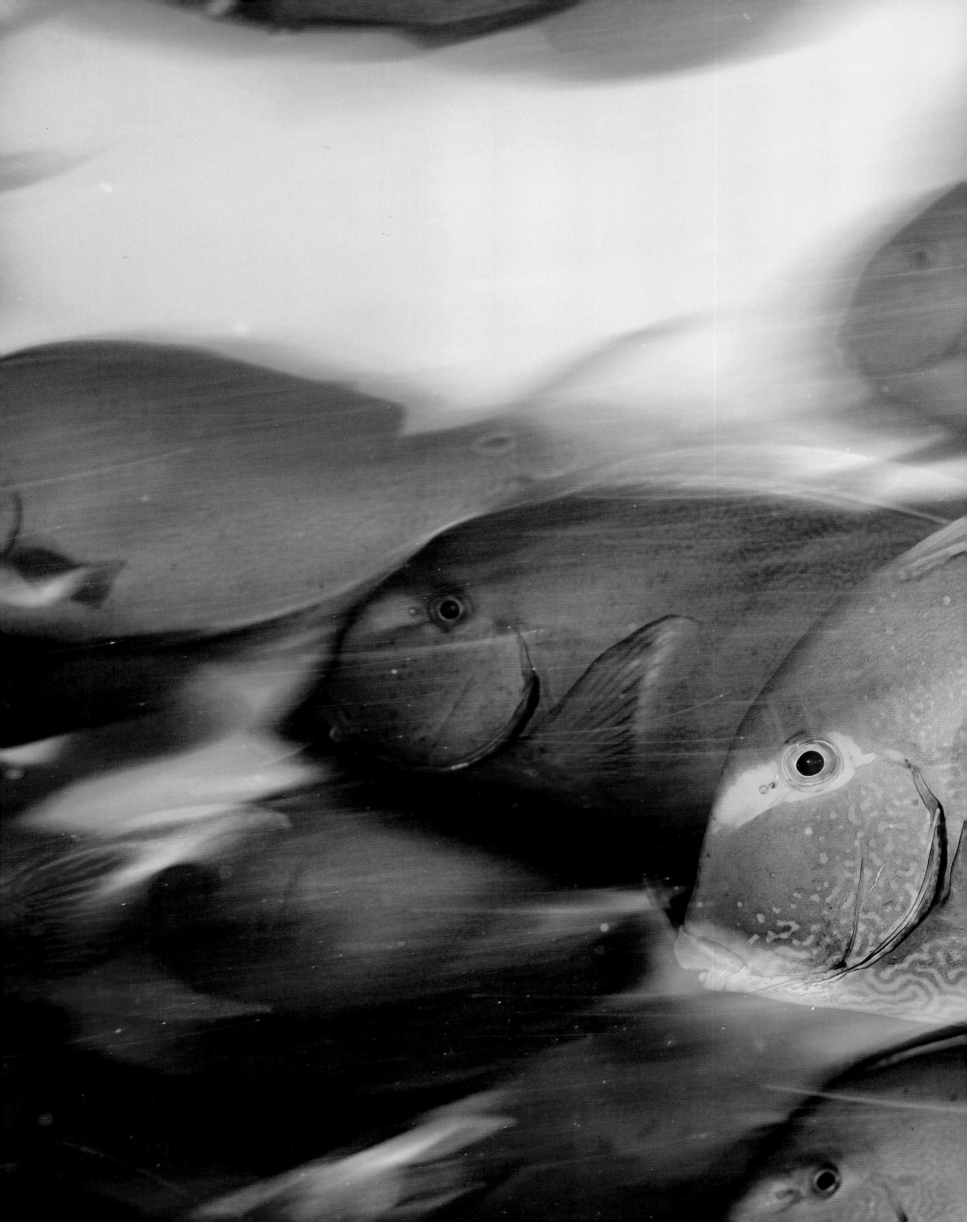

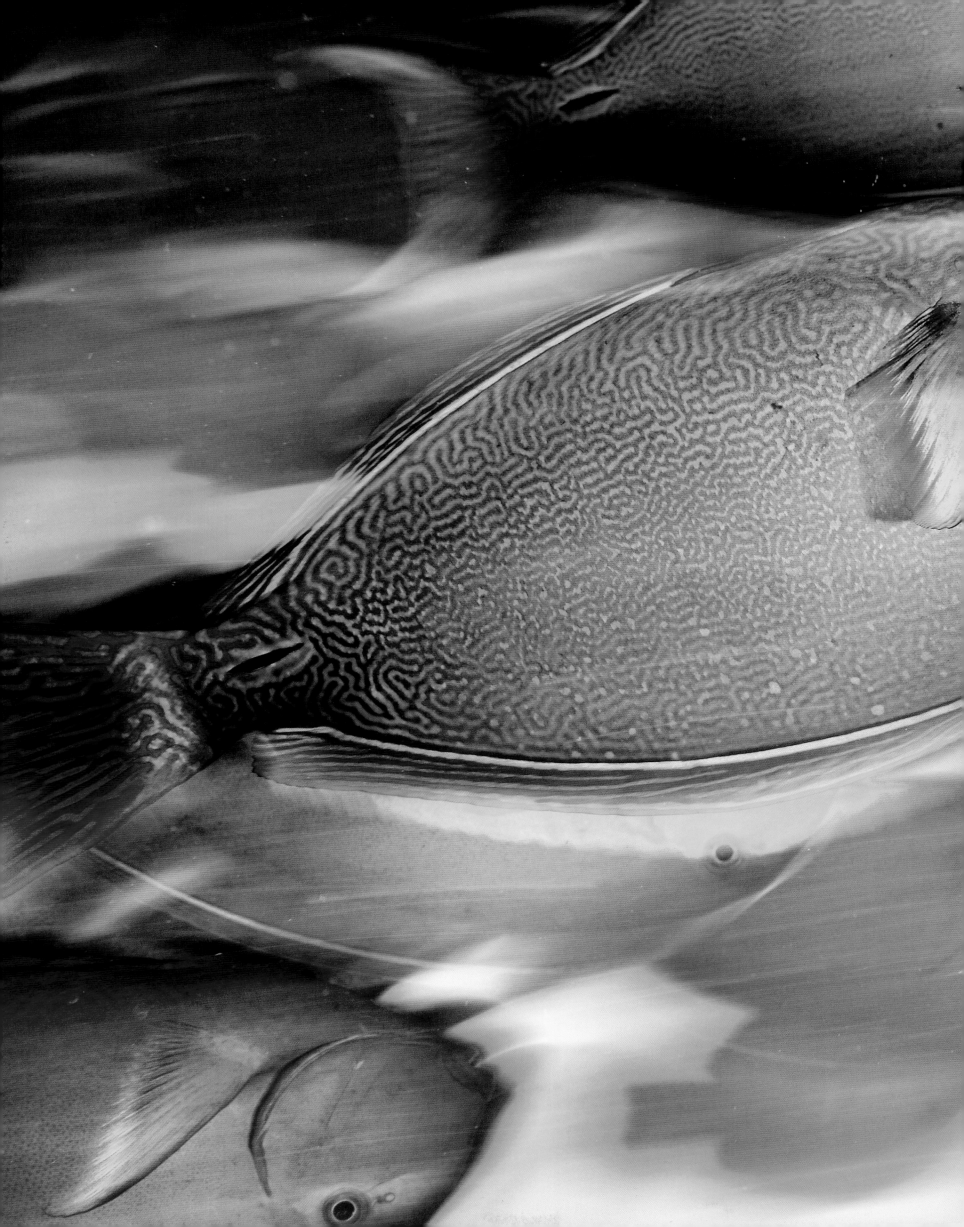

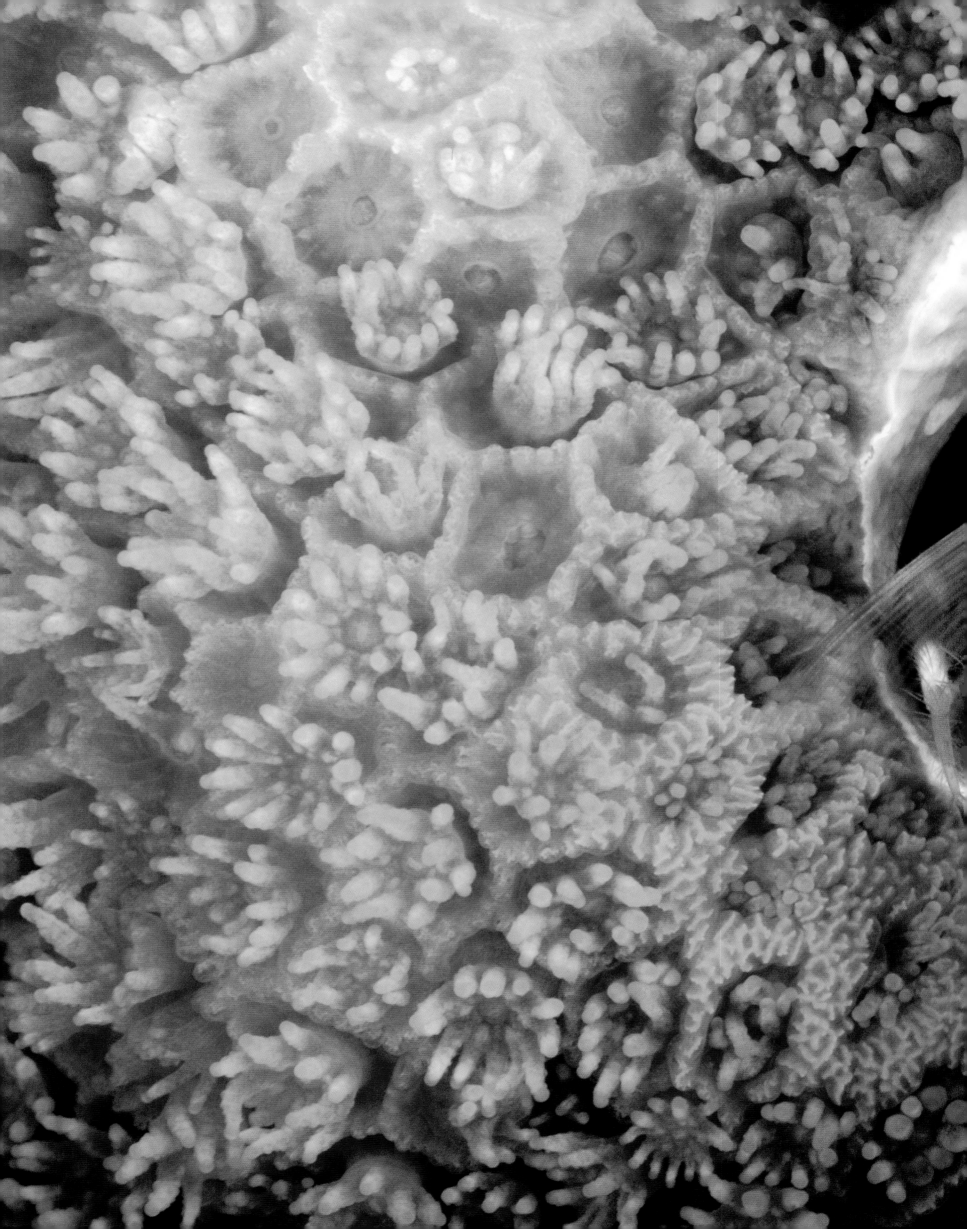

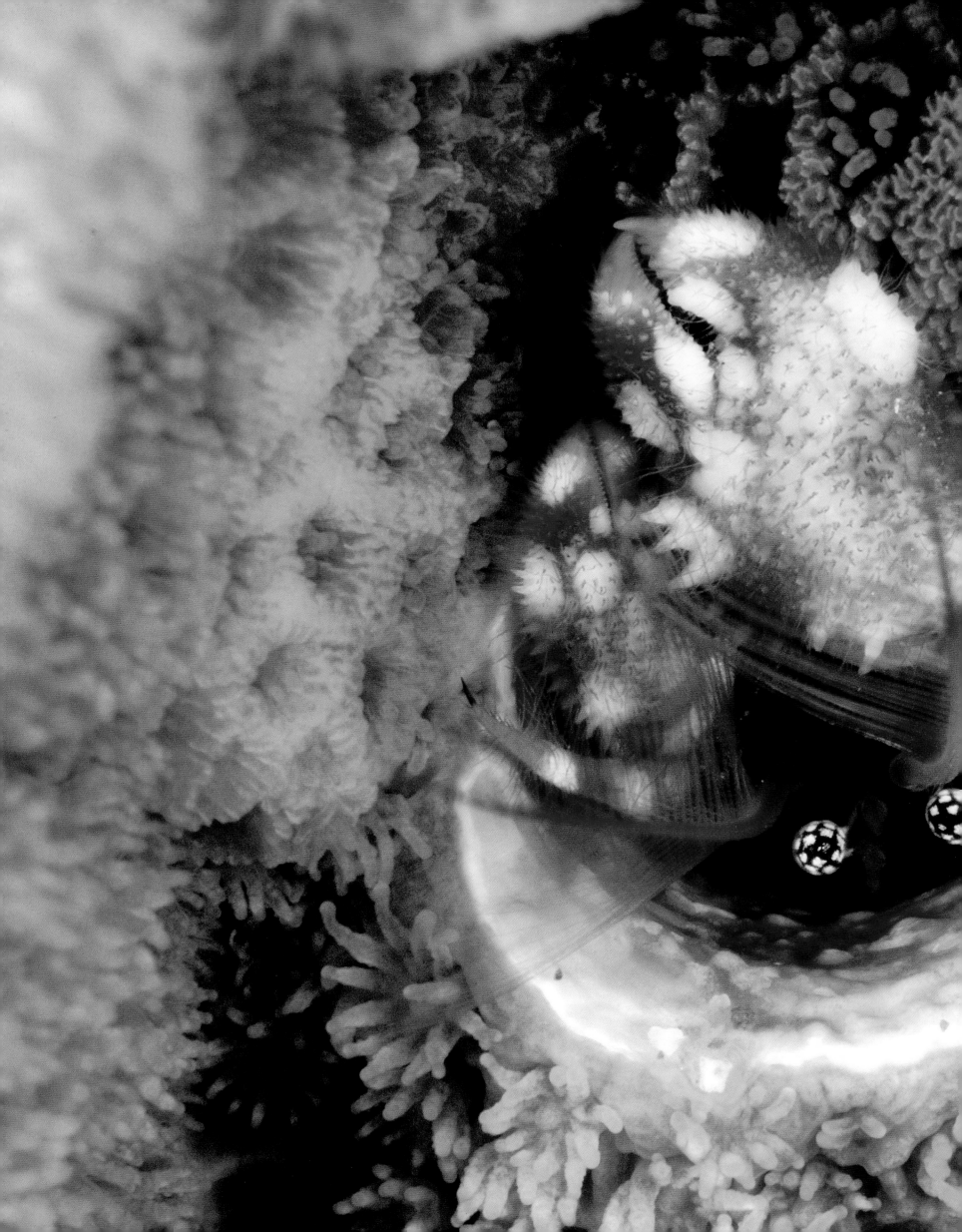

OVERFISHING: THE THREAT OF COLLAPSE

Until recently, the gigantic schools of cod that populate the waters of Newfoundland in the North Atlantic were still one of the best examples of the ocean's extraordinary productivity. These schools, whose size and density shocked the first explorers to the area in the fifteenth century, provided most of the fish eaten in Europe for three centuries. Until the 1950s, they provided fishermen with roughly 250,000 tons of cod a year! Fishing on this scale could probably have continued indefinitely.

But the postwar period brought a previously unknown type of ship to waters off the coast of Newfoundland: enormous trawlers (German, British, Soviet, Spanish, etc.), able to drag huge fishing nets over the seafloor twenty-four hours a day, hoist them aboard using powerful cranes, and deep-freeze their catch on the spot—previously, cod was fished by hook. In a few years, the volume of catches increased spectacularly, to 810,000 tons in 1968. The increase slowed, then year after year the figures began to drop, until they finally collapsed. In 1990, 97 percent of the cod of years past were missing along the coasts of Canada, and in certain offshore zones the species had completely vanished. In 1992, the Canadian authorities responded by entirely closing the Newfoundland fishery, angering fishermen and leaving forty thousand people unemployed. The region, whose resources were primarily based on the fishing industry, soon saw its economy collapse.

The boats left to chase other fish in other seas. After a twenty-year ban on cod fishing in the North Atlantic, the recovery has only just started: Stocks have barely reached 10 percent of the 1960 level.

FORMIDABLE EFFECTIVENESS

Many specialists fear that the collapse of Newfoundland cod stocks is only a kind of dress rehearsal for the drama lying ahead for global fishery. Over the last half century—in other words in a very short amount of time—fishing has radically changed both in scale and in nature, severely straining the fish populations of the entire ocean. But since this activity takes place both beneath the surface and far from the coasts, the extent of the upheavals produced has often gone unnoticed by the general public: In supermarkets, the shelves are still fully stocked. To understand the extent of the crisis, one must look at the global statistics provided by the FAO (Food and Agriculture Organization of the United Nations). These statistics, often deemed conservative because they are based on government declarations and do not take into account leisure fishing or fishing for personal consumption, indicate that from 1950 to 1990, the volume of global fishing more than quadrupled, growing from 20 million tons a year to 90 million tons. This figure has never been repeated since, with global captures stagnating, or even dropping from year to year.

How did mankind manage to quadruple the volume of fish taken out of the sea and reach the unprecedented figure of 90 million tons per year in barely five decades? As illustrated by the example of cod, this figure is due to a methodical strategy for industrial-izing fishing, generously subsidized (currently between 20 to 30 billion dollars in annual subsidies), and served by rapid technological evolution, as well as low hydrocarbon prices.

OPPOSITE: **Killing of Atlantic bluefin tuna (*Thunnus thynnus*) during a *mattanza*, traditional fishing, in the Mediterranean**

To this day, Sicilian and Sardinian fishermen carry on an ancient fishing technique, the *mattanza*, or "slaughter." Each year from May to June, fishermen intercept Atlantic bluefin tuna as they migrate in the Mediterranean, along the path that leads to their breeding ground. This fishing method consists of spreading nets known as *tonnara* (tuna nets), then tightening the noose, with the fishermen gradually converging aboard their boats. The actual *mattanza* then begins: The captured tuna are pulled out of the water with butcher's hooks and killed. This macabre tradition attracts many tourists.

90 MILLION TONS

From 1950 to 1990, the volume of global fishing more than quadrupled, growing from 20 million tons a year to 90 million tons. It has since stagnated, and even decreased.

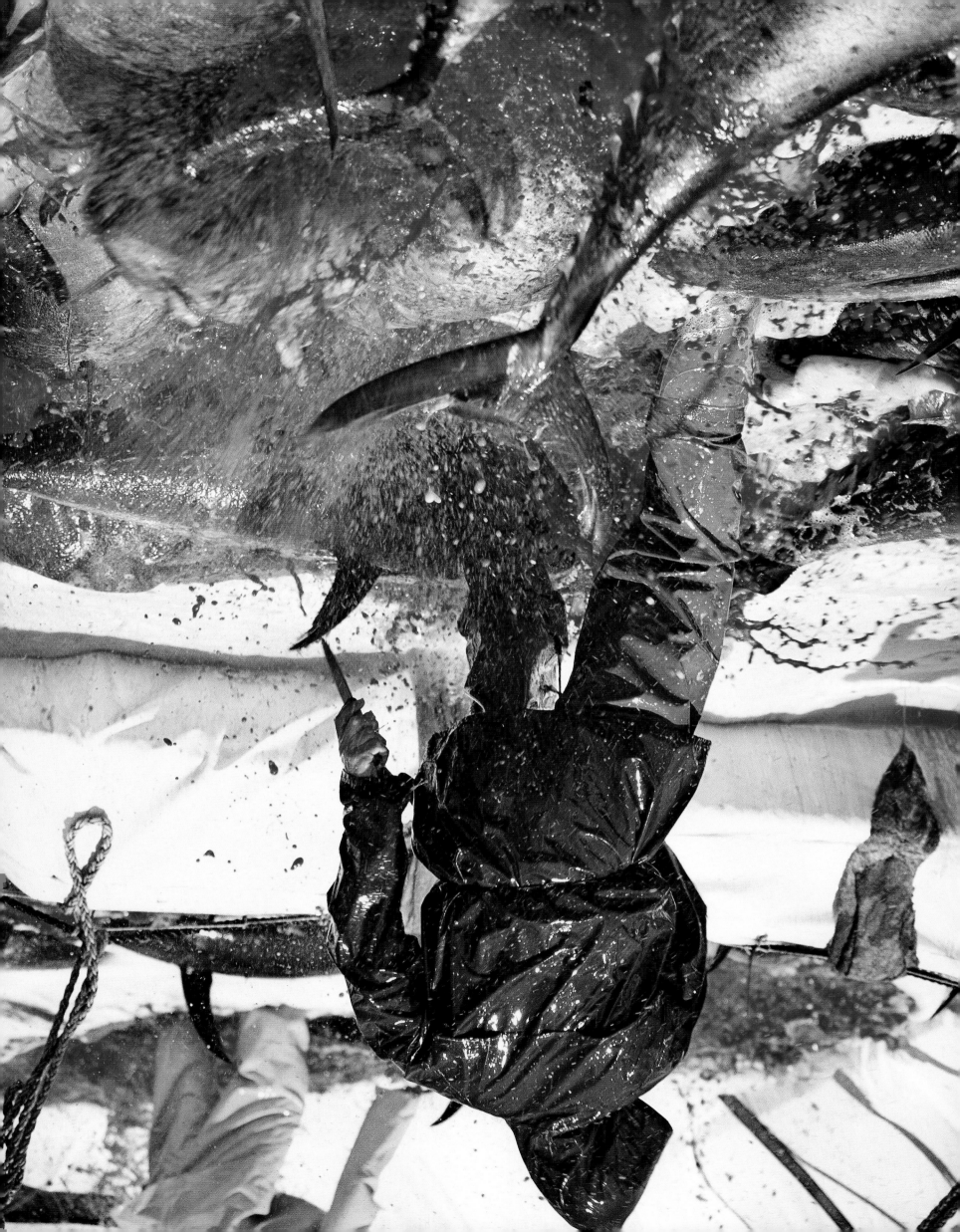

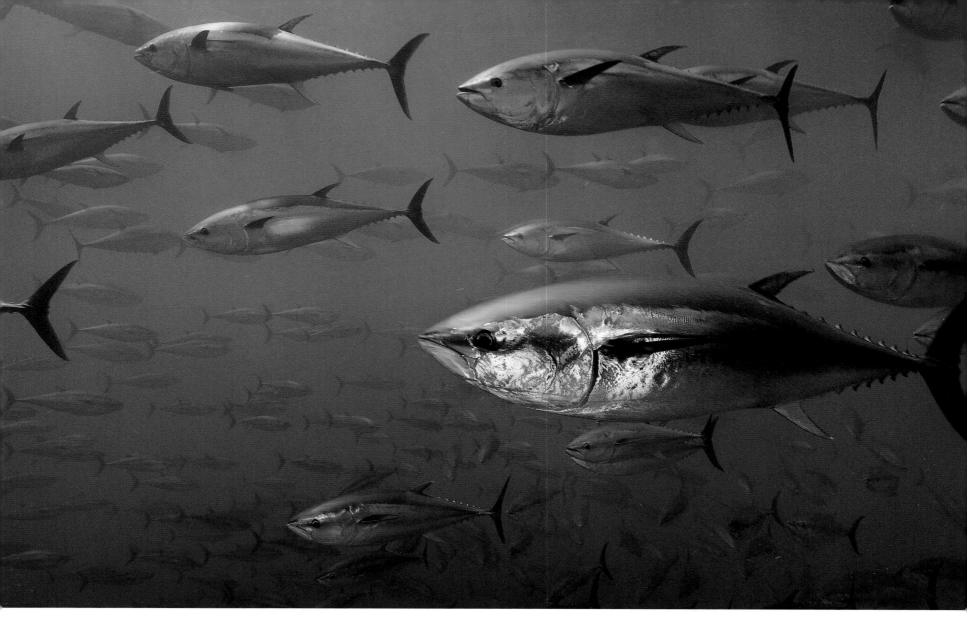

The biggest ships were turned into floating factories—always bigger, extraordinarily energy-consuming, equipped to package fish from the moment it is caught, and therefore to stay at sea for extremely long periods. This system allows ships to sail farther and farther away from their home ports, and therefore to exploit new fishing zones and to remain over potential fish concentrations for long periods, sometimes until the entire stock is caught. The global fishing fleet now includes some 4.3 million boats. But only 2 percent of these—the biggest, more than 80 feet (20 meters) long with a capacity of over 100 tons—spearhead the mechanized army that mankind has launched against fish; these several tens of thousands of ships take the lion's share of captures, and are also responsible for most of the environmental damage.

The increase in boat sizes was accompanied by a variety of highly destructive technical innovations. The use of nylon and other polymers to manufacture nets allowed for much larger, long-lasting nets, while reducing their cost. Constantly more effective remote detection systems for finding fish and assisting navigation (sonar, radar, and more recently, GPS), are used by fishermen to spot shoals, and precisely locate and stay above targeted zones. Most significantly, boats' increased power provides the means to hoist increasingly large nets and reach unprecedented depths, allowing for the widespread use of one of the most environmentally disastrous practices, bottom trawling, which consists of dragging large fishing nets ballasted with heavy metallic structures over the seafloor.

This practice obviously demands considerable traction capacity. On average, global fishing consumes a half-ton of fuel to capture one ton of fish. From a purely industrial point of view, these current practices are absolutely antieconomic. The global fleet is subject to worrisome oversizing due to the competition between an excessive number of fishermen hunting for overly scarce fish; a situation leading to constant power plays

ABOVE: **Atlantic bluefin tuna (*Thunnus thynnus*) swimming near the Spanish coast, Spain**
Marine animals absorb toxic molecules such as heavy metals, lead, mercury, and pesticides, a phenomenon known as bioaccumulation. Toxic molecules are stored in their tissues, then pass from one species to the next via the food chain, sometimes ending up on our plates. An American study revealed that tuna consumption was responsible for 40 percent of Americans' exposure to mercury compounds. In order to limit the risks, certain countries, including those in the European Union, recommend limiting the consumption of large fish by pregnant women.

565,000 EUROS FOR A SINGLE TUNA
A 593-pound bluefin tuna was sold on January 5, 2012, for the record price of 565,000 Euros, during the first auction of the year at the Tsukiji fish market in Tokyo.

with companies vying to control the largest possible share of resources to the detriment of everyone else. Without subsidies, particularly for fuel, the current model would be unsustainable.

THE VICIOUS CIRCLE

The fishing industry is in the process of committing suicide. Indeed, there are an increasing number of signs that resources are on the verge of collapse. Global fishing has slowly been declining for the last twenty years, and the trend is continuing, despite a considerable increase in new initiatives (technology, number and power of boats) and the constant shifting of these fishing initiative to ever more fragile zones and species as previous stocks run out. A sudden drop could be imminent, the example of Newfoundland (among others) having shown that there are often stock thresholds beneath which the species can no longer reproduce, and that once these thresholds are reached, populations suddenly collapse.

Even the cautious FAO's last report stated that the situation has never been as bad as it is today. According to the organization, more than half of fish stocks are currently exploited to the maximum of their possibilities—captures cannot be increased without danger. A third of fisheries are currently overexploited, meaning that they are threatened with collapse if there is not a rapid decrease in catches. And barely 15 percent of them could withstand an increase in fishing pressure! Yet close to 3 billion people get 15 percent of their animal protein from fish, while fishing and aquaculture provide means of subsistence and revenues to approximately 54.8 million people. In other words, the collapse of fishing would have tragic human consequences.

IS AQUACULTURE A SOLUTION?

Faced with this situation, some hope that mankind might still be able to save the indispensable protein contribution from fish by developing aquaculture. Aquaculture is expanding rapidly, particularly in Asia, to the point that on a global scale about 50 percent of the fish consumed by man is now farmed. In fact, fish consumption per inhabitant has continued to rise despite the drop in fishing captures because aquaculture's expansion has compensated for the stagnation of fishing . . . at least so far, for aquaculture growth rates are now also slowing down.

In truth, aquaculture's growth margin is not unlimited, particularly in the case of carnivorous fish (salmon, tuna, sea bass, sea bream, etc.). To be in healthy and preserve their taste, these species need to eat other fish, which is generally provided to them in the form of flours made from small fish such as sardines, anchovies, herring, etc. On average, 3 to 5 pounds of small fish are needed to raise one pound of carnivorous fish. In a certain way, aquaculture is therefore participating in a transfer of natural resources to northern countries: Most of the flour is produced from fish caught in southern waters, where the species in question were once used for human consumption, while carnivorous farmed fish are eaten by consumers in rich countries. And on the pollution front, aquaculture creates problems similar to those found in intensive livestock breeding: heavy concentrations of nitrogen, vulnerability to disease, and consumption of antibiotics, hormones, and other harmful additives to fight infection.

In reaction to these problems, aquaculture farmers are trying to develop procedures that minimize their environmental impact. One potential approach is to favor herbivorous and omnivorous species (carp, tilapia, catfish, brown bullheads, etc.) over strict carnivores (salmonids, sea bass, sea breams, etc.), which increases the proportion of plant proteins (currently soya is often the plant of choice) in fish diets, thereby reducing pressure on the ocean. Additionally, active scientific research is currently exploring different solutions to partially "vegetalize" carnivores' diets, by testing different plants such as the potato

RECREATIONAL FISHING

Any fishing not intended for selling the catch or the fisherman's subsistence is known as recreational fishing. This kind of fishing can take place in freshwater or at sea, on a beach or by diving. Angling, game fishing, and shellfish picking, which consists of collecting seashells on beaches and rocks, are forms of recreational fishing. Consuming the catch is not systematic in these cases. Some amateurs practice no-kill fishing and put the captured fish back in the sea. This is a very popular activity, in which an estimated 10 percent of the world's population has at some time participated, including more than 2.5 million people in France. The impact on fish stocks and ecosystems is far from negligible: French sport fishers, for example, capture nearly the same quantity of sea bass in a year as professionals—about 5,000 tons. Regulations adopted to attenuate this activity's impact generally limit catches to a certain number of fish per species or, more frequently, to a minimal size at capture, which is supposed to guarantee the animal enough time to reproduce. However, accurate evaluation of the captures from this type of fishing remains difficult, due to the lack of reliable supervision of fishermen, their practices, and their catches.

32 PERCENT OF FISH STOCKS ARE OVEREXPLOITED OR EXHAUSTED

According to the statistics of the FAO (United Nations' Food and Agriculture Organization), more than 50 percent of stocks are also exploited to maximum capacity.

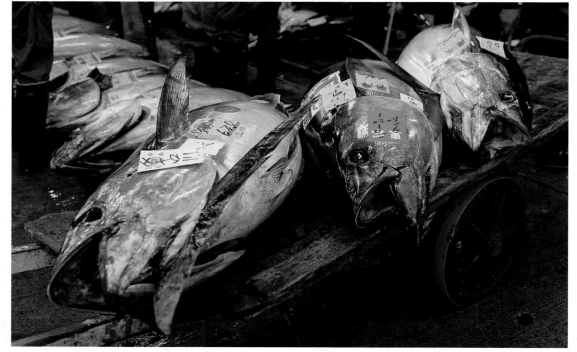

LEFT, TOP AND BOTTOM: **Tsukiji fish market, Tokyo, Honshu, Japan** (35°27' N, 139°41' E)
The Tsukiji market is the biggest fish market in the world: Each year, more than 5.5 billion dollars of sea products change hands here. It employs sixty thousand people. Several thousand tunas can be sold in a single day. They are marked with a brush, then auctioned in the din of the auctioneers' and buyers' calls.

TUNA

Tuna accounts for 5 percent of global annual sea fish catches—or 4.2 million tons. Seven species are principally fished. Skipjack tuna, which is primarily used for canned tuna, accounts for 59.1 percent of catches. Yellowfin tuna comes next, with 24 percent of catches, followed by bigeye tuna (10 percent), and albacore (5.4 percent). The three bluefin tunas (Southern, Northern, and Pacific) make up the remaining 1.5 percent. Bluefin tuna are the biggest and most sought-after. These seven species are divided in twenty-three stocks, of which three stocks are exposed to the most significant overfishing: East Atlantic and Mediterranean, West Atlantic, and Southern stocks. These stocks may never be renewed if we do not take measures to reduce captures.

OPPOSITE: **Tuna on a Japanese ship, Japan**
Despite the existence of international institutions to regulate tuna fishing, such as ICCAT (the International Commission for the Conservation of Atlantic Tunas), overfishing continues to imperil stocks of the species. In 2010, some countries and NGOs acted to save tuna by suggesting bluefin tuna be added to the CITES list (Convention on International Trade in Endangered Species of Wild Fauna and Flora), but the initiative was blocked by the countries that most heavily fish and consume tuna, starting with Japan.

in combination with other plants. Organic fish farms are beginning to appear, as well as various initiatives to optimize the use of resources. In Asia, extensive fish farming in rice paddies, which uses the fish excrement as fertilizer for the plants, seems promising. Some producers are also combining fish farming at sea with breeding oysters, with the oysters filtering particles not consumed by the fish out of the water. The future will tell whether these different approaches will allow aquaculture to meet soaring global demand. Let's hope the answer comes quickly. With every passing year, the oceans' situation becomes worse and we draw closer to a catastrophic collapse.

For more information on this subject and a relevant excerpt from the film *Planet Ocean*, go to http://ocean.goodplanet.org/surpeche/?lang=en

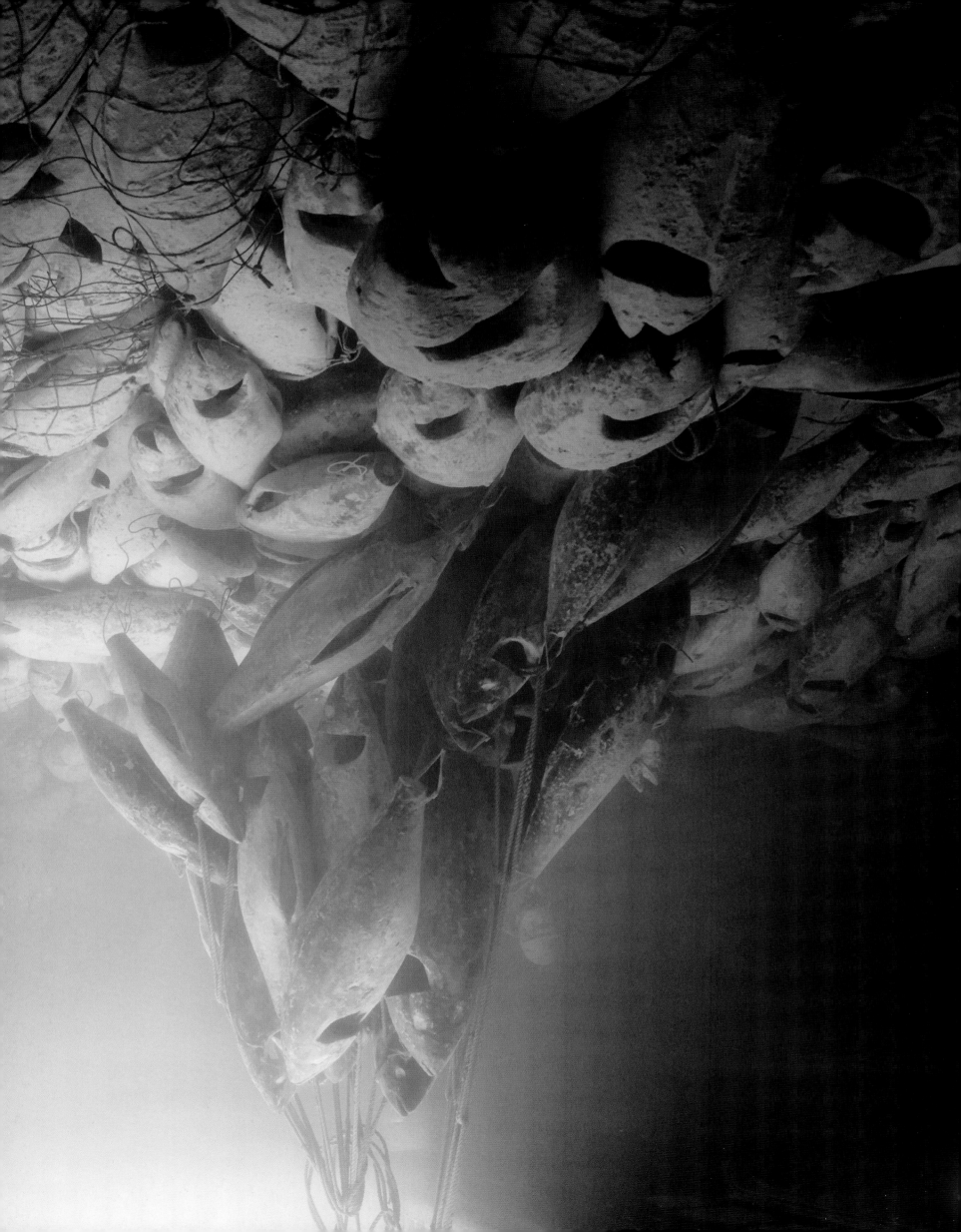

WE CONTINUE TO UNDERESTIMATE THE EXTENT OF THE CRISIS
INTERVIEW WITH DANIEL PAULY

DANIEL PAULY, director of the Fisheries Centre at the University of British Columbia in Vancouver, is the most eminent specialist in halieutic resources in the world. He founded FishBase and SeaLifeBase, the biggest global databases on marine biodiversity, and heads the Sea Around Us Project, whose mission is to study the impact of fisheries on marine ecosystems and to propose solutions in the fishing sector.

What does science have to say about the state of fishing in the world?
The oceans' situation has gotten considerably worse on a global level. And we are headed for a dead end, because the markets and capture capacities are completely incompatible with the sustainability of stocks. With the exception of the United States and Australia, few countries have substantially reduced their fishing.

But we have only recently become aware of how significant the problem is. This happened in two phases. The first phase took place in the late 1990s, when specialists started to realize that specific fish stocks were beginning to collapse. It gradually became clear that these were not isolated phenomena but a global trend. Then in 2001, a study showed that the drop in stocks was neither a recent process nor a moderate one.

By considering the several decades since the onset of industrial fishing, the study showed that losses were enormous: The biomass [a measure of the quantity of fish and other living organisms] had dropped not by 10 percent or 20 percent but 90 percent! To understand the collapse of stocks, we had to look back over the last fifty or one hundred years.

Why is there a discrepancy between twenty-year studies and studies of longer periods?
The stocks that are currently the most studied are those that are still exploited. These are all atypical cases: those which survived exploitation. Statistics are based on North Sea stocks, for instance, but never those of Mauritania, which have already collapsed. Since the stocks that have already disappeared never enter into the equation, the database most scientists are working from is completely inaccurate.

Are these findings universally accepted?
Unfortunately, we are encountering resistance, including in scientific circles: Old-school specialists—the most classic fishery scientists—are focusing on the last twenty years, for which they observe a relative stability of stocks. Thus they profoundly underestimate the extent of the crisis. We are currently unable to make this diagnosis be as widely accepted as it should be.

> "Markets and capture capacities are completely incompatible with the sustainability of stocks."

If we don't agree about the assessment, how can we hope to make people accept the solutions, some of which will be difficult? We have to demonstrate the evidence over and over again. We are faced with the same debate surrounding climate change: Is the climate changing? Because of man? Yes. Nonetheless, there are still many people who believe or argue the contrary. As Galileo would have said: "And yet it turns . . ."

Even an influential researcher like you has trouble convincing people?
I taught researchers all over the world how to evaluate fish stocks. This evaluation is indispensable because data on fisheries still remains incomplete, unequal, partisan, or simply inaccessible. We still need to accumulate data. But every day I observe the lack of resources that scientists the world over have to contend with when they take on this kind of question. And when, against all odds, quality studies are published, it remains extremely difficult to get the information to politicians because politicians are not interested in scientists' opinions. The situation may be connected to a formatting question. In general, fishing data is presented in charts incomprehensible to the general public and to decision makers. Yet the weather report on TV presents extremely complex information in the form of very simple maps, which everyone can understand.

My team and I have therefore decided to turn fishing statistics into maps, in order to clearly visualize stock problems on a global or regional scale. We published a map on the evolution of captures, which demonstrated an observable reality about the world of fishing. We make them available to any organization that wants them.

So there is a divide between scientists and institutions?

No one would ever dream of turning down a high-performance computer from the IT department in favor of an abacus or an old calculator. But that's exactly what is going on with the environment! The scientific understanding of our planet is moving forward by leaps and bounds, but no one is interested. The state finances scientific research with public funds—our taxes—but does not profit from the results. So I try to look at the bigger picture, and now consider my role, as well as that of Sea Around Us, as a bridge between scientists, NGOs, and decision makers. Nonprofits and foundations are very effective at building relationships between scientists and public opinion or decision makers. In the United States, for example, you can take the government to court for poorly managing fish stocks or misusing subsidies. And while individual lawsuits are rare, NGOs have the human and financial resources required to carry through these initiatives. Yet these legal actions must be legitimized and shored up by the scientific community. We're no longer talking about NGOs demonstrating outside scientific congresses but taking their place within them. In a way, we are providing them with the ammunition necessary.

"Politicians are not interested in scientists' opinions."

To come back to fishing, how has it changed in concrete terms?

The first phenomenon, which every researcher has observed, is that fisheries are shifting south. If every scientist can observe a small modification in his own field of study, it appears as a major phenomenon in the context of a global assessment.

Since 1950, fishing's center of gravity has moved south by 0.8 of a degree per year, like clockwork, set to the pace of stock exhaustion. The stereotypical image of a bearded Breton sailor with his pipe and cable-knit sweater no longer reflects reality.

The exhaustion of stocks in the north is leading ships, including European ships—at least the biggest ones—to fish in the Indian Ocean and the South Atlantic, which exposes species previously protected by depth or distance to overexploitation. This is the case, for example, of the toothfish, a deep-sea fish that was still completely inaccessible and never fished a few years ago. The race for the south is off and running. Only the most powerful fleets can compete, which is creating a growing divide with poor countries. This transformation has also led to a globalization of fishing, and nobody knows where the boats come from anymore.

The ships supplying Europe and North America are rotten old boats registered in Panama by Chinese shipowners, with Filipino crews headed by a Ukrainian captain, for example. We have done with fishing what we did with banks: Healthy capital has been mixed with bad capital, which is corrupting the entire system.

Is this change related to subsidies?

Of course: Subsidies make it possible to constantly fish more, farther, and deeper, because the ships need fuel and the technological means. Subsidies are the driving force behind this situation. On a global level, they amount to approximately 25 billion dollars a year, of which nearly 20 billion are directly allocated to the expansion of fleets and fuel supply. The Chinese are investing massive amounts of money in Africa, outspending the Europeans.

Yet couldn't subsidies be used to improve fishery practices?

Subsidies could be excellent catalysts for change. Sea Around Us has tried several times to convince the World Trade Organization [WTO] to promote real reform in the granting of subsidies. But our efforts failed each time. I think the connections between fishing and agriculture are responsible for subsidies being so well anchored in states' policies. Many countries would be ready to reduce fishing subsidies, but they fear that by doing so they would weaken agriculture subsidies in international negotiations or public opinion. This is the case in the United States, among other countries.

Could we still reverse the trend?

Whether you're optimistic or pessimistic, I think it will be difficult to mobilize opinion solely on the question of fishing. In my opinion, the only way out of this crisis will come from a resolution "in passing," if the whole question of global agriculture is completely reexamined. Because as I said, subsidies for fishing and agriculture are closely related. But to do that would require an overall evolution in our way of looking at the planet.

"Many countries would be ready to reduce fishing subsidies, but they fear that by doing so they would weaken agriculture subsidies."

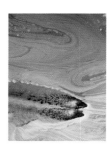

Ventilator in a shrimp farm, Tungkang Lagoon, Taiwan (22°26' N, 120°28' E)

This ventilator oxygenates the water in the shrimp-breeding basins. Tungkang Lagoon in the southwest of the island of Taiwan is crisscrossed with brackish ponds devoted to aquaculture, notably highly lucrative shrimp culture. Asia, where the tiger prawn is the predominant species, provides 80 percent of global production. Since shrimp require warm water to develop, shrimp farming has grown in tropical coastal zones, notably in mangroves.

Marked tuna (*Scombridae*) in the Tsukiji fish market, Honshu, Japan (35°27' N, 139°41' E)

Tuna are marked with red paint before being sold at auction. Buyers inspect the fish one after the other, to assess the color of their flesh, their size, their shape, and especially their freshness, all criteria that affect their value. For example, the meat's quality can be guaranteed by a high rate of fatty matter and signs that the fish was killed soon after it was caught. Shortages due to the exhaustion of tuna stocks have encouraged speculation, making prices climb even higher.

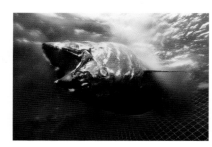

Atlantic bluefin tuna (*Thunnus thynnus*) caught in a fattening cage's net, Mediterranean, Spain

The technique known as tuna fattening consists of capturing young wild tuna, then shutting them in cages in order to fatten them. These tuna cages are principally found in Croatia, Spain, Malta, and Turkey, and the tuna fattened this way are primarily intended for the sushi market. According to the FAO, this practice does not resolve the overexploitation of tuna—in fact it aggravates it. Additionally, the capture of young tuna, more discreet than that of adults, makes it more difficult to precisely evaluate stocks.

Boats off Al Jahra, Persian Gulf, Kuwait (29°20' N, 47°40' E)

Located on the Arabian Peninsula, Kuwait has 180 miles (290 kilometers) of coastline, as well as nine small islands, the most famous of which is Failaka Island at the entrance to Kuwait Bay, and not far from the shared Tigris and Euphrates estuary. The Persian or Arabo-Persian Gulf covers an area of 89,960 square miles (233,000 square kilometers), separating the Arabian Peninsula from Iran. Its name refers to ancient Persia, an area corresponding to present-day Iran.

Silver sweepers (*Pempheris oualensis*) in an underwater cave in Tortola, British Virgin Islands, Lesser Antilles, United Kingdom

Also known as the "hatchet fish," the silver sweeper lives in shallow zones such as lagoons. By day, this little fish less than ten inches (20 centimeters) long hides in caves or in the shelter of coral. By night, it hunts in groups for small fish or small invertebrates.

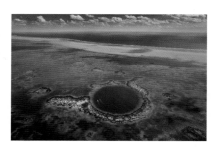

Great Blue Hole, Lighthouse Reef Atoll, Belize (17°19' N, 87°32' W)

This site, loved by divers, is part of a vast system called the Mesoamerican Barrier Reef, which stretches close to 600 miles (966 kilometers) from the tip of Yucatán (Mexico) to the northeast coast of Honduras, skirting the coasts of Belize and Guatemala. It is one of the longest reefs in the world and the largest in the Northern Hemisphere. The Great Blue Hole, a geological peculiarity with its 984-foot (300-meter) diameter, 406-foot (124-meter) depth, and nearly perfect circular form, is a chasm that appeared following the collapse of underground cavities dug through the limestone by water.

Eye of a southern right whale (*Eubalaena australis*), Auckland Islands, New Zealand

Southern right whales make low-frequency sounds practically inaudible to the human ear. Other species emit frequencies audible by humans. These sounds are thought to serve many purposes among whales, including communication, movement, diet, and reproduction. Each cetacean species has its own unique sound. In 1977, the song of the whales was among the "sounds of the Earth" sent into space on the *Voyager* space probe as a record of life on earth.

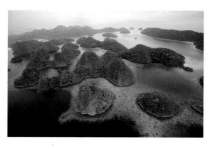

Raja Ampat Islands, West Papua, Indonesia (0°41' S, 130°25' E)

Located between the Indian and Pacific oceans, the Raja Ampat (Four Kings) Islands enjoy a rich diversity of marine species: sharks, skates, corals, and green turtles, to name only a few. The archipelago's remoteness—it is more than six hours by plane and a boat trip from Jakarta—has partially preserved it from the onslaught of tourism.

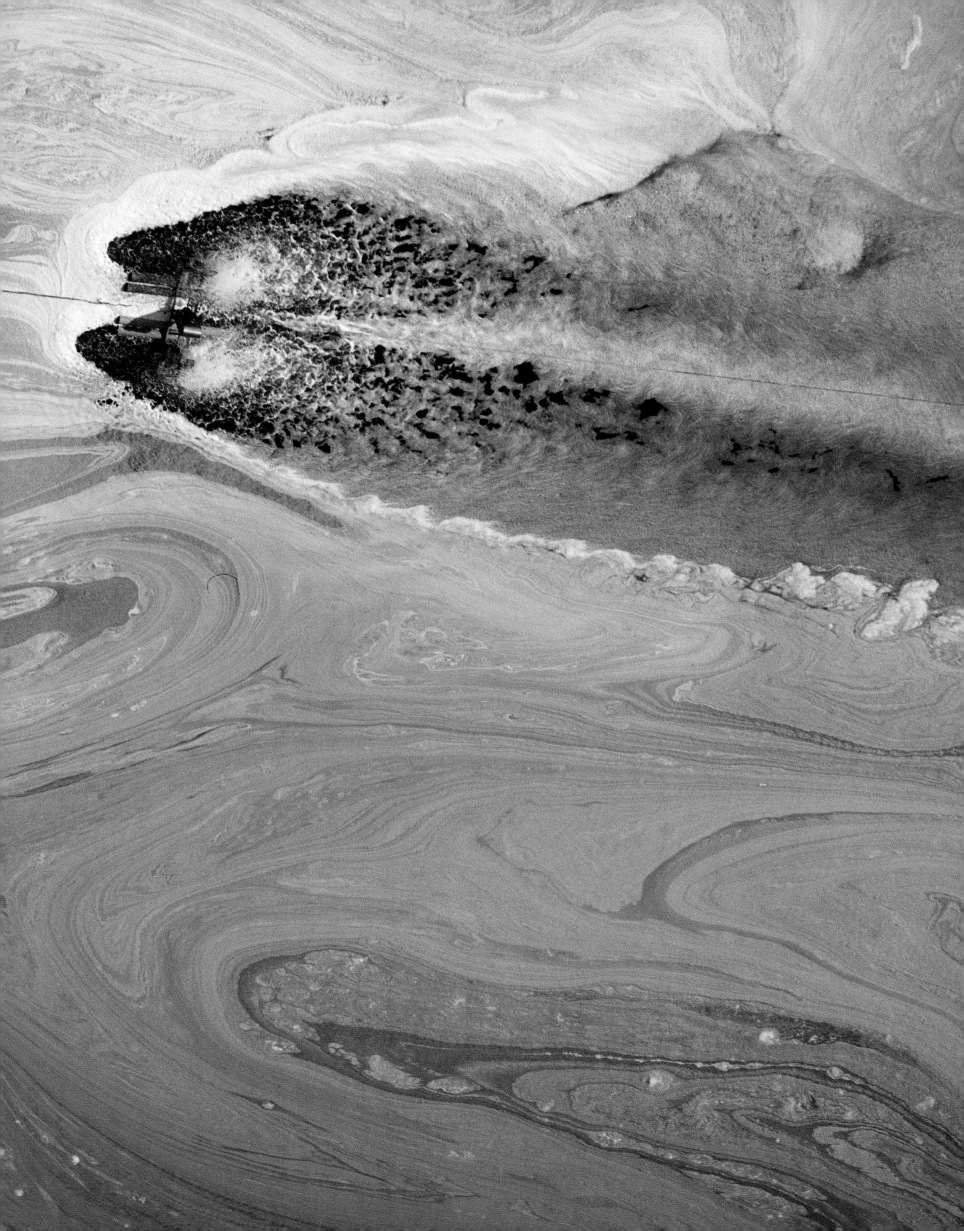

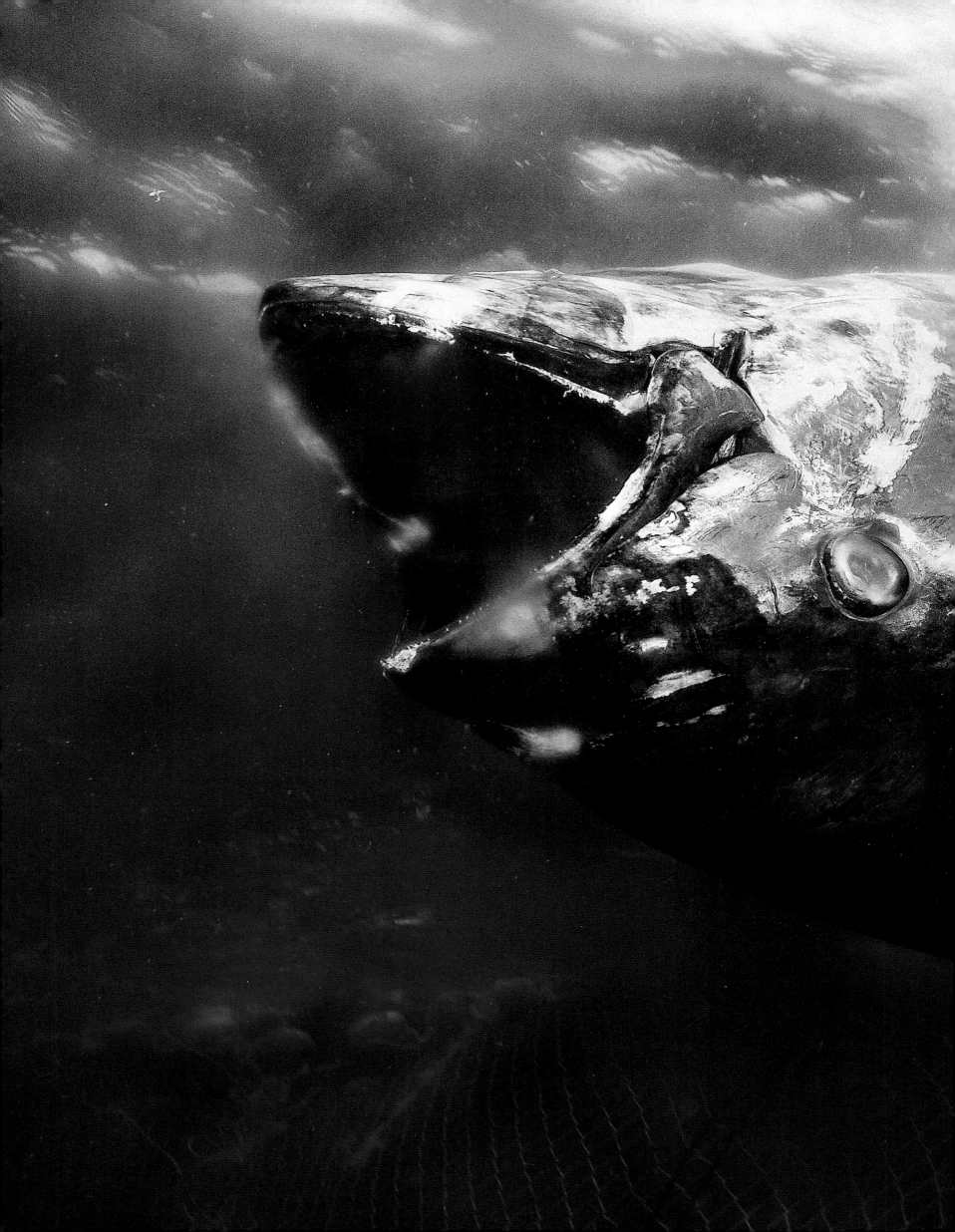

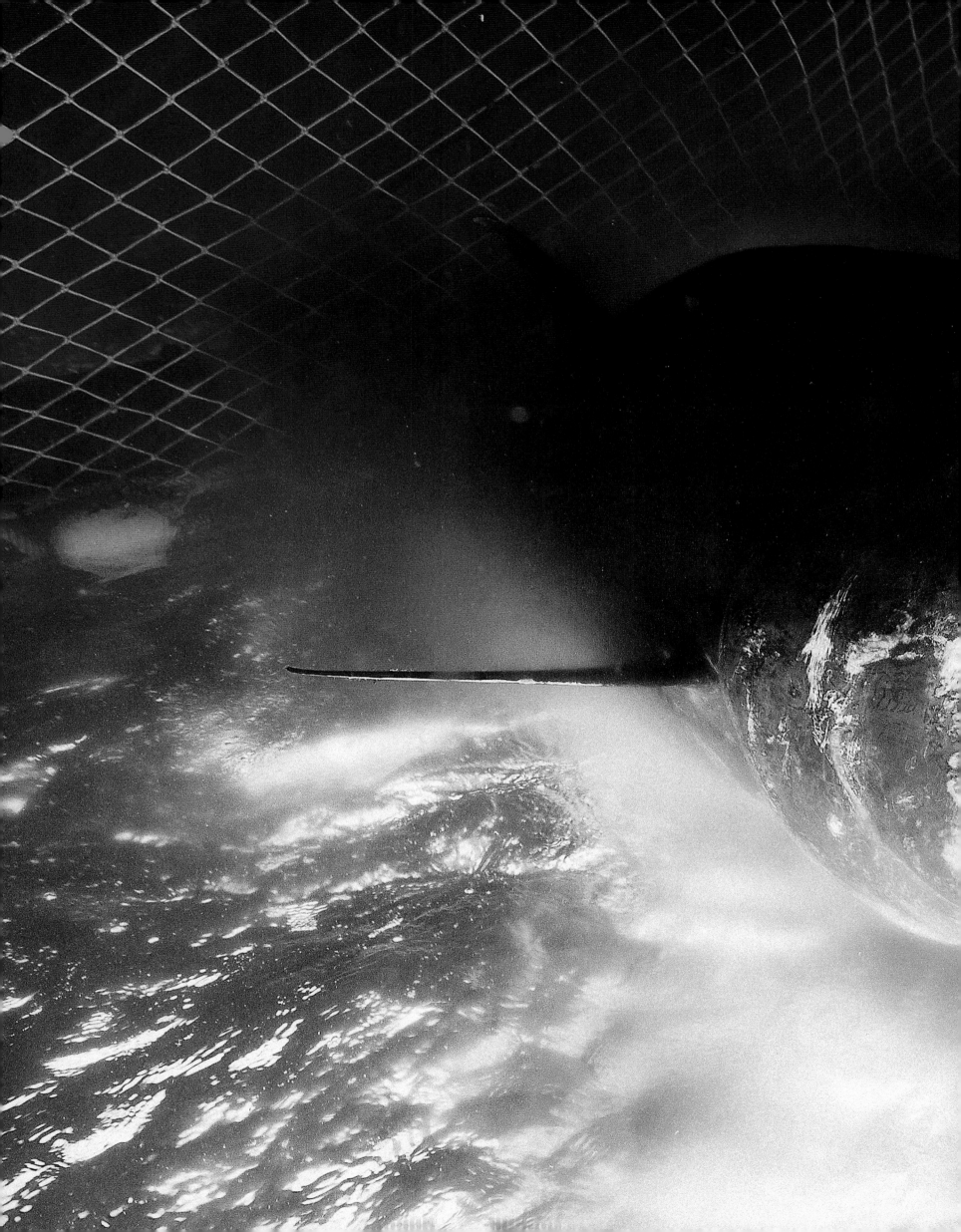

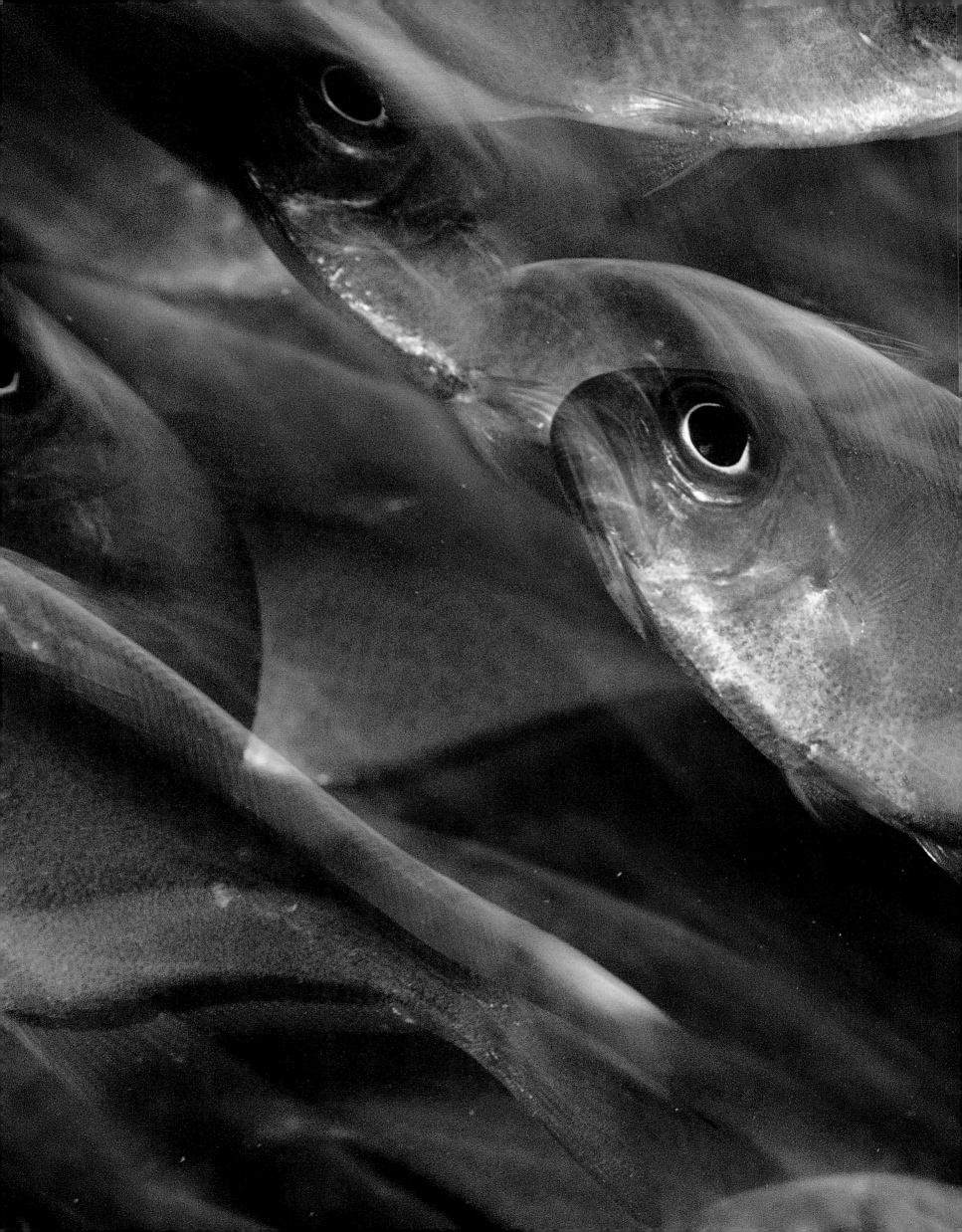

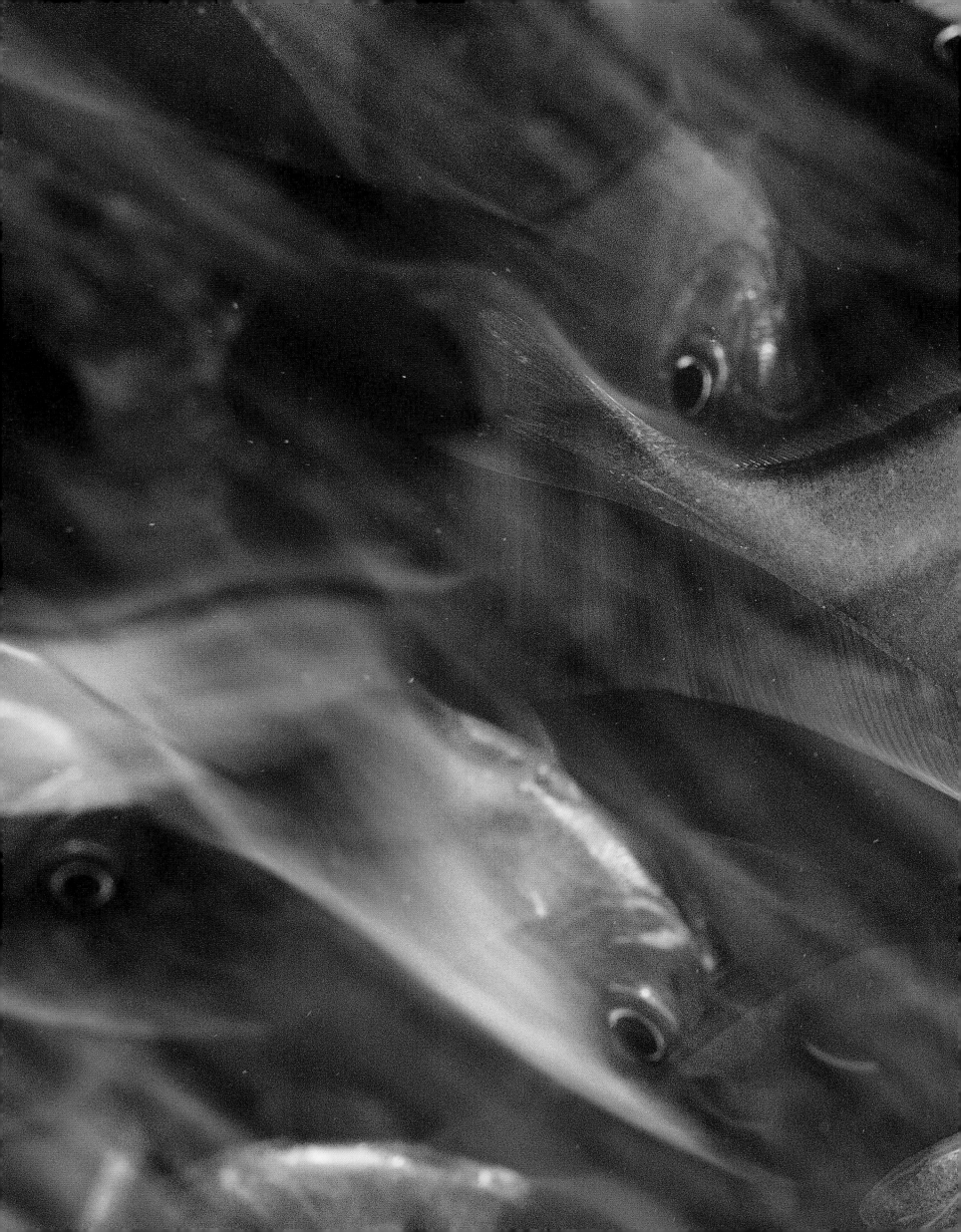

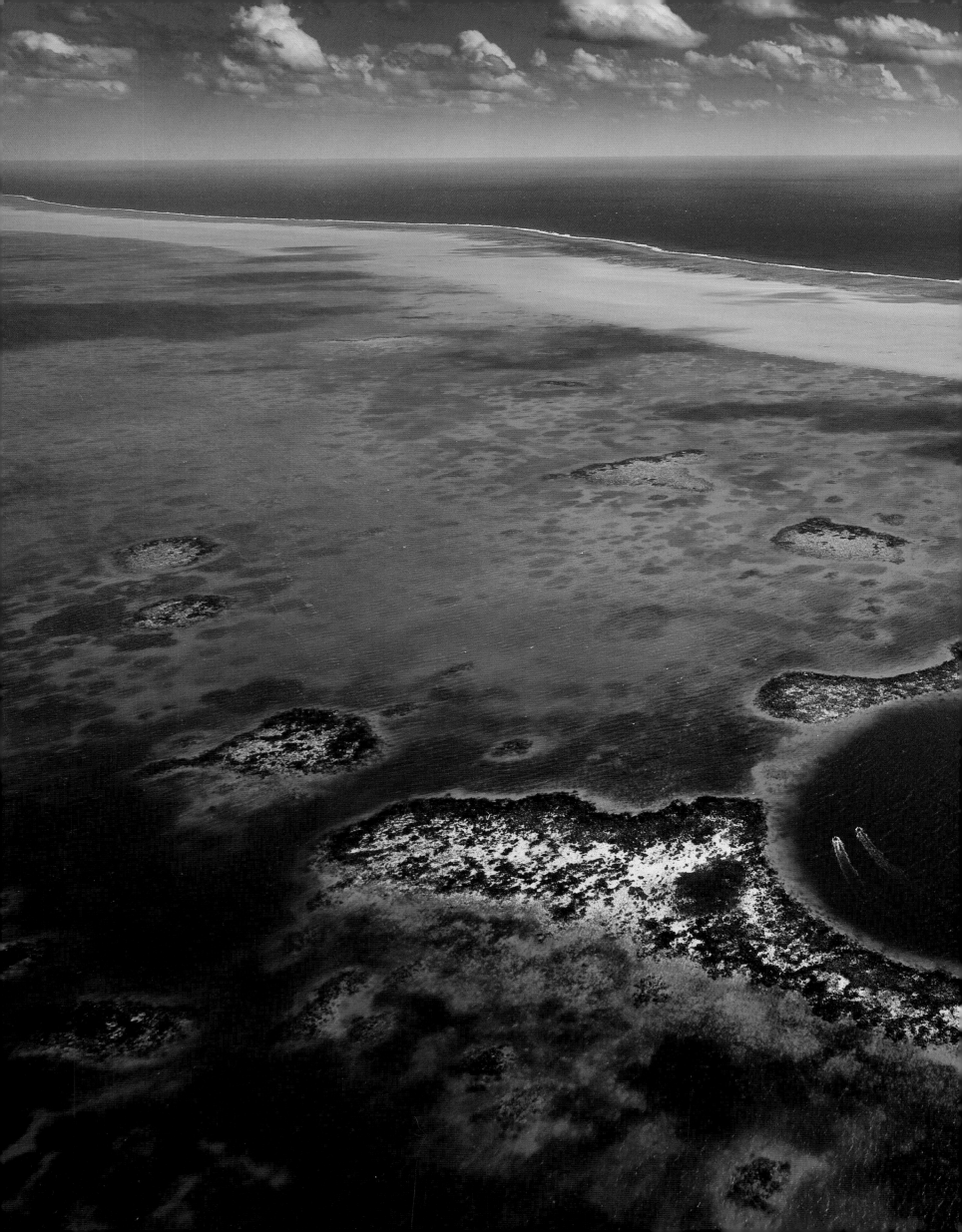

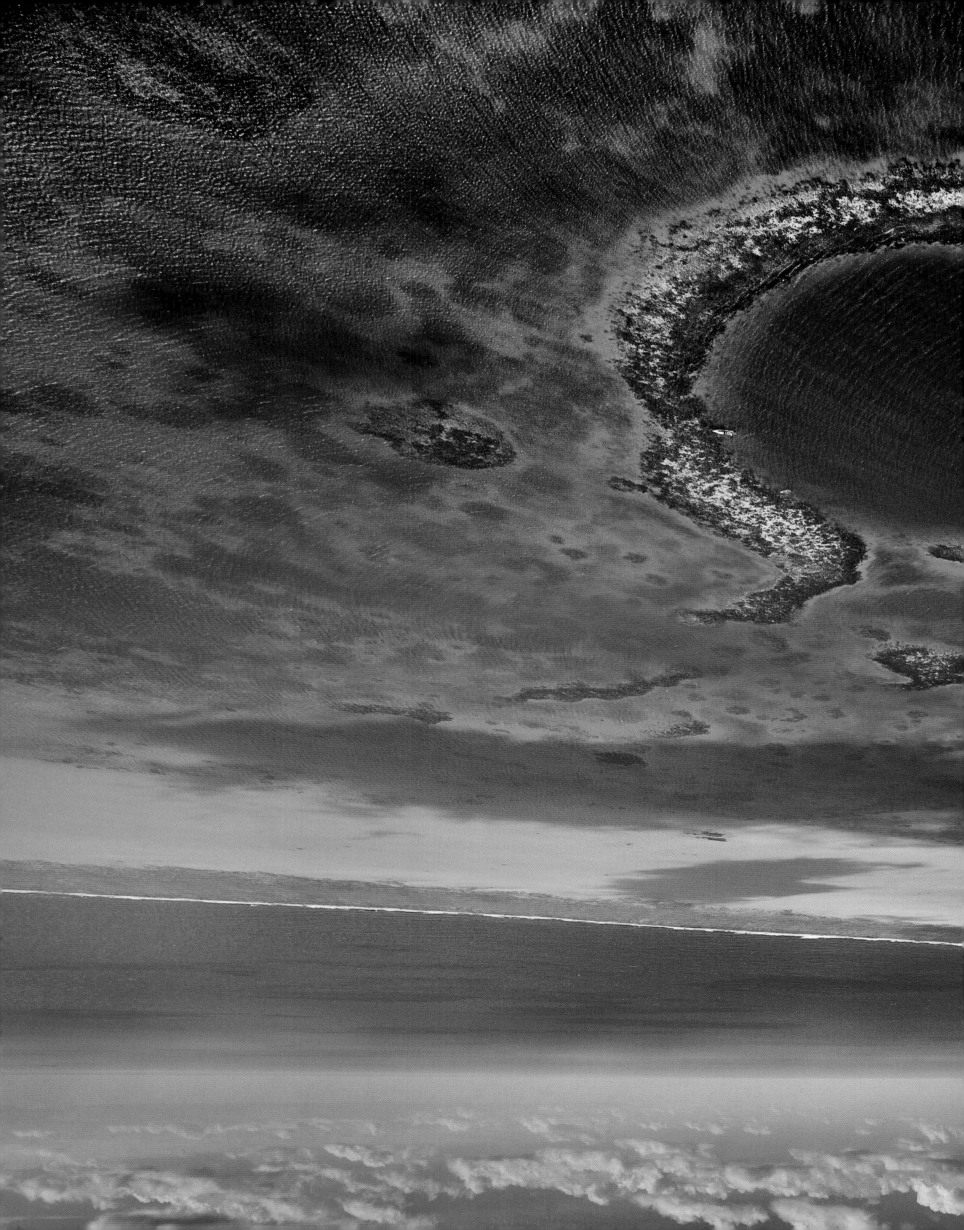

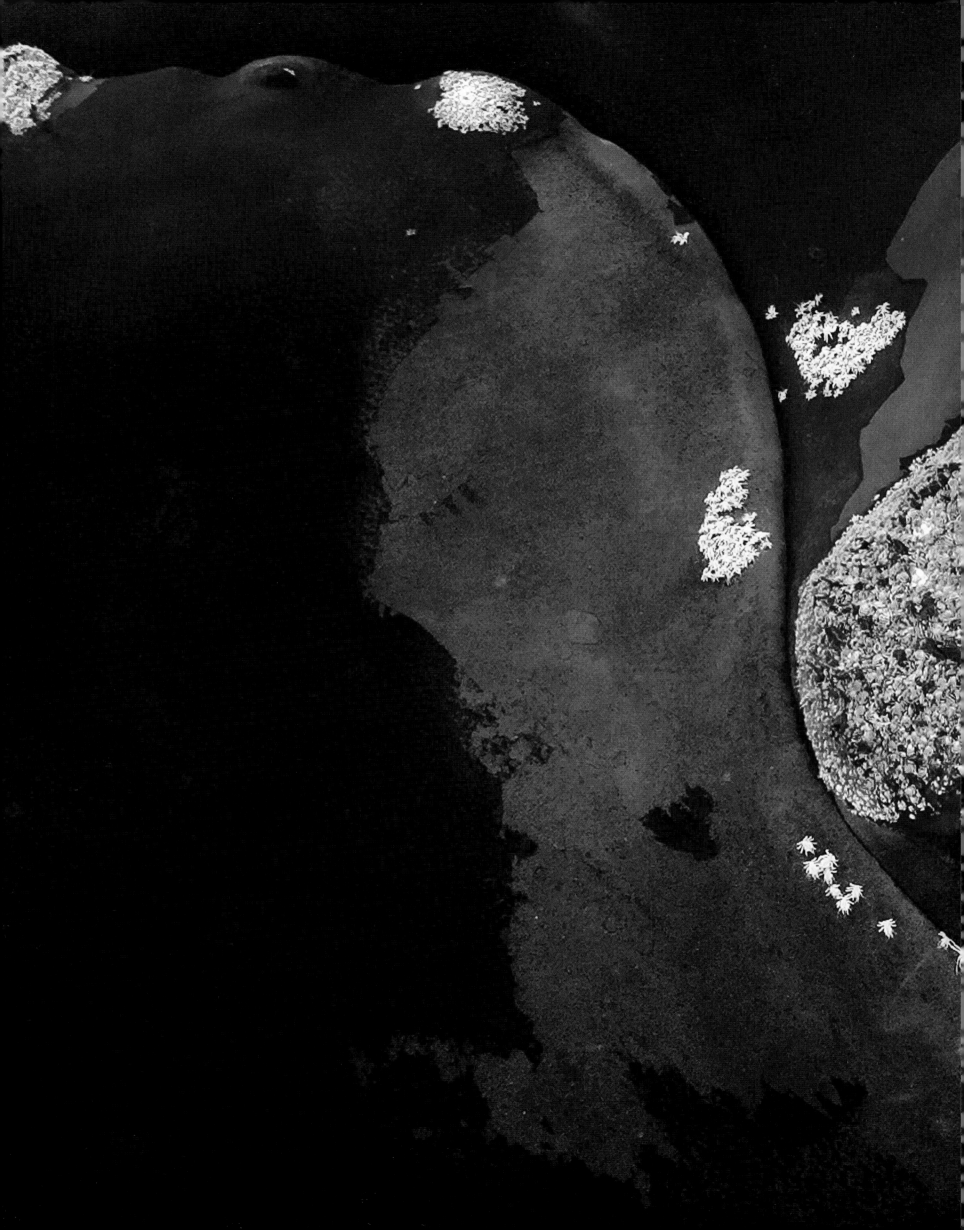

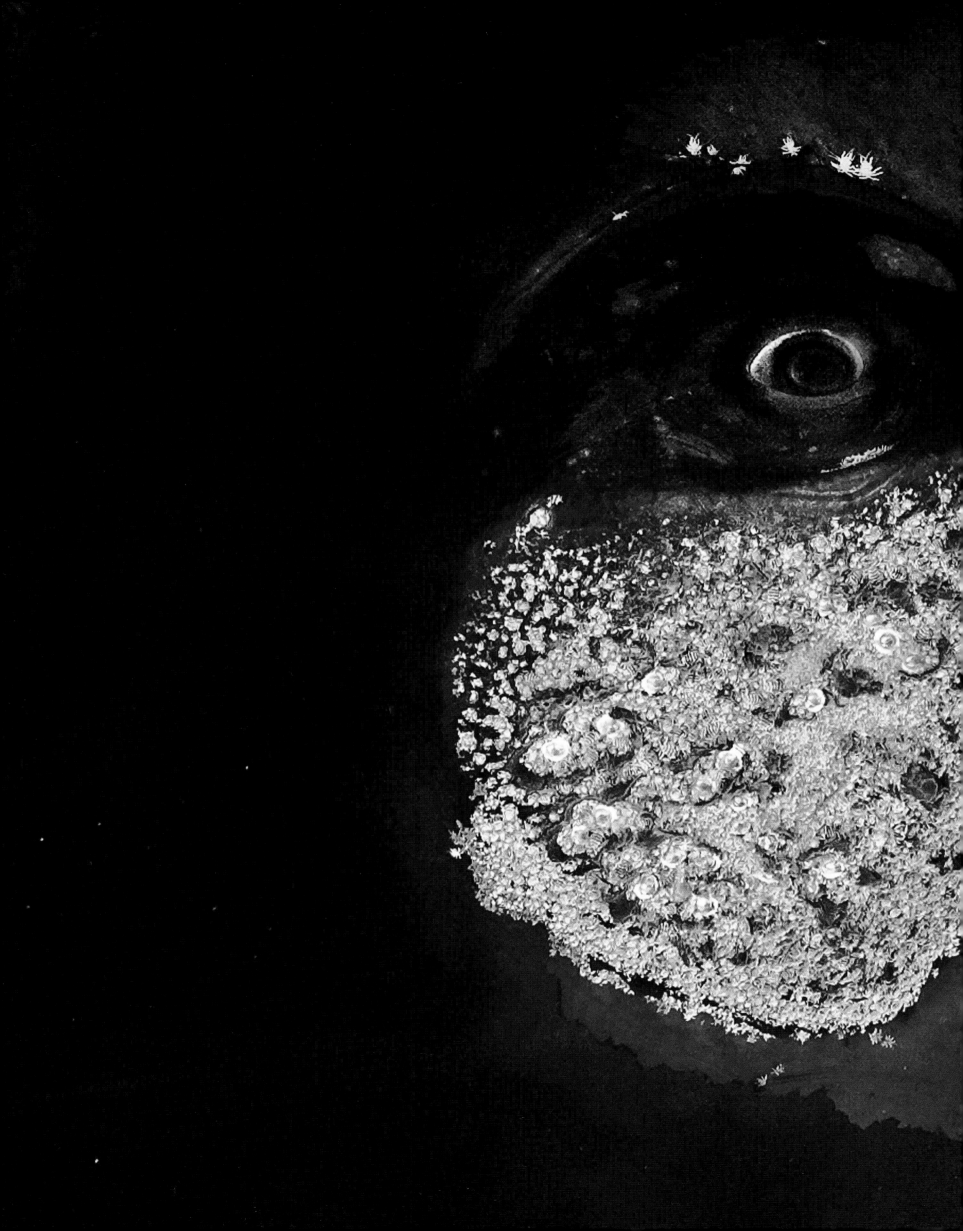

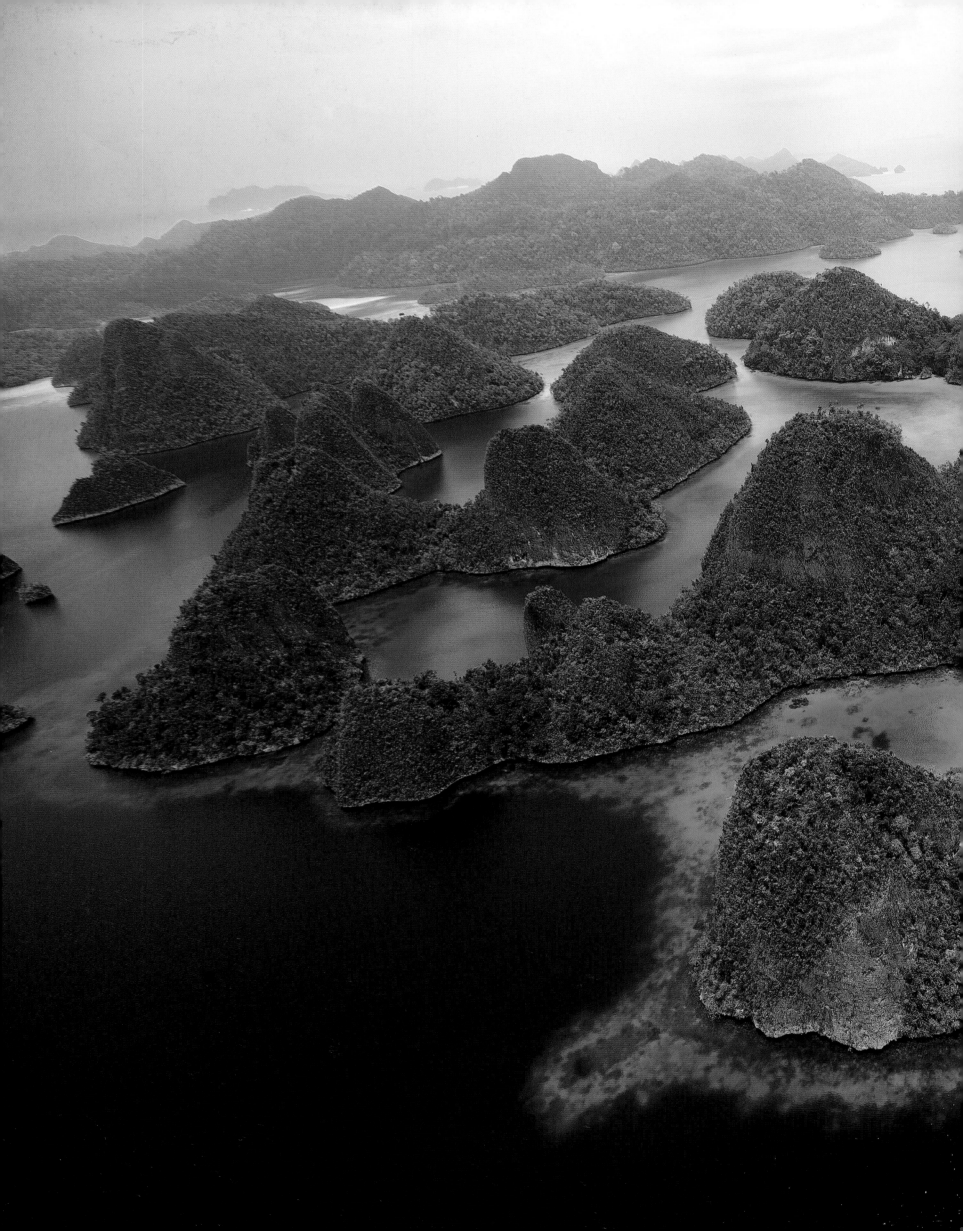

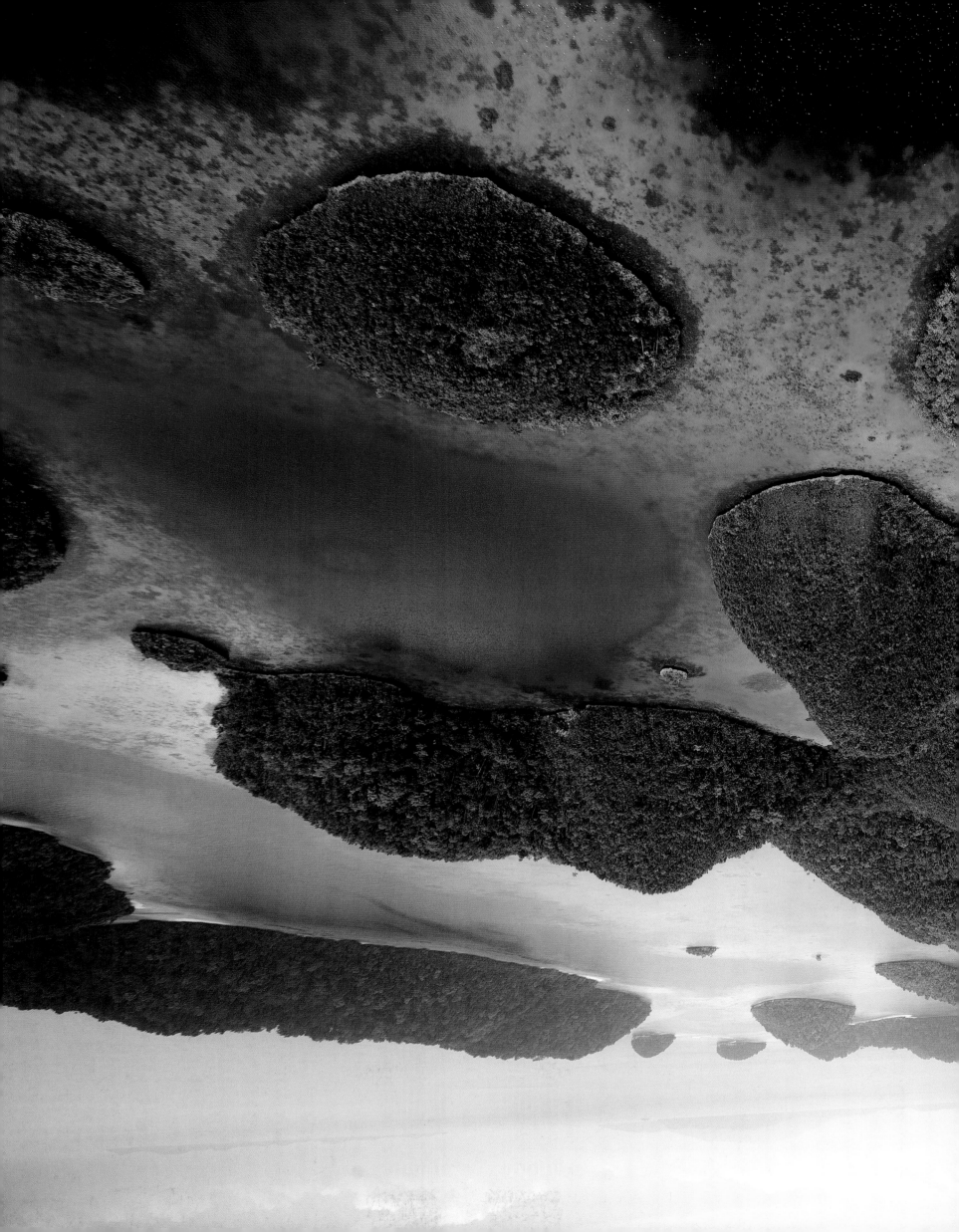

WHEN FISHING GOES OVERBOARD

Some have referred to the technologies used to catch an ever-growing number of fish as weapons in a war waged by mankind against fish. And there is nothing surgical about the war. Of course, these tools take no prisoners, but that is not all: The number of collateral victims is enormous.

BYCATCH

These collateral victims, known as bycatch or incidental catch, are nontargeted animals that are captured and killed but not "landed"—meaning sold, in fishing terminology. Often, they are thrown back in the water already dead. According to the FAO, the total quantity of bycatch in the world averages over 7 million tons, or about 8 percent of captures. But in certain cases, the toll is much heavier. According to a study by the European Union, discarded fish accounts for 60 percent of trawling off the Iberian Peninsula, and 98 percent for langoustine fishing in the North Sea. Shrimp fishing, which is among the least selective types of fishing, is thought to be responsible for 50 percent of global bycatch.

In the case of deep fishing, which relies on huge, heavily ballasted nets scraping the seafloor and tearing out everything in their path, trawlers bring up more than seventy species for every two or three targeted species! Bottom trawling is comparable to deforestation: It destroys vast surfaces of the seafloor, leaving a desert behind. According to certain studies, the surface area destroyed by bottom trawling could be even greater than that annually lost to deforestation in the Amazon forest. Yet this destruction meets with relative indifference.

Bycatch affects not only fish, but also sharks, whales, dolphins, and turtles accidentally caught in nets, as well as albatross and other birds that are attracted by the concentration of captured fish and get caught in the nets trying to peck at them.

The massive amount of discards is not solely due to technical reasons. In most cases, incidental catch would be subtracted from fishermen's quotas if they were landed. To preserve their quotas and not lose money, fishermen discard large quantities of dead fish that would be perfectly consumable.

ENVIRONMENTAL CONSEQUENCES

This practice has a wide range of environmental consequences. Bycatch directly threatens the survival of incidental species. When bycatch consists of juveniles, it endangers the reproduction and future of commercial species. Additionally, discarding dead fish on the surface attracts sea birds that become dependent on this easy resource and run the risk of losing their predatory ability. These practices are also antieconomic because shipowners still have to cover fuel and salary expenses for incidental captures of fish thrown back in the water.

Finally, the biggest problem related to bycatch is an ethical one: It is a massive waste of food. With 3 billion people in the world depending on fish for protein and 13 percent of the population undernourished, these 7 million tons of discarded fish are an aberration.

OPPOSITE: **Fishing boat off Île de Sein, Brittany, France** (48°02' N, 4°50' W)
"Who sees Sein…sees his end." Fishermen risk their lives by executing a dangerous slalom through the reefs of the Raz de Sein. Marine accidents are common in this stretch of sea buffeted by powerful currents between the Pointe du Raz and the Île de Sein. Many fishermen have lost their lives here.

12,355 ACRES (5,000 HECTARES) DEVASTATED BY A SINGLE SHIP
A boat engaged in bottom trawling rakes over the equivalent of five thousand soccer fields per campaign. This fishing technique leads to the destruction of the seafloor, and notably of the reefs in which fish find shelter and food.

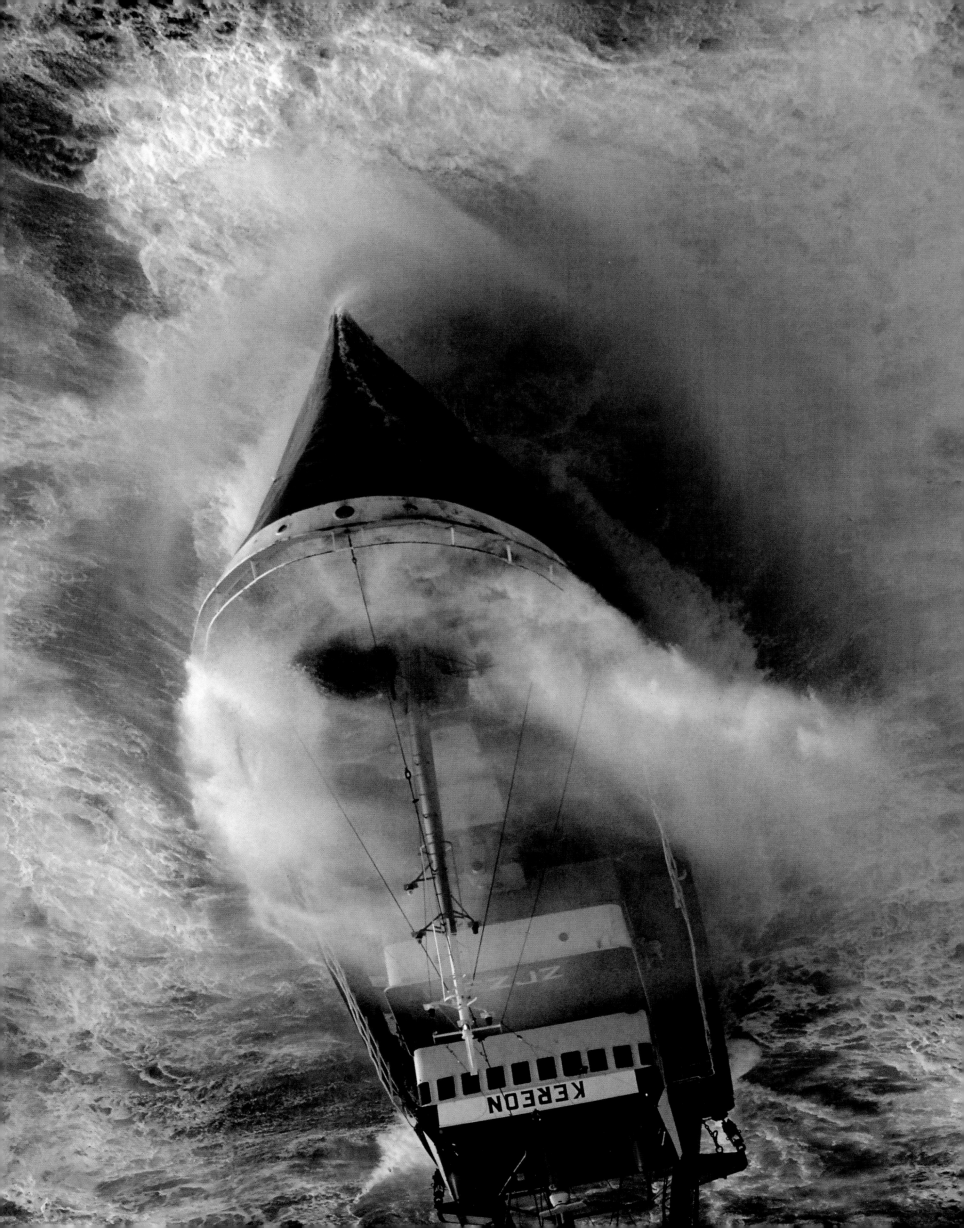

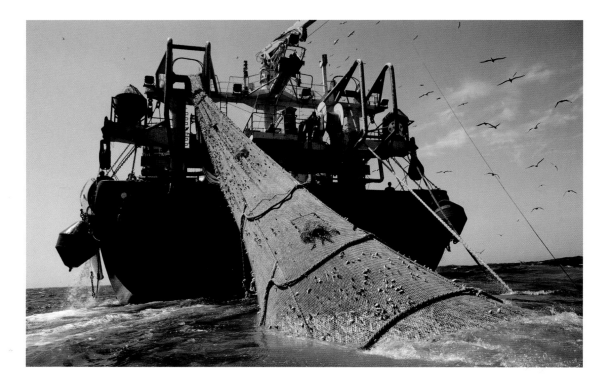

LEFT: The *Helen-Mary* trawler pulling up its nets, Atlantic Ocean, Mauritania

The *Helen-Mary* pulls up its nets 30 miles (50 kilometers) off the coast of Mauritania, one of the most fish-rich zones in the world. Foreign boats are often found in West African territorial waters. Without the technical means to rival with developed countries, African countries are being stripped of part of their resources. In certain cases, this fishing is negotiated and agreed to—Mauritania signed a new agreement with the European Union in 2012 authorizing European boats to access fishing zones for two years in exchange for financial compensation of 113 million Euros.

SOLUTIONS

There are technical solutions that would make it possible to significantly reduce the amount of incidental catches. The design and mesh of nets can be modified in order to limit bycatch, and grills can be added to floating nets to increase their selectivity. Other methods have proven effective for larger species. The implementation of rescue procedures and awareness campaigns aimed at fishermen have reduced dolphin captures in tuna fishing. Incidental turtle catches have been limited in certain shrimp fisheries by adding "anti-turtle" grills on trawling nets. Attaching magnets to equipment can also dissuade sharks from getting too close by affecting their sixth sense: They detect electromagnetic fields through singular organs called ampullae of Lorenzini.

Economic solutions are also conceivable, such as allowing the landing and distribution of species of low-economic value, thus making them accessible to the widest number of people and putting an end to wastage.

GHOST FISHING

Even more absurd than bycatch, ghost fishing refers to all fish futilely killed by lost or abandoned nets and other fishing gear. To return to the comparison with modern war, ghost fishing is the equivalent of victims of antipersonnel mines killed or maimed years after conflicts end.

A recent report stated that abandoned fishing gear accounts for 10 percent of the garbage in our oceans. The gill nets anchored to the seafloor and kept on the surface by floats are genuine traps that can "fish alone" for months, even years. Here, too, solutions exist, notably the use of lines and nets made of biodegradable plastic.

THE DESTRUCTION OF CORAL REEFS

Industrial fishing is not the only threat to the survival of ecosystems. For instance, some more traditional practices imperil coral reefs. The reefs of Southeast Asia—covering a surface of 38,610 square miles (100,000 square kilometers), or 34 percent of the coral reefs in the world, and including more than six hundred of the existing eight hundred coral species—are both among the most beautiful in the world and the most endangered.

Fishing with explosives is far from the smallest threat weighing over these reefs. Despite bans in many Asian countries, this type of fishing continues, often with homemade explosives made with potassium nitrate (which is used to make fertilizer). Explosives are placed in bottles, then left on the reefs, where they can make craters

OPEN-AIR KILLING

Since the 1960s, seal hunting has led to controversy between its Canadian defenders and opponents and the rest of the world. The latter decry its cruelty. Young seals are shot or beaten to death with a hakapik, a club with a metal spike, for their white fur. In France, opposition to seal hunting grew through the activism of actress Brigitte Bardot. In 2012, Canada set its hunting quotas at four hundred thousand individuals for a population estimated at over 5 million. Defenders of this type of hunting argue that it provides a means of support to native communities, does not endanger the species insofar as captures remain proportionally low, and that seals are not a threatened species. Nonetheless, the products of seal hunting find fewer and fewer outlets, since many countries (the European Union, Russia, and the United States) ban seal imports. It is said that the sector is no longer economically viable and depends on subsidies. Seals and sea lions are also hunted off the coast of Namibia from July to November, for similar reasons and using similar methods, but this practice does not attract as much media attention and is generally less well-known. In 2012, eighty-five thousand pups and six thousand adults were killed, according to the International Fund for Animal Welfare (IFAW).

ranging in diameter from 3 to 6 feet (1 to 2 meters). The explosion instantly kills the closest fish, while the blast destroys the swim bladders of fish farther away, thus preventing them from swimming. A study in Malaysia showed that this type of fishing led to a significant decrease in fish diversity, a drop in the number of individuals per species, and a reduction of the average size of individuals. Naturally, fish are not the only victims of this practice, since reefs that are frequently bombed have a 50 percent to 80 percent mortality rate. Additionally, explosives not only kill the coral, but also prevent it from growing back by modifying the ground's topography and destroying the substrate necessary to its development.

DEADLY AQUARIUM KEEPING

Cyanide fishing is another danger. It first appeared in the Philippines in the 1960s, then spread to Indonesia, Vietnam, Thailand, Malaysia, Cambodia, and the Maldives. The cyanide, which is sprayed directly on coral reefs, does not kill all the fish but anesthetizes them and makes them easier to capture. Living fish are used to supply the aquarium-keeping market—notably triggerfish—and restaurants—in which a live fish is worth five times more than a dead fish. Some 65 tons of cyanide are poured on reefs in the Philippines and eastern Indonesia. Cyanide is also dangerous for the reefs: The corals initially lose their algae, then whiten, and finally die with repeated doses of poison. This method is also prohibited in certain concerned countries, such as Indonesia and Vietnam, yet cyanide fishing continues through poaching and the authorities' inability to enforce regulation.

There is a third technique threatening corals: *muro-ami,* a kind of underwater beating inspired by a Japanese method used to empty the reef of all its fish. It consists of spreading a net over the reef, then sending dozens of often very young fishermen to the bottom to

ABOVE: **Carpet of hard corals in shallow water, Kingman Reef, Pacific Ocean, United States**
Kingman Reef forms an 11-by-6-mile (18-by-9-kilometer) triangle, an island of biodiversity in the middle of the Pacific. The corals on the Kingman Reef reserve are thought to be among the fifty reefs least impacted by human activity in the world, to the point that this atoll has become a reference for the study of coral reefs.

38 MILLION TONS OF INCIDENTAL CATCHES A YEAR

While the FAO evaluates the global volume of incidental catches at 7 million tons, the WWF estimates it at 38 million. In other words, for every single ton of fish caught and sold, nearly four times as much is thrown back in the water.

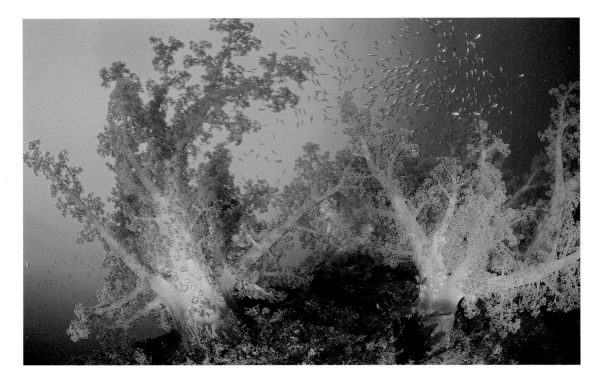

LEFT: Soft coral garden in Suruga Bay, Honshu, Japan

Unlike reef-building corals, soft corals do not have rigid calcium carbonate skeletons. The structure sheltering the polyp colony consists of a hydroskeleton—the water pressure inside it provides a certain rigidity—and calcium carbonate spicules, which are small calcium carbonate stems throughout the coral and the only structures that remain after the coral's death. Like hard corals, these soft corals house symbiotic algae in their tissues to provide their food. Yet some corals live in the deep sea, beyond where light penetrates. For these species, the presence of algae is useless, and their growth is solely supported by their predatory activities.

strike the reef and beat the fish back into the net. This type of fishing was banned in the Philippines in 1986, after it was revealed that minors were employed in its practice, of whom approximately one hundred had died trapped in their own nets. Yet the method endures. These destructive techniques are factors of poverty—on average, Filipino and Indonesian fishermen earn only 25 percent of the average national salary. Along with overfishing, pollution, and sedimentation due to deforestation, it has led to 88 percent of Southeast Asian corals being currently endangered, with 70 percent of Philippine corals already dead.

ILLEGAL PIRATE FISHING

Illegal or pirate fishing refers not only to banned techniques, but to fishing out of season, exceeding quotas—in certain fisheries with high commercial value, catches are thought to exceed authorized quotas by more than 300 percent—as well as unlicensed fisheries and the capture of protected species. According to the FAO, this illegal fishing accounts for about 15 percent of global catches and generates estimated revenues of 10 billion Euros a year.

In the absence of globalized monitoring, regional fishing organizations have major difficulties identifying ships, the names of their owners, or a breakdown of their activities, and thus are often not able to follow and track down criminals; this facilitates criminal activities. Flags of convenience are subject to opaque regulations, allowing pirates to conceal themselves and avoid supervision. A recent FAO study showed that less than 50 percent of countries effectively monitor fishing boats flying their flags on the high seas. These illegal practices do not only harm stocks and ecosystems. Illegal fishing saps resources available to local populations, and endangers its own fishermen, ignoring labor laws through the employment of minors and indecent, even dangerous, working conditions.

OPPOSITE: Starfish (*Acanthaster planci*) feeding on "mushroom" coral (*Fungia sp.*), Kingman Reef, United States

This very large starfish's appearance leaves no doubt as to how dangerous it is. With a maximum width of 20 inches (50 centimeters) and eleven to twenty-two arms, *Acanthaster planci* is a predatory animal. Its body is covered in thorns and toxic mucus that can cause severe edema in humans. When this species proliferates, it literally devastates the reefs: The coral covering can drop from 80 percent to 2 percent in only six months. The reef on the island of Guam has been particularly affected, though every method imaginable has been used to fight this carnivore including manual eradication and specially conceived injecting guns. The reasons for these proliferations remain a mystery.

For more information on this subject and a relevant excerpt from the film *Planet Ocean*, go to http://ocean.goodplanet.org/exces-de-la-peche/?lang=en

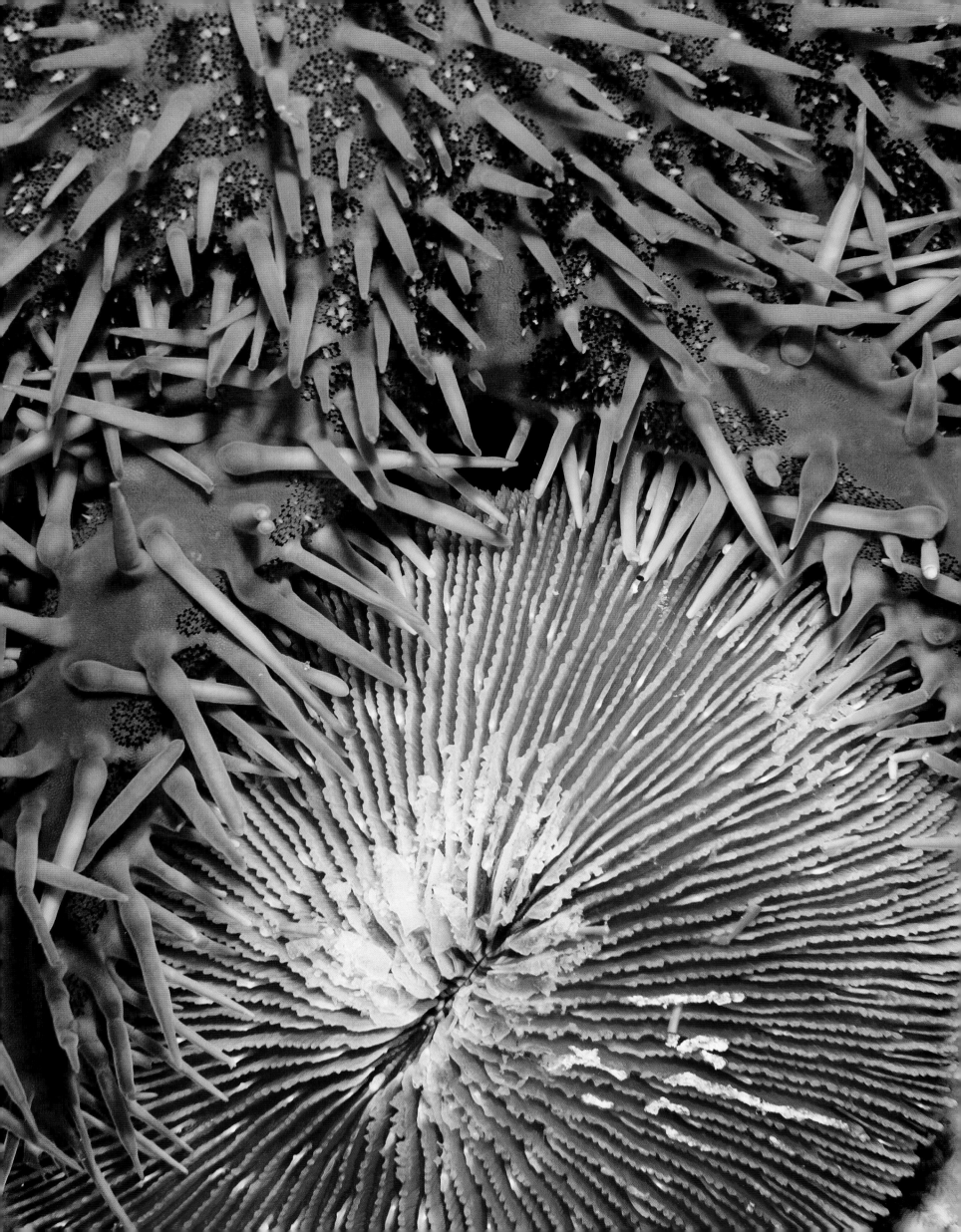

MASSACRE IN THE DEPTHS

INTERVIEW WITH CLAIRE NOUVIAN

CLAIRE NOUVIAN is the author of *The Deep* and curator of the traveling exhibition of the same name. She founded the nonprofit Bloom, which is dedicated to protecting the oceans and small-scale traditional fishing. In 2012, Bloom succeeded in having an advertisement for the Intermarché group (the leading fleet of deep-sea trawlers in France) banned.

Why did you found Bloom, a nonprofit organization that fights for the preservation of deep-sea biodiversity?

I founded Bloom after I discovered the world of the deep sea at the Monterey Aquarium in California several years ago. I was fascinated by these strange animals, these "intraterrestrials," their fragile and ethereal world, plunged in darkness, the slowness . . . By collaborating with a variety of researchers, I have had the privilege of diving in a submersible and coming to an intuitive understanding of these deep-sea environments' extreme vulnerability, "in the belly of the ocean."

"Short-term profit limits to the few the long-term benefits for all."

You became concerned about threats weighing on the deep sea?

The moment I discovered the existence of this peculiar world, I also learned that it was already being savagely exploited and that no one was upset about or even aware of it.

It would be hard to think of anything more destructive and less selective than the enormous deep-sea trawlers that rake the oceans' great depths. When I became aware of these daily massacres in deep waters, there was not a single law to protect international waters from trawling, and Europe had only recently provided itself with a severely inadequate legal framework.

From that point on, I had no choice but to throw myself into the fight to protect these vulnerable organisms. There is a violent contrast between our industrial tools' tremendous technological efficiency and the deep-sea fauna and environment's excessive vulnerability.

Deep-sea fishing sets the world of speed versus the world of slowness; short-term profit limits to the few the long-term benefits for all.

What exactly is deep-sea fishing?

Deep-sea fishing is the result of a failure: our inability to sustainably manage fish populations living at the surface. "Traditional" fish have been decimated by fishing fleets, which is why they turned to the deep sea. Concretely, deep-sea fishing involves industrial-sized boats [up to 165 feet (50 meters) in France and even more elsewhere] that scrape seafloors at depths between 1,300 and 5,900 feet [400 and 1,800 meters] and capture everything there with huge, heavily ballasted trawling nets. Even when their nets are smaller or less heavy, the fact that they are towed turns them into gaping mouths that swallow everything in their path, like a wall of bulldozers advancing in a line through a plain or a forest.

What are deep-sea fishing's environmental consequences?

First, it is a nonselective method of fishing that generates a high rate of discards of undesired fish. Hundred-year-old fish are common in the deep sea. Even though there are a very few species that have an average longevity that would allow them to be exploited sustainably (black scabbardfish, blue ling), capturing them would sacrifice an entire and extremely vulnerable fauna, which is largely unknown to science. Studies show that for every three species targeted by French fishermen in the Northeast Atlantic, seventy-eight others are sacrificed. Deep-sea fishing is a form of blind slaughter that notably threatens deep-sea sharks, whose survival is incompatible with the scale and pace of industrial fishing. Deep-sea trawlers also destroy marine habitats, ancient sponges, and corals sometimes up to several millennia old. People don't realize that there are only six deep-sea coral species that build reefs and that the 3,300 other deep-sea corals live scattered on the seafloor, isolated from each other. This means that the destruction of deep-sea biodiversity takes place in the nets, out of sight. It is even highly unlikely that the organisms crushed by trawling nets are hauled on deck. The damages remain at the bottom of the oceans, forever unknown.

Is this kind of fishing sustainable?

So far no deep-sea fishing has been scientifically described as sustainable; on the contrary, it embodies the very essence of unsustainable fishing, including deep-sea fishing allegedly "managed" in Europe. On the high seas, deep-sea fishing is still being carried out according to a boom and bust logic. When a new deep-sea resource is discovered, its virgin biomass is very large, but it takes less than a decade to make the fish stocks collapse. Ships then move to other stocks until they have finally emptied the deep oceans of their halieutic riches. In Europe, there has been a strict regulatory framework since 2003, but it has failed to ensure deep-sea fishing's sustainability. As for ecosystems, it is impossible to guarantee their integrity with trawlers at work, which is why, in July 2012, the European Commission proposed the historical measure of banning trawling and gill nets in the deep sea.

Who fishes in the deep sea today?

The leading country in terms of volume captured is New Zealand. France is seventh, after Spain and Portugal. Only a dozen French ships, divided among three shipyards, practice deep-sea fishing, and most belong to the Intermarché group's fleet.

On a global scale, about 285 ships fish deep-sea species in international waters. Given the very limited number of boats and nations concerned, I initially thought this fight would be easy to win, but obviously I was wrong. We are faced with industrial strategies backed by major investments, so the few companies involved are ready to do anything to protect their capital, ignoring the fact that it has most often been subsidized by public funds.

Are public subsidies harmful in the case of deep-sea fishing?

Subsidies are financing the massacre. The fleets operated by Intermarché and Euronor (Boulogne-sur-Mer) have respectively been granted several million Euros for the construction and decommissioning of ships. These substantial amounts are more than a helping hand; they are full-on transfers from healthy sectors of the French economy to dysfunctional sectors such as industrial fishing and deep-sea trawling. Without the tax refund on fuel oil, ships could not even leave harbor. Deep-sea fishing is an ogre dependent on public funds. Ultimately, our tax dollars serve to increase fishing pressure on overexploited stocks and vulnerable marine environments.

"Subsidies are financing the massacre."

Isn't deep-sea fishing profitable?

No, the French deep-sea fishing fleets lose a lot of money. The major industrial groups that own them have a strategy of harnessing marine resources and making a profit on selling the fish. From an accounting and fiscal point of view, a loss-making subsidiary is probably in their favor. This is likely the most scandalous aspect of the situation: French citizens are being taxed to finance the destruction of deep-sea biodiversity and prop up structurally loss-making companies.

How much of the market do deep-sea fish account for?

Deep-sea fish (blue ling, black scabbardfish, grenadier, etc.) only account for 1.3 percent or 1.4 percent of the total value of European or French captures. Which is totally marginal, despite a disproportionate effect on the environment and public finances.
Deep-sea species are far from staples of the French diet except for that of our children! Deep-sea fish, like the hoki and the dogfish, are served in 85 percent of school cafeterias.

Is there a way for consumers to take action?

Yes, absolutely. Since our government caves to pressure from industrialists on fishing questions and we cannot count on it to protect the oceans' biodiversity, it is up to us to take things in our own hands. Remember three names—rock grenadier, blue ling, and black scabbardfish—and avoid these fish at all cost. Then you have to stop eating species on NGOs' red lists, avoid predators, and eat less fish, but eat better by buying "local" from small producers working with selective methods.

The industry seems solid. Is this an uphill battle?

Oh yes! Particularly given that industrial lobbies are perfectly well-versed at disinformation techniques and data distortion. They are very good at placing "doubt merchants" charged with influencing decisions at strategic places in the political arena. These are the famous "white coats" found in the tobacco industry or in the debate over climate change, who use their prestige as well as the supposed fundamental objectivity of science to hide the fact that they are hired by lobbies to defend their interests. Industrial lying is increasingly present in our society. I was disgusted to see Intermarché deep-sea fish stamped with a "Responsible Fishing" logo, which is not an ecolabel, though it is an exact copy of the MSC [Marine Stewardship Council] label. Bloom filed suit for false advertising and the advertising was banned by the *Jury de déontologie publicitaire* [Jury for Advertising Ethics]. People don't realize the extent of the lobbies' power and networks; luckily, politicians are sometimes able to carry a long-term vision without caving to pressure from interest groups. The European Commission has just proposed a ban on bottom trawling and gill nets in Europe, a visionary measure, desperately needed to protect both the oceans and French and European taxpayers.

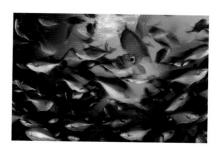

Marine worms (*Sabella*), Belize

The *Sabella* is a marine worm about 3 or 4 inches (10 centimeters) long. It lives vertically, in a tube of mucus and sediments that agglomerate around it. Only two fans of feathery tentacles stick out of the tube. These are used to direct suspended particles of plankton in the current to the worm's mouth. The worm's gills are on its tentacles, as are small sensory organs sensitive to light; these allow the worm to detect variations of luminous intensity and to retract into its tube to protect itself when the shadow of a predator flies overhead, for example.

Village near Panducan Island, Philippines (6°15' N, 120°36' E)

The Philippines' coral reefs account for more than 9 percent of global reefs and have the greatest biological diversity, with more than half being tropical fish. Yet cyanide fishing, which facilitates the capture of fish intended for the fish-keeping market, and the explosive fishing practiced by an unscrupulous minority of fishermen, have devastating effects on local coral reefs, up to 70 percent of which are damaged.

Red pigfish (*Bodianus unimaculatus*) and school of blue maomao (*Scorpis violacea*) in a cave, Poor Knights Islands, New Zealand

Many species of fish gather in dense schools. The term "schooling" refers to these groups and the relationships that unite these fish of the same species. To this day there is much we do not know about the mechanisms structuring schools of fish. We do know that their cohesion allows fish to reduce friction in the water, protects them from predators, and facilitates their reproduction.

Hagia Sophia, Istanbul, Turkey (41°00' N, 28°59' E)

Every day nearly two hundred ships cross the Bosphorus Strait separating Europe and Asia—including many tankers coming from the Caspian Sea. They then cut through the former Byzantium, which became Constantinople, and is now Istanbul. The basilica of Hagia Sophia, built from 532 to 537, stands on the city's western side. After Constantinople fell to the Turks in 1453, Hagia Sophia was turned into a mosque and four minarets were added to it. Since 1934, this masterpiece of Byzantine architecture has been a museum by decree of the Republic of Turkey's secular government.

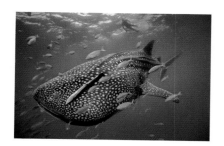

Whale shark (*Rhincodon typus*), suckerfish, and a school of fish, Australia

Along with whales and dolphins, the whale shark has become one of ecotourism's representative species. This practice rests on the observation of intact ecosystems and species in their natural habitats. Ecotourism is intended to allow and incite the preservation of natural environments by placing them at the heart of local economic issues. But abuses are many, and collisions between boats and animals are not unusual.

Atoll of Bora-Bora, Leeward Islands, Society Islands, French Polynesia, France (16°31' S, 151°46' W)

The Leeward Islands of French Polynesia include this 14-square-mile (38-square-kilometer) island whose name means "the first born." Bora-Bora consists of the emerged part of the crater of a seven-million-year-old extinct volcano, surrounded by a coral reef barrier on which coconut tree–covered coral isles have developed. Teavanui Channel is the only passage deep enough between the lagoon and the ocean for ships to enter. The island served as an American military base during World War II.

Harp seal (*Pagophilus groenlandicus*), Gulf of Saint Lawrence, Canada

Hunting is not the only threat faced by harp seals. Global warming destabilizes and weakens the Arctic ice cap, considerably reducing their habitat. Newborns do not have waterproof fur and do not know how to swim. Due to rising temperatures, ice can break under their weight and the seal pups drown. Here, a mother pushes its pup out of the water after it fell in the Gulf of Saint Lawrence.

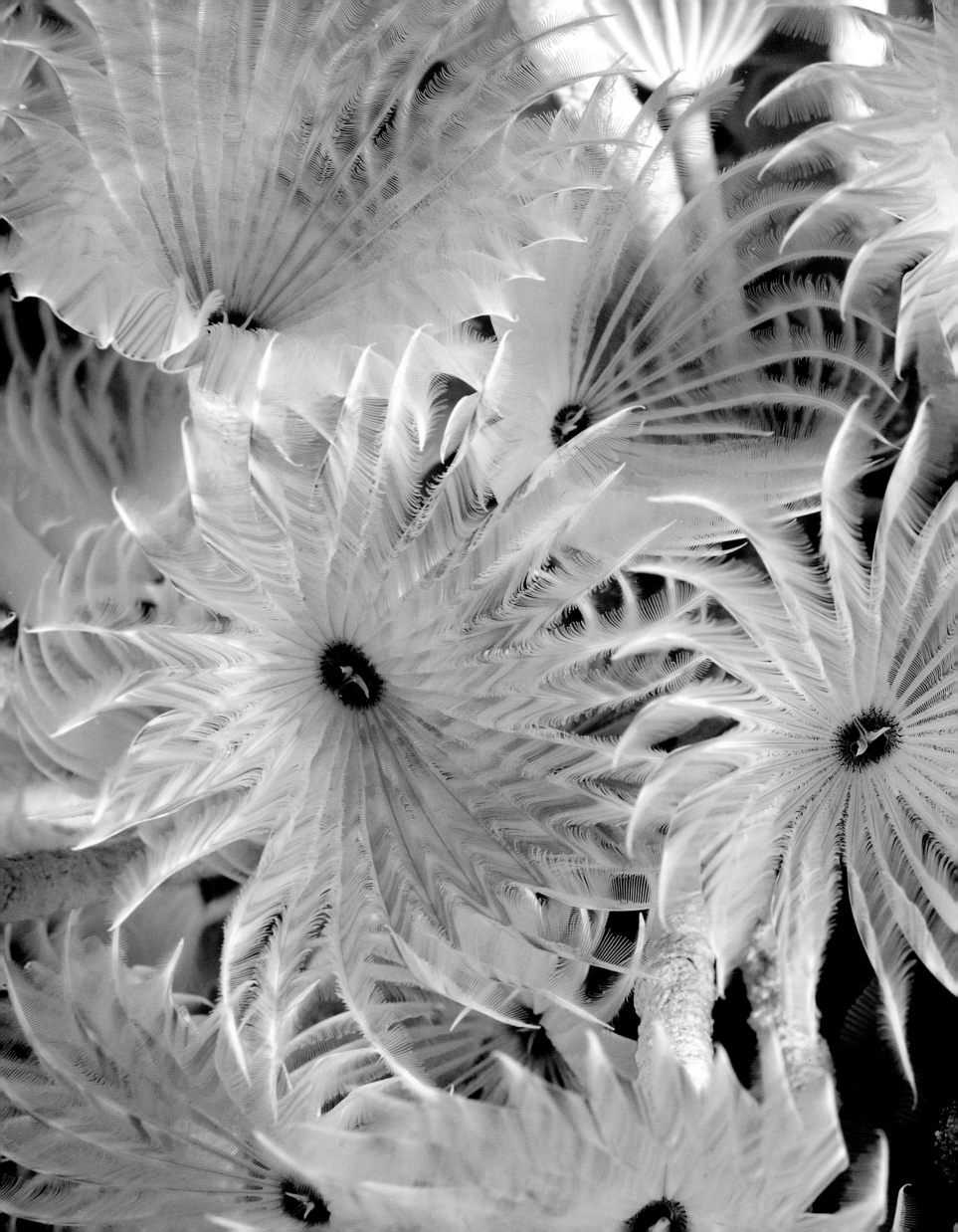

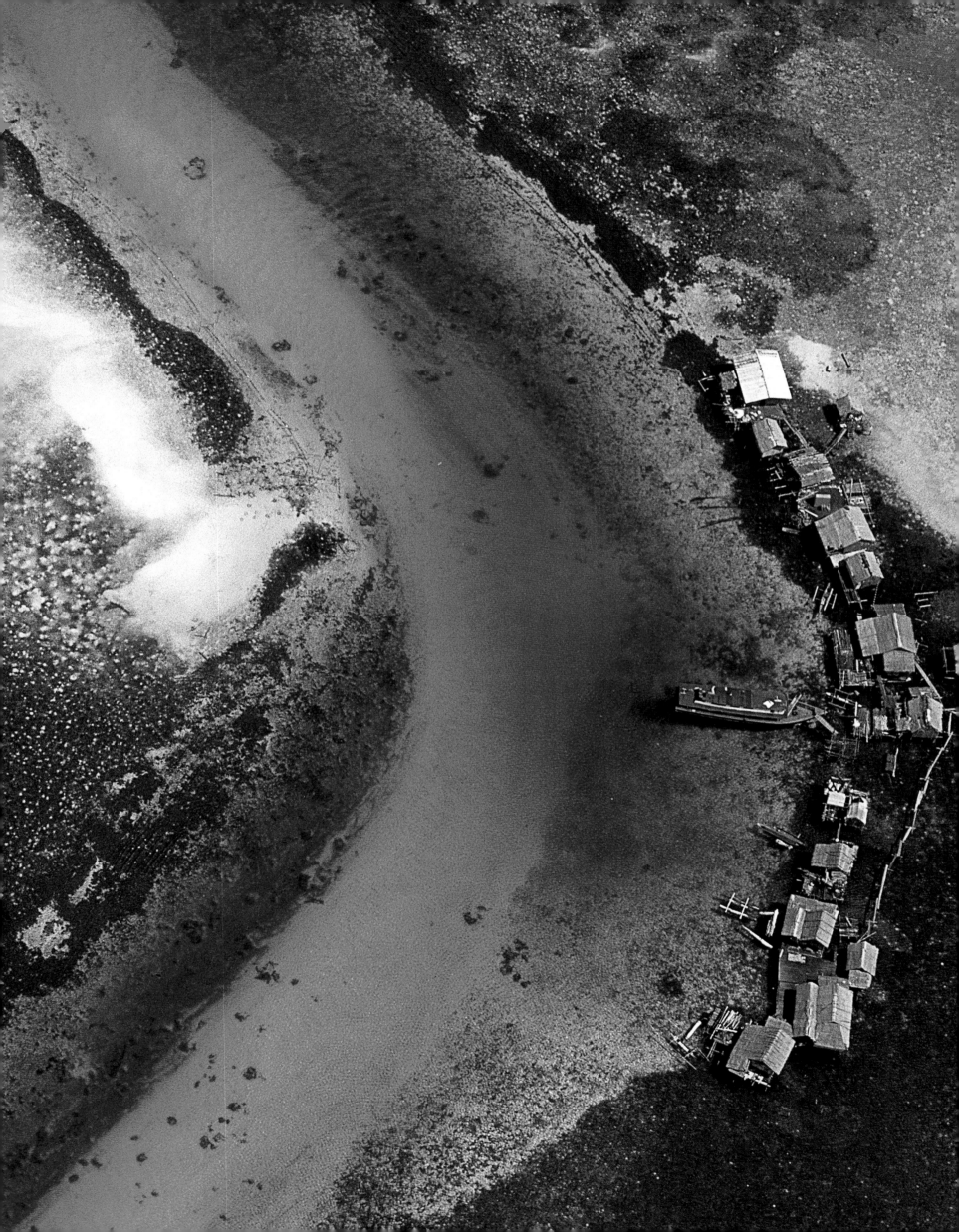

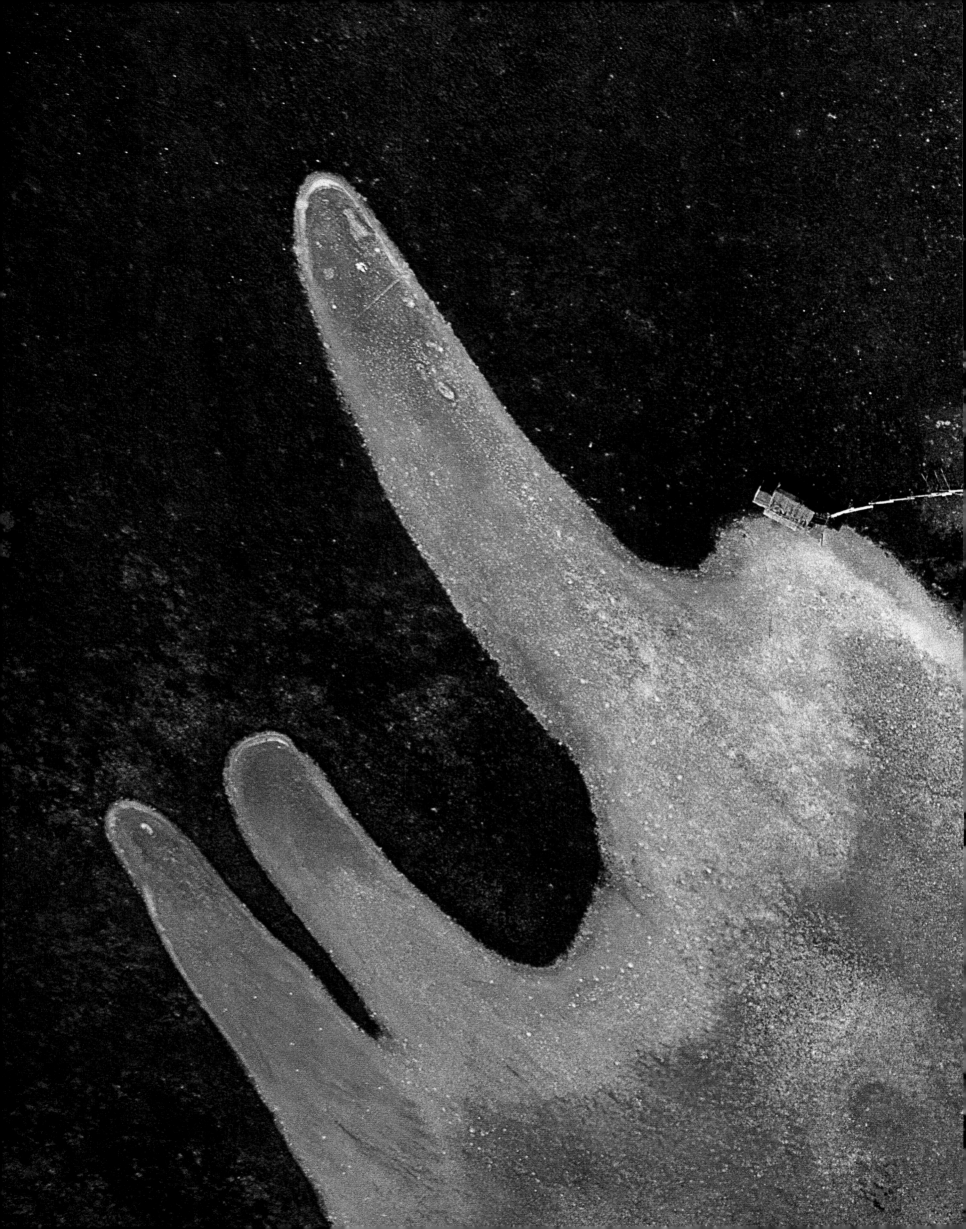

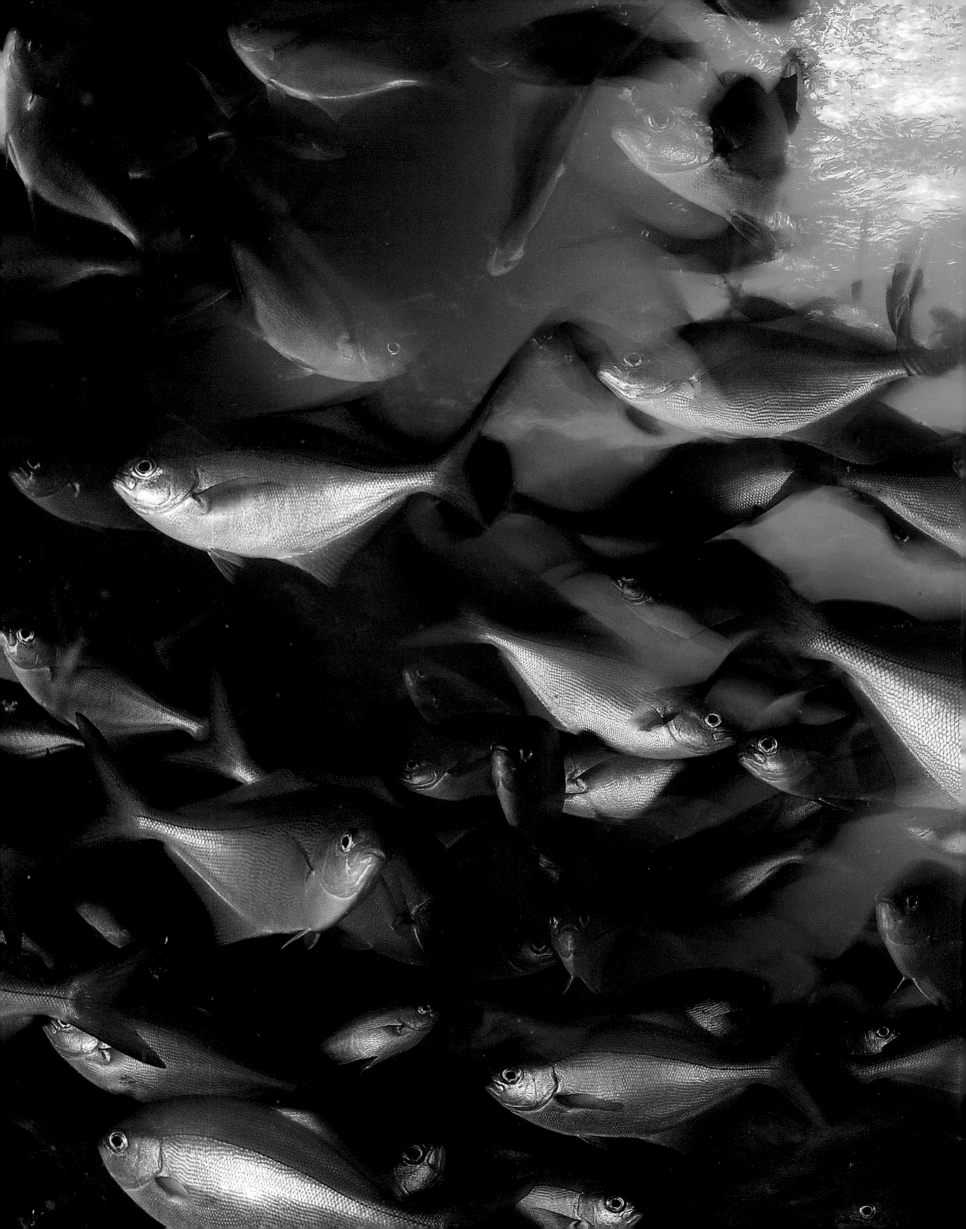

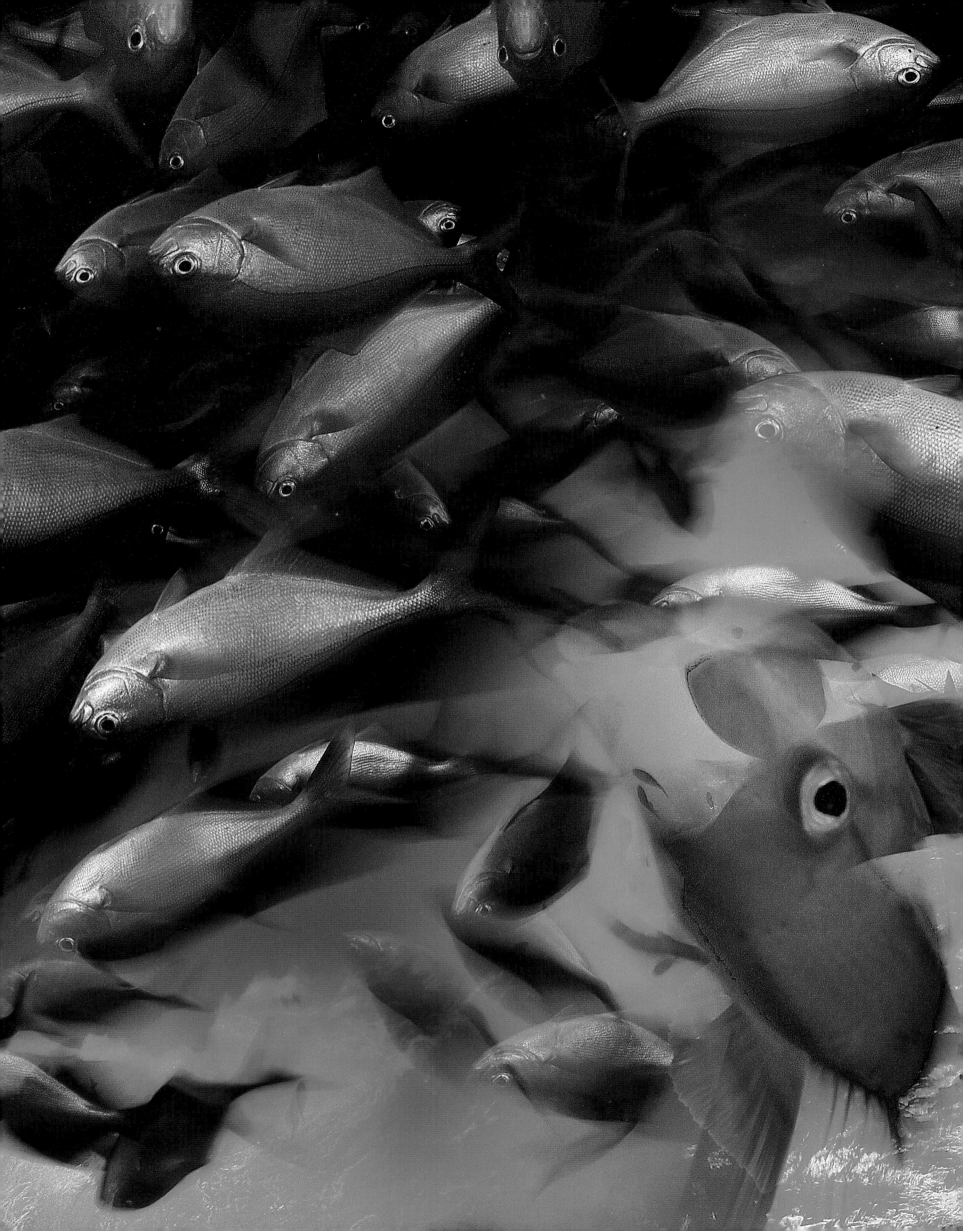

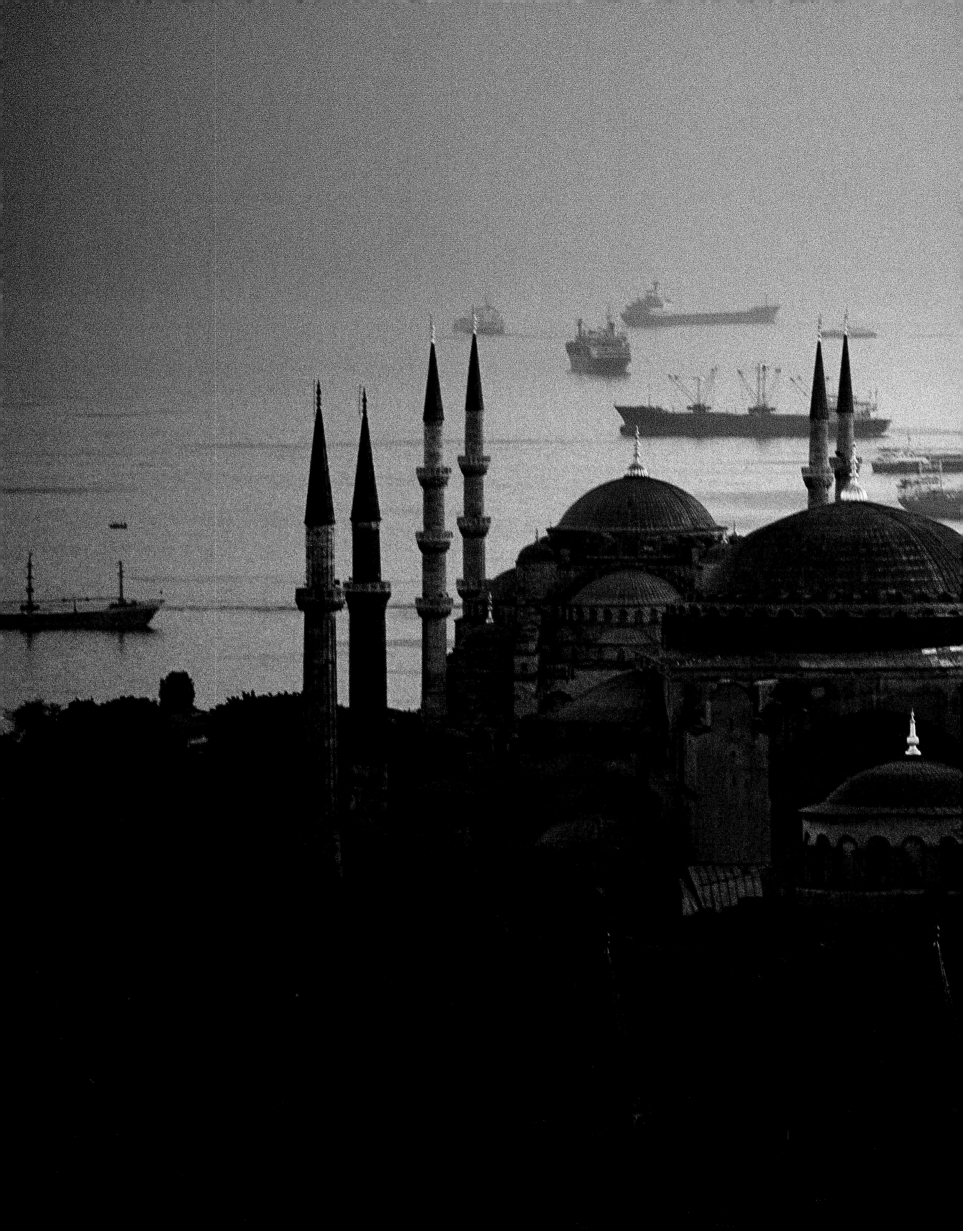

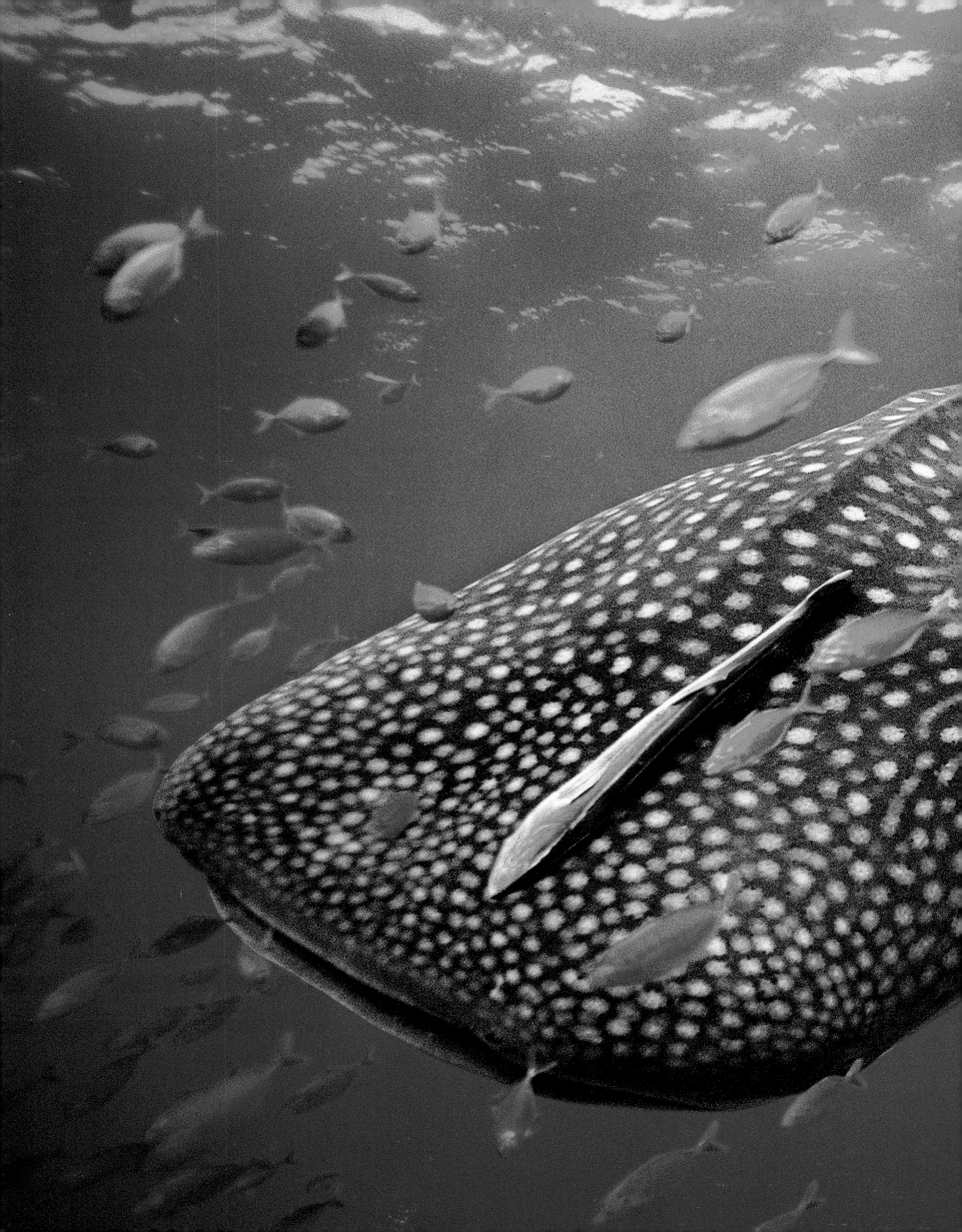

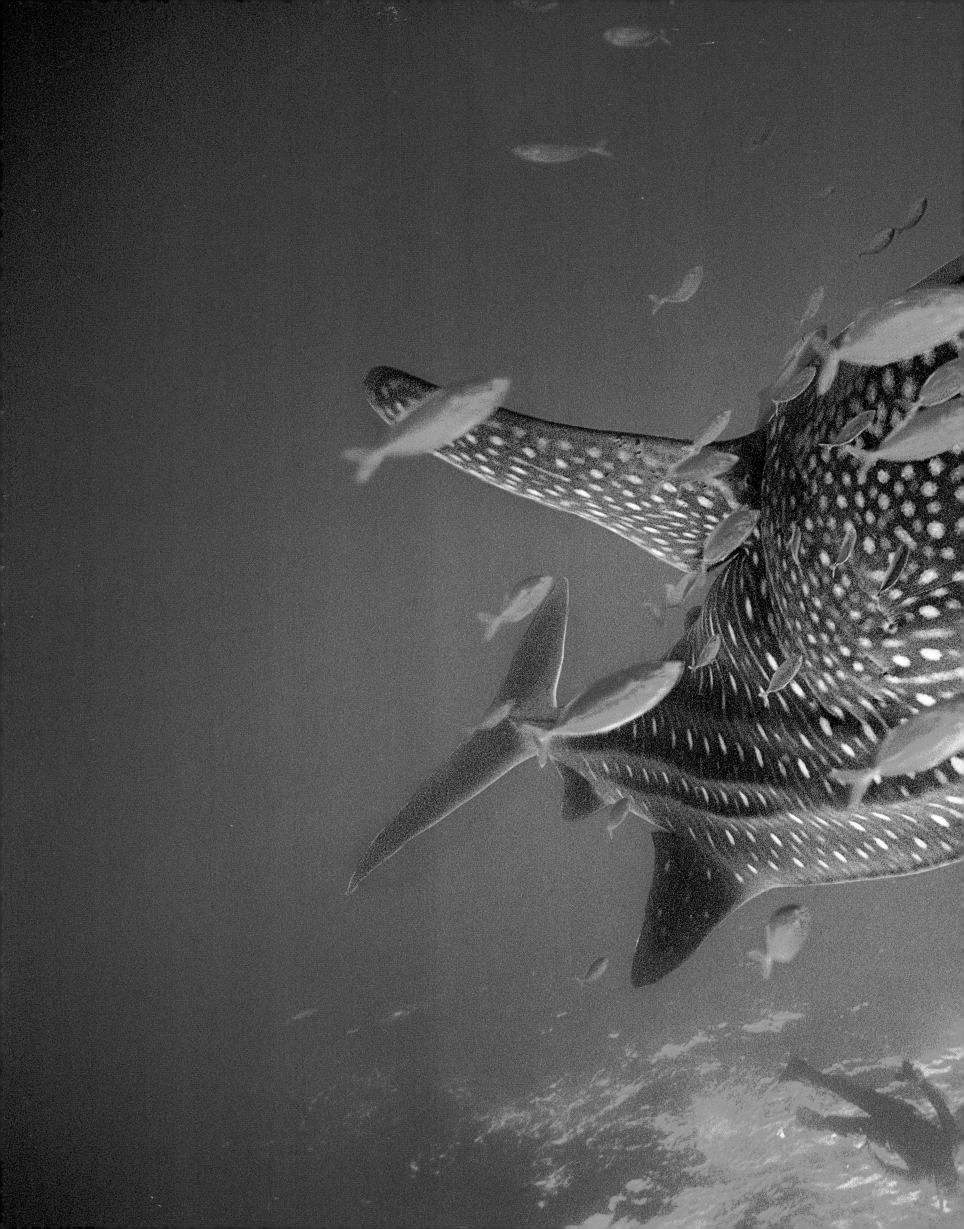

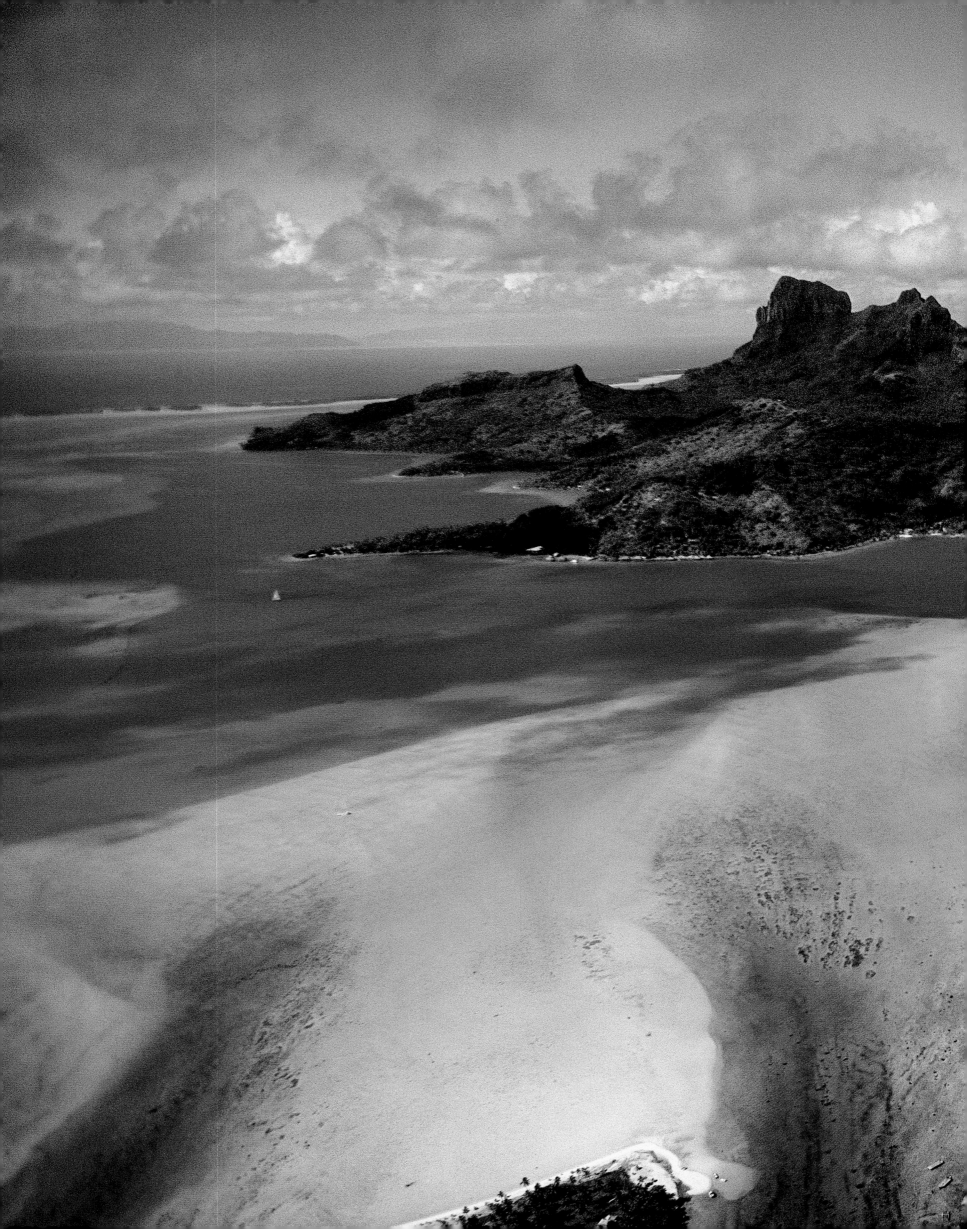

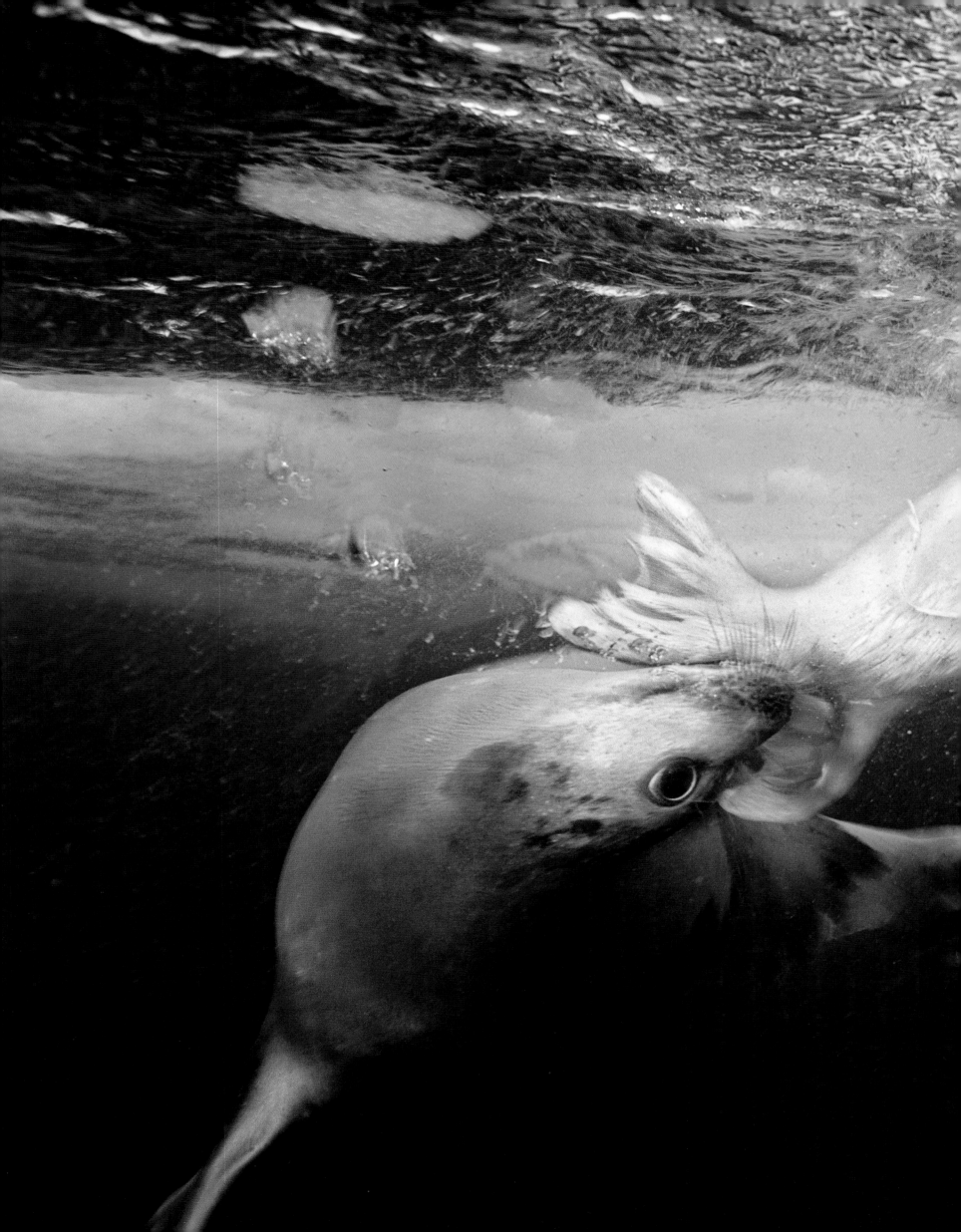

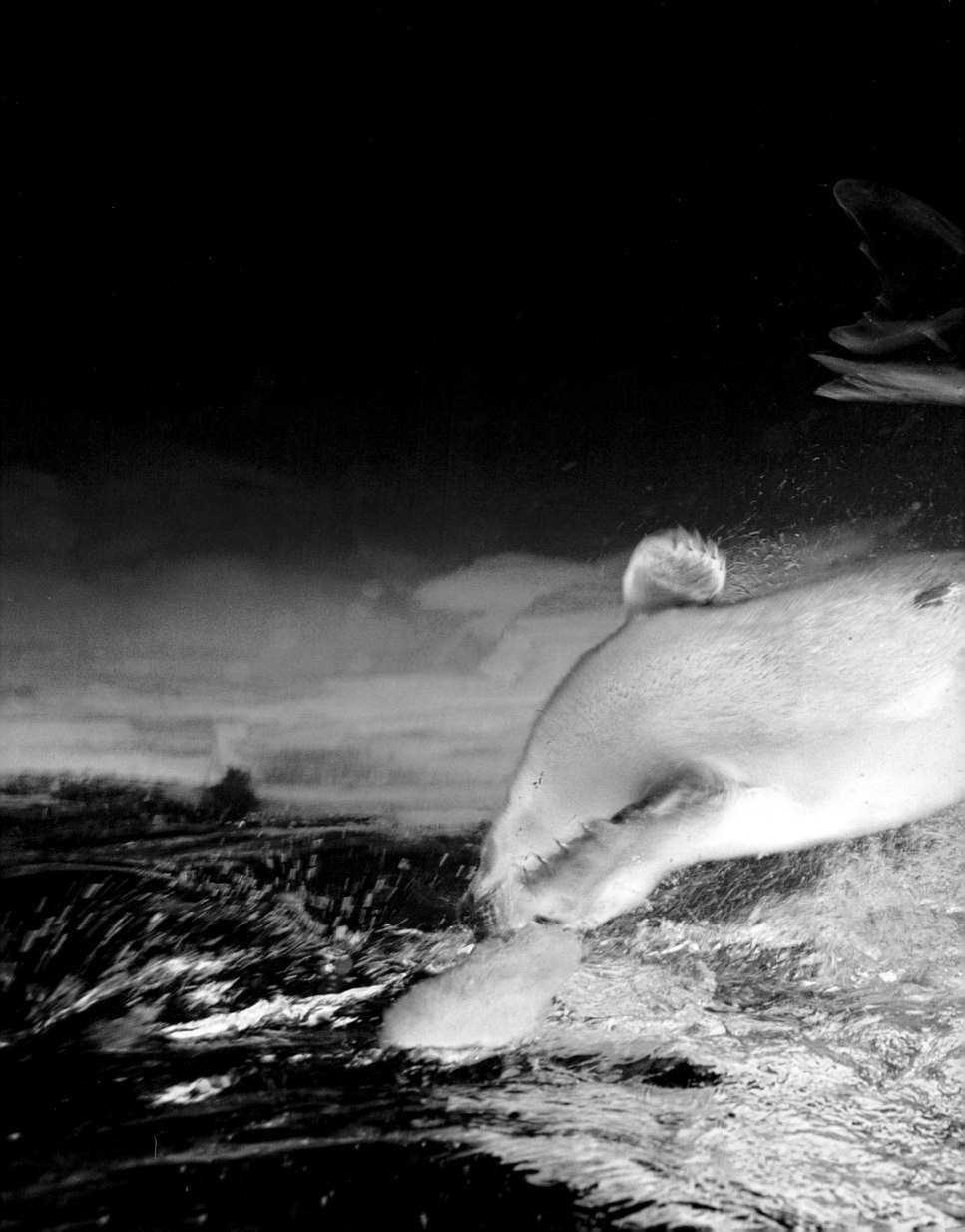

THE END OF THE GREAT PREDATORS

Between 50 and 100 million sharks are killed each year. Often, they are caught by fishermen, their fins are cut off, and they are thrown back in the sea alive . . . where they slowly die. This massacre is being met with stunning indifference, if you consider that most of us would deem it unacceptable to cut off a cow's four legs without anesthetic, then to throw its still living body in a mass grave. Like fish in general, sharks do not howl when they suffer. Nor do they cry. But for those who can imagine their suffering, it is a terrible thought.

There is no denying that these are great predators, carnivores who can kill men. But this is also true of tigers and lions, among many others, and these two felines enjoy far greater public sympathy: Children have stuffed animals that look like them and cartoons feature them as heroes. As for sharks, they suffer from a horrible reputation—partially due, no doubt, to Steven Spielberg's film *Jaws* (1975). Yet lions are far more dangerous than sharks. Each year they kill about 250 people, while large fish only kill a dozen (twelve dead and seventy-five attacks in 2011, according to the International Shark Attack File, which is more than the previous years, with an average of 4.3 dead per year over the decade).

MACABRE LIST

No shark species is found on the list of the ten most dangerous animals for man. In this macabre and somewhat vague ranking, the human race's top enemy is . . . the mosquito. By transmitting various deadly diseases, such as malaria and dengue, mosquitoes are responsible for 2 million human deaths a year! They are followed by snakes, which kill close to 100,000 people a year; scorpions (5,000); crocodiles (2,000); elephants (500); bees; lions; rhinoceroses; jellyfish; and tigers. Sharks only appear eleventh in the ranking! On Wikipedia, one can even find this surprising, though hard to verify, figure: In the United States, ten deaths were attributed to sharks from 2001 to 2010, versus 263 caused by dog bites.

Despite their scary appearance, sharks are extremely vulnerable. They develop slowly, reproduce late, and females only have one or two pups per litter, after an often long gestation. Current catches are therefore exerting great pressure on the populations. A study by the International Union for Conservation of Nature (IUCN) showed that in 2009, 32 percent of high-seas sharks were threatened with extinction. Figures vary, as do situations: There are approximately 490 shark species, all very different, ranging from the whale shark, which can be up to 65 feet (20 meters) long and only feeds on krill, to the dwarf lanternshark (*Etmopterus perryi*), which is less than 8 inches (20 centimeters) long and lives in depths of 650 to 1,640 feet (200 to 500 meters), without mentioning skates, which are related to sharks. Additionally, the situation varies according to geographic zones: In the Mediterranean, for instance, 42 percent of species are threatened.

THREATENED PREDATORS

Overall, the number of sharks around the world has dropped by 70 percent to 80 percent in a few decades. Yet few species are still protected—probably because of their image problem,

OPPOSITE: **Shark caught in a fishing net, San Marco Island, Gulf of California, Mexico**
Between 50 and 100 million sharks are killed each year. Often, their fins are cut off by knife onboard ship, then the sharks are thrown back in the sea dead or dying. Many animal rights activists protest this practice.

490 SPECIES OF SHARKS FROM THE SMALLEST TO THE BIGGEST
There are about 490 species of sharks, of which only five are considered dangerous to man. Their size varies from a length of 8 inches (20 centimeters) (dwarf lanternshark) to 65 feet (20 meters) (whale shark). Most are predators, but some, such as the whale shark, feed on plankton by filtering seawater. Some are found in freshwater.

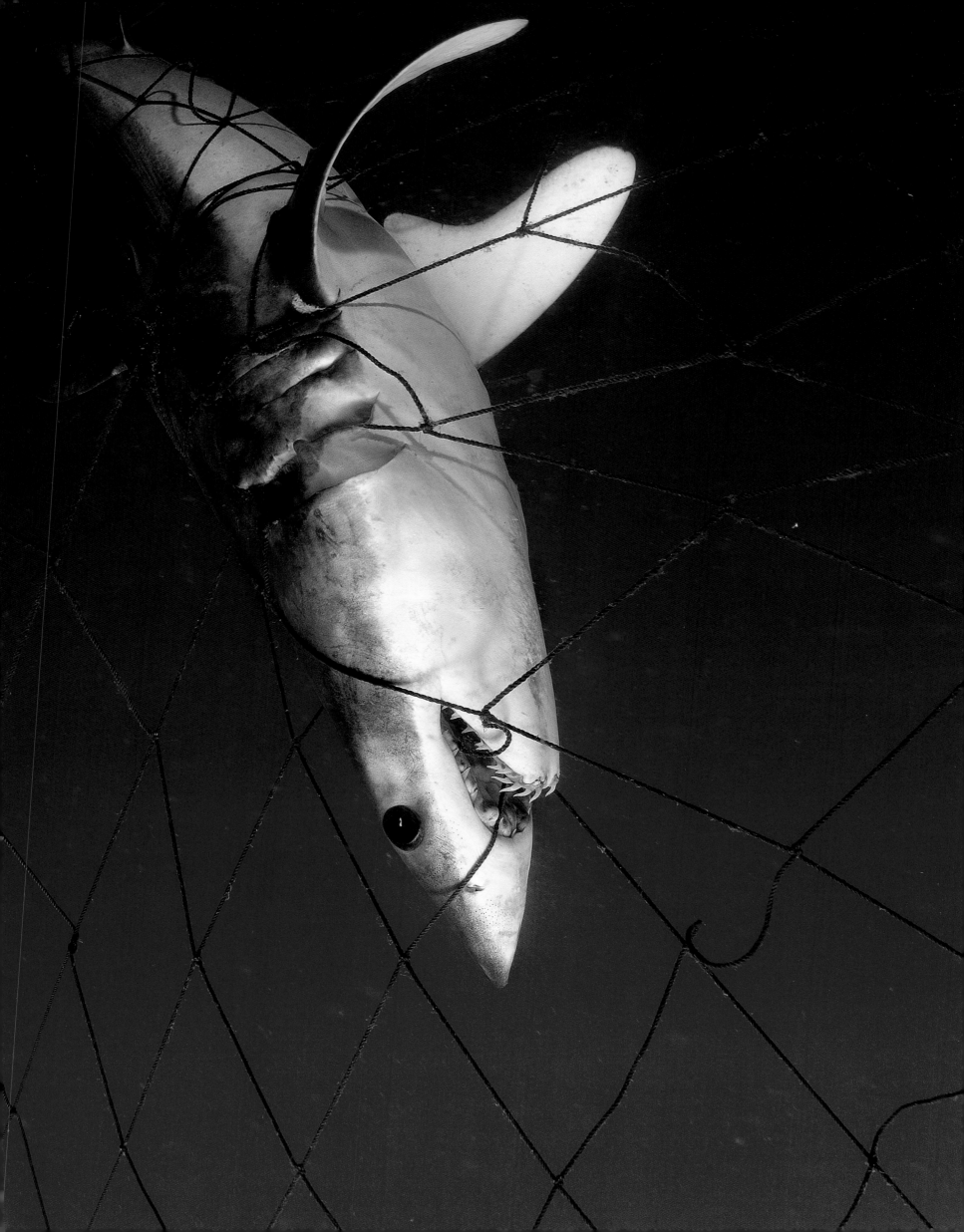

LEFT: Dead thresher sharks (*Alopias sp.*) on a beach on San Marco Island, Gulf of California, Mexico
Cutting off sharks' fins is considered cruel, for they are often hacked from living animals who are then thrown dying into the sea. To put an end to this practice, its opponents demand that fishermen be obliged to land sharks' entire bodies. Banned in Europe since 2003, finning continues by special exemption. Yet certain companies—including Chinese ones—have decided to stop selling shark products.

because the protection of animals is often based on their ability to arouse sympathy; in this regard, pandas and baby seals have a clear advantage over sharks.

Yet sharks play an essential role in ecosystems. Like all great predators, they regulate the balance between the various species positioned "beneath them" on the food chain. One of the most detailed studies on the subject looked at eleven species of large sharks on the East Coast of the United States. The drastic drop in their numbers (by 99 percent of sand tiger sharks and 98 percent of scalloped hammerheads) set off a chain of consequences that foreshadow what could happen elsewhere. The numbers of fish on which these sharks subsisted grew once they were rid of their predator. In turn, these fish feed on scallops, which were nearly all eaten, causing significant damage to the local shellfish industry. Other studies associated the presence of sharks with healthy corals, for similar reasons.

SHARK FIN SOUP

For many years, the principal danger threatening sharks was bycatch or "accidental capture." Sharks, which are not particularly sought-after by fishermen, were inadvertently caught in their nets, then often thrown back in the sea, though their skin has marginal use in the leather trade (shagreen) and their meat is sometimes eaten. In France, consumers generally don't know they are eating shark, which is served under different names such as *siki*, *roussette* (rock salmon), and *saumonette* (dogfish).

But today the danger comes from Asia and its craze for shark fin soup, a rather bland dish, apparently, but one that is highly prestigious. With constantly rising standards of living, hundreds of millions of people now want to taste and serve this soup. Demand is through the roof, prices are rising: Shark fins are being sold for several hundred dollars a piece on the Hong Kong market—which imports between 50 percent to 85 percent of the planet's fins. For fishermen, the fins alone are worth more than the entire shark, which explains why their carcasses are thrown directly back into the sea—a practice known as finning.

ASIAN MAFIAS

So what is to be done? In 2003, the European Union banned the practice of finning on boats. Plagued by numerous exceptions and gaps, this measure proved ineffective. Yet Europe is far from playing a marginal role. According to the FAO's official figures, Europeans fished 112,000 tons of shark in 2009. Spain is far in the lead. But France comes in second, with 19,498 tons of shark fished.

MARINELANDS

In 2011, the People for the Ethical Treatment of Animals (PETA) filed suit against several American marine animal parks, accusing them of slavery. Basing itself on the 13th Amendment of the American Constitution, which bans slavery, the organization wanted to obtain the liberation of killer whales kept captive and servile. In early 2012, the courts rejected the suit. Defenders of animal rights condemn this kind of amusement park because, like zoos, they keep wild animals locked up in cramped spaces and subject them to ill treatment. Additionally, cetaceans held in captivity are thought to have a reduced life expectancy. On the other hand, these parks' promoters argue that they play an important educational role, providing information and awareness to the general public. They also point to initiatives to treat, then free, marine mammals, despite ambivalent results. Keiko, the killer whale made famous by the film *Free Willy*, was released into its natural environment in 2002, following pressure from the general public. Sadly, Keiko's example showed that a killer whale that had lived in captivity would later have difficulty joining a wild pod and feeding itself autonomously. The famous killer whale died of pneumonia in 2003.

The issue of statistics is made extremely complex by widespread fraud. Fins are often imported, exported, reexported; sometimes they are not landed (i.e., sold) in the same port as the carcass. The market is therefore very opaque. A 2006 study of the Hong Kong market suggests that catches are three to four times greater than what is declared to the FAO. In fact, the Asian mafias that organize fin trafficking operate throughout the entire world. In 2006, the film *Sharkwater* (see interviews with Rob Stewart and Paul Watson, pages 190 and 286) revealed the extent and power of this mafia in Costa Rica—a country celebrated for its respect for the environment!

METHODS OF PROTECTION

Two options to protect sharks are currently under consideration: restricting fishing through various means of control and reducing demand by informing the Chinese public of the extent of the disaster. These steps are promoted by a growing nonprofit movement that has recently met with some success.

Several protected zones have been created in Central America and the Pacific: in Colombia, Venezuela, Honduras, the Maldives, and Micronesia, among others. In 2009, Palau created the first shark sanctuary—which is the size of France. A law banning finning was passed in the United States in 2011.

In November 2011, the European Commission approved a law requiring European ships to exclusively land sharks that still have their fins, completing the 2003 law. But the law must still be approved by the European Council of Ministers and the Parliament.

THE CHINESE GOVERNMENT INTERVENES

In China, various initiatives have been launched, and several organizations are campaigning in favor of sharks and against shark fin soup. Restaurants and supermarkets

85 PERCENT OF SHARK FINS PASS THROUGH HONG KONG

The Hong Kong market imports between 50 percent and 85 percent of shark fins in the world, then have them sent to continental China and the rest of Asia. But due to trafficking, it is believed that catches are three to four times greater than what is declared.

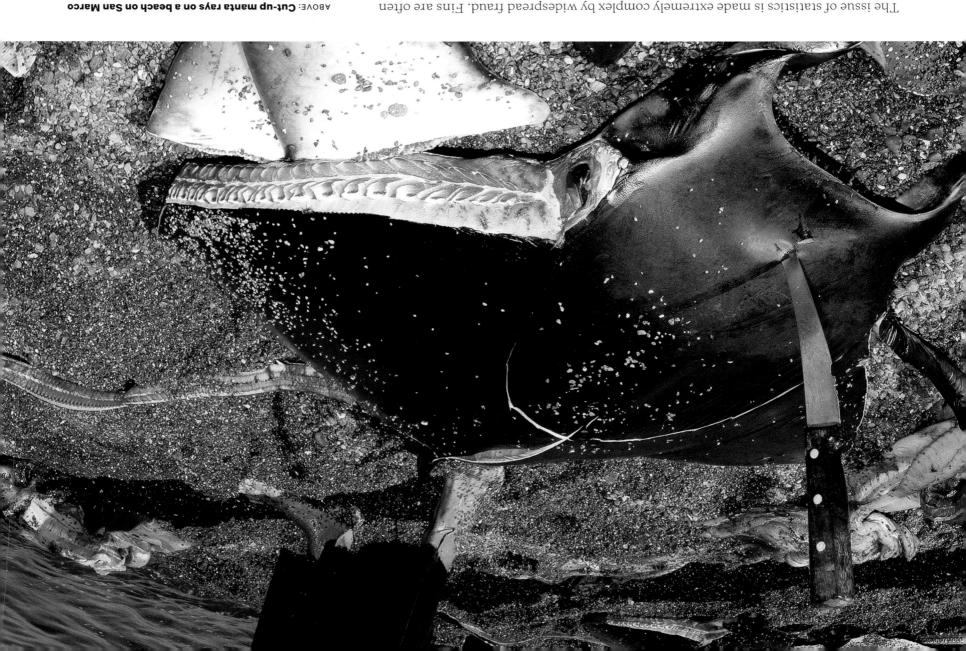

ABOVE: Cut-up manta rays on a beach on San Marco Island, Gulf of California, Mexico

The Mexican island of San Marco, located off of Baja California Sur, has a population of less than one thousand. In certain areas of Mexico, shark catches can account for up to 6 percent of fishermen's captures. Manta rays are increasingly sought after by poachers because their meat and skin are in ever-growing demand on the Asian market. Their gills are turned into powder used in certain traditional medicines.

LEFT, TOP: Mako (*Isurus oxyrinchus*) shark fins sold at a market on the island of San Marcos, Gulf of California, Mexico
The great predators are often killed for their fins, in the same manner that rhinos are killed for their horns. Shark fin soup is a delicacy in Asia, where rising standards of living have led to increased demand for this product from the sea.

LEFT, BOTTOM: Dead thresher shark (*Alopias sp.*) stuck in a net trap, Mexico
Net traps extend vertically from the ground, held in place by anchors or weights and floats on the surface. Large marine animals, such as turtles and sharks, are collateral victims of this fishing method.

have taken the dish off their menus and shelves. In July 2012, the Chinese government announced that it wanted to remove shark fin soup from the menu for official banquets. While this news is of major significance, the conditions for applying the decision remain to be specified. International mobilization is finally bearing fruit, though the situation remains extremely worrisome. This mobilization will need to gain even more momentum to be up to the challenge at hand.

OPPOSITE: Caribbean reef shark (*Carcharhinus perezii*) swimming through a school of fish, Bahamas
The reef shark lives in the reefs of the West Atlantic. This predator at the top of the oceanic food chain principally feeds on bony fish, cephalopods, and octopuses. On average, the reef shark is 8 feet (2.5 meters) long and weighs under 155 pounds. Some shark species can eat up to 10 percent of their body weight per week.

For more information on this subject and a relevant excerpt from the film *Planet Ocean*, go to http://ocean.goodplanet.org/requins-en-danger/?lang=en

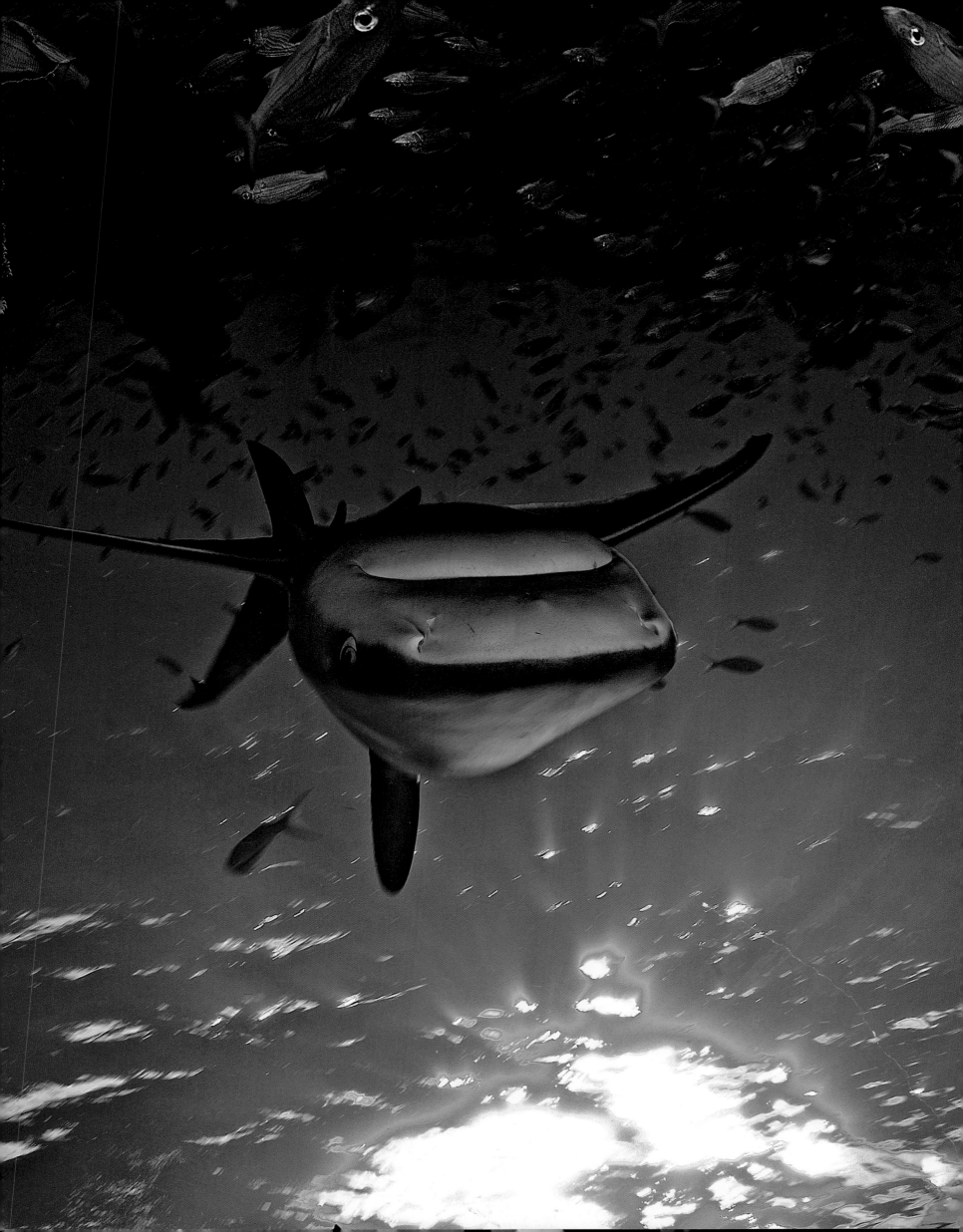

WE NEED WARRIORS AND HEROES

INTERVIEW WITH ROB STEWART

ROB STEWART, an underwater photographer, biologist, and director, is a lover of sharks. In 2006, he directed the film *Sharkwater* in order to deconstruct the myth of the man-eating shark.

Your film shows you holding a 6-foot [2-meter] shark in your arms. Isn't that dangerous?

No, not at all. But you need to know how to do it; you can't grab a shark any old way. In fact, there's a trick to it. Sharks have a sixth sense, electroreception. They can detect magnetic fields with sensors under their snouts, which enables them to head straight for their prey. If you pet them there, they freeze and you can do just about whatever you want with them. This is what is called a state of tonic immobility. You also shouldn't act afraid of them; you have to remain as calm as possible in order not to frighten them and to let them gradually get closer to you.

You mean that sharks are afraid of man rather than the opposite?

All the conditions are in place to stoke the fear of sharks. They live in the depths of the ocean in still largely unknown areas, which feeds people's imaginations and makes it easy for myths to spring up. Then you have the media who sell more papers if they headline "Another Shark Attack!" and promote a negative image of sharks. And of course there are movies like *Jaws*, which came out at a time when we knew next to nothing about sharks and contributed to their reputation as killers and man-eaters. But sharks don't eat any more humans than I do. Victims of shark attacks die from hemorrhaging, not because they've been devoured alive. Every year millions of people swim in waters where sharks hunt. If they really wanted to eat us, they would do it without any difficulty. The problem is that since sharks are scared of man, the only interactions we have with them are attacks. Dolphins have a much friendlier image because they are playful; they get close to boats and leap out of the water. Yet they can be just as dangerous, though they do not bite.

Did you make *Sharkwater* to take apart this man-eater image?

Yes. At first, I wanted to give people a different view of the shark than what they see in the media. Seeing a shark underwater is a truly unforgettable experience, and people who are scared of sharks change their minds once they've seen them underwater, because these animals are incredibly beautiful and display ultrasophisticated behavior—for example, their sixth sense, electroreception, allows them to get their bearings when visibility is limited. They are one of the last species to have this sense, which was first found in vertebrates' common ancestor 500 million years ago. Sharks have been present on earth for more than 400 million years. They have survived five major extinction crises and have seen life reborn on earth. Sharks are the "last dragons," the "last dinosaurs."

> "Do you want your children to be able to live on this planet? Then stand up and get involved!"

Is *Sharkwater* a way of alerting people about shark massacres?

Exactly. Each year, between 50 and 100 million sharks are killed, notably for their fins. Every day, between seven thousand and ten thousand sharks are landed in vast hangars in the port of Kesennuma, Japan, where employees cut off their fins. But most of the time, fins are cut off directly on board ships and the rest of the body is immediately thrown back into the sea. Over the last decades, shark populations have been decimated this way. Sharks are at the top of the food chain. Among the great marine predators, they are the ones with the most varied prey, and their disappearance could lead to severe unbalances within ecosystems.

How was your film received? What was its impact?

Sharkwater was very well-received at the box office, but the most important thing for me is that it got things moving. For example, early in 2011, the governor of the island of Saipan, in the Mariana Islands, banned the shark fin trade after a primary school class, which had seen the film, wrote to him and asked him to protect sharks. More generally, over the last five years, many states—Hawaii, Guam, Oregon, the Marshall Islands, Maryland, and other American states—have banned finning and/or banned shark fin soup because people have rallied after seeing the film. Ways of thinking are evolving, not as quickly as we might have hoped, but this is already an initial victory. *Sharkwater* showed me what man can do when he knows what is happening. That's why I've decided to go further now, with a new film called *Revolution*, and I hope it will have the same effect.

What is this new film about?

It's a film about man's survival on earth in the face of the destruction of ecosystems. We are currently going through a major environmental crisis, and no one knows how we will come out of this century. To have any hope, we need everything to change, and to do that we need massive mobilization, what I call a "revolution," similar to the one that led to the end of slavery or brought civil rights to African Americans. All the ingredients are in place for such a revolution: We are in a critical situation, people know something is wrong, that there is more and more injustice and inequality, and that it is time for all that to change.

What do we need to do for this revolution to take place?

We have to gather together, get beyond the stage of individual actions, and find a new way of living. Telling people "You have to walk to go to work, consume less, become a vegetarian, etc." won't be enough. We have to shift into high gear. We are the pivotal generation. Do you want your children to be able to live on this planet? Then stand up and get involved!

Red snapper (*Lutjanus campechanus*), Kingman Reef, United States

The red snapper has become a sought-after and expensive fishing resource, particularly in the Gulf of Mexico. Since the 1990s, red snapper stocks have been subjected to a great deal of pressure from sports fishermen and half of catches can be attributed to this activity. A victim of this intentional fishing, the snapper is also a collateral victim of shrimp fishing. Snapper fishing quotas therefore had to be lowered in order to preserve stocks. Juvenile red snapper were also recently released close to artificial reefs in order to supplement the populations already present.

Waste from a seawater desalination plant in Al Doha, near Al Jahra, Persian Gulf, Kuwait (29°21' N, 47°49' E)

Kuwait meets 75 percent of its water requirements by desalinating seawater. After being treated through instantaneous thermal distillation (flash system), water unfit for consumption is released into the sea where it mixes with the waters of the Persian Gulf like a monster with multiple tentacles. Every day the earth's seas provide 706 cubic feet (20 million cubic meters) of freshwater (or about one percent of the freshwater consumed around the world), thanks to 12,500 desalination units spread across 120 countries.

Pacific electric ray (*Torpedo californica*) in a kelp forest, Cortes Banks, California, United States

Kelp forests are ideal habitats for Pacific electric rays. These ecosystems are genuine marine forests composed of algae, the biggest of which, *Macrocystis*, can be up to 150 feet (45 meters) tall. These algae provide shelter and food to the species that develop there.

Ship graveyard at Kerhervy, Lanester, Morbihan, France (47°45' N, 3°20' W)

Several dozen decommissioned boats lie in the marine graveyard at Kerhervy. The oldest are the tuna boats of Groix Island, which have been inexorably sinking into the cove's silt since 1920. Ships over fifteen years old make up 40 percent of the global fleet, but account for 80 percent of accidental shipwrecks.

Guitarfish (*Rhinobatos sp.*), rays, and other fish species thrown from a shrimp boat, La Paz, Baja California Sur, Mexico

Shrimp fishing is the least selective type of fishing. It is singly responsible for half the incidental catches in the world. A 2010 study carried out in Senegal's exclusive economic zone revealed that shrimp boats discard a large amount of crustaceans, fish, and mollusks of all sizes. The percentage of incidental catches in the nets was at 70 percent during the day and up to 99 percent at night! This type of fishing technique destroys ecosystems and is deeply wasteful.

Cape fur seals (*Arctocephalus pusillus*) on a rock near Duiker Island, Cape Province, South Africa (34°03' S, 18°19' E)

Gregarious Cape fur seals gather in colonies along the coasts to couple and give birth. These semiaquatic mammals spend most of their time in coastal waters looking for food: fish, squid, crustaceans. Though categorized in appendix two of the Convention on International Trade in Endangered Species of Wild Fauna and Flora, which is intended to limit international trade of threatened species, seals are commercially hunted in Namibia.

A leatherback sea turtle (*Dermochelys coriacea*) lays its eggs on Matura Beach, Trinidad, Trinidad and Tobago

During nesting periods (from March to July in the Atlantic Ocean and September to March in the Pacific), leatherback sea turtles come out of the water to lay eggs on beaches. Plage des Hattes in Guyana is considered the most important site for leatherback turtles to lay their eggs. At nightfall, turtles dig a hole in which they lay about one hundred eggs. Scientists estimate that on average just one of these eggs will reach maturity.

Blacktip reef sharks (*Carcharhinus melanopterus*), lagoon of Millennium Atoll, Line Islands, Republic of Kiribati

The former Caroline Island was renamed Millennium Island in 1999, shortly before the beginning of the year 2000. Since the 1994 realignment of the most westerly time zone, UTC+14, and the readjustment of the international date line to the Kiribati area, the island became the first point on earth—with the exception of the poles—where the new day begins. The exceptional celebrations that took place here for the millennium changeover led to the atoll's new name. The island has extremely well-protected reefs.

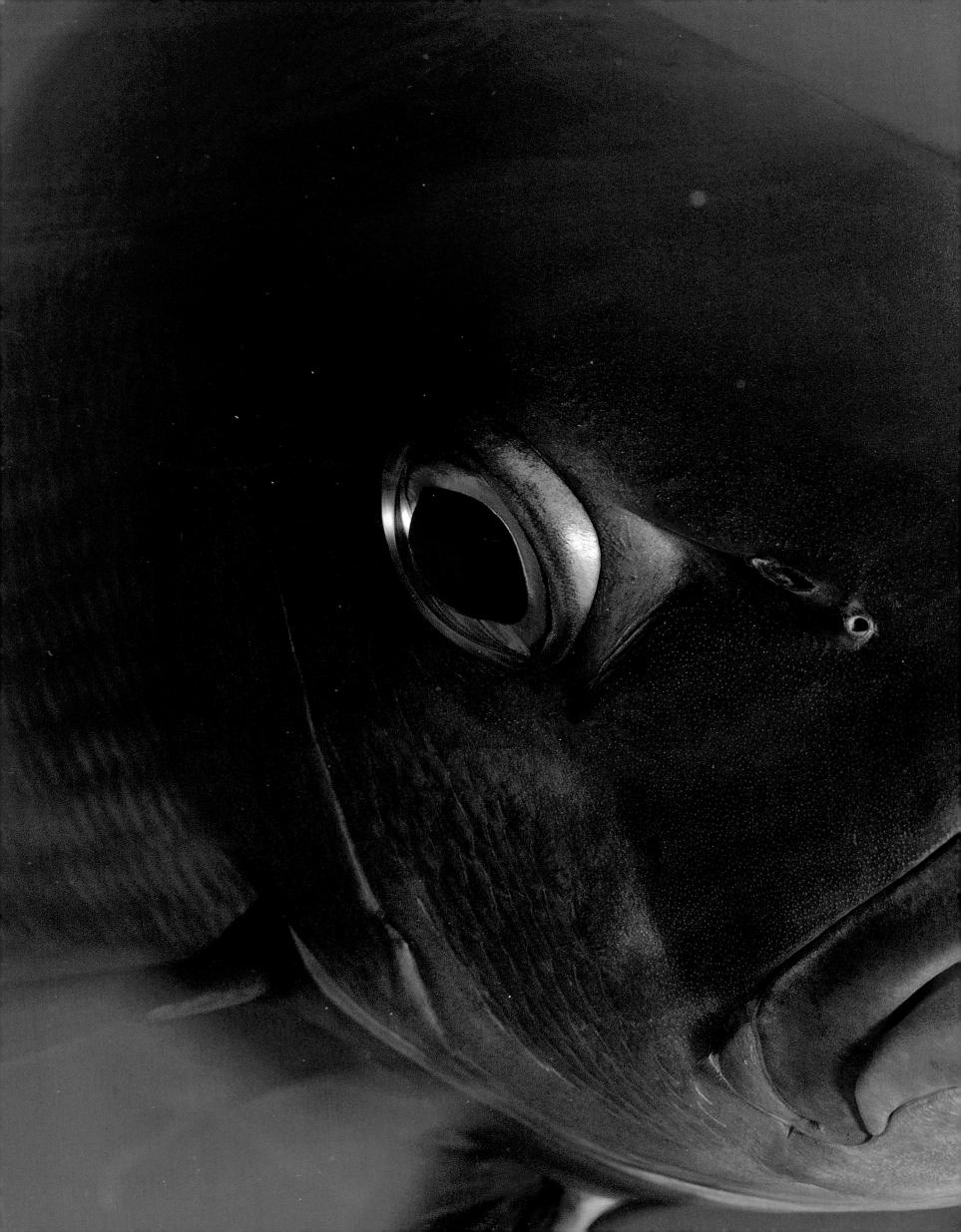

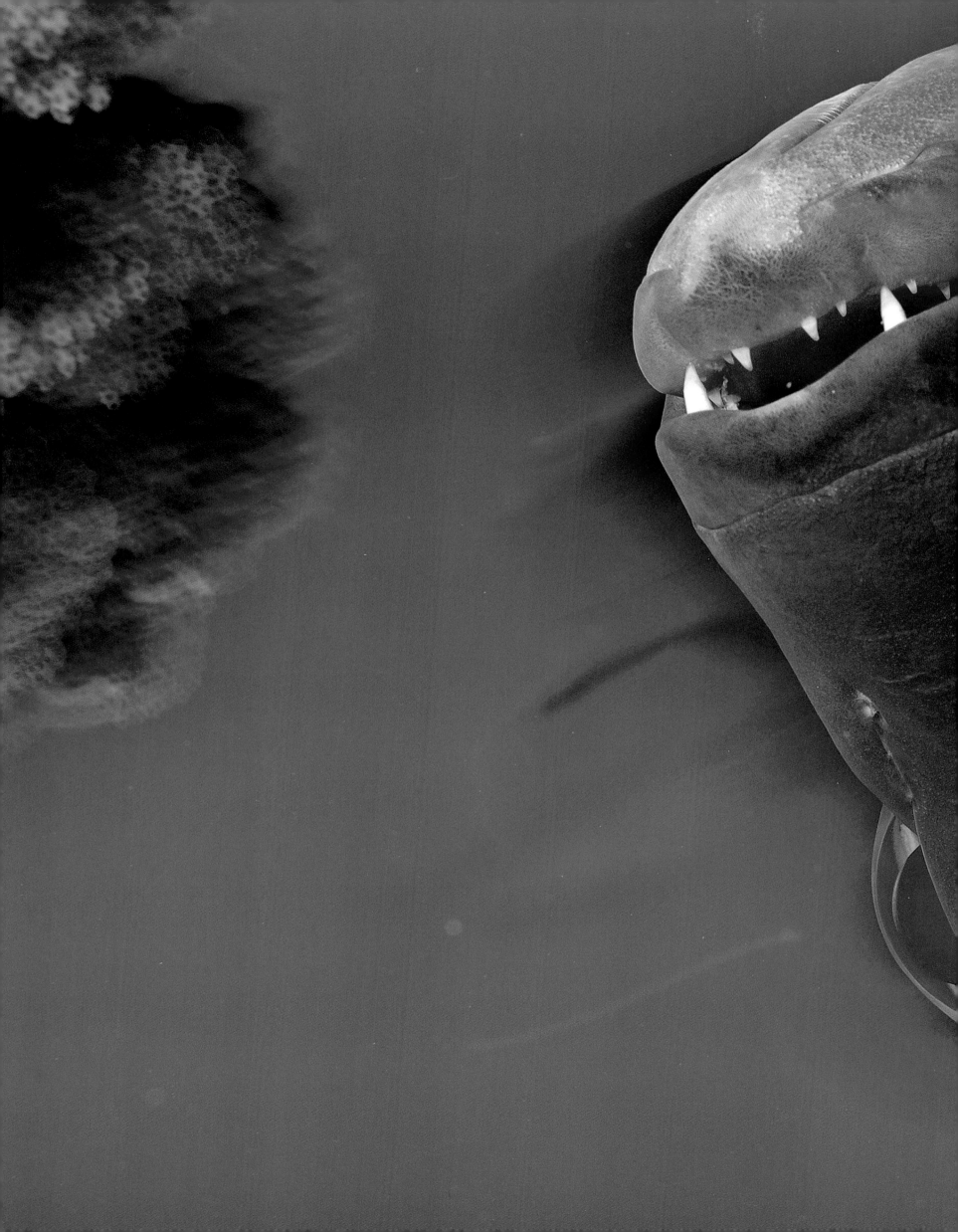

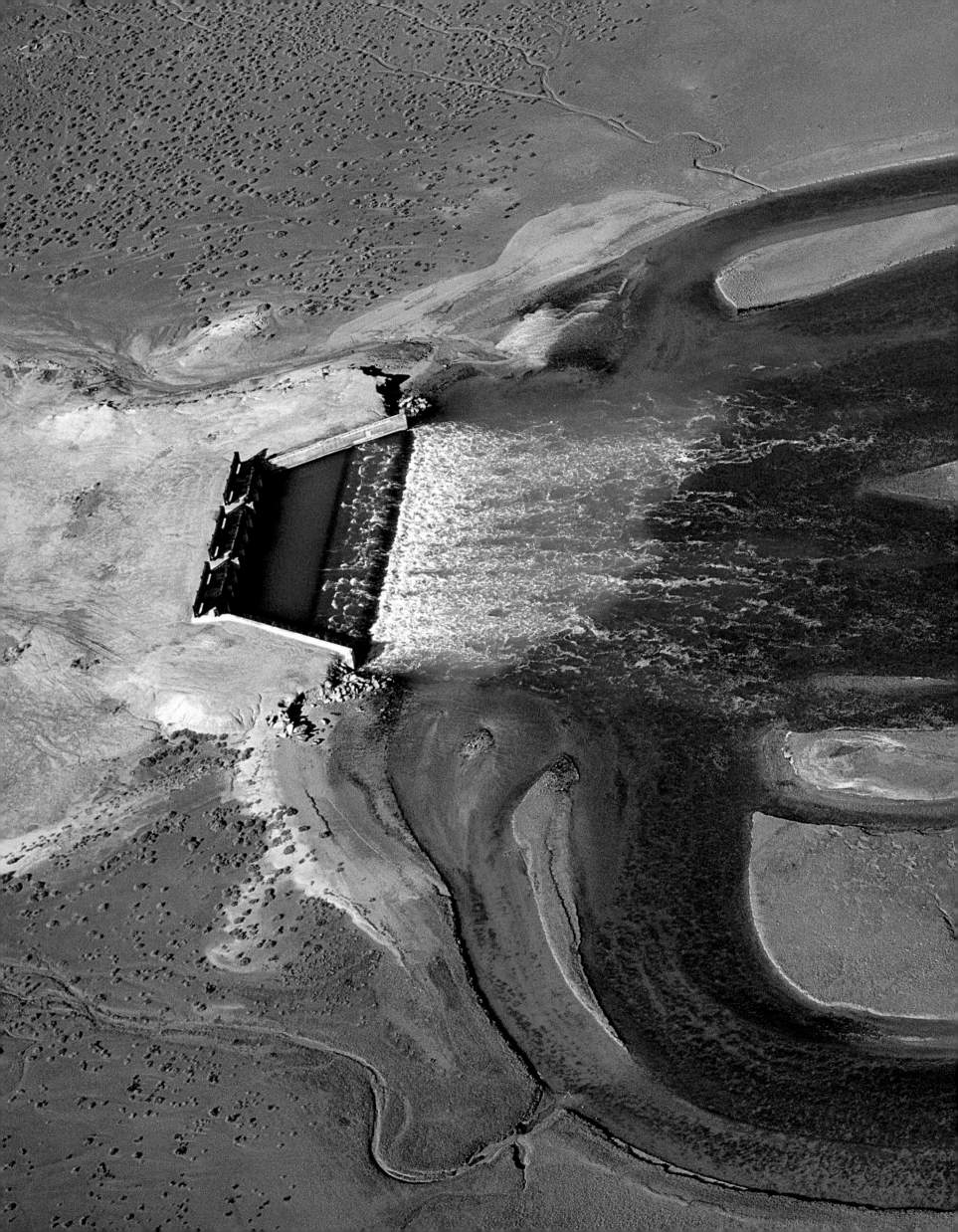

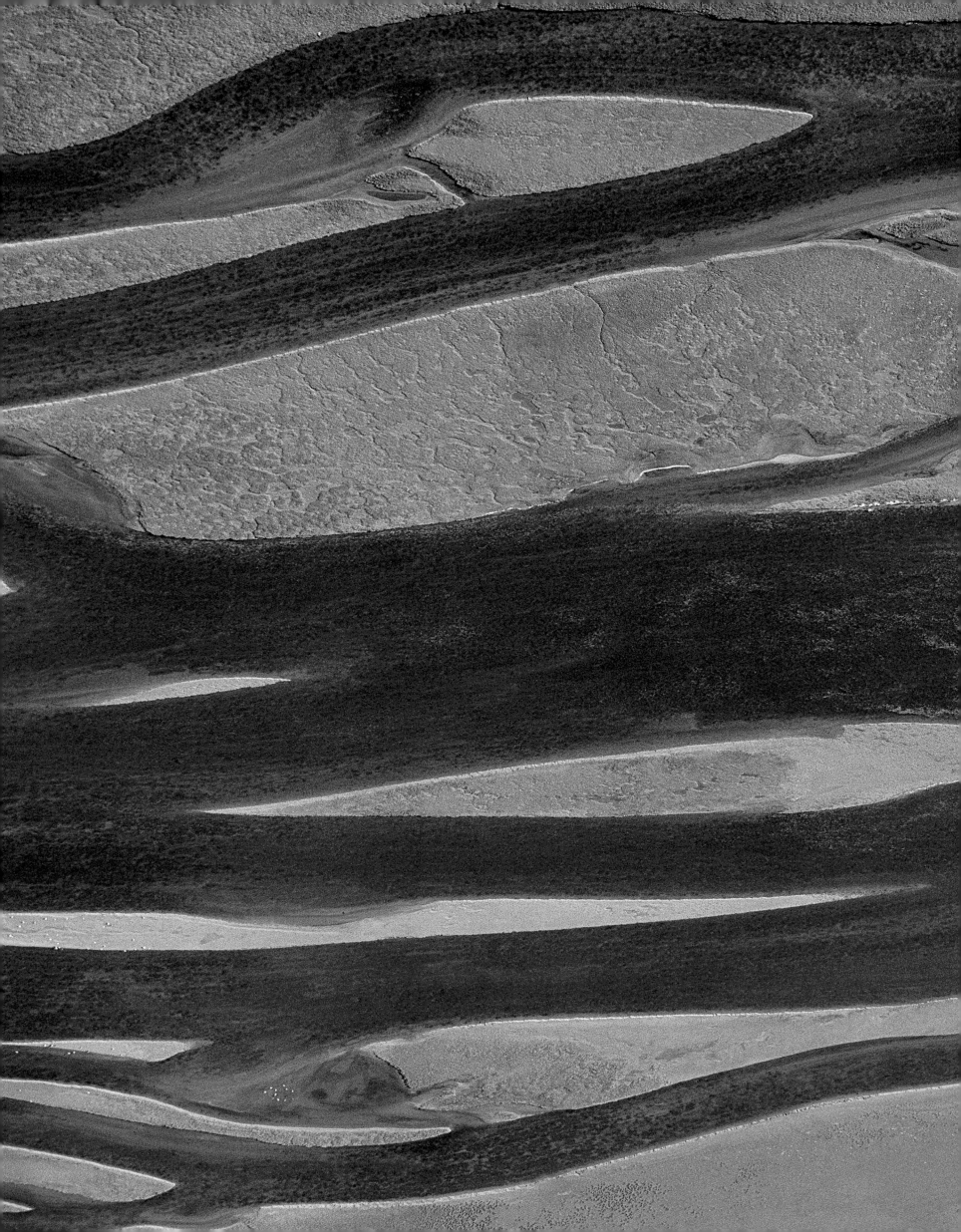

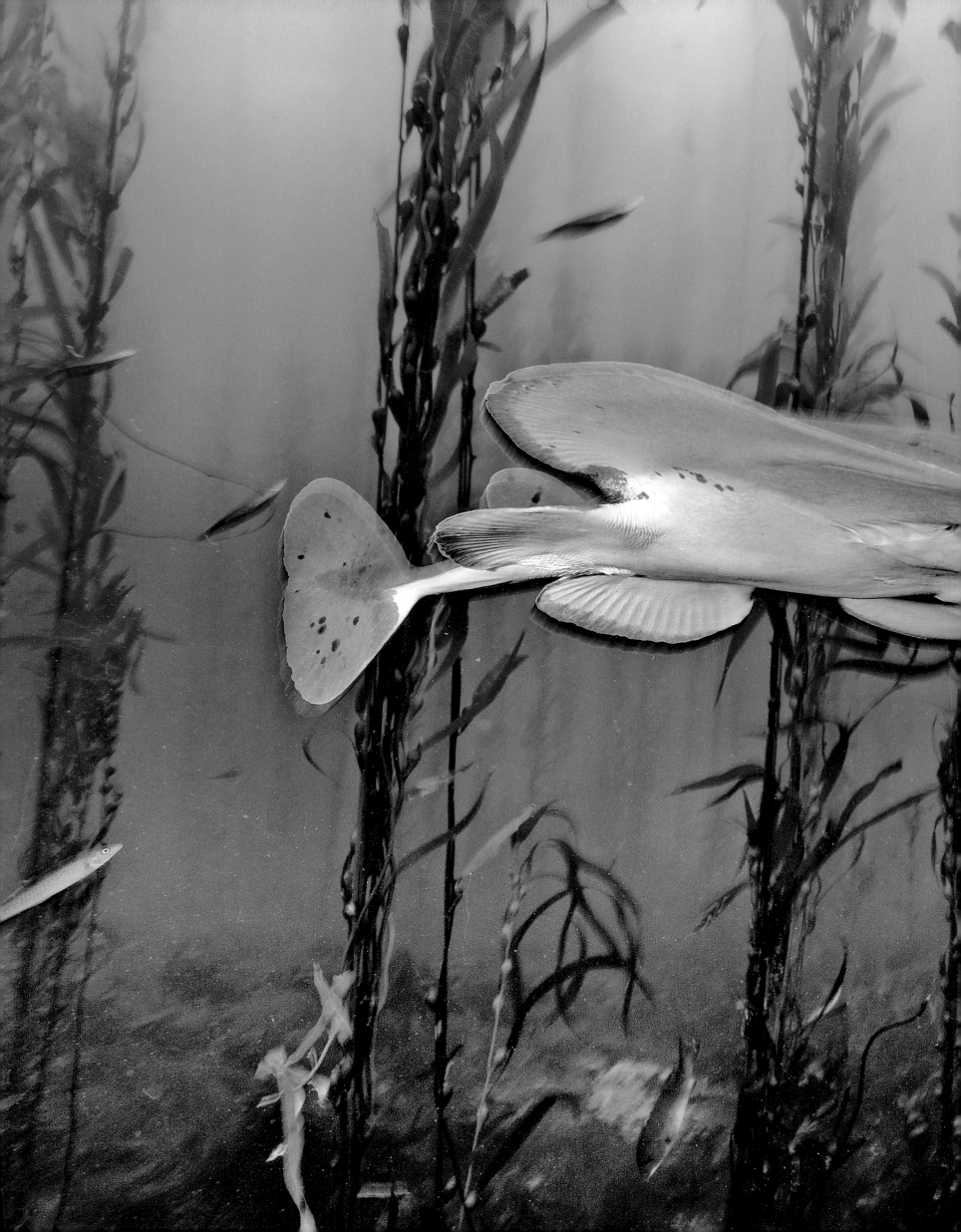

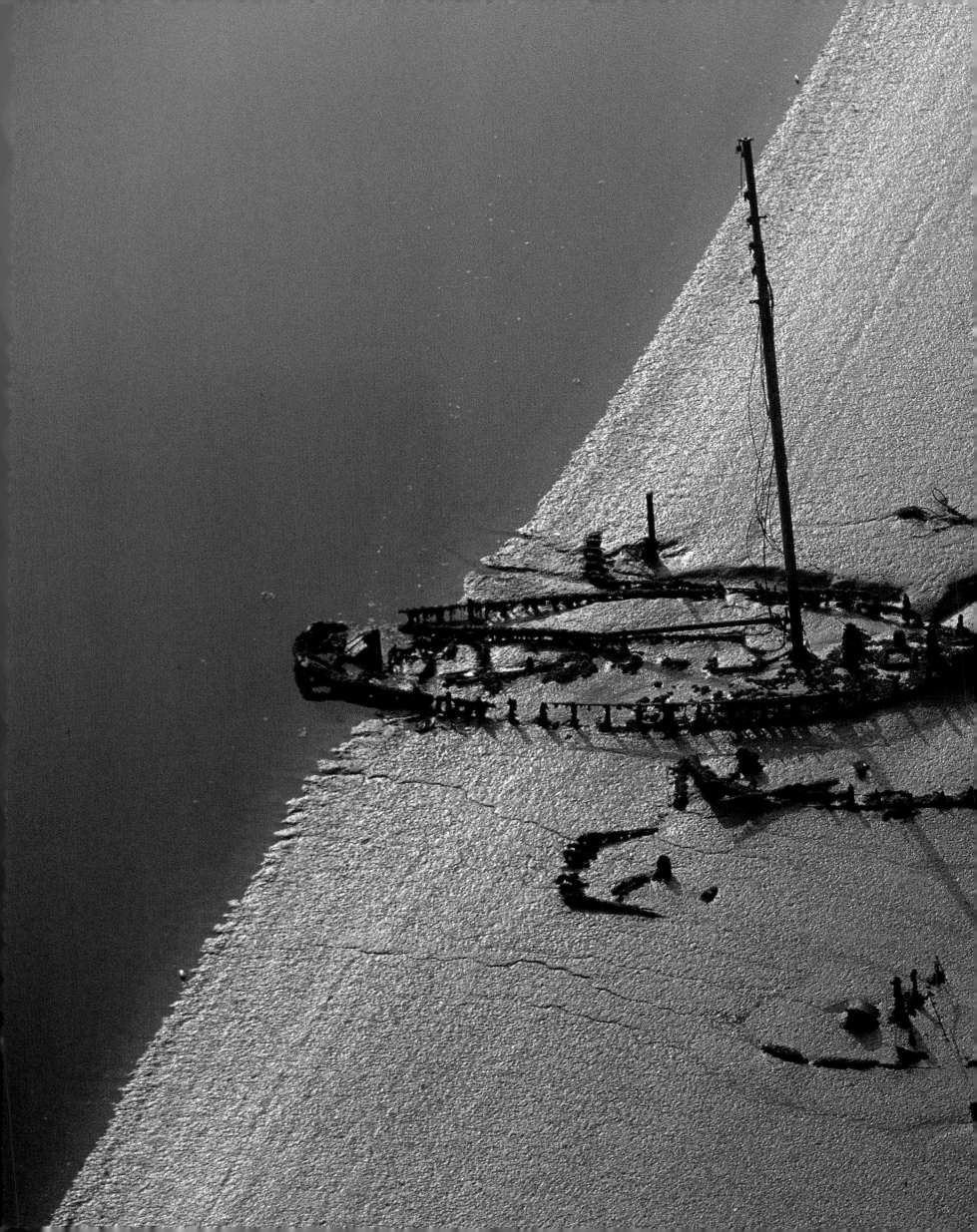

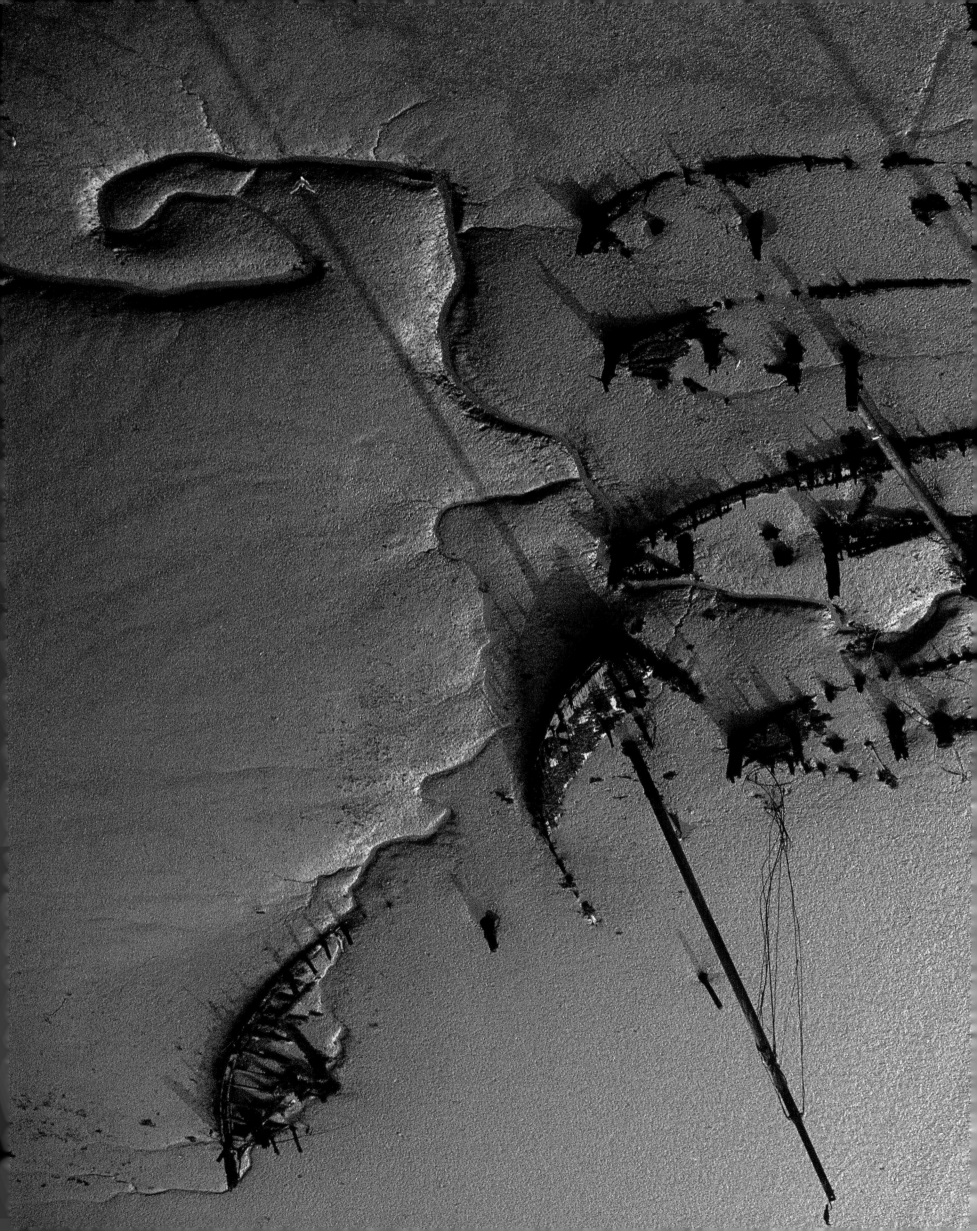

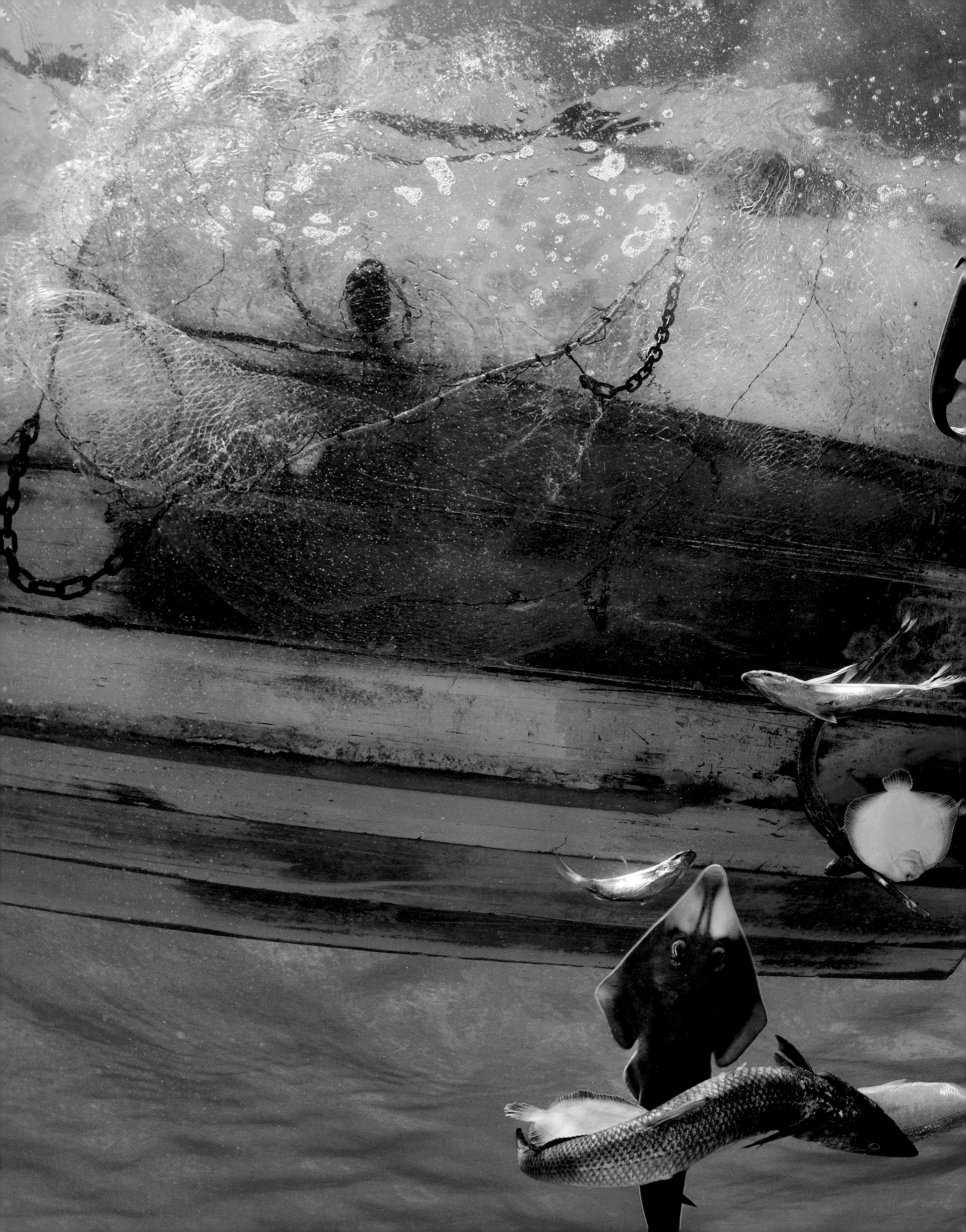

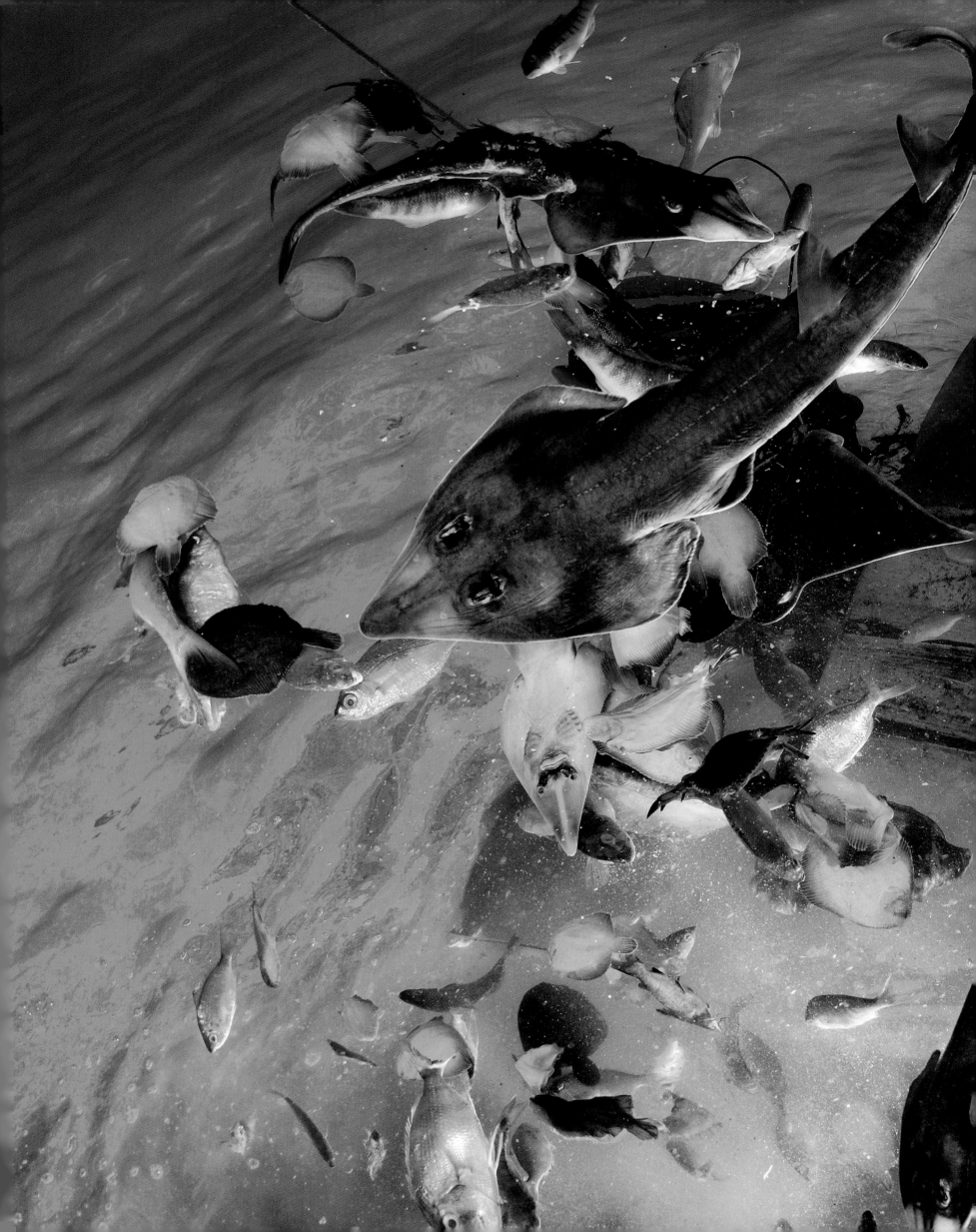

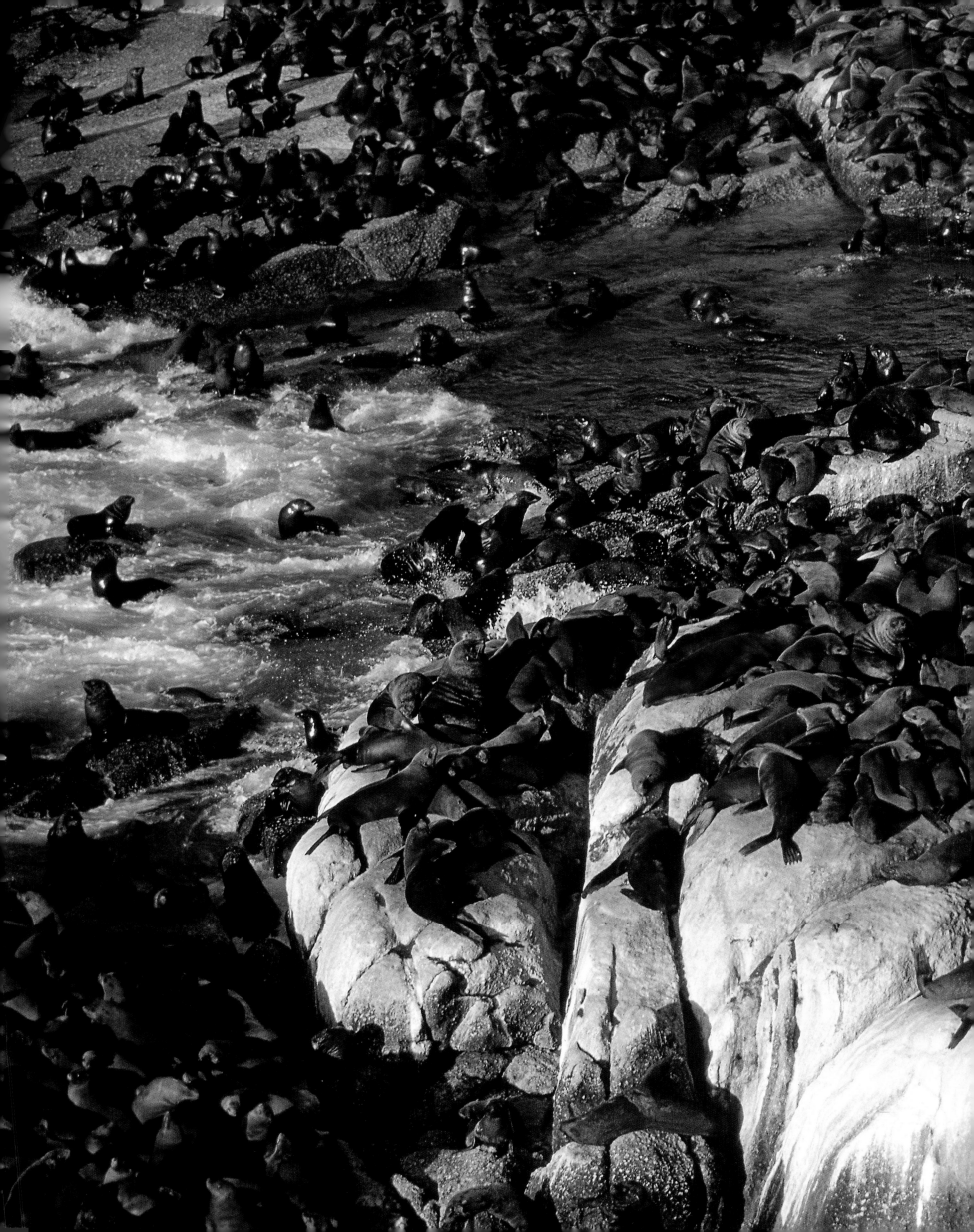

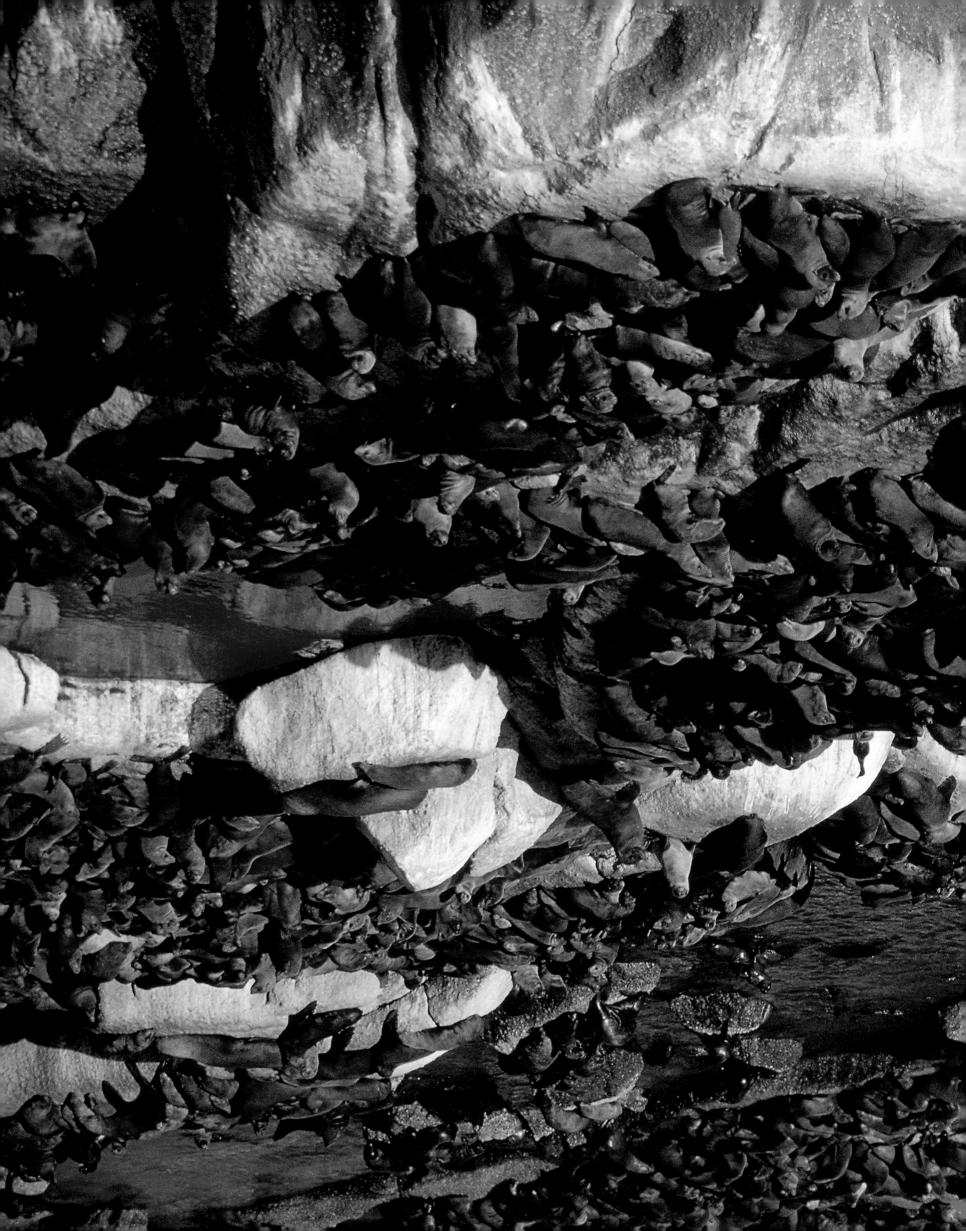

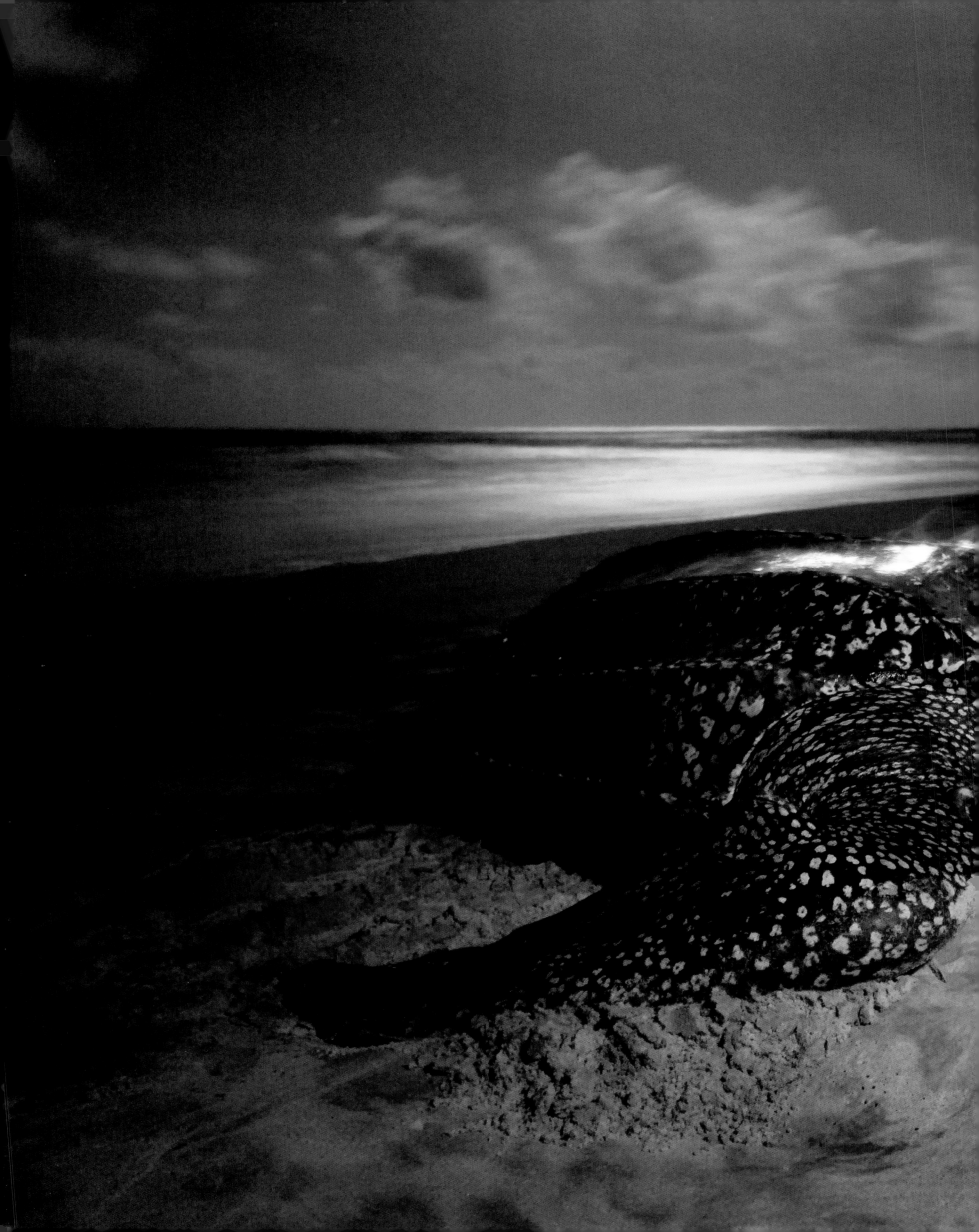

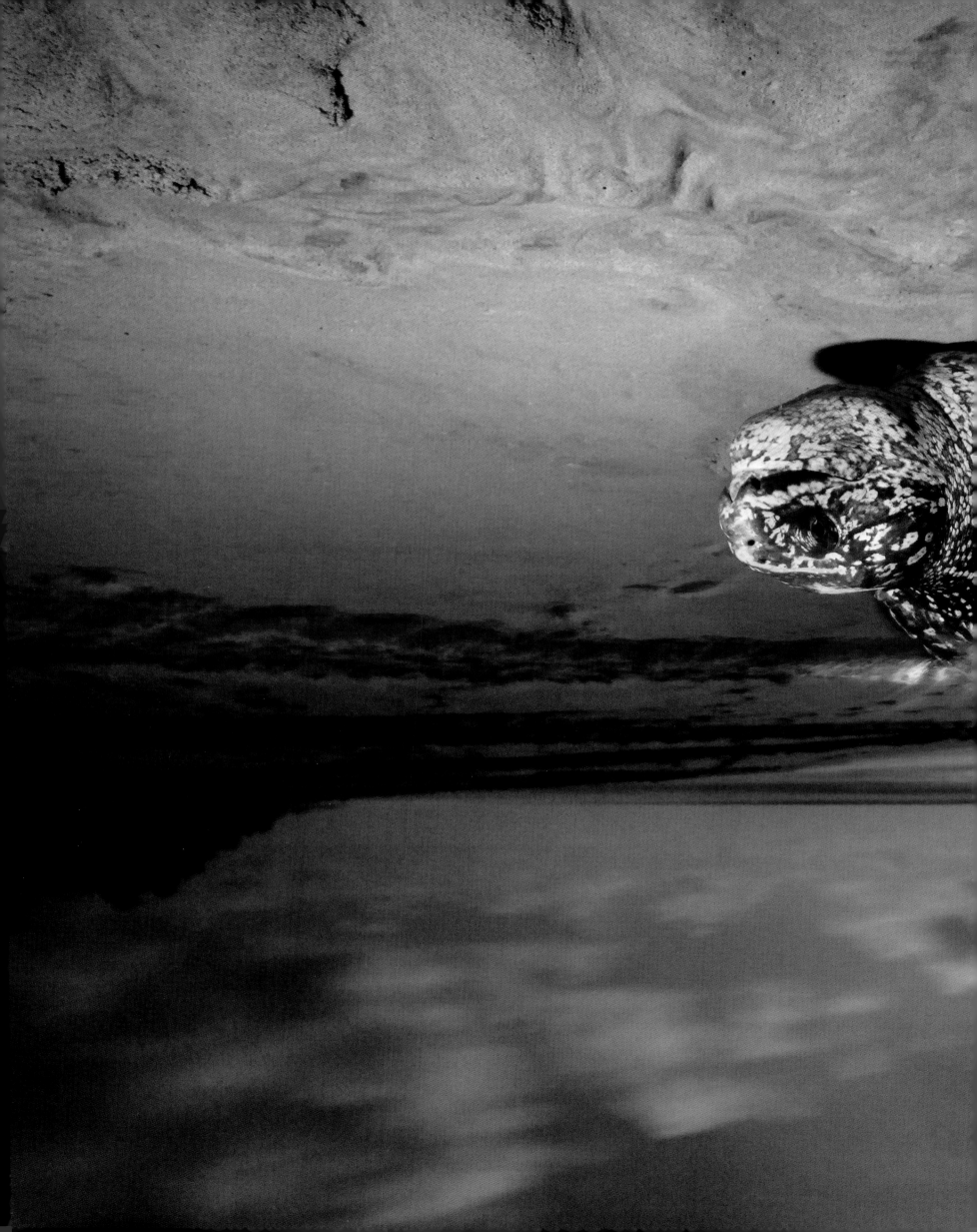

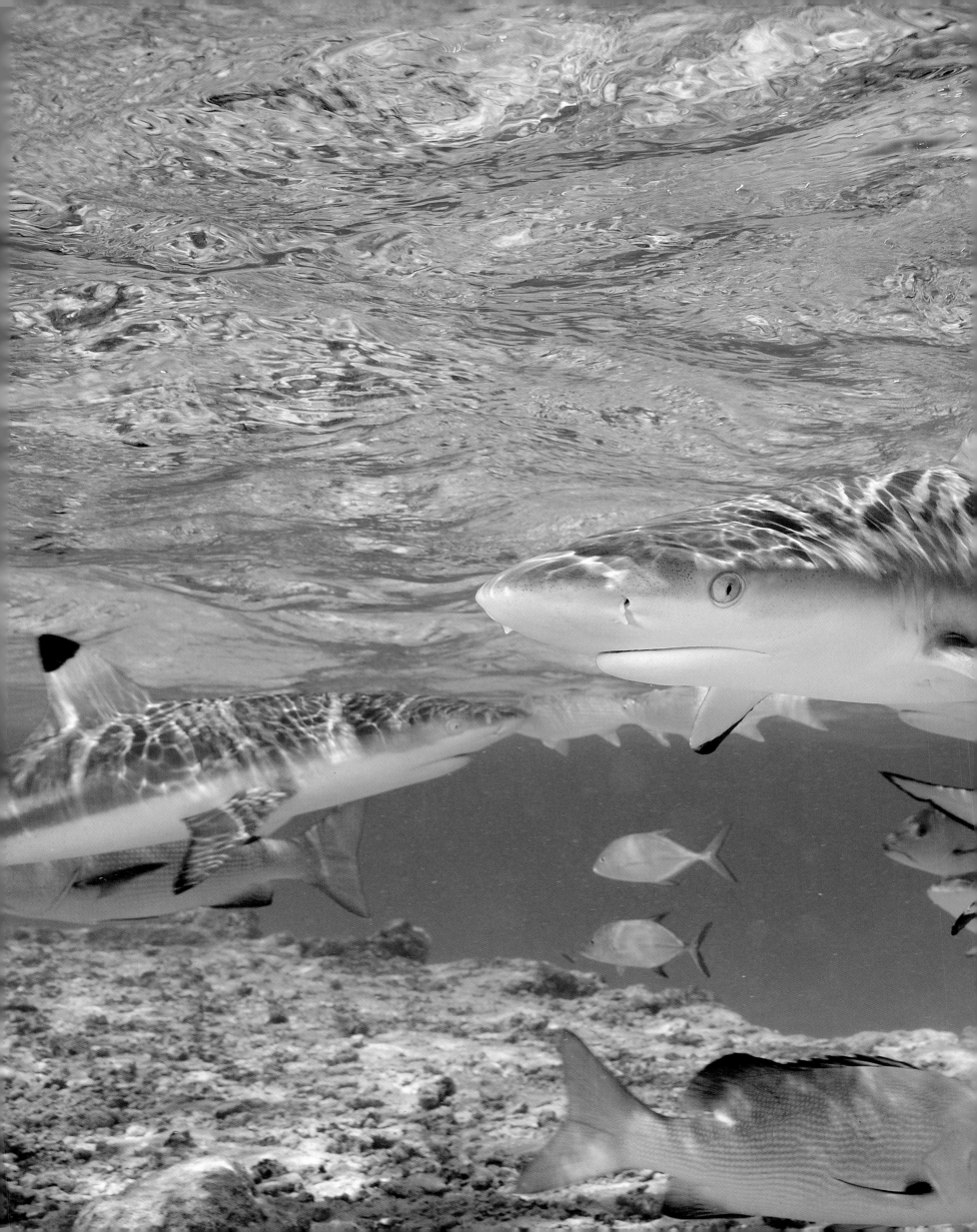

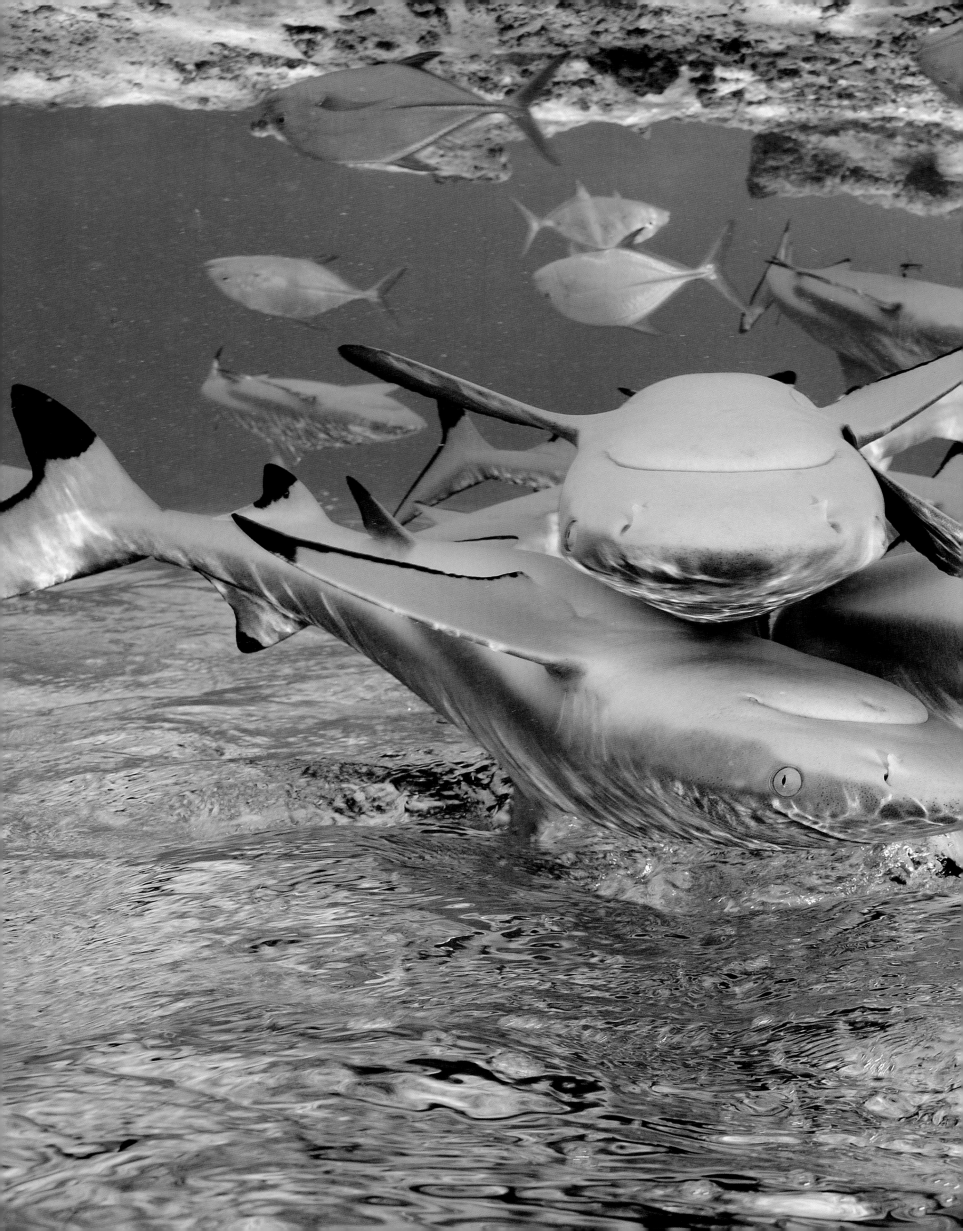

GLOBAL HIGHWAYS

ontrary to what many believe, maritime transport has never been replaced by more rapid or "modern" aerial transport. To this day, maritime traffic still accounts for close to 90 percent of international commercial exchanges. It has even considerably increased, following the upward curve of trade and the spread of globalization. In 1950, 500 million tons of merchandise were traded by sea; today, 8 billion tons of merchandise are carried over the oceans every year. Each day, close to fifty thousand ships follow international routes, which are like highways of the seas made up of straits, ports, and canals.

In fact, only the number of people traveling by sea has declined. For centuries, ships were the only way to cross the oceans, and they carried pilgrims, immigrants, and slaves. Today they are only used for short distances—inlets, coastal islands, and archipelagos—or by the poorest refugees and clandestine migrants. Leisure shipping remains strong, thanks to cruises, a booming sector with several million people a year boarding one of the five hundred ships operating around the world.

THE CONTAINER REVOLUTION

In the 1960s, maritime merchandise transport underwent a revolution through the invention of the container, which considerably simplified the manipulation and storage of merchandise, while keeping it protected. In 2010, 12 million containers were sailing the world's seas. A new class of ship, the container ship, was introduced. One of the biggest of these ships—the 1,302-foot-long (369-meter-long) *Emma Mærsk*—was launched in 2006, and travels between Asia and Europe, carrying more than eleven thousand of these large crates per trip.

Maritime freight allows for the transport of merchandise from one end of the planet to the other at low cost, making it less expensive to import manufactured goods than to make them. One notable consequence of this form of globalization has been the deindustrialization of the West. The asymmetric nature of commercial exchanges means that close to 50 percent of containers from Asia are transported empty from Europe and the United States.

But not all merchandise is transported in containers. Some is placed directly in the hold of specialized boats: minerals, grains, liquids, gas, etc. The comings and goings of tankers (designed to transport liquid combustibles) account for about 35 percent of global maritime transport.

WHAT IS THE ENVIRONMENTAL IMPACT OF MARITIME TRANSPORT?

Whether they run aground or sink at sea, tankers are responsible for oil spills, which are among the most tragic, widely publicized maritime pollutions. Yet these shipwrecks have diminished, thanks to advances made in ship security (such as the gradual enforcement of double hulls), as well as inspections and procedures decreed by the MARPOL international convention, ratified by over one hundred countries. National regulations,

OPPOSITE: **Wreck of the *Eduard Bohlen* on Skeleton Coast, Namibia** (23°59' S, 14°27' E)
The Benguela Current from the Antarctic runs along the coast of Namibia, which is a mix of beaches, reefs, and shallows. It is responsible for the Namib Desert's aridity, but also a strong swell, violent currents, and a thick fog that hides the shore. The Namibian coast is much dreaded by navigators cruising off its shores to reach the Cape of Good Hope at the southern tip of the African continent. Countless rusty shells of boats, airplanes, and all-terrain vehicles litter the coast, as well as the bony remains of beached cetaceans and sometimes even humans.

12 MILLION CONTAINERS TRAVEL THE PLANET'S SEAS EACH YEAR
This is a rough figure calculated in twenty-foot equivalent unit (TEU), or the size of a small container of about 1,340 cubic feet (38 cubic meters). But there are various sizes of containers. Each year, between five thousand and fifteen thousand of these boxes are lost at sea.

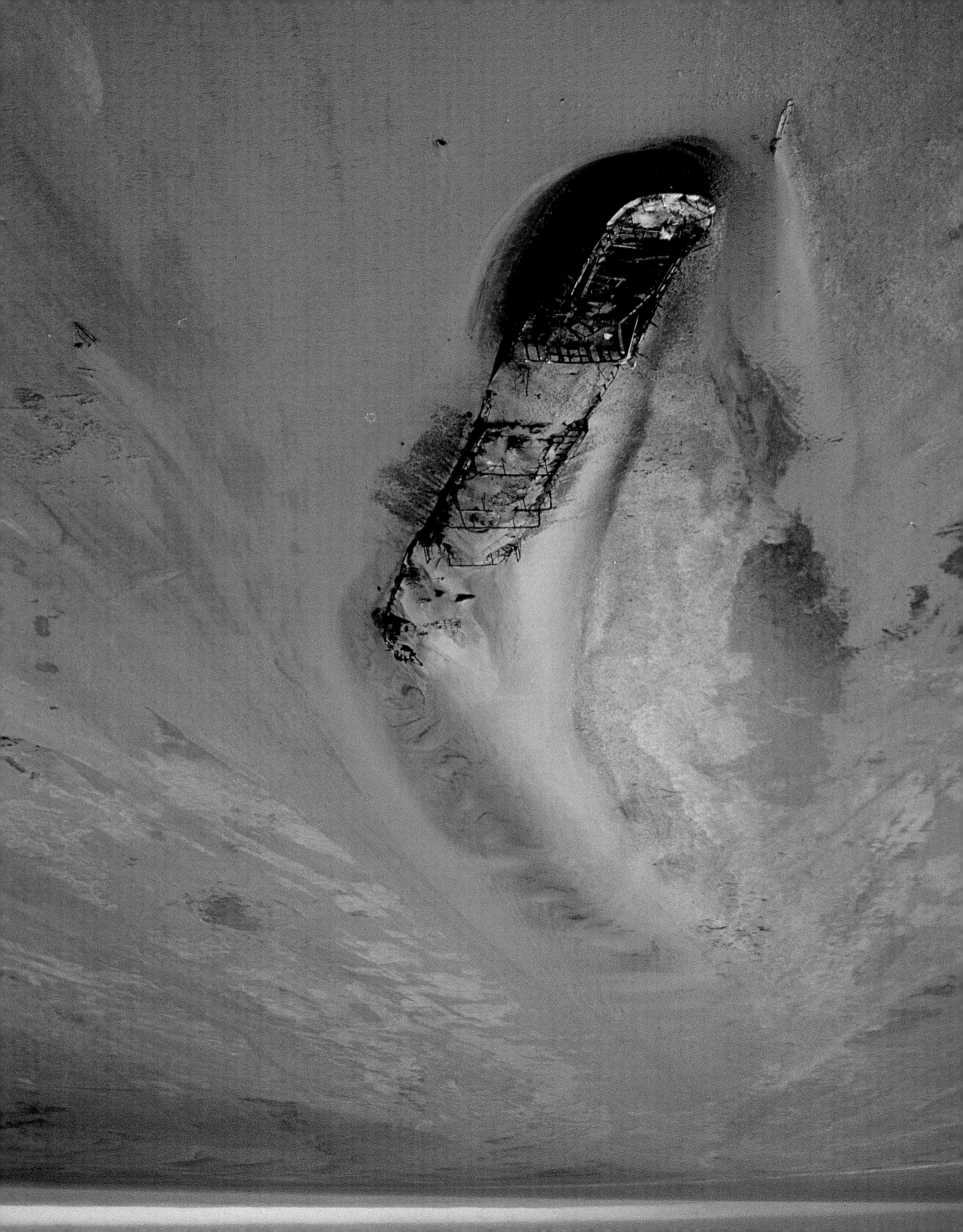

LEFT: **Red lionfish (*Pterois volitans*) seeking shelter in a sponge in the Belize Barrier Reef**
This species, native to the Indo-Pacific area, is known for its extremely venomous fins and its terrifying invasive potential. Introduced in the mid-1990s via ballast waters and fishkeeping, the red lionfish settled along the coasts of North America, the Gulf of Mexico, and South America. Without a predator, the red lionfish has proliferated to the point that it has reached concentrations of 250 individuals per 10,763 square feet (1,000 square meters)! Its expansion has been detrimental to the balance of the native ecosystem and local fish, notably fish with high commercial value.

such as those implemented in the United States after the *Exxon Valdez* disaster (40,000 tons of oil in Alaska in 1989) and in Europe after the *Erika* disaster (30,000 tons of oil off the coast of Brittany in 1999), have also played their part.

Today major disasters only account for a small share of oil discharged in the ocean, far behind clandestine degassing.

Aside from this discharge, maritime transport is often seen as an activity that does not lead to much pollution. Ships have the advantage of transporting large quantities of freight, which means less pollution than transporting the equivalent volume by road or air. Maritime transport only accounts for 3 percent of human CO_2 emissions. But the fuel used at sea has a very high sulfur rate—around twenty-seven thousand parts per million—and therefore motors discharge sulfur dioxide, a greenhouse gas and noxious pollutant.

THE BASEL CONVENTION

Ships sometimes transport dangerous cargo or toxic waste. The Basel Convention, signed in 1989 by 170 countries—with the notable exception of the United States—regulates the movement of dangerous waste and bans the export of toxic waste, save certain exceptional cases. Nonetheless, waste is sometimes spilled at sea when ships run aground or are illegally discharged. This happened when the *Probo Koala* spilled oil and chemical waste off the Ivory Coast in 2006, causing seventeen deaths and poisoning thousands.

Ships themselves can sometimes be considered waste, given how many chemicals they contain—asbestos, PCB, etc. In this case, they fall under the regulations of the Basel Convention and must theoretically be dismantled to protect personnel and the environment. But the operation can take a complex, even fantastic turn—as with the Clémenceau aircraft carrier, which was sent to India, brought back to Europe, and finally dismantled in the United Kingdom after much controversy. Much of global dismantling takes place in Bangladesh and India. This provides work for the local population, but also has significant sanitary and environmental implications.

Additionally, ship traffic is a nuisance for oceanic fauna. While there are no statistics about this, collisions between ships and marine mammals are common and kill many animals. The noise generated by maritime traffic can also harm marine animals—in the last fifty years, the sea's noise level has increased by 20 decibels.

Cetaceans, among others, communicate and find their bearing thanks to sound. The use of highly powerful military sonar is strongly suspected of leading to dolphin and whale beachings.

SHIP DISMANTLING

Between five hundred and a thousand large ships are sent to the scrap heap every year. At the end of their lives, boats become waste, but not just any kind of waste, due to their size and the presence of various materials, some of which are toxic (asbestos, PCB, lead, rust, fuel residue) and others that can be recycled (steel). The recycling or dismantling of ships is therefore a lucrative, complex, and dangerous activity, often subcontracted in developing nations to save money. It is often carried out with little protective equipment and minimal security, causing a significant number of injuries—some of which are lethal—and long-term health effects, due to the inhalation of toxic fumes or contact with noxious substances.

Hundreds of workers in Bangladesh, India, China, and Turkey die during ship-cutting operations every year. If it is ratified, the Hong Kong Convention agreed to in 2009 should improve the situation within a few years. It notably calls for shipowners to provide dismantling yards with a list of dangerous materials in the ship before its destruction and for inspections and sanctions in case these measures are violated.

THE INTERNATIONAL MARITIME SYSTEM

As with land transportation, we need traffic regulations on the oceans: Commercial routes must be mapped, marked out with beacons, and supervised. To this end, we must have coast guards, first-response equipment, icebreakers (in certain areas), regulations for the identification of owners and responsible parties in the case of accidents, etc. The Ushant shipping lane—off the coast of Brittany—provides one of many examples of what can be achieved. This maritime lane is one of the most heavily trafficked in the world, with over fifty thousand ships a year, or nearly two hundred a day. A northbound lane and a southbound lane—in other words one-way zones—are separated by several nautical miles with specific navigation rules and are supervised day and night, particularly since the *Amoco Cadiz* disaster of 1978, and a high-seas tugboat is permanently on call.

It is also indispensable to establish a network of communication and regulation among large international ports, since these ports are found all along the major commercial routes. They reflect the economic and commercial power of the regions in which they are located. A major example is Shanghai, the biggest port in China, and now the biggest in the world, ahead of Singapore and Rotterdam. Thirty million containers passed through Shanghai in 2011, or rather 30 million TEU (twenty-foot equivalent unit; a unit represents a basic container; there are bigger and smaller ones). The management of these ports is often entrusted to private companies. In recent years China has invested billions of dollars in various ports in Europe, America, and Africa (Le Havre, Piraeus, Panama, among others), and the Hong Kong-based Hutchison Whampoa Limited has become the largest port investment and management company in the world.

ABOVE: **Yangshan Port, Hangzhou Bay, Shanghai, China** (30°38' N, 122°03' E)
Located some twenty miles from Shanghai, China's economic capital, the Yangshan islands are home to the biggest deep-water port in the world. It is connected to the city of Shanghai by the Donghai highway bridge, which is 20.2 miles (32.5 kilometers) long, of which sixteen are above the sea.

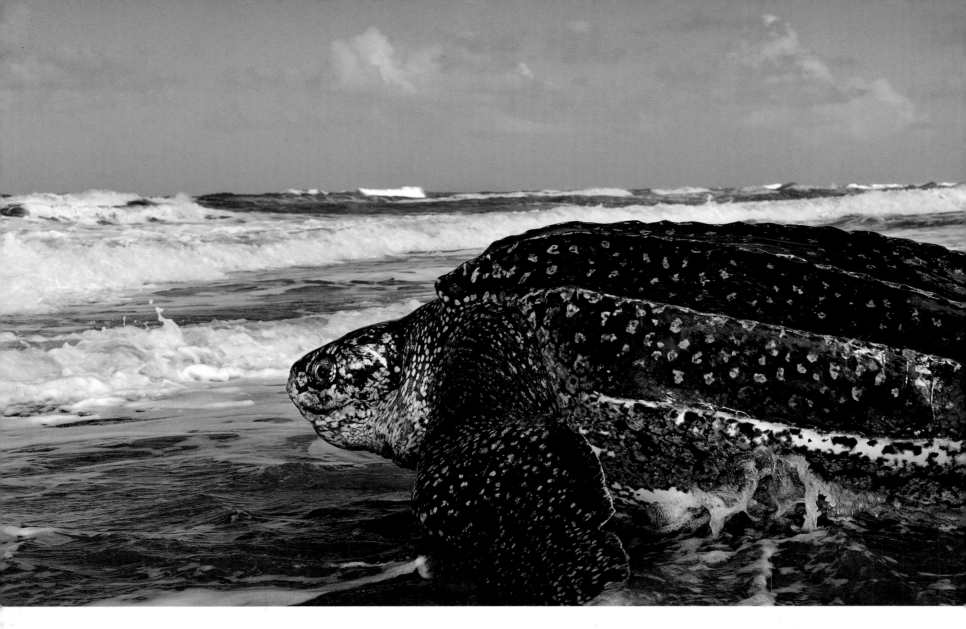

FLAGS OF CONVENIENCE AND BLACK FLAGS

The implementation of global governance of marine commerce has to contend with at least two problems: flags of convenience and piracy.

Flags of convenience allow ships to be registered in countries that are not sticklers for regulations, and that allows shipowners to pay fewer taxes, to avoid their responsibilities in case of accidents, and to circumvent labor laws. The *Erika*, for example, was chartered by the French company Total, but flew a Maltese flag, was owned by an Italian, insured by a company in Bermuda, and had an Indian crew. As for the *Probo Koala*, it was registered in Panama, belonged to a Greek company, was chartered by a Swiss and Dutch company, and had a Russian crew. This is a major problem, given that more than half the ships in the world sail under a flag of convenience.

As for piracy, it is undergoing a significant resurgence. It is particularly rife off the coast of Somalia, where more than half the acts of piracy in the world are reported, but the Southern Gulf of China and the Gulf of Guinea should also be mentioned. In the Gulf of Aden, which sees close to 20 percent of global maritime merchant traffic, 237 attacks and 28 boat hijackings were recorded in 2011. While the cost of these attacks (security on ships, trials, ransoms) has diminished due to the heavy presence of military ships in the area, it remains estimated at 7 billion dollars in 2011, of which 2.7 billion dollars was spent on the over-consumption of fuel due to merchant ships' increased speed in these waters.

SHORTENING DISTANCES, PASSING THROUGH CONTINENTS

Navigation routes are improved by digging large canals, which save time and a lot of money. The Suez Canal, which was dug in the nineteenth century, shortened the trip between Europe and Asia by nearly 5,000 miles (8,000 kilometers). As for the Panama Canal, which was opened in 1914, it reduced the distance traveled by a ship sailing from

ABOVE: **Female leatherback sea turtle (*Dermochelys coriacea*) crawling back to the sea after having laid eggs on Matura Beach, Trinidad, Trinidad and Tobago**

The leatherback sea turtle is among the animals that travels the farthest in the ocean. To get from its feeding areas to its laying zones, it embarks on transoceanic journeys covering thousands of miles, which are thought to last two to five years, the time required to accumulate enough reserves to reproduce.

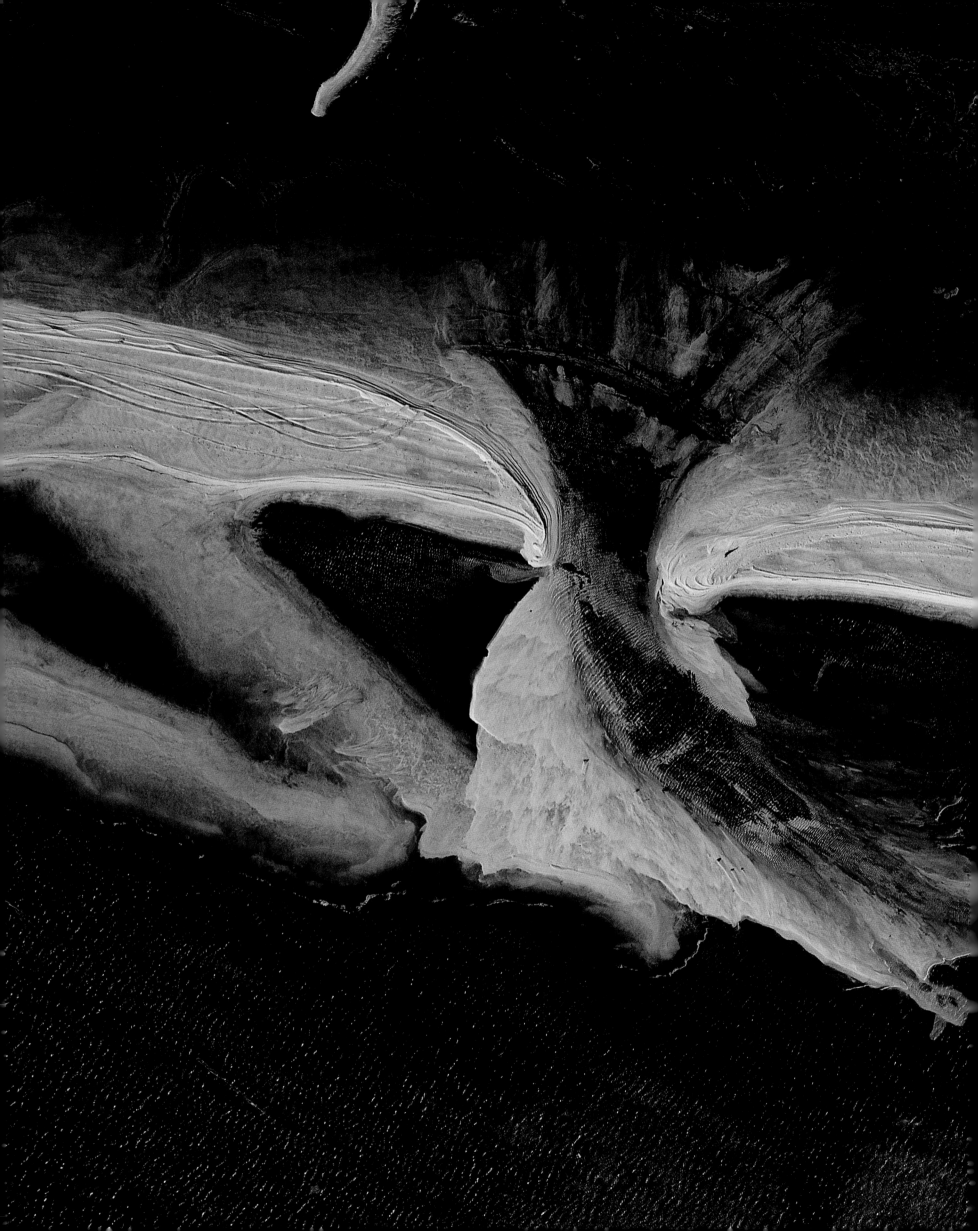

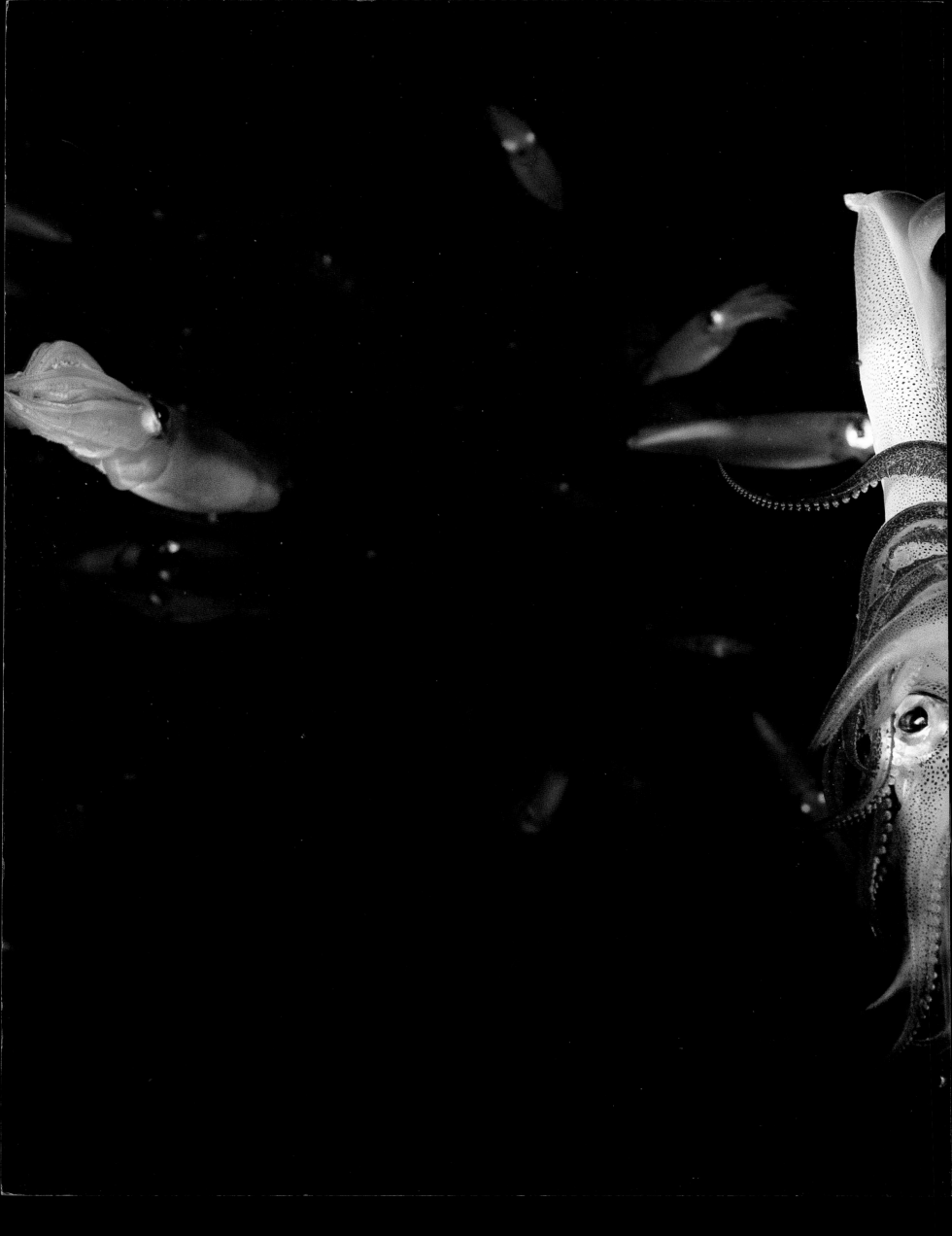

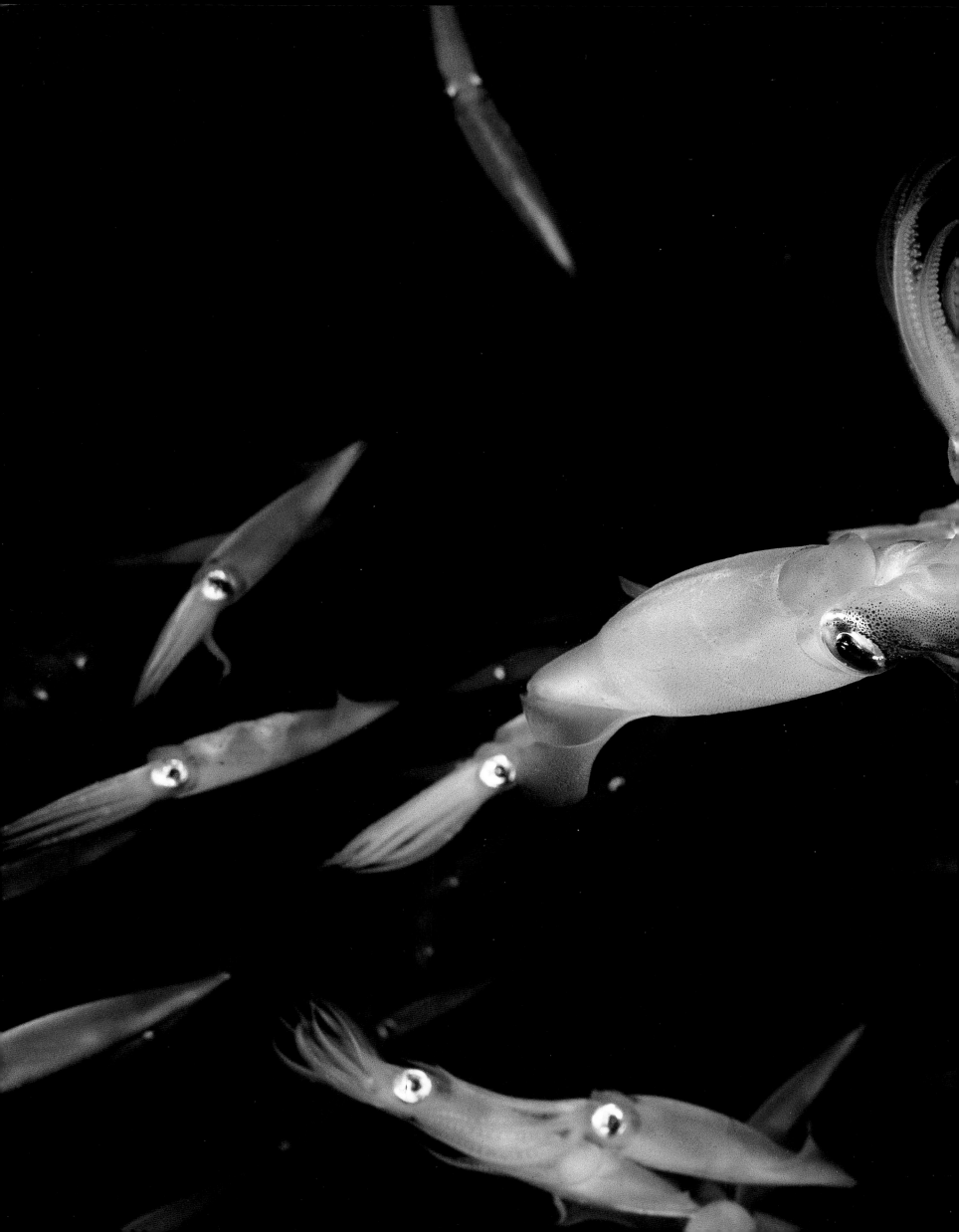

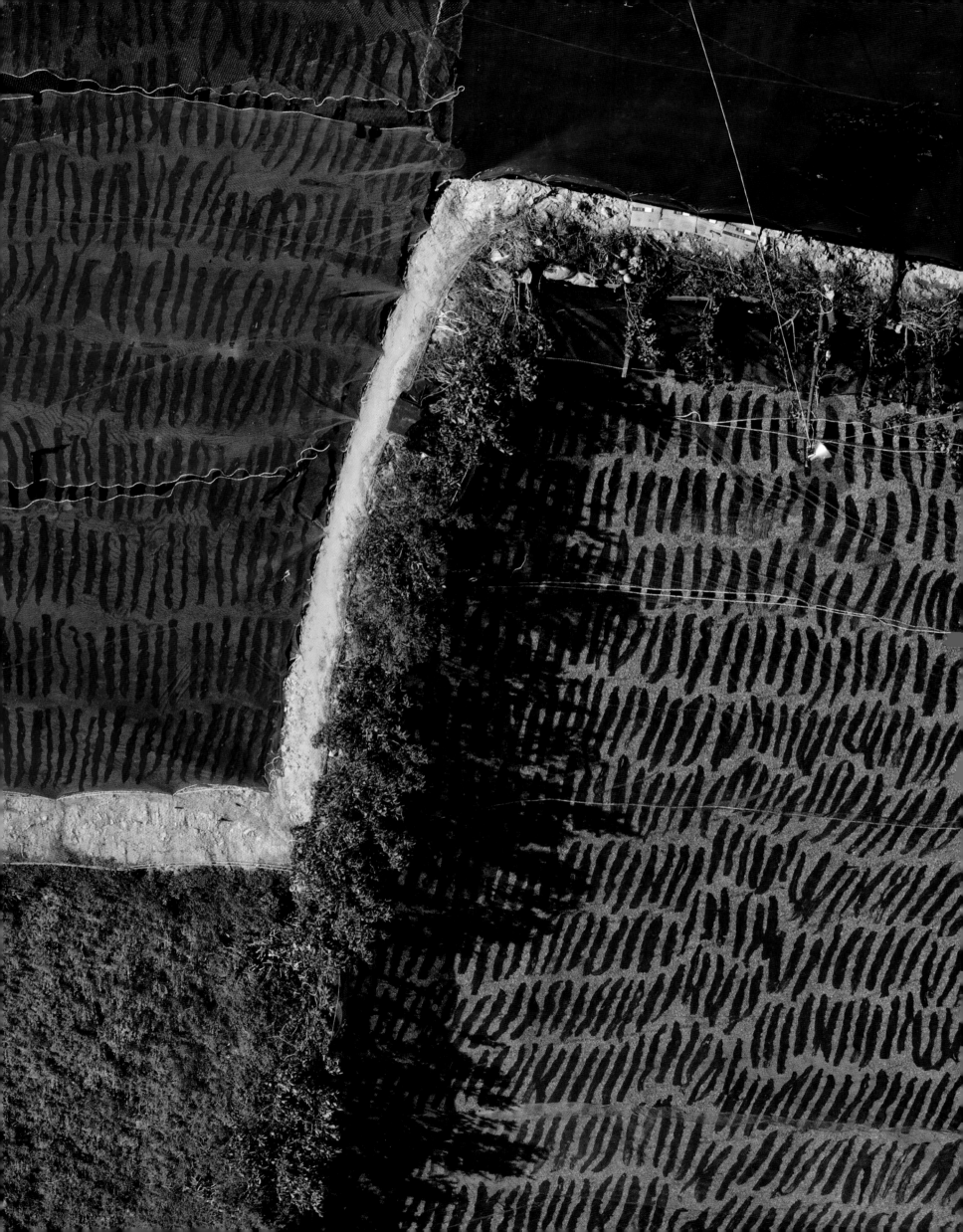

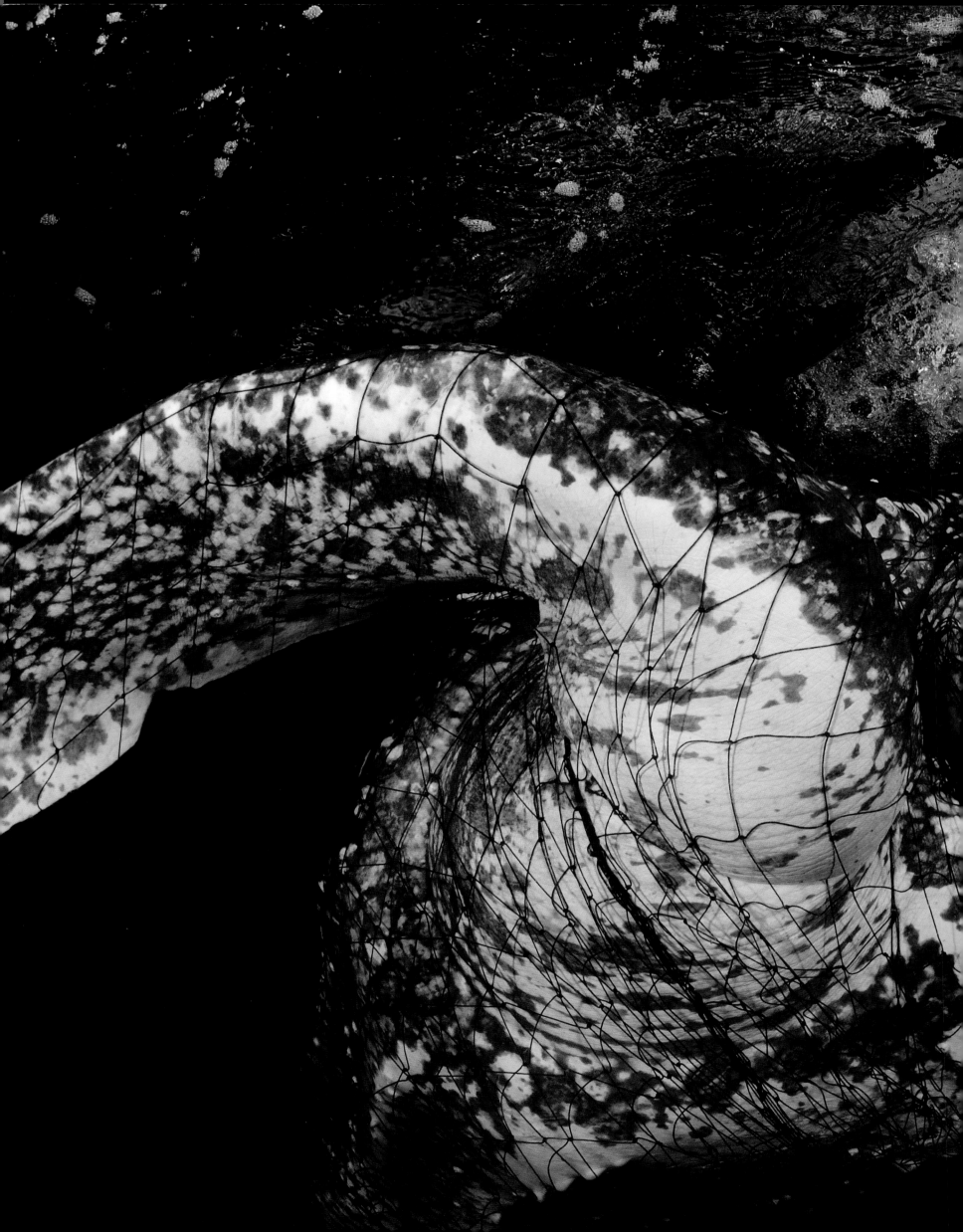

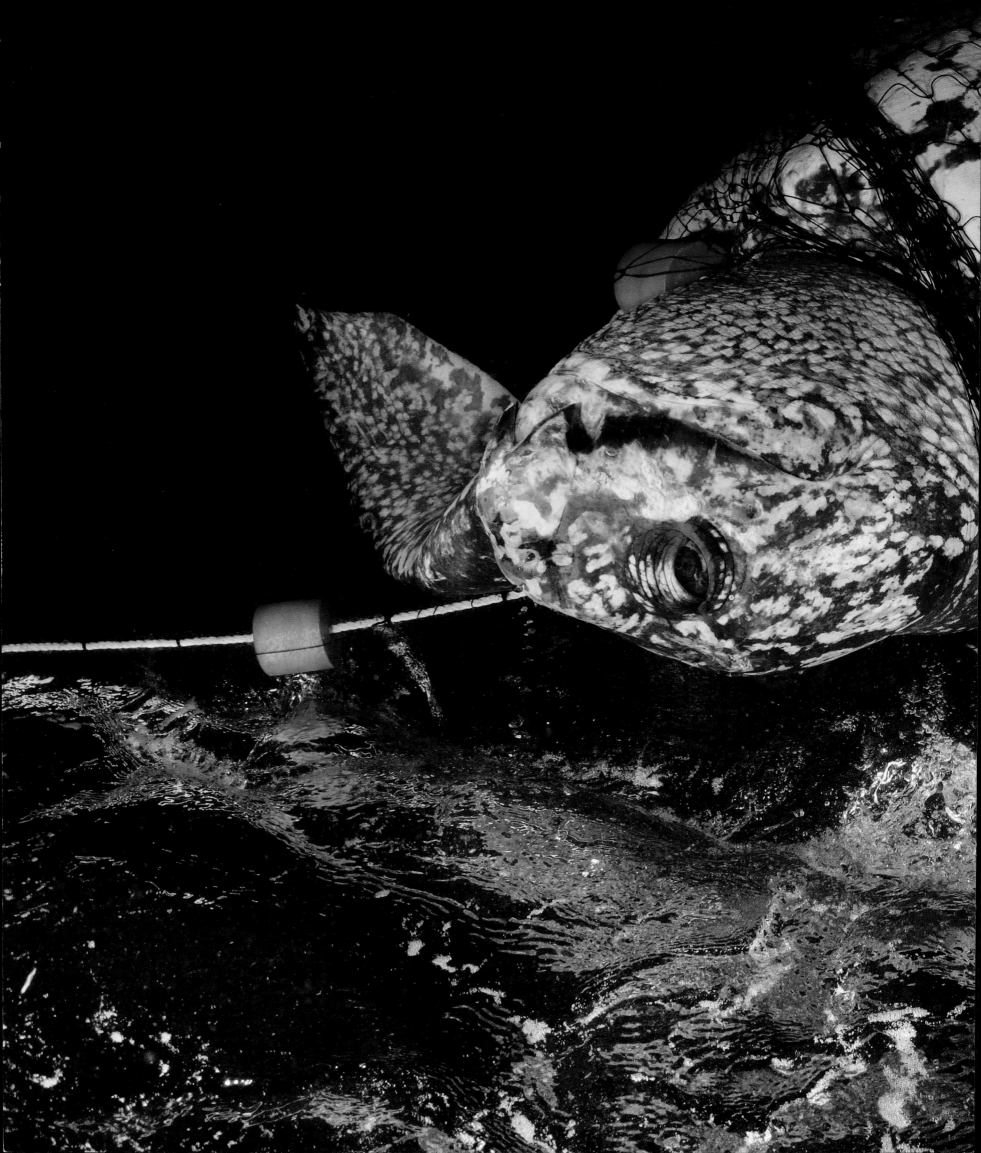

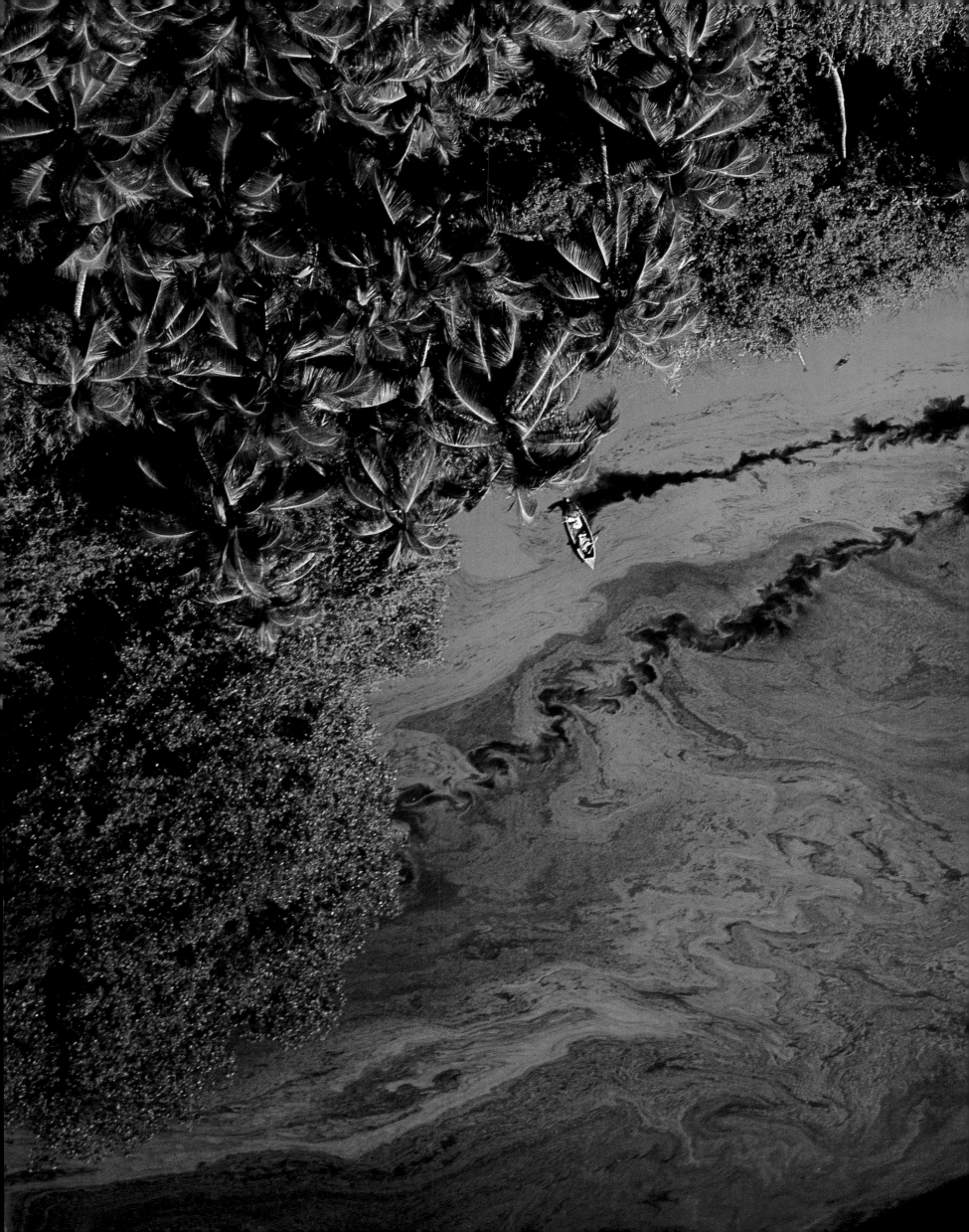

THE BREAKDOWN OF THE CLIMATE REGULATOR

For the last few years, the scientific community has been scrutinizing the evolution of sea levels with growing concern. After several millennia of stability, the global ocean has been rising since the 1900s. During the twentieth century, water levels rose by 0.6 inches (1.7 mm) per year. Today the trend is accelerating, with water levels rising by more than 0.12 inches (3.2 mm) a year, according to satellites, the only tools able to accurately measure the global ocean. Their data is confirmed by a global network of tide gauges, instruments attached to the seafloor to measure water levels.

Two words explain this worrisome increase: global warming. And while the details of the calculations and measurements are complex, the basic mechanisms of rising water levels are easy to understand. Two processes are at work. The first is thermal expansion. Warming the ocean increases its volume (as with most solid, liquid, or gaseous bodies). The ocean has absorbed most of global warming, and is therefore expanding, which makes its level rise. The second process is the melting of continental ice. Enormous quantities of water are immobilized in the form of ice in the two vast Polar ice caps (Greenland and the Antarctic) and in the thousands of continental glaciers scattered around our planet, from Siberia to the Himalayas, from the Alps to the Andes, and collectively known as the cryosphere. Within the cryosphere, only the part of the ice cap located east of the South Pole still appears to be stable. The vast majority of terrestrial glaciers (more than 90 percent) are melting, as are the ice caps in Greenland and west of the Antarctic, causing the ocean, which ultimately receives all this water, to rise. If this increase were to continue at the current rate, significant problems would probably not occur before the end of this century. But given the cryosphere's rapid regression, and particularly the accelerated melting of the Greenland and west Antarctic glaciers, most specialists expect that the increase will heavily accelerate. The opinion now dominant in the scientific community is that sea levels will rise by more than 3 feet (one meter) during the twenty-first century—perhaps by a lot more.

AN EXTRA 3 FEET IN ONE CENTURY

Given the enormous concentration of wealth and populations in coastal zones, a rise of 3 feet (1 meter) in one century raises the risk of colossal damage. There are millions of humans living in the planet's lowest areas, such as Bangladesh and the Nile Delta, as well as island states. One also thinks of Shanghai, the leading global commercial port for merchandise—the city is at a very low elevation, and port installations are particularly vulnerable to coastal storms—or another globally important city, New York, which is notorious for being poorly protected against rising waters. And while it is difficult to provide accurate figures, millions, even hundreds of millions, of people could have to leave their homes to become "eco-refugees."

The danger is very real and demands that we resolutely tackle global warming. This is all the more urgent given that beyond the problem of rising water levels, other lesser-known disruptions of the ocean attest to the extent that this ecosystem from which life was born has been diseased by our carbon emissions.

OPPOSITE: **Harp seal mother (*Pagophilus groenlandicus*) and her pup in the waters of the Gulf of Saint Lawrence, Canada**
Harp seals live in the Arctic waters of the North Atlantic. Three major populations are known: those north of Russia, south of Spitzberg (Svalbard), and in Newfoundland. Newborns, which are called pups, are famous for their immaculate white fur. Unfortunately, this fur gives seal pups tremendous commercial value. Each year, close to four hundred thousand seals are killed on the ground, and 95 percent of their fur goes to the fashion industry.

AN AVERAGE INCREASE OF 0.72°F (0.4°C) ON EARTH SINCE 1992
If the trend continues, temperatures could rise by 6.3°F to 7.2°F (3.5°C to 4°C) in 2100.

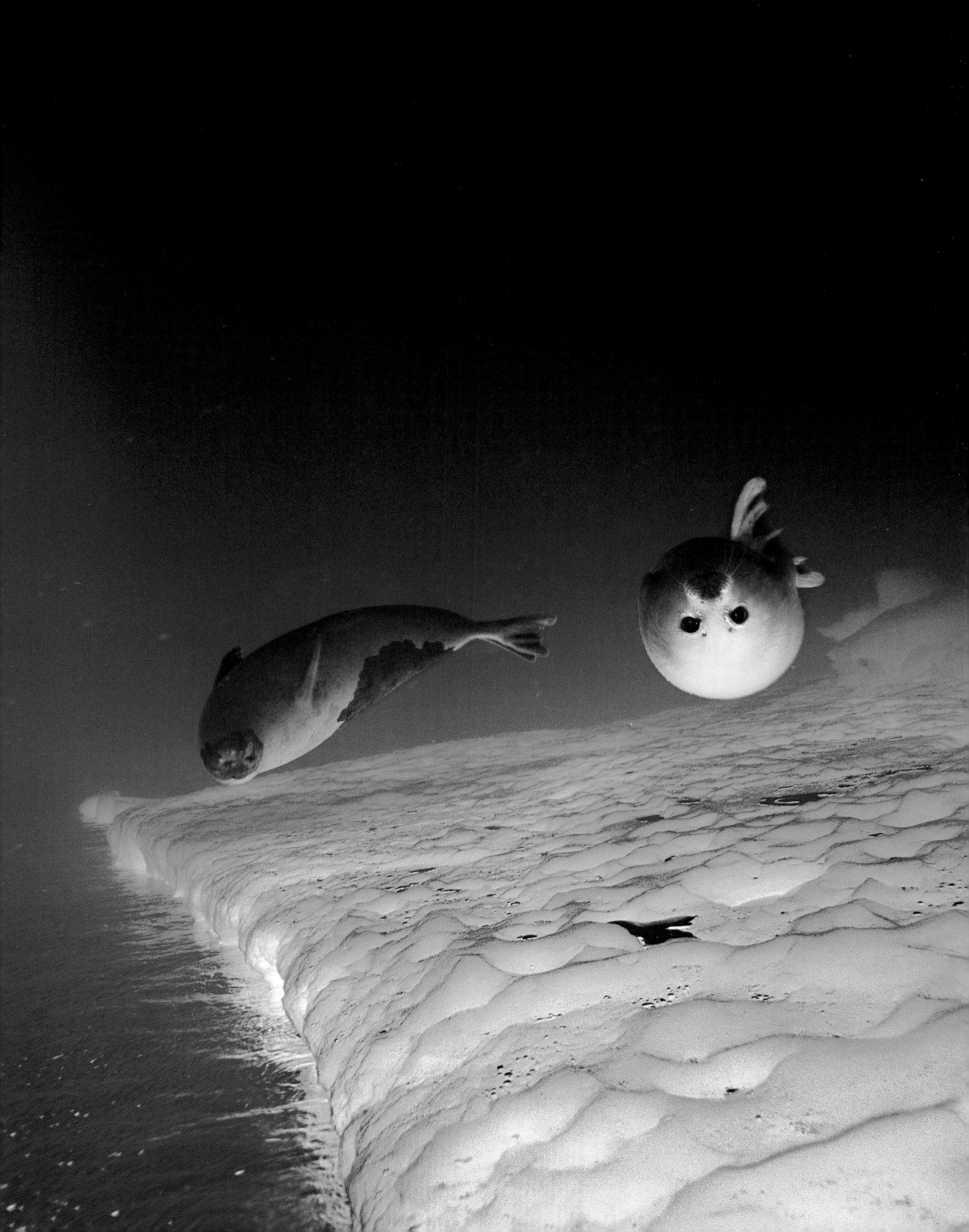

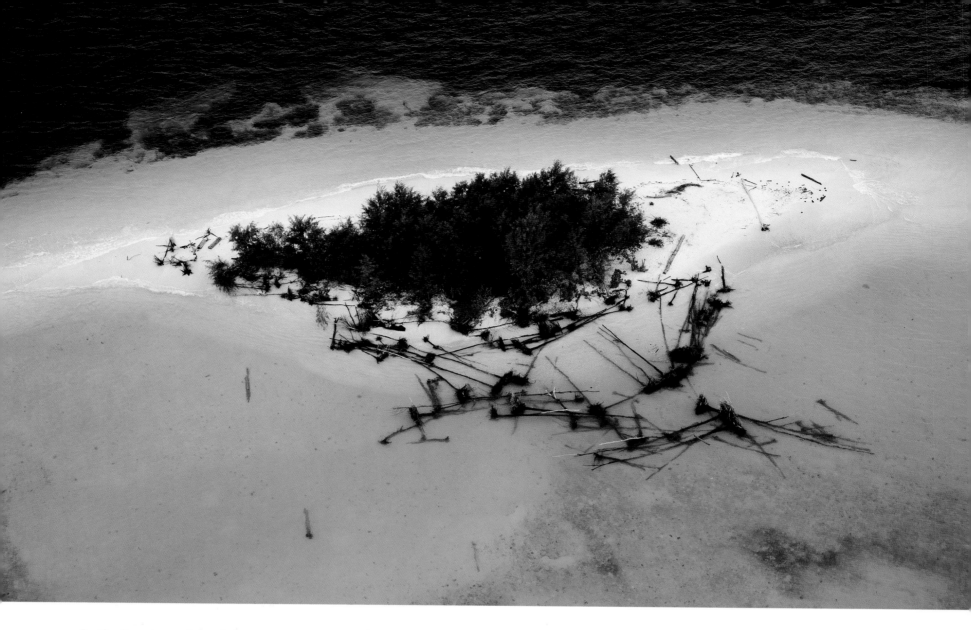

In the "earth machine," the ocean serves as a climate regulator that attenuates contrasts, thereby making our planet more inhabitable since life adapts poorly to extremes. This function is particularly important given that human activities warm the earth and create various unbalances. The ocean acts as a buffer, partially absorbing the most brutal shocks we inflict upon our environment; a buffer that principally acts upon two interconnected factors: temperature and atmospheric carbon.

THE CARBON PUMP

Additionally, the ocean buries most man-made atmospheric warming in its depths. It is estimated that only 10 percent of the energy captured by the planet due to our greenhouse gas emissions actually increased air temperatures. The remaining 90 percent went into the ocean, principally into the depths. Of course, it did not disappear and will eventually spread to the surface, but anything that can absorb sudden shocks to a living planet like ours is crucially important.

The ocean also plays a key role in regulating terrestrial temperature. It removes from the atmosphere a large percentage of the carbon we emit, doubly attenuating the planetary shock caused by our hydrocarbon consumption. No less than a third of human emissions of carbon dioxide (CO_2) produced since the beginning of the industrial revolution were absorbed by the ocean instead of warming the sky. This oceanic "carbon pump" is due to a dual phenomenon. On the one hand, there is a "physical pump" due to the fact that CO_2 is a gas soluble in water. All along the surface of air-water contact, carbon dioxide molecules are dissolved in seawater, thereby taken out of the atmosphere and no longer warming it.

While the "physical pump" would work just as well in a sterile ocean, a second pump, known as the "biological pump," is due—as the name indicates—to the effects of living matter. The term "biological pump" simply refers to the consumption of very

ABOVE: **Raja Ampat Islands, West Papua, Indonesia** (0°41' S, 130°25' E)

Scattered around four main islands, the Raja Ampat (Four Kings) Archipelago consists of 1,500 small islands. According to a 2002 report by the NGO Conservation International, the area has one of the richest marine biodiversities in the world, including more than half of known coral species—more than 550 different species—and several hundred fish species.

35 PERCENT MORE ACIDITY IN THE OCEANS

Oceanic acidity is measured in pH (potential hydrogen). In 1800 the oceans' pH was 8.2. Today it has fallen to 8.05. Scientists predict a pH of 7.85 in 2100, a 152 percent increase in acidity.

large quantities of CO_2 taken from the surface by marine plants, principally planktonic algae, to ensure their development. Many of these algae then fall to the ocean floor in the form of "planktonic snow" (a mix of herbivore bodies and excrement, mucus, and organic particles), which durably isolates the carbon, of which they are made, from the atmosphere.

Unfortunately, despite its enormous volume (320 million cubic miles [1,340 million cubic kilometers] of water!), the global ocean is already undergoing significant transformations caused by our carbon dioxide emissions. While our limited understanding of the mechanisms of the climate machine prevents us from making precise predictions regarding the effects of these changes, the general trend has been established. Everything indicates that our emissions are weakening the ocean's regulating power, which is worrisome both for the organisms that live there and for the entire planet's climate, both on the continents and in the oceans.

AT THE HEART OF THE PROBLEM

One of the main concerns regards the future of a current known as AMOC (Atlantic Meridional Overturning Circulation). AMOC flows deep in the North Atlantic and is solely responsible for nearly a quarter of the energy transported toward the Poles. The current contains enormous quantities of waters from the Tropics, which flow toward the deep sea. These waters have released their heat into the atmosphere and are now cold and salty—and therefore dense. The problem is that the North Atlantic is one of the fastest-warming areas in the world. Its water is increasingly less cold and is becoming fresher due to glaciers melting at high latitudes (Canada, Siberia, Greenland, etc.). The water's descent to the deep sea, which relies on cold and salinity, will therefore slow down—though specialists debate the speed and extent of the slowdown. With a reduced AMOC, a smaller proportion of atmospheric CO_2 is dragged into the deep sea and the circulation of the Tropics' warmth to the north is diminished, causing noticeable climate disruption.

The "physical pump" for carbon is also ailing. The laws of physics stipulate that warm water dissolves less gas than cold water: The ocean's gradual warming of the ocean reduces its capacity to absorb CO_2. The ocean's superficial layer—where the most exchanges with the atmosphere take place—has already warmed by 1.44°F (0.8°C) since the preindustrial era, and this increase will inevitably continue.

THE ACIDIFICATION OF THE OCEANS

It is difficult to predict the biological pump's evolution. However, we do know that we are headed for waters that are both warmer—as we have just seen—and more acidic. The ocean's acidification is due to the chemistry of carbon dioxide, which forms carbonic acid when it dissolves in water. As large quantities of CO_2 due to human activities accumulate in the ocean, the ocean becomes more acidic. It has already lost something on the order of 0.1 pH (unit of measurement of acidity) in one century. By the end of the twenty-first century, acidification could reach 0.4 or 0.5 pH. These significantly different chemical conditions could make life much harder for organisms that synthesize a calcareous shell, notably an entire range of phytoplankton, corals, and mollusks. We do not know yet whether other living organisms feel its effects. In any case, we must expect wide-ranging ecosystem changes if this trend continues. Certain species will be replaced by their rivals, others may disappear without leaving successors, others yet may proliferate.

THE DEATH OF CORAL

Coral reefs are on the front lines of climate change. With the increase in temperatures, corals become bleached. This happens when the coral is separated from zooxanthellae, the symbiotic algae they shelter, which leave the polyps or lose their photosynthetic capacity. If this loss is prolonged, the coral dies. Coral are also affected by the increase in

THE POLAR BEAR

The melting of sea ice is a threat to the polar bear, which uses it as a platform to rest and hunt seals. Sea ice is indispensable for the polar bear to feed itself and stock up on fat. Though the species has already survived—sometimes by crossbreeding with brown bears—several periods of glaciation and warming over the last six hundred thousand years of existence, its future seems uncertain with sea ice melting. This bear has become a representative of the victims of global warming. The spring melting of ice is advancing eight days per decade, in ever-greater proportions, shortening the polar bear's hunting season and extending its period of fasting. In 2011, researchers observed a female that had to swim for nine days, covering 426 miles (687 kilometers) without interruption, to reach the sea ice. In Hudson Bay, Canada, the population of polar bears has dropped by 22 percent since 1987, and the bears have become skinnier. On average, females weigh 65 pounds (30 kilos) less than they did thirty years ago. Faced with the foreseeable disappearance of Arctic sea ice and, consequently, of the polar bear, some argue for capturing more animals in order to put them in the safety of zoos. But the polar bear, which is carnivorous (unlike the brown bear), is used to having gigantic hunting grounds at its disposal and does not handle confinement well. Twenty to twenty-five thousand polar bears currently live in the wild and the IUCN considers the animal to be vulnerable. In the United States, it is categorized as an endangered species.

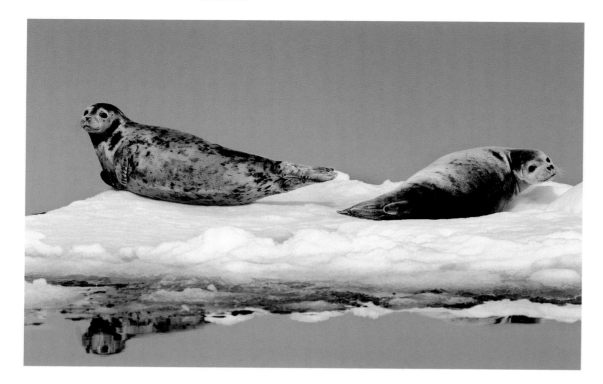

LEFT: **Common seals (*Phoca vitulina*) resting on a drifting block of ice, Okhotsk Sea, Hokkaido, Japan**

The common seal, also known as the "harbor seal," populates the coasts of the northern hemisphere and the Arctic Ocean. There are believed to be between 5 and 6 million seals in the world. On a global scale, these seals are not threatened, but they are facing difficult situations locally. Along Norwegian coasts, bycatch is responsible for 48 percent of local seal deaths.

the concentration of CO_2 and the resulting water acidification. Acidification makes it more difficult for corals to calcify, or make their calcareous skeletons. These threats come in addition to those already weighing over coral reefs, such as overfishing and pollution. The state of coral reefs around the world has alarmed and mobilized the scientific community. In 2012, 2,600 oceanographers from around the world gathered in Australia and issued a call to act for the survival of this fundamental ecosystem.

MELTING SEA ICE

In closing, we need to mention sea ice, another part of the ocean that has a major impact on the climate. On a global scale, sea ice is significantly shrinking, very probably due to global warming. But a closer look reveals that sea ice in the Northern Hemisphere is rapidly disappearing (–11.5 percent in surface area per decade over the last thirty years), while the sea ice surrounding the Antarctic at the South Pole has slightly increased in thirty years (+2.7 percent per decade). The reasons for this increase are not well understood, but may be linked to a change in regional winds. Logic and all forecasters agree that the shrinking of sea ice will continue in the north and eventually affect the south—though we do not know at exactly what stage this will happen. Sea ice is a natural air conditioner for the entire planet. Sunbeams bounce off its shiny surface and go back into space having generated minimal warming on earth. But once the sea ice has melted, the dark ocean absorbs sunbeams and stores their heat. The surfaces in question are vast: Arctic sea ice covers an area of over 4 million square miles (12 million square kilometers), and its Antarctic counterpart covers over 5 million square miles (14 million square kilometers). Sea ice is like a "mirror" bigger than the North American continent and its effects are global!

As this inventory of the many interactions between ocean and climate has demonstrated, the marine environment's climate regulator is now backfiring, and rising sea levels threaten coastal populations as well as a significant portion of global wealth. The solutions to protect the ocean are the same as those required by the entire biosphere, starting with an urgent reduction of our greenhouse gas emissions.

OPPOSITE: **Green sea turtle (*Chelonia mydas*) feeding on sea grass, Belize**

Green sea turtles can be found close to eelgrass (ribbon-shaped marine plants) in many tropical regions. At the adult stage, their diet is almost exclusively composed of sea-grass leaves. Their survival is therefore closely linked to that of underwater sea grass, which is currently threatened by human activities.

For more information on this subject and a relevant excerpt from the film *Planet Ocean*, go to http://ocean.goodplanet.org/ rechauffement-climatique/?lang=en

SEA GRASS

The vast underwater prairies in most of the world's oceans do not consist of algae but of grasses very similar to the terrestrial plants, which is why we call them sea grass. Plants left the marine environment some 475 million years ago. A few specimens returned to the oceans a hundred million years ago. These plants originated the sixty-four species of sea grass currently found on earth. This evolving history and the characteristics of sea grass make them the most terrestrial ecosystems in the marine world.

Unlike algae, these marine plants have roots, leaves, flowers, and fruit. Most of their reproduction takes place asexually and they grow by extending their network of underground roots (their rhizome). Consequently, a single individual can extend over several miles and reach a venerable age. One Algerian sea grass is thought to be between eighty thousand to two hundred thousand years old. Flowering—which allows for sexual reproduction—is rare; less than once a year in the case of the Posidonia sea grass in the Mediterranean.

Sea grass are among the most varied ecosystems in the world and are genuine hot spots of biodiversity. Emblematic species such as dugongs, manatees, and turtles come to eat sea-grass leaves: A dugong can eat up to 90 pounds (40 kilos) of sea grass a day, and the *Chelonia mydas* green turtle up to 4.5 pounds (2 kilos). Sea grass is also home to numerous species that do not directly eat the grass. This is the case of several fish species (groupers, barracudas; both adult and juvenile), mollusks, marine worms, urchins, starfish, and crabs. Sea grass is also a sanctuary for particularly fragile species such as the sea horse. There are about fifty endemic or highly dependent species in Posidonia sea grass.

Sea grasses are also considered engineers of the ecosystem, which means that they shape the ecosystem surrounding them. Sea-grass leaves retain sediments, and their roots stabilize the seafloor, thus protecting it against erosion. Sea grass naturally filters water. It produces large quantities of oxygen through its photosynthesis activity, and aerates sediments through its roots.

On a global scale, sea grasses are among the most productive ecosystems, given that they store 27 million tons of carbon a year. Recent studies show that, unlike forests, which principally store carbon in wood, sea grasses store up to 90 percent of carbon in the ground. In the Mediterranean, these prairies developed the capacity to sequester carbon up to several meters under the surface. Over the centuries, more than 19 billion tons of carbon have been stored in sea grass.

Like corals and mangroves, underwater prairies are highly fragile ecosystems, particularly vulnerable to human threats from the coast. They even serve as sentinel environments that reveal the existence of environmental disruptions. Studies estimate that 29 percent of sea grasses have already disappeared and that their disappearance is currently continuing at a rate of 1.5 percent per year. Pollution, dredging, grass torn out by anchors, eutrophication, overfishing, freshening (decrease in salinity), and the introduction of species such as the algae *Caulerpa taxifolia* are all threats to these essential ecosystems.

PREPARING THE ARCTIC FOR TOMORROW'S PROBLEMS

INTERVIEW WITH MICHEL ROCARD

MICHEL ROCARD

Former prime minister of France, Michel Rocard was appointed French ambassador in 2009, and is responsible for international negotiations concerning the Arctic and Antarctic poles. Here, he assesses what is at stake in the Arctic, a vast area in the midst of major transformation, where resources have been made more accessible by climate change and are aggressively coveted by bordering nations.

The melting of sea ice is fueling competition for Arctic resources. What is at stake in the area?
The Arctic holds many riches. Important deposits of gas and liquid petroleum have been found there: close to 30 percent of all gas reserves and 14 percent of oil reserves. The problem is that the rights to these resources are not clearly established because they are all in zones not currently subject to jurisdiction. In the Arctic, the key issue is the extension of coastal states' rights beyond the limits of exclusive economic zones [EEZs], because this is where most of the deposits discovered are located. Since 1982, an international convention signed in Montego Bay has codified the right to the sea and establishes these EEZs. Coastal states have sovereign rights in these zones—which are at a maximum distance of 200 nautical miles from their coasts—notably concerning the exploration and exploitation of the seafloor and its subsoil.

To extend these rights, a state has to prove that the seafloor and oceanic subsoil are a natural extension of its terrestrial territory. It then submits a request for expansion to a special UN committee, the Commission on the Limits of the Continental Shelf [CLCS], which, after examining the proof, rules on its validity and does or does not authorize the state to extend its sovereignty by 140 nautical miles. A state can then have rights over a distance of 350 miles from its coasts.

> "Canada, Denmark, the United States, Norway, Russia, and several other states currently want to obtain rights to the riches within the Arctic's oceanic subsoil."

What are bordering countries currently claiming?
Canada, Denmark, the United States, Norway, Russia, and several other states currently want to obtain rights to the riches within the Arctic's oceanic subsoil. The very first country to make such a request and receive a positive answer was Norway. In 2009, Norway received an extension of its rights around the Svalbard Archipelago.

Additionally, Norway was long in conflict with Russia over the Shtokman deposit, in the Barents Sea, which has proven to be the third- or fourth-largest natural gas deposit in the world. After nearly forty years of disagreement, the two nations finally agreed on a division treaty in 2010. Today another zone is widely coveted: the Lomonosov Ridge, a 1,200-mile [2,000-kilometer] underwater mountain chain that runs under the North Pole. So far, the Russians have been the most active. They planted their flag there in 2007, and they have already made several requests to the CLCS. But the commission's response was the same each time: "Your case is not convincing."

This explains why every summer, Russian geology students spend their vacation coring the oceanic subsoil to shore up their country's request. Russia has announced that it will submit another request to the CLCS in 2012. But it is not the only one claiming rights over the area: Norway, Canada, and Denmark have all stated they would put requests before the Commission in 2013. The United States is also interested in a huge gas deposit in the Bering Strait, but since it did not sign the Montego Bay Convention, it does not have access to the CLCS proceedings; for the time being, any American request for extension of rights is inadmissible.

What is the situation concerning new possibilities for navigation and the opening of sea routes, thanks to the melting of sea ice?
Regarding future commercial navigation through the Arctic, all coastal states are obliged to allow commercial ships right of passage. While this does not concern many states, it does imply that those concerned are responsible for security and rescues. For the time being, none of them have refused this responsibility. They see it—and this is particularly perceptible in

Canadian discourse—as an expression of their sovereignty, and therefore they don't intend to surrender any of these prerogatives. The problem is that none of them are able to invest the 5 to 6 billion dollars required to develop the Arctic.

There is currently not a single lighthouse, beacon, observation plane, fleet of rescue helicopters, icebreaker, or port all the way from Cape North to the Bering Strait, along Siberia, and via the Canadian islands. All of that is needed for development; without it, insurers will never cover navigation.

"[No state is] able to invest the 5 to 6 billion dollars required to develop the Arctic."

What are the major environmental issues in the Arctic?

The main issue, and the most terrifying one, is the melting of the ice, but it depends on factors that are not only taking place at the Poles. The fight against greenhouse gases is a global fight that faltered in Copenhagen and has since failed in the other international congresses, leaving the environment in the Polar regions to continue deteriorating. But that is not all: The melting of the ice will soon enable other activities that are damaging to the environment, such as oil drilling, fishing, transport of merchandise and passengers, and tourism. My sense is that it would be best to start preparing today for the environmental constraints of tomorrow, before the area is opened to commercial activities and traffic. This would include, for example, banning the discharge of waste at sea and degassing and requiring ships to use fuel meeting certain requirements, etc.

While these legal regulations are necessary to protect the Arctic from pollution, the bordering countries do not currently accept them. We will have to make them change their minds, and to do that the entire world must mobilize itself.

What place do indigenous people have in these discussions between states primarily concerned with economic matters?

There are about three hundred thousand inhabitants of the Arctic, half of whom are Inuit. They principally live along the coasts, and for them the situation is terrible because they are losing their sources of food. Their situation varies according to the country. Denmark, for instance, is in the process of granting Greenland its independence. The population is exclusively Inuit: Of the 55,000 Greenlanders, there are 54,500 Inuit people and 500 Danish civil servants. This is not inconsequential, notably in terms of oil exploitation security.

Currently, no one is sure that Greenland's government will have the means to ensure oil exploitations' security. If it cannot do so, the task will fall to major oil companies, and the government will have to be strong enough to impose regulations upon them. In Russia, indigenous people have gathered in RAIPON [Russian Association of Indigenous People of the North], and this association is also a permanent observer with the Arctic Council. There is also the Inuit Circumpolar Council, which represents the Inuit of Alaska, Greenland, and Canada, but the creation of an Inuit government in Greenland could slightly destabilize this circumpolar council.

"It would be best to start preparing today for the environmental constraints of tomorrow, before the area is opened to commercial activities and traffic."

Is their voice truly heard in discussions between states?

We are in the midst of a profound change. The Arctic Council, which gathers the governments of bordering countries and the representatives of indigenous people, was set up in 2000. Before then, no one listened to indigenous peoples. Now there are six institutional representations of indigenous peoples and they are heard, notably as soon as something vital is at stake for them. Granted, they do not have much influence on the discussions on certain subjects because they are, for example, not yet able to take responsibility for decisions to grant oil exploitations or fishing permits. But today it is out of the question to make an Arctic policy that would not take them into account. And their survival will probably be partially accompanied by assimilation.

What is France's place among these states and indigenous peoples, and what is your role as ambassador?

France's place is that of a member of the European Union that happens to be a permanent observing member of the Arctic Council. Depending on the issues, I am either the voice of France, or sometimes that of Europe.

Does France take into account the Arctic question and more generally the effects of climate change?

The CIA once published a report on the effects of climate change on the United States' security. The French navy is seriously invested: It regularly carries out observation missions in the Arctic to keep a close eye on the situation's evolution. But compared to the United States, we are far less concerned with the Arctic in strategic terms, for it is much farther away. It is not an essential strategic zone for France.

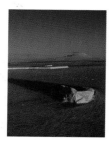

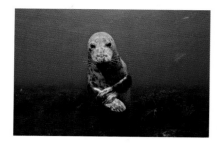

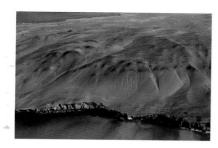

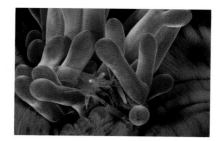

Ross Sea and Mount Erebus, McMurdo Sound, Antarctica
(76°12' S, 163°57' E)

Most of the icebergs in the Southern Ocean are formed from the three major ice shelves of the Antarctic coast—the Ross, Filchner-Ronne, and Amery. Composed of continental ice from the ice cap's descent to the sea, they rise 100 to 130 feet (30 to 40 meters) above the surface, and often reach close to 1,000 feet (300 meters) below the surface. Once they arrive in the ocean, they are gradually eaten away by salt water. While certain icebergs are only a few feet long, the largest ones can be truly gigantic.

Gray seal (*Halichoerus grypus*) in the waters of the Gulf of Maine, United States

The gray seal inhabits the coastal areas of the North Atlantic and likes rocky zones, islets, pebble beaches, and kelp forests. It is a carnivorous mammal that feeds on fish, crustaceans, and mollusks. The biggest European colonies of gray seals are in England, Ireland, and Scotland. In France, they can be observed on the Sept-Îles Islands in Brittany.

El Candelabro ground drawing, Paracas Peninsula, Peru
(13°47' S, 76°18' W)

Commonly known as the Chandelier (*El Candelabro*), this 650-by-200-foot (200-by-60-meter) geoglyph carved in a cliff on the Paracas Peninsula on the Peruvian coast is thought by specialists to represent a cactus or the constellation of the Southern Cross. It is believed to have been made by the peoples of Paracas, a civilization of fishermen established in the seventh century BC. Visible at sea from a great distance, El Candelabro was probably originally created to aid navigation and continues to be a landmark for present-day sailors.

Sea anemone serving as a shelter to a transparent shrimp, Kingman Reef, United States

Because it is transparent, this shrimp can easily hide in this anemone, whose venomous tentacles provide an ideal shelter. Camouflage strategies are widespread in the oceans: Stonefish look like rocks and watch for their prey by blending in to the seafloor; similarly, certain crab species stick various debris on their shell in order to better camouflage themselves.

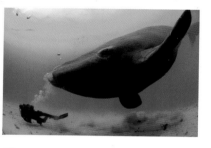

Venetian Lagoon, Venice, Italy
(45°18' N, 12°12' E)

The Venetian Lagoon covers an area of nearly 200 square miles (500 square kilometers) between the Italian coast and the Adriatic Sea and is the largest wetland in Italy. Today it is threatened by urban and industrial pollution, notably from hydrocarbons and heavy metals. Additionally, the city of Venice sank by 9 inches (23 centimeters) over the course of the twentieth century and must face rising sea levels. To do so, seventy-eight mobile dikes, spread over the lagoon and able to contain tides of up to 10 feet (3 meters), should be operational in 2014.

Parrotfish (*Scaridae*) feeding on coral, Kingman Reef, United States

Parrotfish live in tropical regions throughout the world. They owe their name to their beak-shaped mouths whose powerful bite shatters shells and corals—the debris is then ground up in an internal pocket that absorbs nutrients. The parrotfish also uses its beak to scratch corals and remove the algae growing on their surface.

Banc d'Arguin, Gironde, France
(44°34' N, 1°15' W)

A group of sandy islets changing shape and position with the wind and marine currents, the Arguin Bank is a stopover for migratory birds at the mouth of the Arcachon Basin. It is home to a colony of four thousand to five thousand pairs of sandwich terns (*Sterna sandvicensis*), which is among the three largest colonies in Europe. Its surface area varies from 375 to 1,200 acres (150 to 500 hectares). It was declared a natural reserve in 1972 and added to the European Natura network in 2000.

Diver and southern right whale (*Eubalaena australis*), Auckland Islands, New Zealand

The right whale is 50 feet long (15 meters). But the biggest whale—and also the largest living animal on the planet—is the blue whale. Spanning 98 feet (30 meters) and weighing 170 tons, it shatters all the records. And yet its diet is based on krill: zooplankton no longer than 7 millimeters and weighing no more than 2 grams.

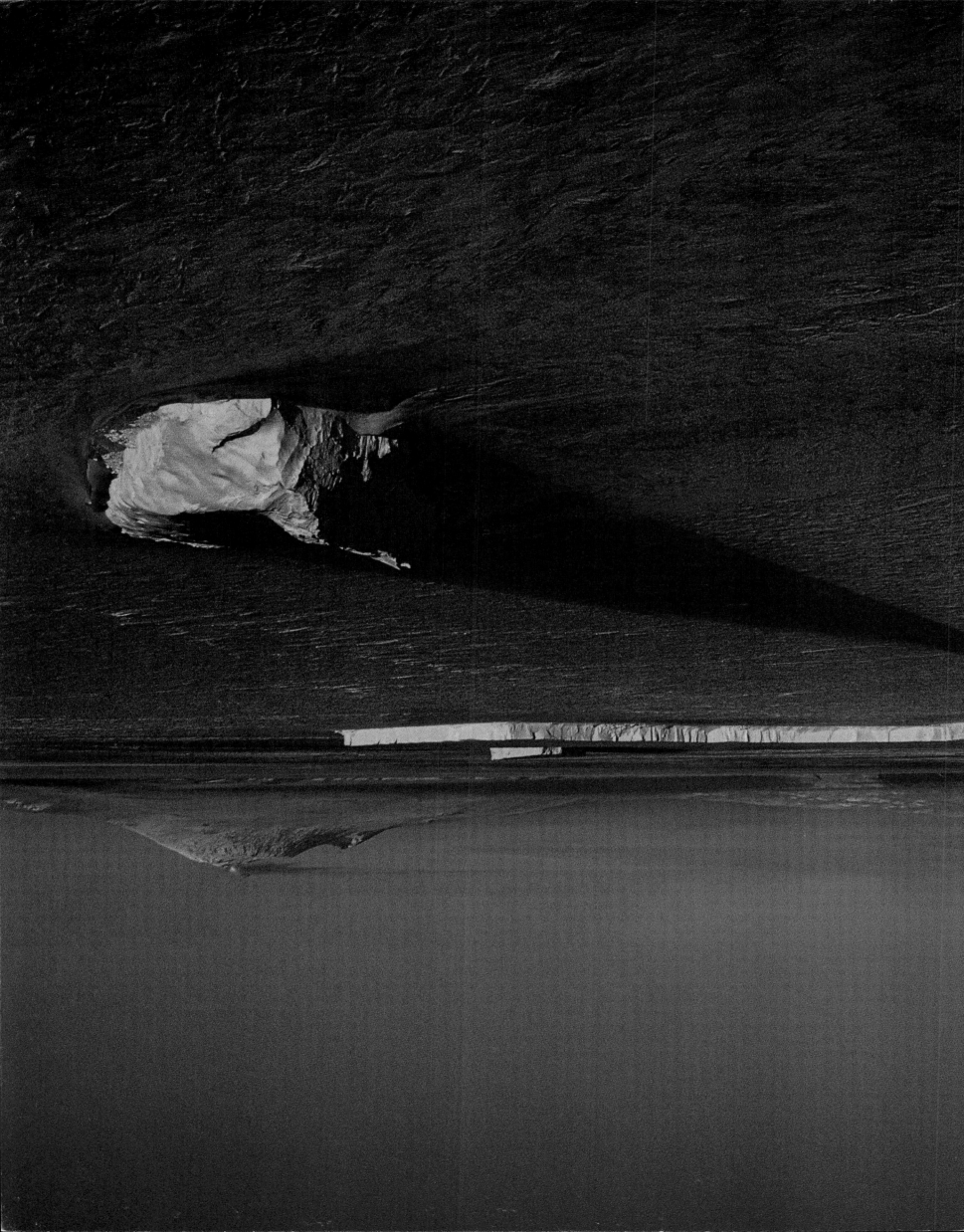

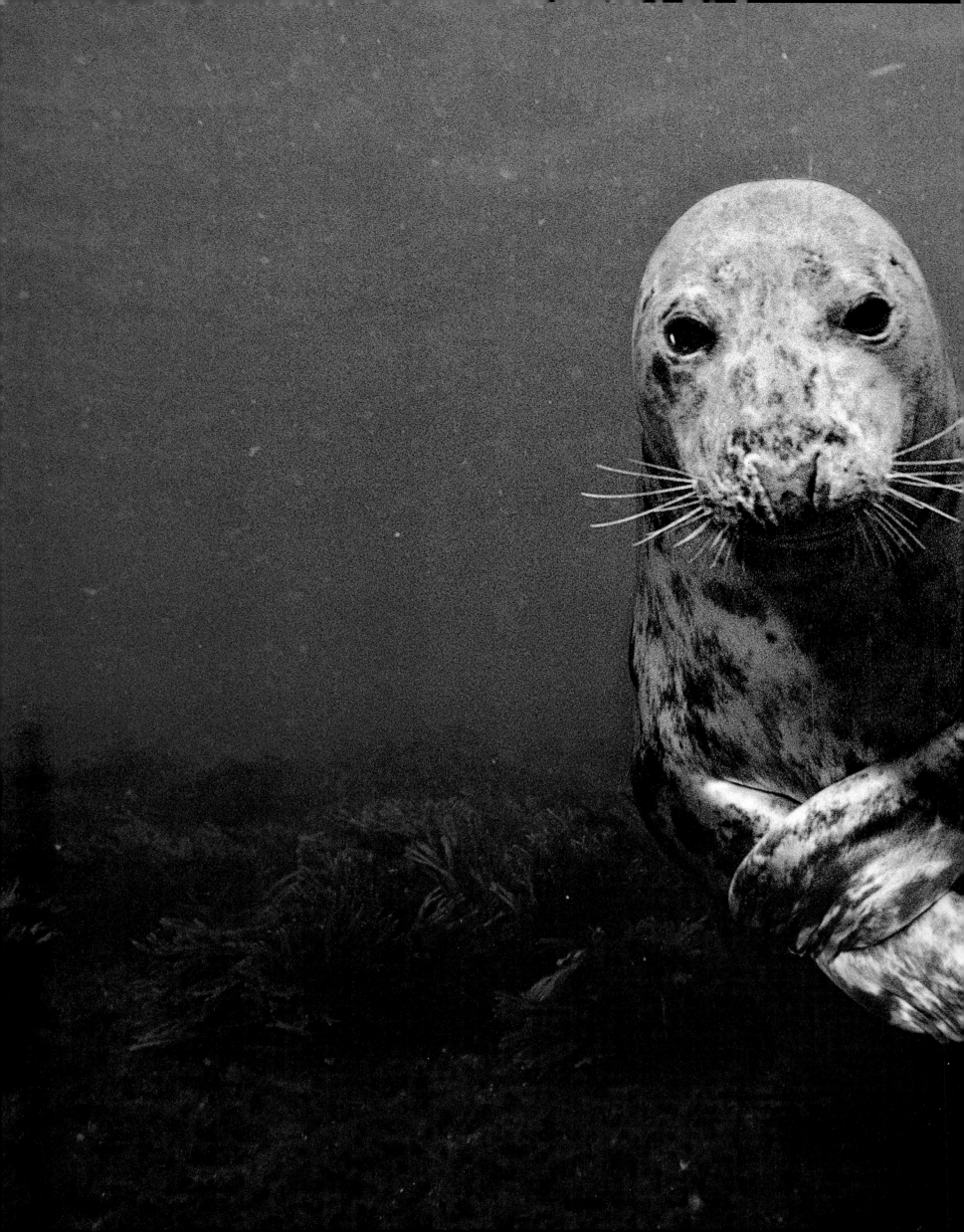

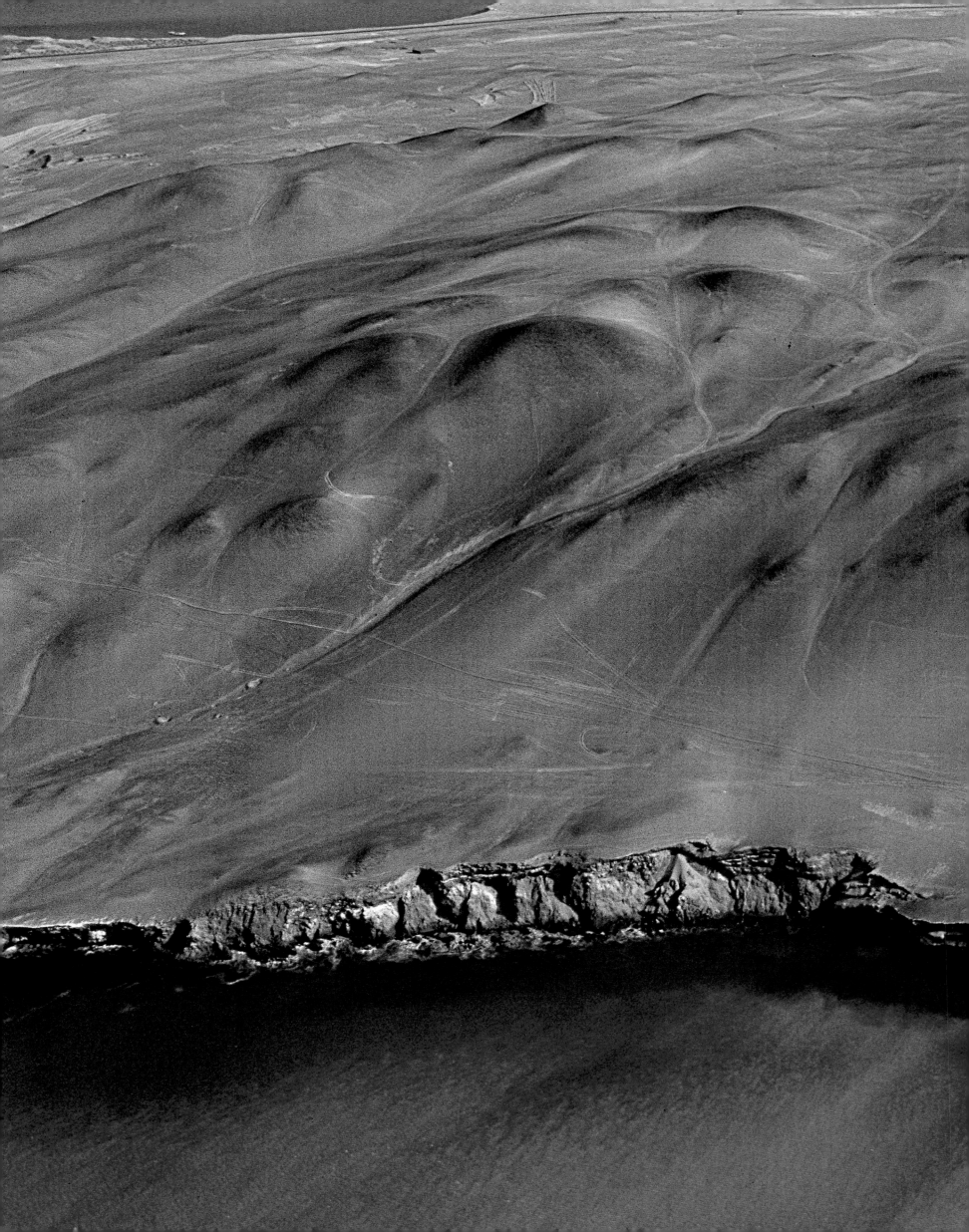

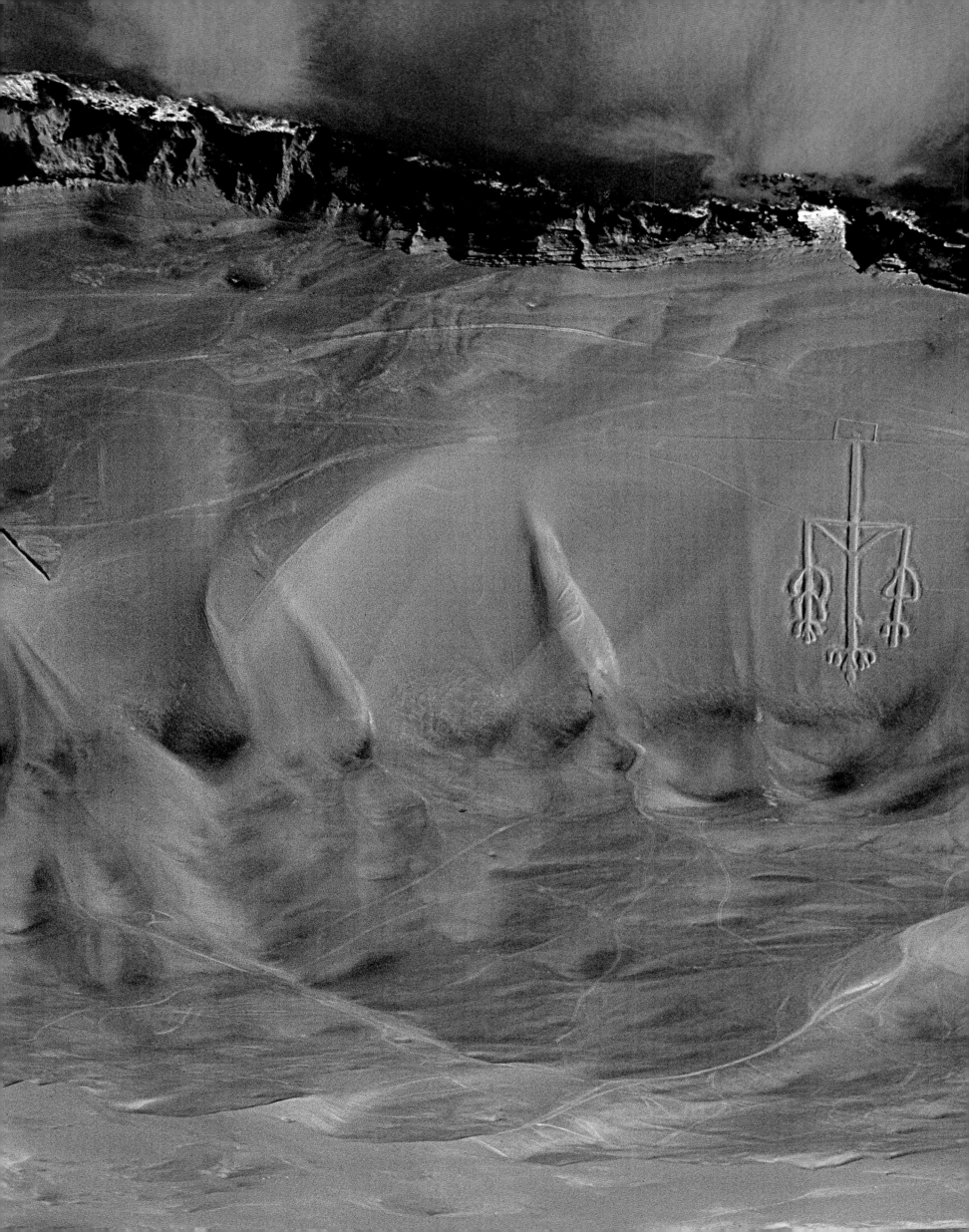

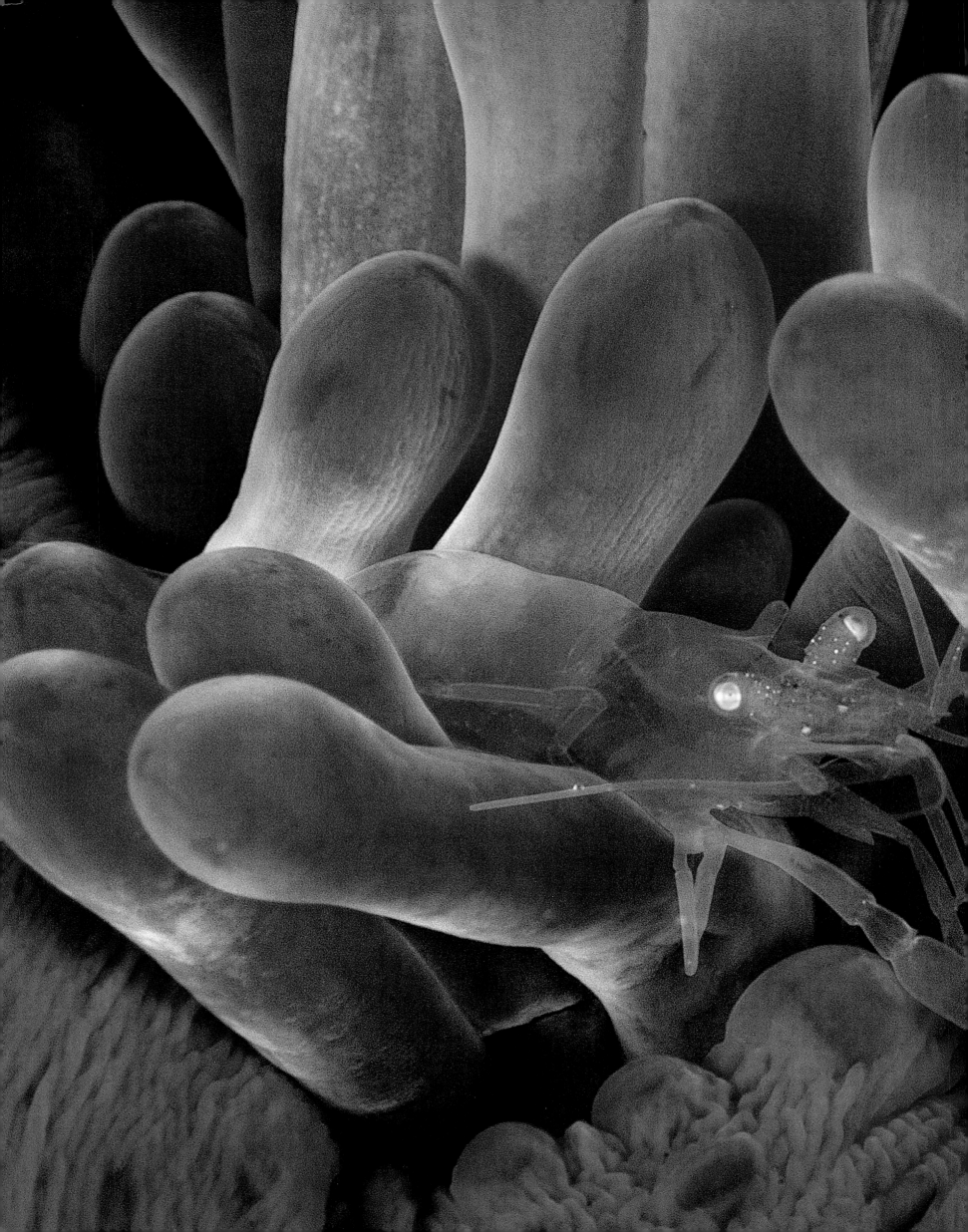

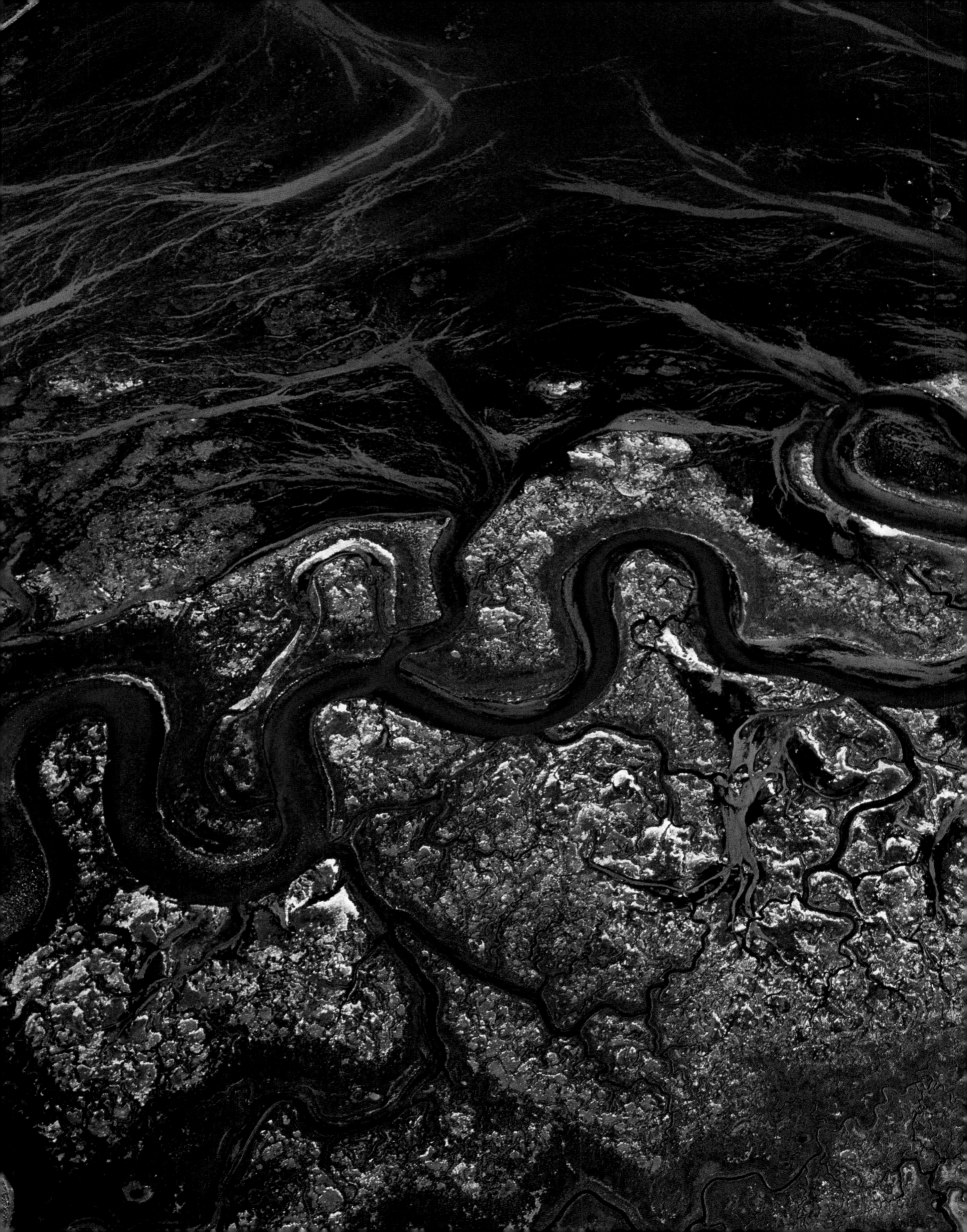

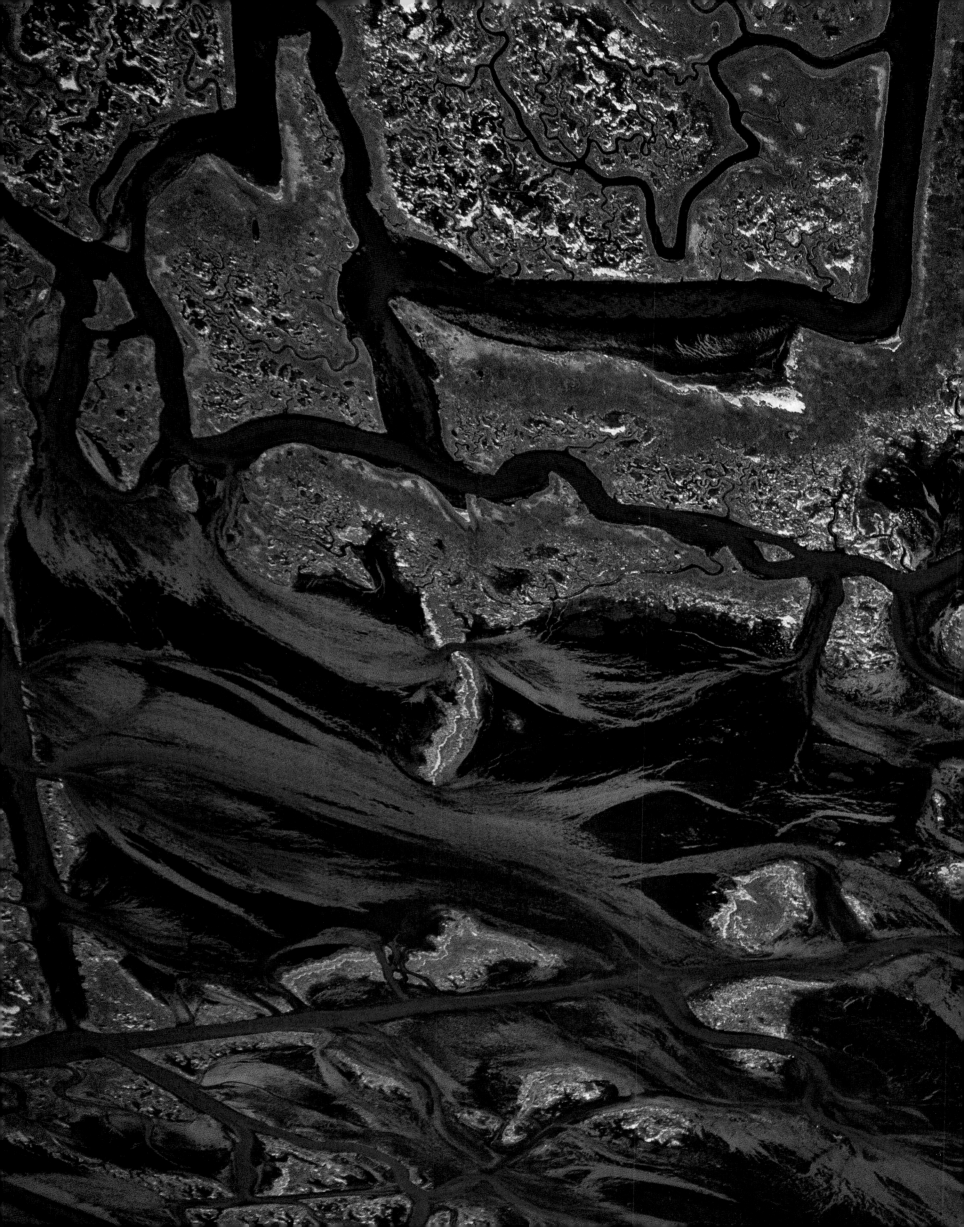

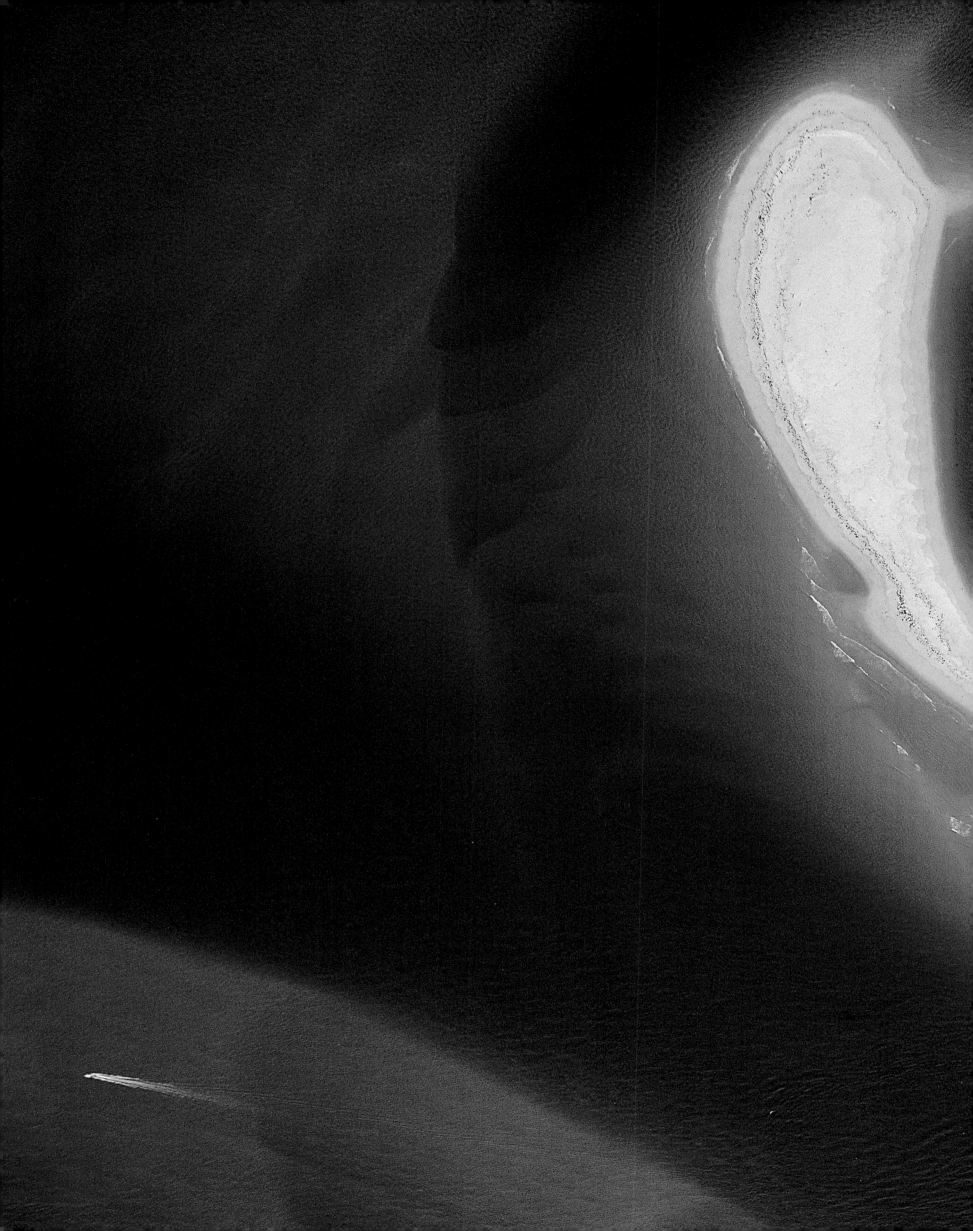

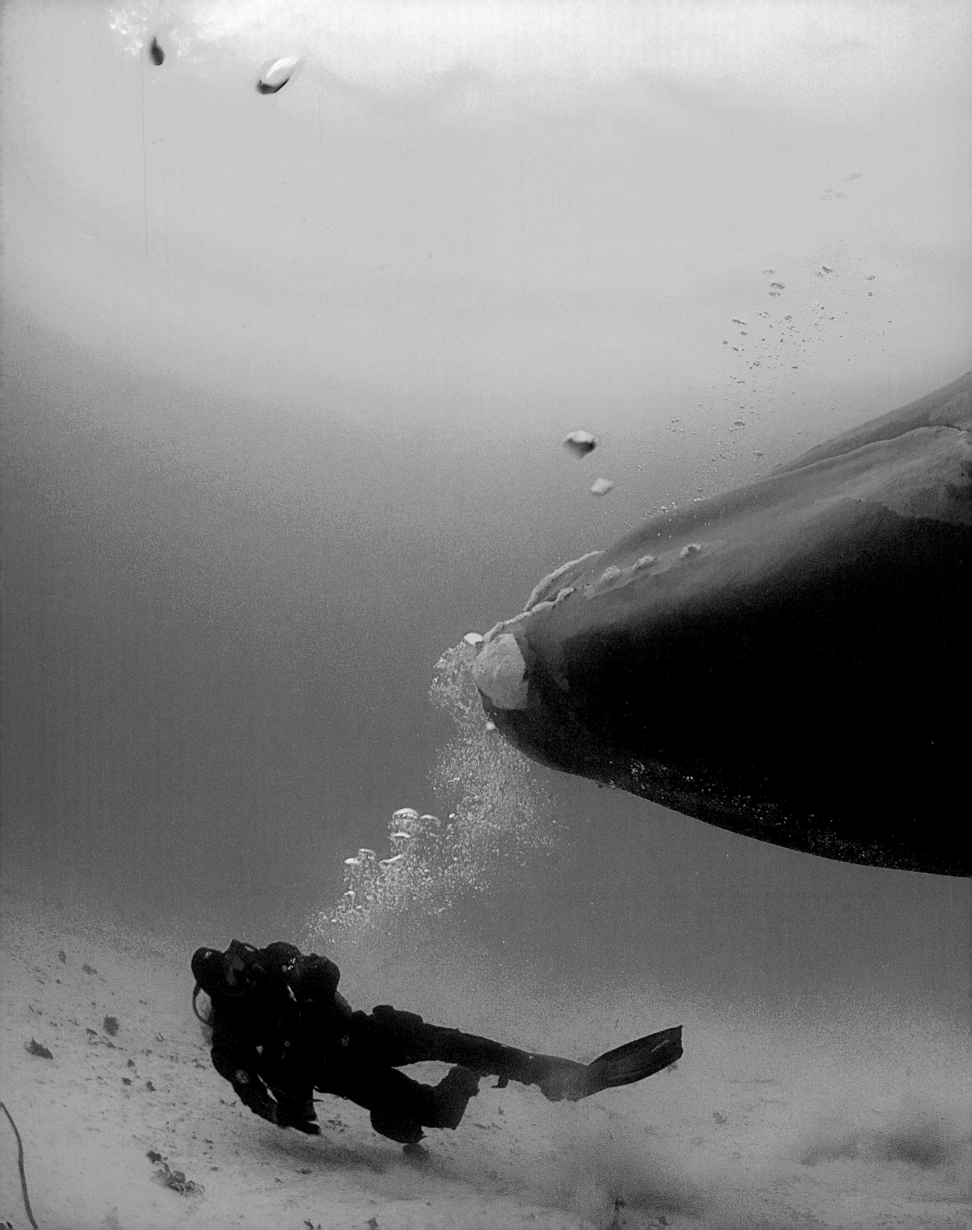

TOWARD SUSTAINABLE OCEAN MANAGEMENT

Is the die cast? Is humanity fated to make do with an ocean not only emptied of its fish, but practically sterile, ruled by jellyfish and microbes? Probably not, for the regenerative capacities of the marine environment—the likely cradle of terrestrial life—are considerable. Compared to the continents, this environment is more stable, less subject to extremes, protected from drought and ultraviolet rays, and easier to recolonize. According to many scientists, it could regain the abundant life that characterized it one or two centuries ago in just a few decades—so long as it is protected from certain harmful effects of human activities.

How? First, by using a tool universally lauded by scientists: marine protected areas. Marine protected areas are the oceanic counterparts of natural parks: zones where human activities are regulated in order to preserve the environment. But while the proportion of protected spaces on the continents is about 13 percent, it is far less in the oceans. In 2011, the total extent of protected marine surfaces was 1.6 million square miles (4.2 million square kilometers), divided over some seven thousand marine protected areas—or about 1.4 percent of the global ocean. And the percentage barely increases when you exclusively consider coastal zones, where marine protected areas are most numerous but only cover 7 percent of coastal waters.

MARINE PROTECTED AREAS

To gauge how low this figure is, you have to realize that specialists estimate that between 25 percent and 50 percent of the ocean should eventually be protected in order for the oceans to be properly managed. In 2002, the Johannesburg Earth Summit set the objective of marine protected areas covering 10 percent of the ocean by 2012—obviously, the goal was not reached. Additionally, there are at least two snags to the current figures, however low. First, as on the continents, there is a significant proportion of "paper parks," areas whose protection is theoretically in effect, but is not enforced in the field due to lack of means or bad faith on the part of the authorities. Even when applied, legislation often remains too permissive. It is often restricted to a ban on certain highly destructive fishing techniques, the protection of a few emblematic species, or a limitation on certain particularly disruptive human activities. The proportion of marine protected areas truly banning the removal of anything from the sea is still tiny (0.08 percent of the ocean).

Yet it is essential that the authorities do not become discouraged, and continue to develop the global network of marine protected areas. The number of projects is constantly increasing, showing how effective this kind of initiative is when well applied. The example of Mombasa, Kenya, where a full protection area was set up on a coral reef in 1991, is enlightening. In thirteen years, the fish biomass has increased from 160 pounds per acre to 890 pounds per acre (180 kilos per hectare to 1,000 kilos per hectare)! A 2009 study of fifty-five marine protected areas around the world recorded an average biomass increase of 465 percent in entirely protected zones. The benefits extend to neighboring areas, where

Countless coral islets and continental islands dot the narrow channel that separates Queensland, in northeast Australia, from the Great Barrier Reef, some 20 miles (30 kilometers) offshore. At 42 square miles (109 square kilometers), Whitsunday Island is the biggest of the seventy-four islands making up the archipelago of the same name, which was discovered by the British navigator James Cook on Whitsunday in 1770. As with this beach on Whitehaven, the islands' shores are characterized by the exceptional whiteness of the sand, which is essentially composed of grains of quartz.

1.4 PERCENT OF THE OCEANS' SURFACE CONSISTS OF MARINE PROTECTED AREAS

Marine protected areas are the oceanic counterparts of the terrestrial natural parks, which cover approximately 13 percent of land surfaces.

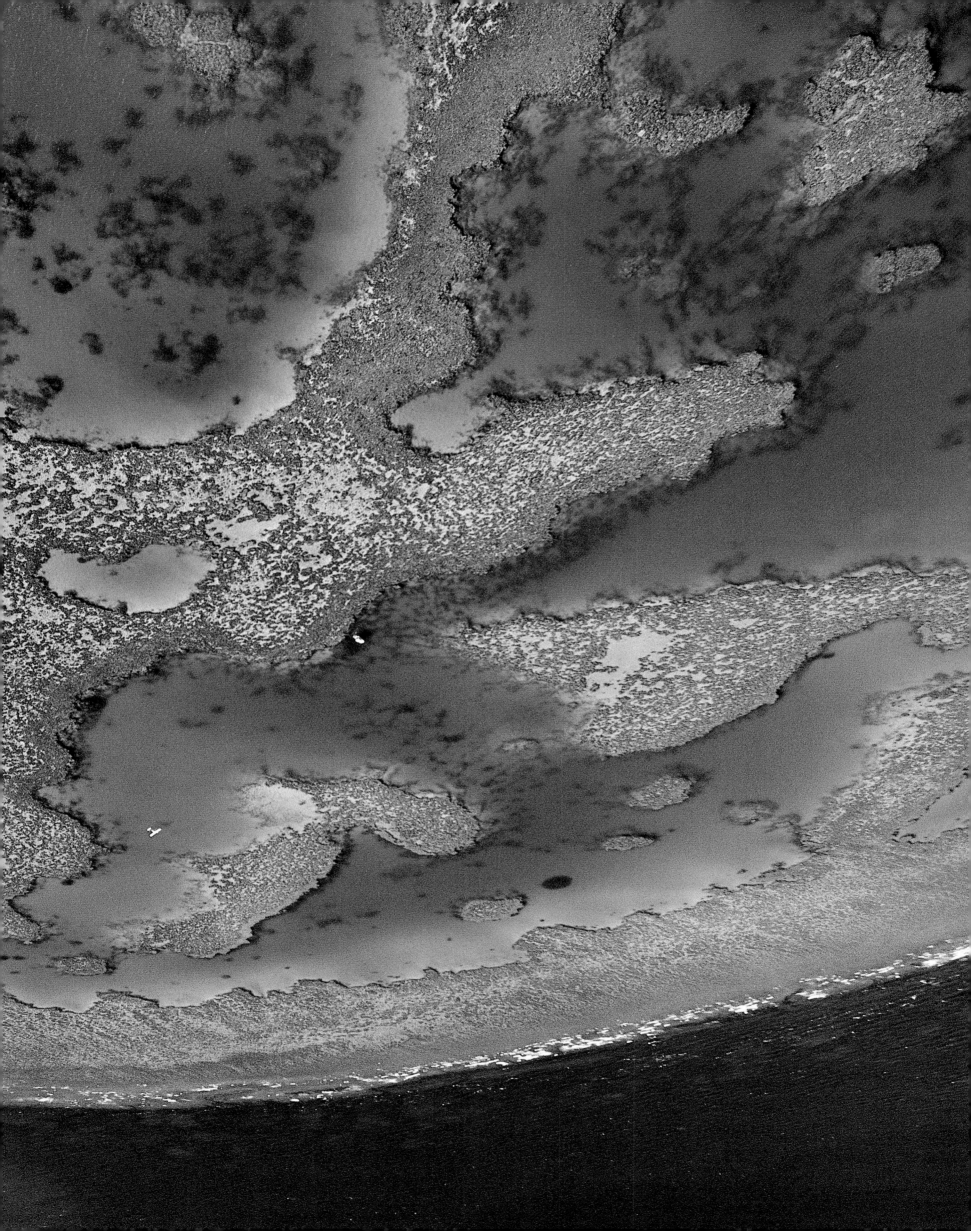

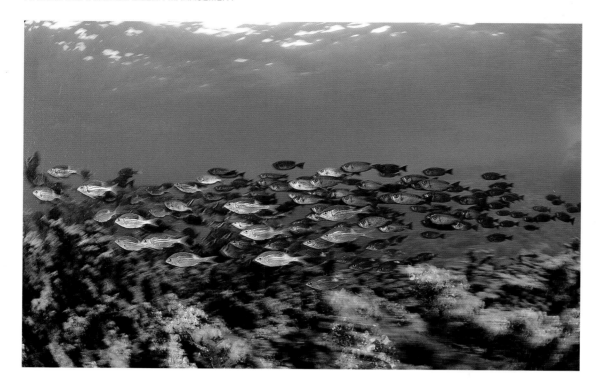

LEFT: **School of dark-banded fusiliers (*Pterocaesio tile*) above a coral reef**
Fusiliers form large schools in the reefs of the Indo-Pacific. These fish essentially feed on zooplankton: microscopic organisms suspended in the water column. They display a wide variety of colors, which change from day (blue/yellow) to night (red/green).

fishing is authorized, through the phenomenon of spillover, which is also documented in various studies. The increase of densities in the protected zone provides contiguous habitats with adults, larvae, and eggs, which spread for miles around, thus increasing the biomass available to fishermen.

This shows, once again, that the protection of the oceans is also in fishermen's best interest; additionally, it incites them to participate in the creation and management of these marine areas.

Essential to the ocean's regeneration is not only an increase in the quantity of marine protected areas, but also working toward the implementation of real marine protected area networks, which are interconnected and take into account the diversity of marine habitats. Some 150 highly diverse "ecoregions" have been described, according to climate, nature of the seafloor, currents, and depth. It is essential that at least 10 percent of each ecoregion be properly preserved. While coral reefs and mangroves are now—correctly—identified by decision makers as valuable environments, other habitats, such as underwater prairies, deep sea corals, and underwater mountains, to name only a few, are still little-known and poorly protected.

TWO EXCEPTIONAL INITIATIVES

Awareness is certainly growing. However insufficient, the global total of marine protected areas increased by 150 percent from 2002 to 2010. Since then, two exceptional initiatives have been launched. In April 2010, the United Kingdom decided to create a vast natural marine park encompassing the Pacific Chagos Islands and covering 210,000 square miles (640,000 square kilometers) (south of the Maldives, in the Indian Ocean). In June 2012, the Australian government announced an even more significant initiative: It increased the number of marine reserves from twenty-seven to sixty, for a total surface area of 1.1 million square miles (3.1 million square kilometers), and made the Great Barrier Reef Marine Park and the Coral Sea Marine Reserve into the largest contiguous protected marine zone in the world, stretching over 501,000 square miles (1.3 million square kilometers). Overall, more than a third of Australian seas will now be protected.

By comparison, only 21.5 percent of French mainland waters are protected—sometimes in name only—and only 1.15 percent of French overseas waters, despite the recent creation of the French Southern Territories national nature reserve and the Mayotte and Les Glorieuses marine parks (north of Madagascar).

6 PERCENT OF FISHERIES ARE CURRENTLY LABELED MSC
In 1997, the MSC label (for Marine Stewardship Council) was jointly implemented by the WWF and Unilever, in order to guarantee sustainable management of fisheries. The MSC label guarantees consumers reasonable fishing practices that are respectful of ecosystems and stocks, reduce incidental catches, and are in compliance with the laws in force.

Other major maritime nations are preparing projects, some of which are transnational, though significant resistance is at work everywhere, sometimes from industrialists, most notably in the fishing sector, and sometimes from local communities hostile to any restriction on their activities.

ECOSYSTEM-BASED MANAGEMENT

Obviously, the move to sustainable ocean management does not only consist of creating more and more marine protected areas, however indispensable they may be. It is also important to control what takes place in authorized fishing zones and to pay attention to the continents, which are closely connected to the marine environment. Concerning the management of fisheries, it is necessary to promote what is known as ecosystem-based fishery management. The regional fishery management organizations (RFMO) that determine regulations for fishing and capture quotas, too often reason exclusively by species: tuna, salmon, hake, cod, etc. It is indispensable to work toward more comprehensive management. In order to manage a fishery in an ecosystem-based manner, one must notably ensure that the needs of predators—fish, marine mammals—are met when evaluating the potential for catches. It must also be ensured that the techniques employed do not have a harmful effect on the rest of the ecosystem, such as on other organisms sharing the same habitat. Ecosystem-based management of fisheries requires ecologists to be permanently involved in monitoring fishing. For example, knowing the number and age of tuna fished is not enough; dolphins, sardines, and even plankton must also be monitored to truly control fishing's impact.

Once we have determined the quantity of fish that can be removed without deteriorating the ecosystem—the TAC (total allowable catch)—the next question to be

ABOVE: **Combtooth blenny hiding from predators, Kingman Reef, Pacific Ocean, United States**
Blennies spend most of their time on the seafloor, where they find food and shelter. These fish hide in crevices in rocks, between corals, under sediment, or in empty shells. They are characterized by their imposing eyes and more particularly by their pectoral fins, which allow them to move across the seafloor. The combtooth blenny, which is just about an inch long, is distinguished from other blennies by its jaw.

LEFT: **Catamaran in the Society Islands, French Polynesia** (17°00' S, 150°00' W)
Indonesian waters contain 18 percent of the coral in the world, while Australia has 17 percent; the Philippines, 9 percent; and French overseas territories, 5 percent. Coral formations cover a total of 5,513 square miles (14,250 square kilometers), including those that carpet the clear depths of the Polynesian archipelago in the Pacific Ocean, over which this catamaran seems to be flying.

answered is how they will be shared between fishermen. This is a difficult problem to resolve and most potential solutions have drawbacks.

Giving free rein to competition between fishermen until the TAC is reached incites them to overequip themselves in order to capture the greatest share of the resource possible. Limiting the fishing period has the same effect. Many economists are now leaning toward exchangeable individual quotas, a system by which each fisherman is given (or must buy from the state) the right to catch a certain quantity of fish. He can space out this quantity over the year as he sees fit and potentially resell his rights to a third party. In this case, fish become a kind of capital for the fisherman, including when still in the sea, and the fisherman is therefore encouraged to preserve it. This system has yielded positive results, but it requires adjustments to minimize the risk of having industrialists use their financial power to buy all the individual quotas.

THE EXAMPLE OF BLUEFIN TUNA

This system depends on the implementations of quotas sufficiently restrictive to effectively limit fishing to levels compatible with the species' reproduction. Representatives of the fishing industry pressure national and international authorities in national ministries—such as in Brussels—to make these quotas as large as possible. Just as every fisherman defends his interests against those of his fellow fishermen by trying to catch as much fish as possible, every government defends its industry's short-term interests by trying to obtain the highest quotas. Even if this means putting a mortgage on the future. In this sense, the case of bluefin tuna is representative. ICCAT (International Commission for the Conservation of Atlantic Tunas) has been responsible for managing the fishing of this species in the Mediterranean and Atlantic since 1969. In 2010, it allowed 13,500 tons to be fished (including close to 2,000 tons for France). Despite the fact that bluefin tuna stocks have dropped by 90 percent in the last fifty years, the quota was only lowered by 600 tons for 2011 (to 12,900 tons). At the same time, environmental NGOs are basing themselves on scientific data to call for a drastic reduction of 6,000 tons, to give the stock a reasonable chance of building up again.

Additionally, not all captured fish is declared. According to a study by the Pew Environment Group, 12,373 tons of bluefin tuna were officially captured in 2009, but 32,564 tons were put on the market—which reveals the extent to which fraud is endemic. As the case of bluefin tuna demonstrates, any efficient management system will require independent scientific monitoring and governmental supervision along with putting the

SURFRIDER

In 1984, a handful of worried surfers mobilized in Malibu, California, to preserve their favorite beach from pollution. They had no idea that they were laying down the groundwork for what would become the Surfrider Foundation, one of the most important NGOs for the protection of coastlines and oceans. Nearly thirty years after it was founded, it now has sixty thousand members around the world.

The members of Surfrider defend the ocean, but are first and foremost its "users," committed to conserving its use for recreation and sports. Directly exposed to the pollution they denounce, they carry out numerous awareness campaigns by cleaning beaches or fighting for the quality of swimming water. In France, for example, Surfrider gained prominence in the late nineties by publishing its "black flags," symbols of the coastline's insalubrity, in response to "blue flags," a tourist ecolabel awarded to beach towns and marinas for the quality of their water.

Surfrider is supported by a highly active watchdog network, the Keepers of the Coast. Throughout Europe, these volunteers investigate harm to the ocean and combat it with Surfrider's logistical, legal, scientific, and media support. Thanks to this system, the NGO considers forty-two of the campaigns led by Keepers of the Coast over the last four years to be victories, including the cancellations of a project to pour dredging mud in Quiberon Bay, in Morbihan, or of the extension of a marina in Sweden.

regulations in place. Without monitoring, an unexpected environmental process could be set off at any time—given the complexity of ecosystems—and reduce our efforts to naught. Without supervision, the temptation for fishermen to fish more than they are allowed is obviously strong. But both monitoring and supervision are costly activities, which nations are trying to unload, though it is an accepted fact that self-supervision by professionals does not work. Nonetheless, there are a few examples of well-managed fisheries that could serve as starting points for reestablishing sustainable fishing on a global scale. One could cite the example of krill fishing in Antarctica, carried out under the authority of an organization called the Commission for the Conservation of Antarctic Marine Living Resources (CCAMLR). Boats seeking to fish krill must request to do so from CCAMLR and be equipped with geolocation systems allowing their exact position to be identified at all times; they often carry independent observers, and transmit the total figures for their captures to the authorities every few days. With this data and other information about the ecosystem, CCAMLR's scientific committee can ensure that the fishing does not cause damage, and potentially—as has previously happened—close zones that have been overfished and ask boats to continue their activities elsewhere.

In other words, regenerating the ocean requires getting involved on several fronts at once. Of course, on a fundamental level, success will only be guaranteed once man has profoundly changed his relationship to nature, moving from a predatory relationship to one of responsibility and genuine management. But until that happens, it is possible to obtain partial progress in a wide range of fields. And we have multiple tools to do so: sustainable consumption, support to preservation organizations, and political intervention through our elected officials.

For more information on this subject and a relevant excerpt from the film *Planet Ocean*, go to http://ocean.goodplanet.org/aires-marines-protegees/?lang=en

ABOVE: Aggregation of cubera snappers (*Lutjanus cyanopterus*) during the spawning period, Belize
Cubera snappers come together to couple at each full moon in the spring, from April to June. In May, when the reproduction period is at its strongest, between four thousand and ten thousand individuals rise to the surface to reproduce. The aggregation begins exactly forty minutes before sunset and ends ten minutes after. This phenomenon can be observed inside the Gladden Spit Marine Reserve, a zone where all captures are banned.

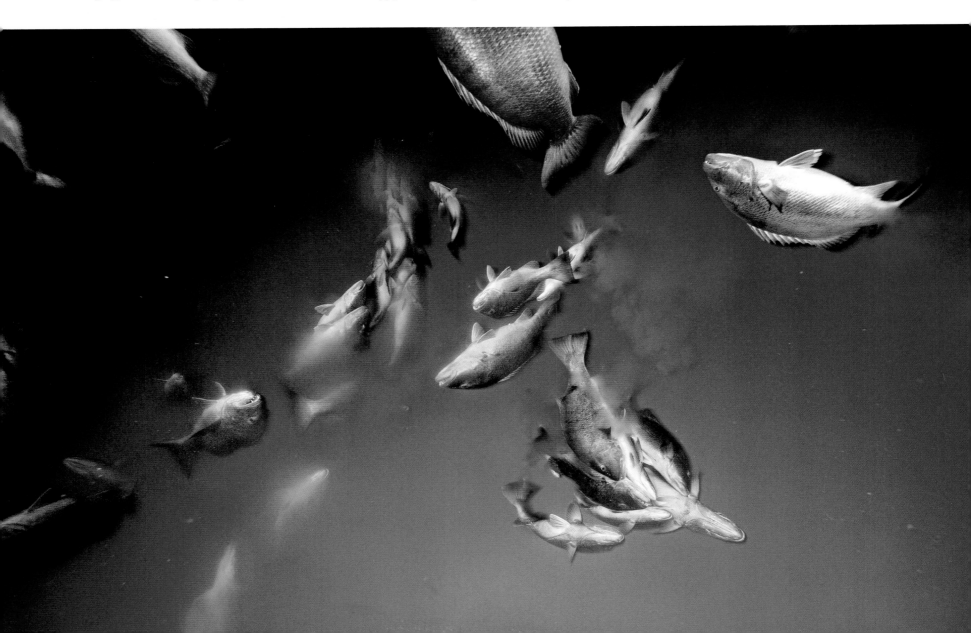

MAKING FISHERMEN PARTICIPATE

INTERVIEW WITH SANDRA BESSUDO

SANDRA BESSUDO has been fighting for years to protect Malpelo, a Pacific island some 300 miles (500 kilometers) from the coast of Colombia. She founded the Malpelo Foundation, dedicated to protecting the island and its waters, which harbor exceptional biodiversity and a shark population. Thanks to her efforts, the island has become a protected zone.

In 2010, Bessudo was appointed Colombia's Minister of the Environment, and later High Advisor for the Environment and Biodiversity for the President.

Why devote your life to protecting Malpelo Island?
As a natural site, Malpelo is a priority for Colombia and the entire planet! Like those of the Galápagos, this volcanic island's waters are a treasure trove of biodiversity. The island is particularly important for its huge schools of hammerhead sharks and silky sharks—animals that have always fascinated me. I discovered this fabulous place in 1987 and started organizing diving expeditions there in 1990. Malpelo is a forty-hour boat trip from the coast of Colombia, with no drinking water on site, so you really have to plan ahead. I started to see the ravages caused by fishing boats at that same time. That's where the battle started.

Your actions have been very successful.
I was lucky enough to meet Colombian President César Trujillo. We took the plunge together and he agreed to help me protect Malpelo. Then in 1995, under the presidency of Ernesto Samper, the island became a sanctuary for fauna and flora: An area reaching 6 miles [10 kilometers] around the island was protected. But there was still no concrete way of genuinely protecting it. I offered my services and started working with the national parks, in charge of Malpelo. Then I created my foundation to carry on the fight in a different way.

In 2006, the protected area was extended to 25 miles [40 kilometers] from the coast, which at the time made it the ninth-largest marine protected area in the world. The International Maritime Organization also categorized the area as a Particularly Sensitive Sea Area [PSSA]; ocean liners are no longer allowed to go there. That same year, years of effort paid off and Malpelo was added to UNESCO's World Heritage List.

Why is this international recognition so important?
First of all, it reinforced what we had undertaken. But it also confirms the fact that protection of the oceans is an issue that reaches beyond borders. In fact, in 2004, four nations signed an agreement known as the San José Declaration, which established the Marine Conservation Corridor of the Eastern Tropical Pacific, also known as CMAR: a large marine area covering 521 million acres [211 million hectares], including five national parks and connecting the islands of Cocos (Costa Rica), Coiba (Panama), Malpelo and Gorgona (Colombia), and the Galápagos (Ecuador). This is particularly important for sharks, which are known to migrate. Taking protective measures in a single place is not enough for them.

International cooperation also takes other forms: The presidents of Colombia and Costa Rica joined together to ask CITES to categorize the hammerhead shark as a protected animal—so far without success.

"Protection of the oceans is an issue that reaches beyond borders."

What is the biggest threat to Malpelo?
Malpelo Island is isolated and deserted. In one way, that makes things easier, but we have a lot of problems with illegal fishermen who come from the coast. At the beginning, I would climb on boats to stop them, but the commander of the Colombian Navy asked me to stop because I was in danger of being killed. The Navy then gave me a ship that had been seized during an operation against drug trafficking. We fixed it up and started patrolling. Recently, the Navy gave us a second boat. But our system remains fragile. Last year, when two of our boats were damaged at the same time, the illegal fishermen quickly returned. In Colombia, where people eat shark meat, local fishing is important. Yet now fishermen come from all over the world, and they take everything they can find. They know that shark fins pay. And mafias encourage their illegal trade.

What has becoming a government minister changed?
When I was appointed minister, a lot had already been put in place. But being part of the government makes it easier for me to talk to the president and politicians, to inform them and make them aware . . . and that is essential. Because if they don't know the problems, they can't take care of them. But being a minister also means spending my life in Parliament defending myself from attacks, and I am not sure that is the best way to make these issues move forward. I chose to remain a High Advisor to the President and now I run the Presidential Agency for Social Action and International Cooperation. A significant part of the budget is dedicated to the environment, to the oceans or reforestation, for example.

What advice would you give to someone who wanted to create a marine proteced area?
Today, with the world's population rapidly growing, it is essential to remind people how important the protection of the oceans is to ensure food security. We have to explain that protected areas also serve to repopulate neighboring areas and can therefore be beneficial to fishermen. Because fishermen—who are often extremely poor—do not know all that. They have to be told, again and again. But that's hard to explain to people who are hungry and whose only goal is to feed their kids at night. Maybe we should also not have recourse to total protection. There are other solutions that authorize sustainable fishing practices—which are also useful to make the population participate. On Malpelo, we implemented a series of sanctions: Boats can be confiscated, there are heavy fines . . . Yet if we limit ourselves to imposing constraints, it is much harder to make fishermen participate.

Tévennec Lighthouse in the Raz de Sein, Finistère, France (45°04'17" N, 4°04'17" W)

Many legends tell of the curses that afflict the isle of Tévennec at the western tip of Finistère. Yet this lighthouse, inaugurated in 1875, has made the area safe. Its light was automated in 1910 and has been powered by solar panels since 1994. Since the keepers of the Cordouan lighthouse in Gironde retired in 2012, the profession has died out and there are no more state lighthouse keepers watching over France's lighthouses.

Yellowhead jawfish (*Opistognathus aurifrons*) incubating its eggs in its mouth, British Virgin Islands, United Kingdom

This little fish, around 4 inches (10 centimeters) long, can be found in the waters of Florida, the Bahamas, the Caribbean Sea, and the Gulf of Mexico. It lives on the seafloor, where it digs tunnels through the coral sand. It spends most of its time in a vertical position above its tunnel or only peeking its head out of the hole. Its food source is zooplankton, which it sucks into its tunnel with its movements. This genus is known for incubating its eggs directly in its mouth for about ten days.

Shark Bay: Henri Freycinet Harbour, Western Australia (26°32' S, 113°37' E)

Shark Bay has been on UNESCO's World Heritage List since 1991, due to its exceptional natural landscape. It is a sparsely populated area, with barely one thousand people living along its 930 miles (1,500 kilometers) of coastline. Its inhabitants generally survive thanks to tourism, fishing, and cattle breeding.

Two-spot red snapper (*Lutjanus bohar*) swimming near a school of surgeonfish (*Acanthuridae*), south of the Line Islands, Republic of Kiribati

This snapper species can be up to 30 inches (80 centimeters) long. Juveniles have two white spots on their dorsal fins, to which they owe their name. Young two-spot red snappers are herbivores, while adults feed on other fish such as surgeonfish. Snappers generally live in schools, above the reefs and the sandbanks.

Louis S. St-Laurent icebreaker in Resolute Bay, Nunavut, Canada (74°42' N, 95°18' W)

In service since 1969, the *Louis S. St-Laurent* is the biggest and oldest icebreaker currently in use in Canada. With a reinforced hull, powerful propulsion (20,000 CV), and a projecting bow, it moves through sea ice by cracking and breaking the ice under its weight. It opens maritime routes to supply the most northerly human settlements. With ice shrinking under the effect of global warming, new navigable routes could be opened, including the famous Northwest passage.

School of Achilles surgeonfish (*Acanthurus achilles*), Vostok Islands, Republic of Kiribati

Achilles surgeonfish are tropical fish inhabiting Oceania's coral reefs. The bright orange spot near their caudal fin is a sign of sexual maturity. These fish principally feed on the algae that develop on the corals' surface. By doing so, they contribute to the reef's health, preventing it from being invaded by algae.

Eroded plateau, Poike Peninsula, Easter Island, Chile (27°06' S, 109°14' W)

Erosion has stripped away the superficial layers of soil, revealing volcanic bedrock. Easter Island was once covered in giant palm forests. But in the fifth century, this 66-square-mile (171-square-kilometer) island was colonized by Polynesian populations, who gradually cleared the entire island to build homes, sanctuaries, and the famous gigantic statues of faces known as moais. In the early twenty-first century, immigration and tourism are bringing new threats to the island, which was added to UNESCO's World Heritage List in 1995.

Atlantic bluefin tuna (*Thunnus thynnus*) in a fattening cage, Mediterranean Sea, Spain

According to the most recent estimates, the population of Atlantic bluefin tuna in the Mediterranean has been reduced by 50 percent over the last forty years, essentially due to the pressure from overfishing and captures of young tuna for fattening. Mediterranean bluefin tuna is categorized "endangered" on the IUCN Red List of Threatened Species.

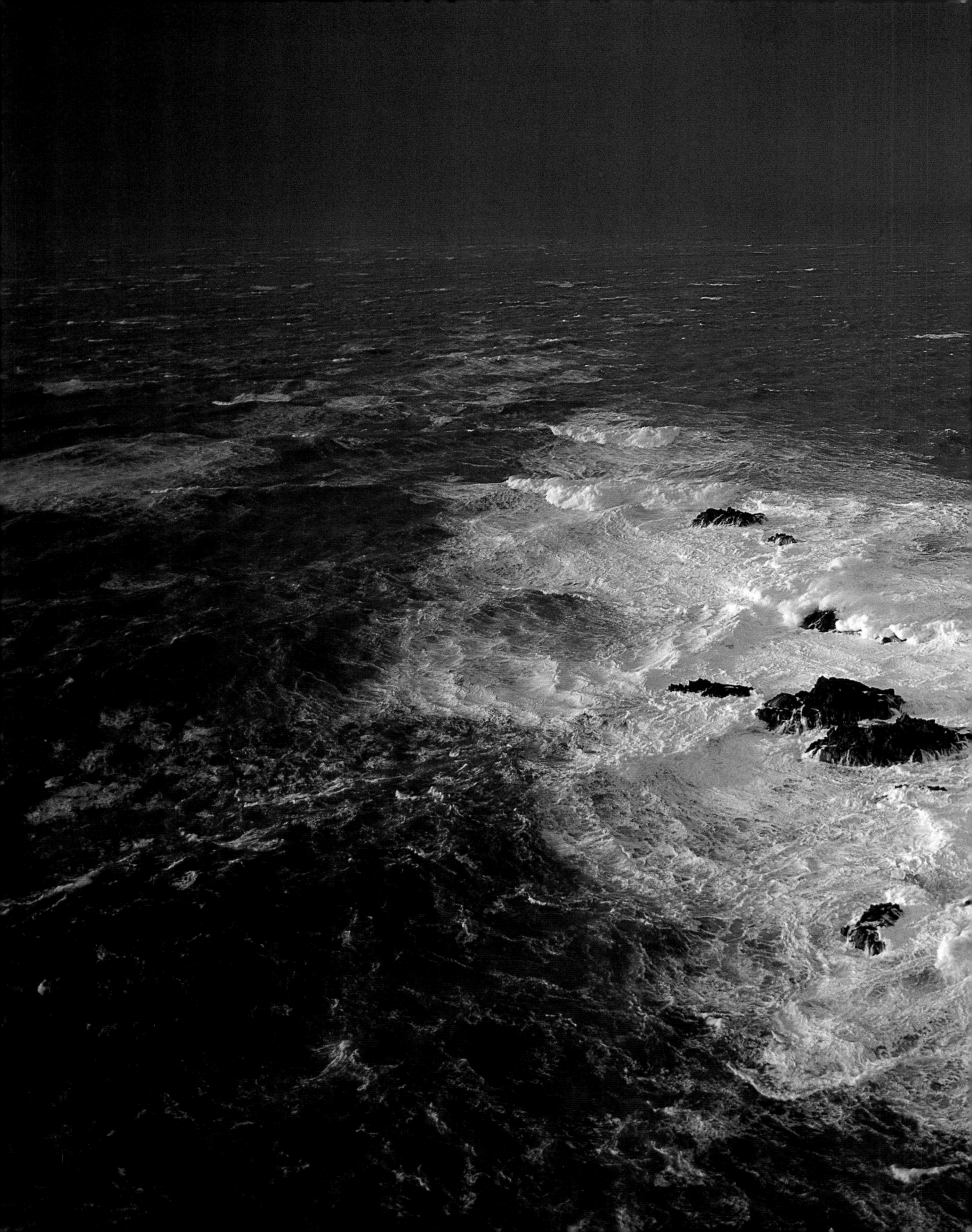

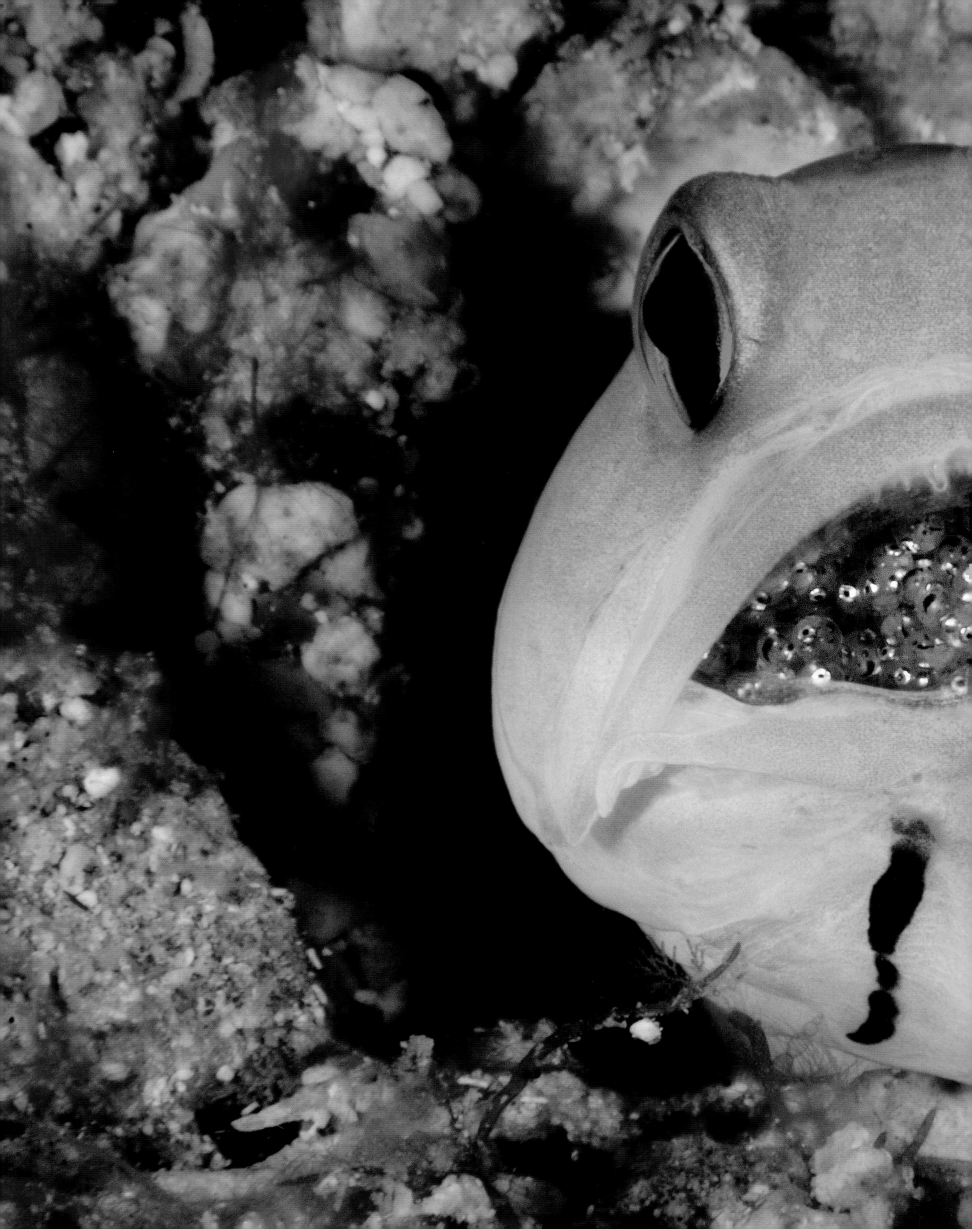

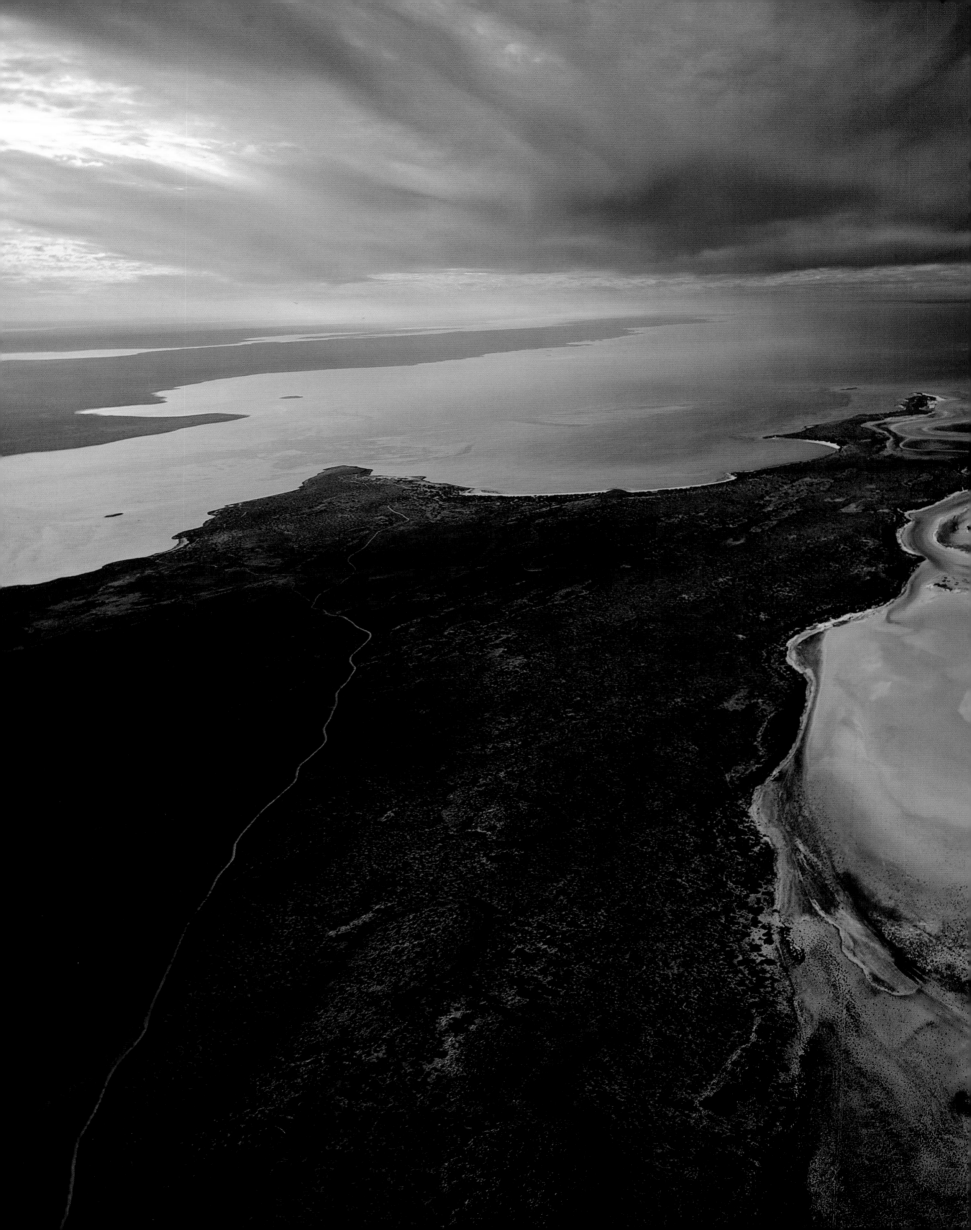

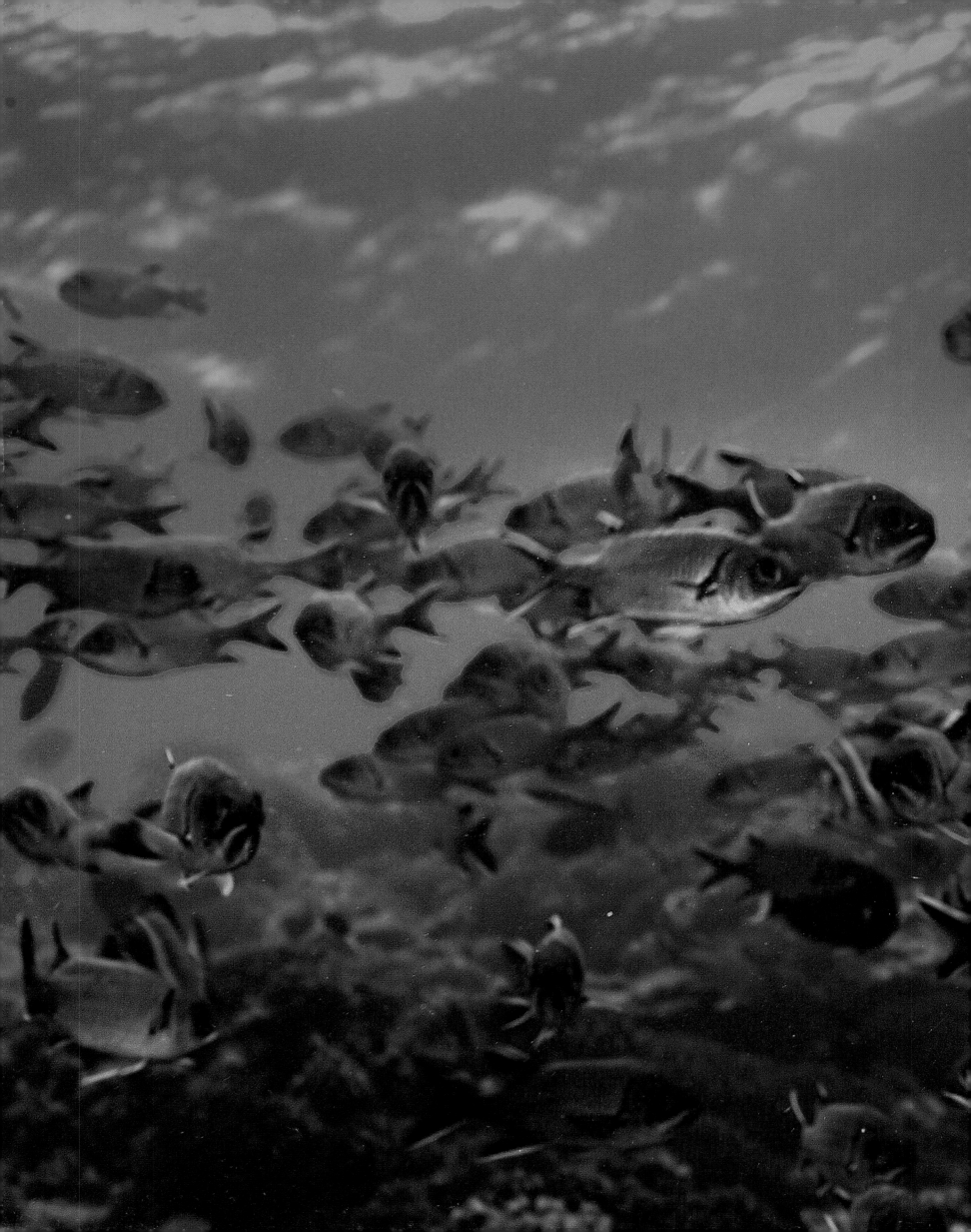

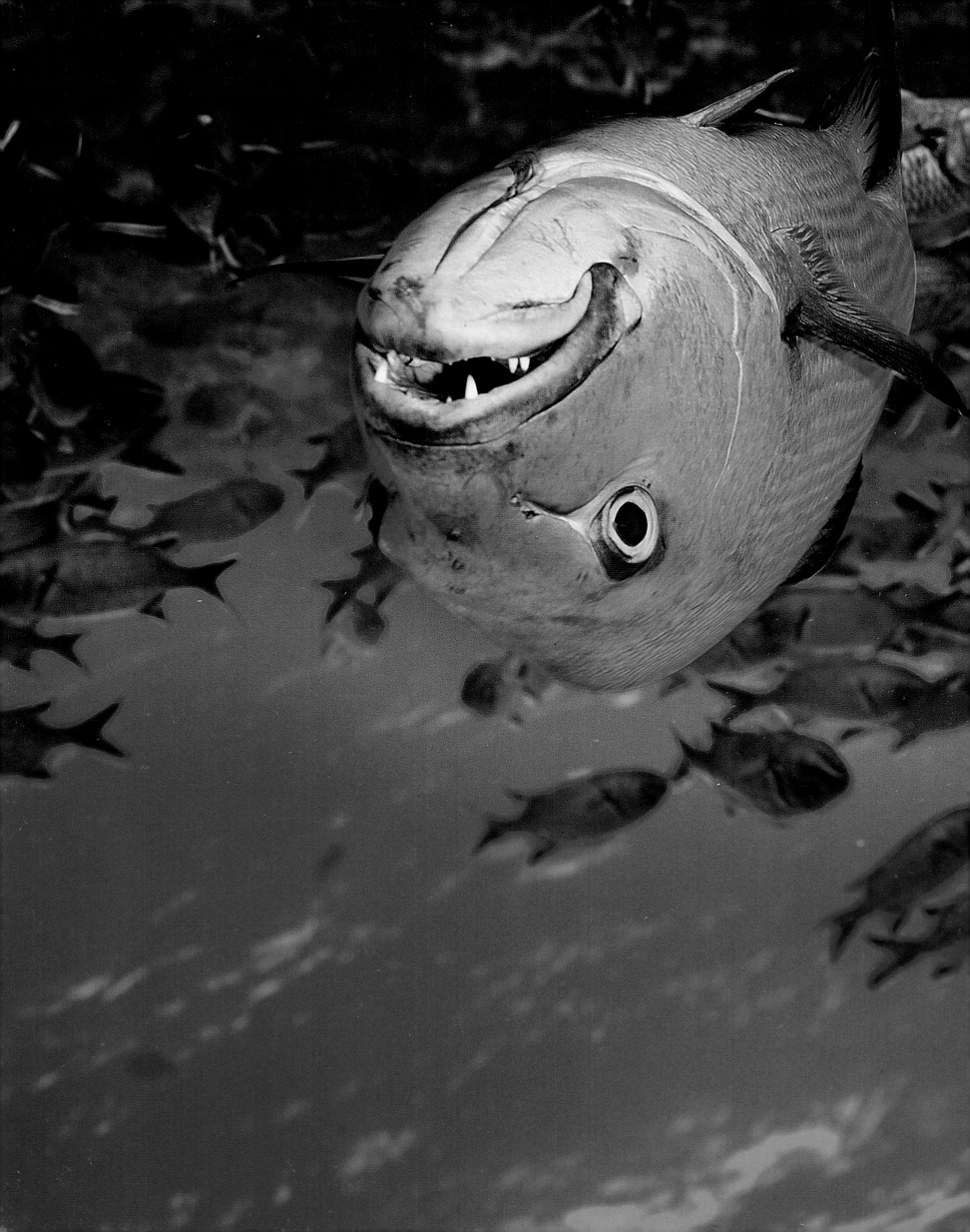

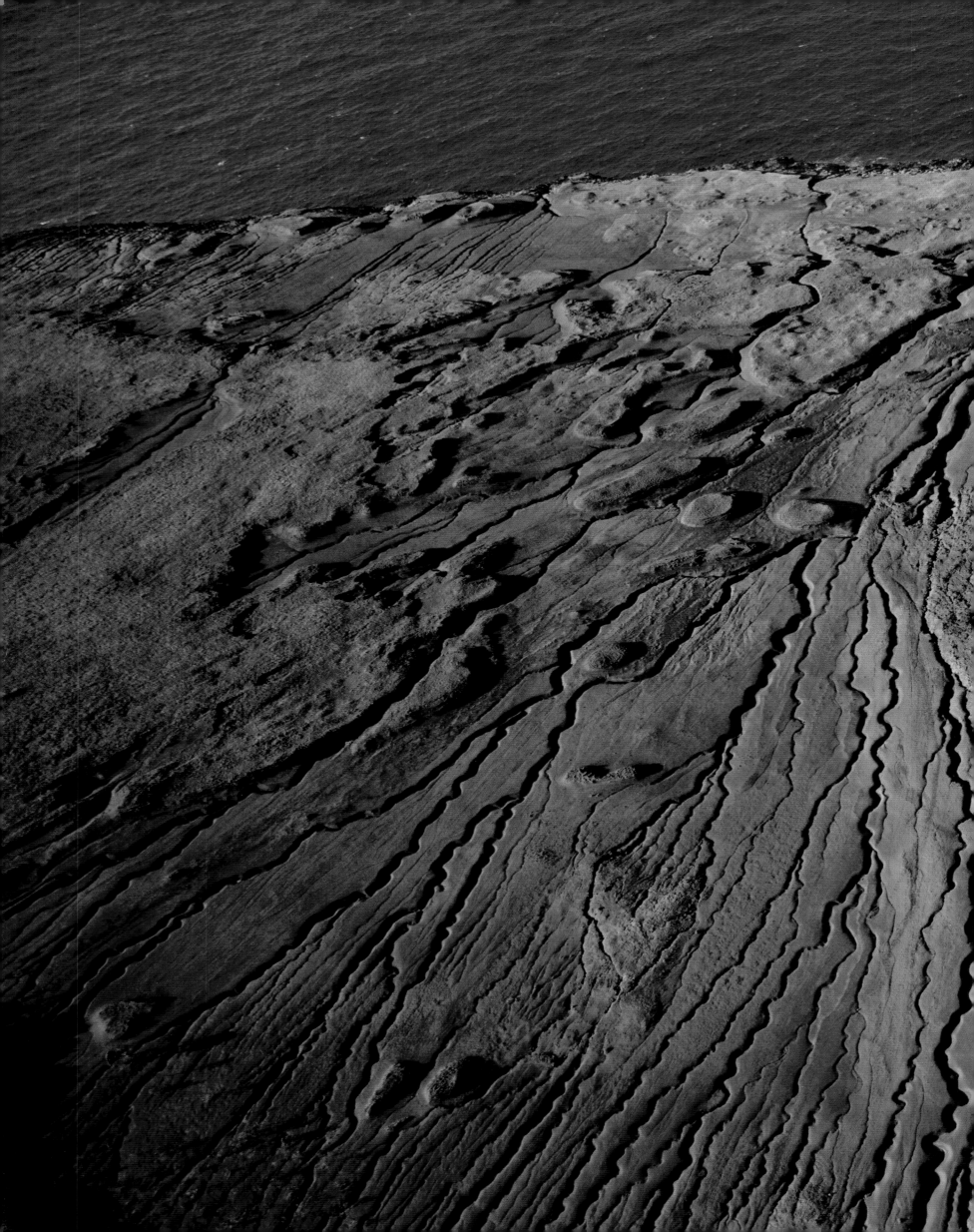

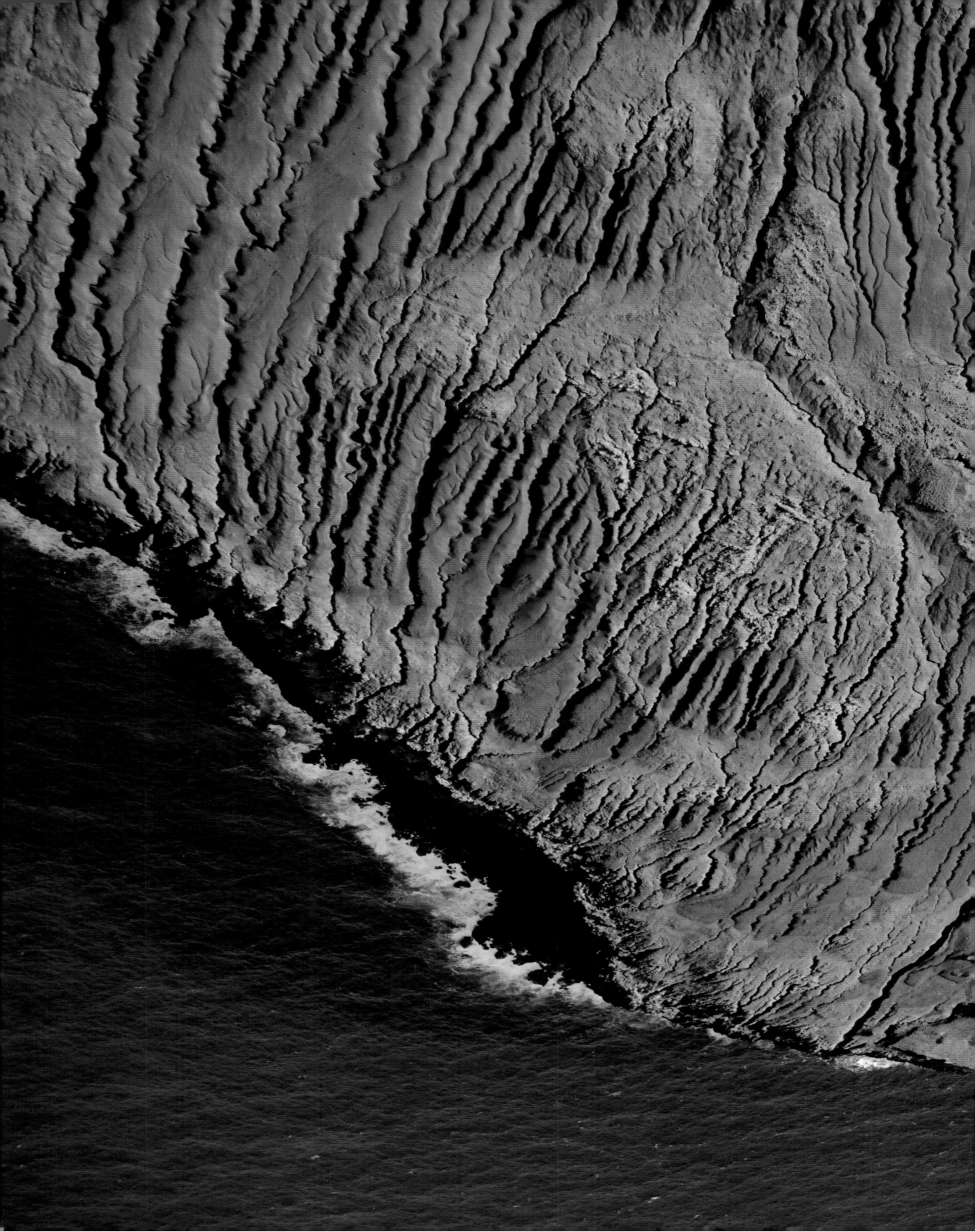

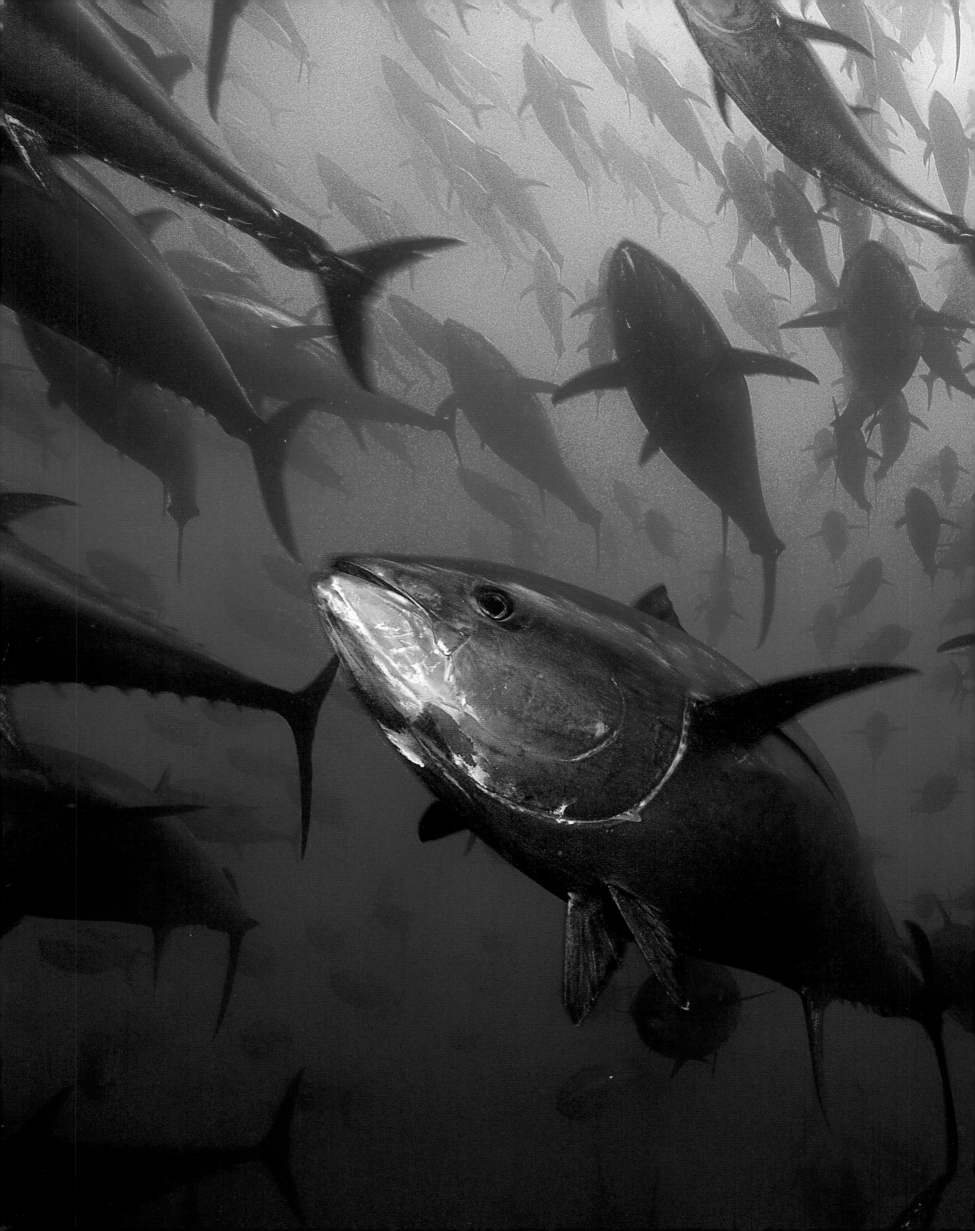

A NEED FOR GOVERNANCE

Will we be able to save the oceans, and by doing so save ourselves? We don't know. Yet we do know the solutions, which are detailed in this book: marine protected areas, fishing quotas, sustainable consumption and fishing, fighting pollution and global warming. The issue is not so much a scientific or technical one as it is a political one—in the widest sense. It is not too late: The oceans have a remarkable capacity for regeneration.

The late twentieth century witnessed a series of international agreements that seemed to point the way to reasonable protection of the oceans: the 1971 Ramsar Convention on wetlands; the 1973 MARPOL convention on the prevention of oil slicks, and several related texts; the 1946 International Whaling Commission and the 1986 moratorium on whale hunting; the 1982 United Nations Convention on the Law of the Sea, which came into force in 1994; and the 1989 Basel Convention on the transportation of hazardous waste. Other more general conventions also touched on the oceans, such as those on trade in endangered species (CITES), in 1973; biodiversity, in 1992; global warming, also in 1992; and the Stockholm Convention on Persistent Organic Pollutants, in 2001.

Since the beginning of the twenty-first century, this process has come to an end, though more local agreements, on the management of fishing zones, for example, have been signed. International conferences on the environment keep yielding negligible results: hollow declarations, devoid of concrete or restrictive applications. The International Summit in Rio, in June 2012, was supposed to be a milestone, twenty years after the first Rio Summit laid the groundwork for sustainable development. Concerning the oceans, the summit was supposed to address the governance of international waters, but the final declaration referred any decision to a work group charged with elaborating an agreement by 2014.

It appears that the change in the international balance of power—in other words, the emergence of new giants such as China and Brazil, as well as most countries' desire to refuse any outside interference, including the United States—is now preventing the creation of any major international agreement on the oceans. It is to be feared that such an agreement is no longer even a pipe dream, but rather an anachronism.

THE INTERNATIONAL WHALING COMMISSION

Despite all its limitations, the creation of the International Whaling Commission, to take only one example, demonstrated what such an international agreement could yield. In 1986, international mobilization and the catastrophic situation of several populations of whale species led to a moratorium on whale hunting—with significant exceptions. Granted, the importance of whale hunting had become secondary and whaler fleets were already on the decline: Neither whale blubber—used for certain lubricants and public lighting in the nineteenth century—nor whale meat were still truly indispensable and were already being replaced by more effective or less costly alternatives, thanks to hydrocarbon and aquaculture.

OPPOSITE: **Fishermen in pirogues in the Gulf of Guinea, Ivory Coast** (4°58' N, 4°27' W)
Small-scale fishing, also known as pirogue fishing, is practiced along the Ivory Coast's 310-mile (550-kilometer) coastline and the vast lagoons of the eastern coast. About 90 percent of the roughly ten thousand fishermen on the coast are of Ghanaian background. Fishermen use long pirogues between 26 and 60 feet (8 and 18 meters) long, equipped with an outboard motor, and are based out of Abidjan or Grand-Bassam. They generally fish at night, using gill nets and purse seines stretching hundreds of feet. This small-scale fishing provides about 60 percent of the country's fish production.

70 PERCENT OF THE OCEANS' SURFACE IS OUT OF JURISDICTION
According to the United Nations Convention on the Law of the Sea, in the high seas—the part of the oceans not controlled by any state—the freedom of the seas prevails: freedom to navigate, fly over, lay cables, build artificial islands, carry out scientific research, etc. Ships are subject to the laws of the state whose flag they fly and only that country's warships can control them (except in cases of piracy). This freedom opens the way to pillage and overexploitation. Environmentalists are looking for a way to regulate ships based on environmental factors.

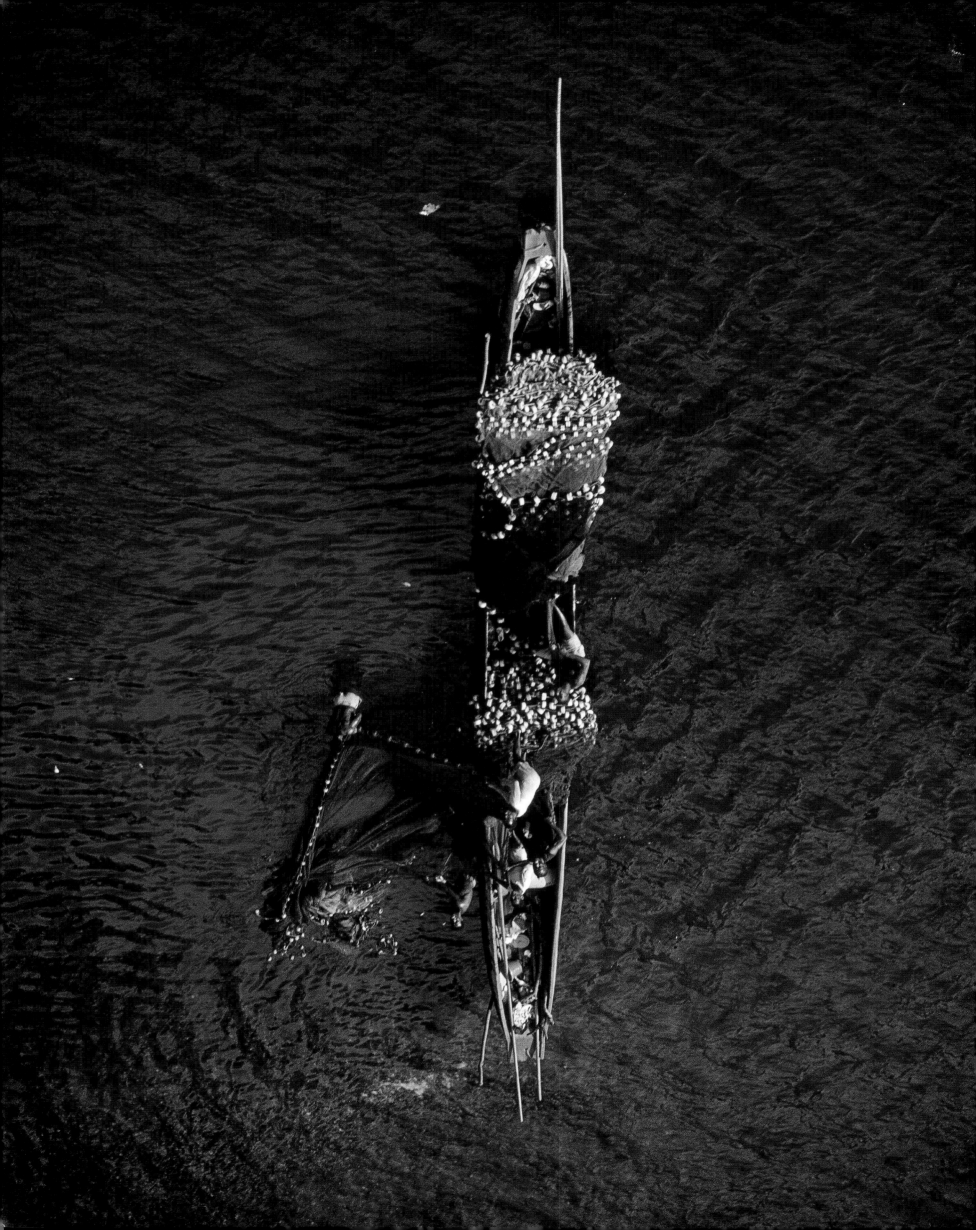

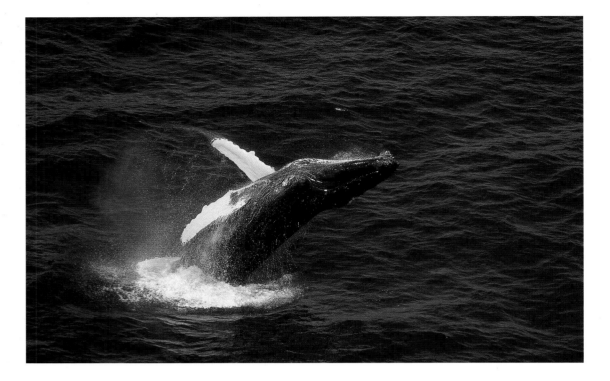

LEFT: **Whale in Samana Bay, Dominican Republic**
(18°20' N, 69°50' W)
Summering in the Arctic, whales migrate to the southern seas in winter to reproduce. Until the 1950s, this migratory marine mammal was subject to intensive exploitation, both for its meat and the oil from its blubber, a phenomenon that led it to the brink of extinction. The moratorium on whale hunting voted in 1986 staved off its disappearance—for the time being. Despite its flaws, it stands as an example of the decisions and results that can be achieved by the international community.

Nonetheless, twenty-five years later, populations of several marine mammals have slightly increased. The population of humpback whales grew from twenty thousand individuals in 1986 to thirty-five thousand in 2005. Progress is slow, tied to the animals' reproductive cycle: Large cetaceans reach sexual maturity late (sometimes at around twenty years old), and gestation lasts between ten and fifteen months according to the species, leading to the birth of a single calf, which the mother will generally take care of over a long period. Five whale species remain on the IUCN Red List of Threatened Species.

Short of banning all commercial fishing, the Whaling Commission created two vast sanctuaries, the first in the Indian Ocean, the second in the Antarctic (covering 19 million square miles), in which it is forbidden to fish for whales.

SCIENTIFIC HUNTING

Japan, which does not recognize the Antarctic sanctuary and is constantly seeking to repeal the moratorium, obtained a dispensation for scientific hunting, a deeply hypocritical move whose objective is known by all to have nothing to do with the advancement of science. According to the Japanese Institute of Cetacean Research (ICR), this fishing has yielded an average of twenty scientific publications a year, or two hundred over the last decade, most of which are of minor interest and only available in Japanese. By comparison, the PubMed international database lists 2,949 publications on the subject over the same period, or ten times more, without killing a single whale.

So-called "traditional" fishing is also authorized in Canada, Norway, and many other countries. According to the official figures for 2009, 1,851 whales were intentionally killed—a significant figure, but one that is far lower than those before the moratorium.

DUMB AND UGLY

The public sympathy enjoyed by marine mammals has also benefited seals. While seal hunting continues, the intense campaigns of the seventies and eighties led to a ban on hunting seal pups under a year old, and a certain number of countries have banned seal hunting or the sale of seal fur. Since 2009, this has been true of the members of the European Union. As we have seen ("The End of the Great Predators," page 184), a similar global movement of sympathy for sharks could help to protect them and avoid their oncoming extinction.

But, in general, fish are in trouble, particularly given the widespread opinion that they are smelly, dumb, and impervious to pain. Simple, common, small, often gray inhabitants

EEZ

The "cod wars" pitted Iceland against the United Kingdom from 1952 to 1976. When Iceland decided to extend its fishing zones to 12, 50, then 200 miles from its coasts to protect its fish resources, the British Navy intervened to "protect" its trawlers fishing in the zone. Ships collided, a few shots were fired, but there were no casualties and war was never truly declared. The British eventually recognized Iceland's claims. The agreements they reached set the foundations for an essential international convention, which defines the maritime zones over which a state exercises exclusive rights, notably a right to fish and prospect. This the United Nations Convention on the Law of the Sea, signed in 1982, also known as the Montego Bay Convention. It implemented what are now known as exclusive economic zones, or EEZs, which extend a maximum of 200 miles (370 kilometers) from the coast. If two countries' EEZs interpenetrate, the limits of each zone must be set by mutual agreement or by decision of an international court. Nonetheless, numerous disagreements remain unresolved, notably between the countries bordering the China Sea and the North Atlantic.

of the oceans, they are unable to arouse a general movement of sympathy like those enjoyed by baby seals and pandas. Their future is dark. The people fighting for their protection are generally not doing so out of sympathy for the animal, but for the rational preservation of a resource and maintaining the balance of the ecosystems—two essential ideas, but ones that are much harder to convey to the general public and politicians. This theoretical vision of the protection of the oceans faces tremendous difficulty in convincing people and imposing itself.

THE TRAGEDY OF THE COMMONS

Our inability to sustainably and collectively manage this essential resource is emblematic of the current environmental crisis. Garrett Hardin, an American philosopher of the second half of the twentieth century, wrote a fundamental treatise on modern environmentalism known as *The Tragedy of the Commons*. Hardin first formulated it in 1968 in an article published by *Science* magazine.

This simple analogy is the basis of the text: Imagine a village in which the herdsmen graze their cows on a commons. Each herdsman has an individual interest in improving his revenues and thus to expand his herd. But each additional cow grazes a little more grass. As their numbers increase, the cows graze a bigger portion of the field. Until there is no more grass. Eventually, when the field is completely grazed, the herdsmen lose all their cattle because they can no longer feed them. "Finally, however comes the day of reckoning . . ." Hardin writes.

RUIN IS THE DESTINATION

The philosopher follows the metaphor to show that in such a system, each individual is incited to use always more of the resource and thus accelerate the catastrophe: "Ruin is the

ABOVE: **The Corcovado overlooking the city of Rio de Janeiro, Brazil** (22°57' S, 43°13' W)
From atop a 2,329-foot (704-meter) rocky peak called Corcovado (hunchback), the statue *Christ the Redeemer*, by Paul Landowski, dominates Guanabara Bay and Rio de Janeiro. Here, the 1992 Earth Summit laid the foundations for sustainable development and resulted in the three most important international conventions on the environment: climate, biodiversity, and the prevention of desertification. Twenty years later, in June 2012, another international summit, the much anticipated Rio+20, did not yield any decisions, revealing the weakness of international institutions.

283

destination toward which all men rush, each pursuing his own best interest in a society that believes in the freedom of the commons," Garrett Hardin writes—which is also a direct refutation of Adam Smith's theory of the invisible hand.

In this context, even if a particular herdsman becomes aware of the threat and decides to behave "well," nothing will change: He will just have left a little more grass for his less-virtuous colleagues and barely delayed the final catastrophe. Individual good intentions are not enough to save the world.

Hardin considers various applications of this metaphor (pollution, overpopulation, etc.) and explicitly establishes the parallel with overfishing: "Likewise, the oceans of the world continue to suffer from the survival of the philosophy of the commons. Maritime nations still respond automatically to the shibboleth of the 'freedom of the seas.' Professing to believe in the 'inexhaustible resources of the oceans,' they bring species after species of fish and whales closer to extinction."

TWO SOLUTIONS

Garrett Hardin concludes that when a resource is public, but its use allows private gain and the resource is exhaustible, the system inevitably leads to catastrophe. He considers two overall solutions to the crisis: Either the resource remains public but profits become public—nationalization—or the profit remains private, in which case the resource is also privatized—privatization at its strongest. In all cases, these general considerations only open a large debate on the way to proceed in concrete terms: Whether the resource is to be publicly shared or privatized, on what basis should it be done?

These issues are clearly at work in the management of fisheries. In certain cases, access to the resource is to be privatized by attributing fishing quotas to groups of fishermen, and even individual fishermen. In other cases, collective rules for access to the resource

ABOVE: **Eroded iceberg in Unartoq fjord, Greenland** (60°28' N, 45°19' W)

Most icebergs adrift in Baffin Bay and the Labrador Sea have come from Greenland's west coast. Between ten thousand and forty thousand of them are recorded each year. Every spring and summer, deep in the fjords, the glaciers calve, which means that blocks of ice come apart under the effect of the glacier's pressure and the action of the swell and the tides. Due to global warming, the Greenland ice sheet is now melting at a rate of 59 cubic miles (248 cubic kilometers) per year and scientific studies show that the phenomenon has accelerated since the beginning of the twenty-first century.

For more information on this subject and a relevant excerpt from the film *Planet Ocean*, go to http://ocean.goodplanet.org/gouvernance/?lang=en

LEFT: **Dokdo Islands (The Liancourt Rocks), South Korea** (37°14' N, 131°52' E)

In English, these rocky uninhabited islands are known as the Liancourt Rocks, after the whaler that discovered them in 1849. In Korean, they are the Dokdo Islands, in Japanese, the Takeshima Islands, and they are located in the Sea of Japan, also known as the East Sea at Korea's request. As can be gleaned by this toponymic diversity, the islands are the object of dispute. According to the treaties that ended World War II, the area is managed by South Korea, but Japan has constantly claimed it. There are a great deal of maritime disputes around the world—particularly in Southeast Asia.

LOBBY VERSUS LOBBY

Drift nets, which are notably used in swordfish and bluefin tuna fishing, have been banned in Europe since 2002. But certain countries, including France, Italy, Turkey, and Morocco, were still using them from 2005 to 2010. Basing itself on photos and technical documents, the NGO Oceana (founded in the United States) brought the case before the European Commission and the International Commission for the Conservation of Atlantic Tunas (ICCAT). The effect was dissuasive. The use of litigation to deal with fishermen's illegal activities and force them to comply with the law is part of Oceana's mission. But that is not Oceana's only weapon: The NGO is also an active lobbyist.

Protection of bluefin tuna, sharks, turtles: The issues are many. "Functioning as a lobby allows us to be involved in regulation as it is being elaborated. Because afterward it is often too late to revise these laws, particularly when the sectors concerned are economic giants like the oil or fishing industry. Faced with powerful economic interests, environmentalists must be able to exert pressure, to have their voice heard, and to defend another policy," according to Nicolas Fournier, responsible for European affairs with Oceana.

But the balance of power remains off-kilter. According to a somewhat outdated 2003 study that still serves as a reference, at the time there were twenty thousand lobbyists and fifteen thousand European civil servants in Brussels. The numbers have increased since, but probably not to the advantage of defenders of the environment. In 2011, the European Union created a register of over five thousand interest groups for the sake of greater openness. But many lobbies prefer to remain in the shadows. And these are neither the least powerful nor the most environmentally friendly.

are to be implemented—with global governance for the high seas, for example. None of these solutions is simple, none is without drawbacks, and none is valid in the same way in various contexts. All require those involved to agree to them sooner or later, even if this can potentially be imposed in a relatively authoritarian manner if one of the parties enjoys the balance of power.

THE HOUSE IS BURNING

Garrett Hardin's article led to a great deal of discussion, reflection, and refutation. But nearly fifty years after it was published, we see no notable evolution. Though Hardin sometimes took contestable positions on other subjects, his far-seeing pessimism remains disturbing: "Natural selection favors the forces of psychological denial. The individual benefits as an individual from his ability to deny the truth even though society as a whole, of which he is a part, suffers." As French President Jacques Chirac put it: "The house is burning but we're looking away."

Finally, it is likely that our inability to think ahead promises unexpected catastrophes such as the one that occurred in 1992, when the fishermen of Newfoundland were stunned to discover that they had emptied their waters of all their fish and had made themselves unemployed. As some environmentalist thinkers have put it, we might have to count on the "educational value of catastrophe" for humanity to progress.

FOOD SECURITY

Alternatively, the situation could evolve through the emergence of another issue: the question of food security. When feeding 9 to 10 billion people really becomes a problem, states will begin to change both their agricultural and fishing policies. Fish stocks may then become as precious as hydrocarbon deposits. And it will be time to take care of them.

RAISE THE BLACK FLAG

TEXT BY PAUL WATSON

PAUL WATSON, cofounder of Greenpeace, is a radical defender of the oceans, a troublemaker, and a pirate. After being ousted from the famous environmentalist organization in 1977, he founded the Sea Shepherd Conservation Society. After spectacular operations against seal hunting, he rammed and sank twelve whalers in the 1990s. He revealed the massacre of dolphins in Taiji Bay in Japan and leads an annual naval battle against Japanese whalers in the Antarctic. And these are only a few of his exploits.

On May 13, 2012, he was arrested in Frankfurt for events that took place in 2002. Invited by the government of Costa Rica to fight overfishing, Watson had boarded and inspected a ship illegally fishing sharks and had escorted it to harbor. The boat's crew likely had connections in high places, for Sea Shepherd's crew was the one to be arrested upon arrival. Fearing an unfair trial, Watson and his team took to their heels.

Arrested in Germany ten years later, then released on bail, Watson secretly fled the country on July 25, 2012. The interview we had planned with him was no longer possible. His text we are publishing, with his agreement, predates these events. Whether or not you agree with his ideas and methods, Paul Watson displays the courage and commitment the planet needs.

It takes a pirate to stop a pirate and that is why the flag of the Sea Shepherd Conservation Society is the Jolly Roger. Yes, we be pirates! I'm not going to pretend otherwise. On the high seas we are indeed rogues and we sail under the stars that we choose to guide us, pointing our bows to wherever the need calls us. After all, it was not the British Navy that ended piracy in the Caribbean in the seventeenth century. That honor fell to Henry Morgan—a pirate. And it was pirate Jean Lafitte who stood with Andrew Jackson at the defense of New Orleans in 1814. It was pirate John Paul Jones who founded the United States Navy and the Russian Navy two centuries ago. It was pirates Sir Francis Drake and Sir Walter Raleigh who served Her Majesty Queen Elizabeth I with great distinction. Simply put—pirates get things done without bureaucratic red tape.

"Pirates get things done without bureaucratic red tape."

Yes, we be proud pirates, however, we are disciplined pirates with our own special code of honor. That code demands that we do not cause injury or death to our enemies and that we operate within the framework of international conservation law—meaning that we only oppose unlawful exploitation of marine life. We are an antipoaching organization.

We are pirates who hunt pirates. Kind of like the Dexter character from the popular television series of the same name, we are very specific about who we target. We do not target legitimate operations, even when we may disagree with them. We are not a protest organization. We don't hang banners, we intervene against illegalities.

As such, we have been called vigilantes. And indeed, we are vigilantes, because when the law exists yet enforcement does not, a vacuum is created that allows for the actions of vigilantism. Sea Shepherd acts where enforcement does not exist or has failed. Our justification is the United Nations World Charter for Nature that allows for nongovernmental organizations and individuals to intervene to uphold international conservation law. We are vigilante pirates operating on the high seas, yet bound by a code of honor to not inflict death or injury upon any person.

The Greenpeace Foundation condemns us for being violent. Yet we have never harmed a single person. What we have done in the past is destroyed property, but only when that property was used to illegally destroy life. We view such acts as nonviolent, and refer to them as aggressive nonviolence, as even Dr. Martin Luther King Jr. remarked that violence cannot be committed against property. "I am aware that there are many who wince at a distinction between property and persons—who hold both sacrosanct. My views are not so rigid. A life is sacred. Property is intended to serve life, and no matter how much we surround it with rights and respect, it has no personal being. It is part of the earth man walks on; it is not man." (Dr. Martin Luther King, Jr., *The Trumpet of Conscience*, 1967.)

Therefore it is our view that the destruction of a harpoon, a gun, a sealing club, or a longline are all acts of nonviolence because the result is the prevention of cruelty, suffering, and death to a sentient being. But we can't really blame Greenpeace or any other mainstream organization for opposing us because, well, the truth is . . . we be pirates!

And as pirates, we are like the ladies of the evening of the conservation movement, meaning that many members of these groups secretly applaud and agree with us, but they don't want to be seen in public as doing so. We can live with that.

We have also been called ecoterrorists, but then anyone who disagrees with anyone else's views is labeled a terrorist these days. The word "terrorist" used to mean something, and was a word to instill fear, yet today when His Holiness the Dalai Lama is officially designated as a "terrorist" by China, we don't mind being called such.

Our answer to that is simple. We're not hiding in a cave in Afghanistan, and our accusers can either arrest us or give the rhetoric a rest before they dilute the language

and potency of such a word. As proud Sea Shepherd pirates, we have no problem with being condemned by the forces of destruction on this planet, and the rhetoric of condemnation is a steady onslaught from whalers, sealers, shark finners, seal clubbers, fish poachers, and polluters. The more enemies we recruit from that crowd of ecological criminals, the more successful and credible we become.

"We are like the ladies of the evening of the conservation movement, meaning that many members of these groups secretly applaud and agree with us, but they don't want to be seen in public as doing so."

The whalers, sealers, and other sea-going poachers hate us like they hate no other groups opposing them; in fact, they are fanatical in their hatred of us to the point of amusement at the silly things they try to do to stop us. If we were not a threat, if we were not effective, we would not have earned such passionate animosity.

Some of the other conservation and environmental organizations oppose us also, mainly because we don't conform to their idea of what we should be. When we stepped beyond the bounds of petitions, lobbying, demonstrations, and banner hanging, we fell out of favor with much of the "green" crowd, but our objective is to stop whaling, not to protest it. And we don't serve the conservation and environmental movements, we serve the global ecosystem, specifically the marine ecosystem. Sea Shepherd does not conform to the bias and narrow-mindedness of the so-called conservation and environmental movements. We don't

have a leftist agenda nor do we have a rightist agenda. In fact, we have no political agenda at all. We may not be politically correct but we strive to be ecologically correct. Sea Shepherd operates independent of cultures, race, nationalities, and philosophical beliefs. We represent exclusively the interests of all marine species, and we do so from a deep ecological and biocentric perspective. In other words we are not involved in human priorities in any way. This has motivated some to call us misanthropic. We have no problem with that.

People are free to call us whatever they like, any name they wish, and they are free to accuse us of anything they like. We don't care, because opinions are irrelevant, and besides, we be pirates and therefore we're not impressed with how we are viewed by people who disagree with us.

It really does not matter because we embrace those who do support us and we remain unconcerned about those who don't. We don't try to be all things to all people, but we remain consistent and accountable to ourselves. Sea Shepherd is what we are, and that means we are aggressive interventionists. We may destroy and seize property used to illegally destroy life. We may say things some people don't like to hear. We will inevitably do things that some people don't like. And we may sometimes use tactics some people disagree with.

"The more enemies we recruit from that crowd of ecological criminals, the more successful and credible we become."

Thus we expect opposition. We are not a large organization and we have no intention of ever being so. We are a crew of volunteers, activists, and sailors intent on saving our oceans from ourselves and the ecological destruction of humanity. We reject a bureaucratic structure and we are

not interested in becoming mainstream or respectable. I mean, who ever heard of a respectable pirate? We are rabble-rousers, risk takers, troublemakers, and, well, pirates—always have been, and always will be. "Mister Professor [. . .], I am not what you call a civilized man! I broke with society in its entirety for reasons that only I have the right to judge!" (Captain Nemo in Jules Verne, *Twenty Thousand Leagues Under the Sea*.)

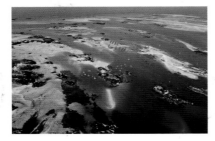
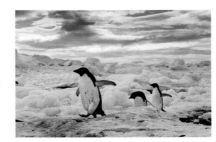

Juvenile squids (*Sepioteuthis lessoniana*) under the surface of Futami Harbor, Ogasawara Islands, Japan

This species of "bigfin" squid is common in tropical waters of the Indian and Pacific Oceans. Abundant in the first 330 feet (100 meters) of the water column, these squid colonize coral reefs and sea grass. Particularly active at night, which is when they prefer to eat, they dive deeper during the day to keep away from predators, notably birds.

Chausey Islands at low tide, Channel, France (48°52' N, 1°50' W)

The Chausey Islands have the strongest tides in Europe, with an amplitude of 45 feet (14 meters). Twice a day, water covers and uncovers their rocks and shores. Their land area grows from 160 acres (65 hectares) at high tide to nearly 10,000 acres (4,000 hectares) at low tide. The archipelago is home to more than three hundred plant species and numerous bird species, of which several are rare and protected. Only twelve inhabitants live there year-round, but in 2005, the islands welcomed 71,500 visitors, accentuating the pressure on this fragile environment.

Adélie penguins waddling on ice sculpted by the wind, Antarctica

The Adélie penguin is a marine animal, spending 90 percent of its time in the water. This species endemic to the Antarctic continent and its islands is a great consumer of krill, a small crustacean found in abundance in the waters of the Southern Ocean. It is the red from krill—rather than blood—that colors the penguins' excrement and stains the ice.

Salt marshes near Tsangajoly, Toliara Province, Madagascar (19°52' S, 44°33' E)

The dry climate and proximity of the ocean in the southwest of Madagascar are ideal for salt marshes. These have been exploited not only for their salt, but also for spirulina, a blue microalgae, easily cultivated even in the most arid regions, whose nutritional value is significant. Despite the wide dissemination of refrigeration processes, certain countries continue to use salt to preserve food, notably meat and fish, which makes it a sought-after substance.

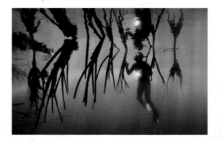
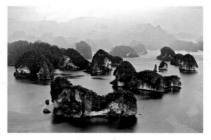

Fish of the *Astroscopus* genus hiding in the sediment of Suruga Bay, Izu Peninsula, Honshu, Japan

Fish of the *Astroscopus* genus are bottom-dwelling fish able to bury themselves in sediments to conceal themselves. These widespread fish are called "stargazers," because the position of their eyes on top of their heads make it look like they are gazing at the stars. They eat small fish and crustaceans, which they capture thanks to the poison spines on their backs, similar to those of weevers.

Green algae in shellfish beds in Saint-Brieuc Bay, Côtes-d'Armor, France (48°32' N, 2°40' W)

A recurrent source of pollution in Brittany for decades, the proliferation of green algae can be attributed to the agro-industry: use of synthetic fertilizer, animal waste, and discharge of effluent from industrial pig and chicken breeding. These pollutants, nitrates, and phosphates are carried to sea by rivers. There, they promote the proliferation of algae, which decompose outside of salt water and release hydrogen sulfide (H_2S), a toxic gas.

Exploration of a mangrove in deep waters, at the edge of a lagoon, Belize

Transitional spaces between the terrestrial and aquatic environments, mangroves are particularly rich in animal and plant species. Like swamps, these environments were long considered unsanitary and unproductive and were drained and dried out for agriculture and urbanization. Over the last thirty years, 20 percent of the world's mangroves were destroyed. Yet they are very useful, for they filter water, preserve biodiversity, protect coastlines and soil from flooding, drought, and erosion. They are also important carbon wells.

Raja Ampat Islands, West Papua, Indonesia (0°41' S, 130°25' E)

A small earthly paradise with a great variety of fish such as skates and sharks, the Raja Ampat (Four Kings) Islands attract divers and fishermen. Cyanide and explosive fishing was practiced here until 2007, when the local government decided to establish a marine protected area.

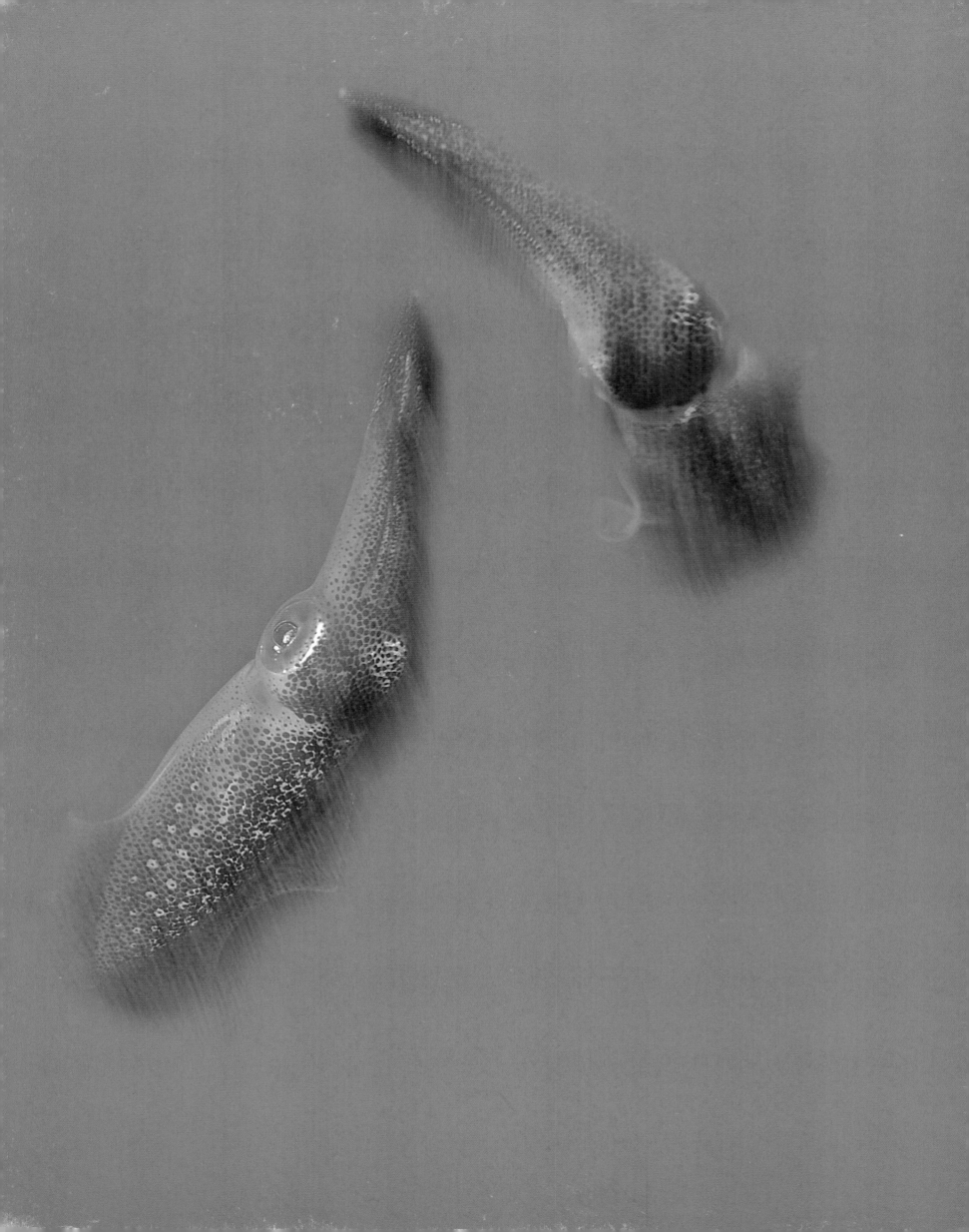

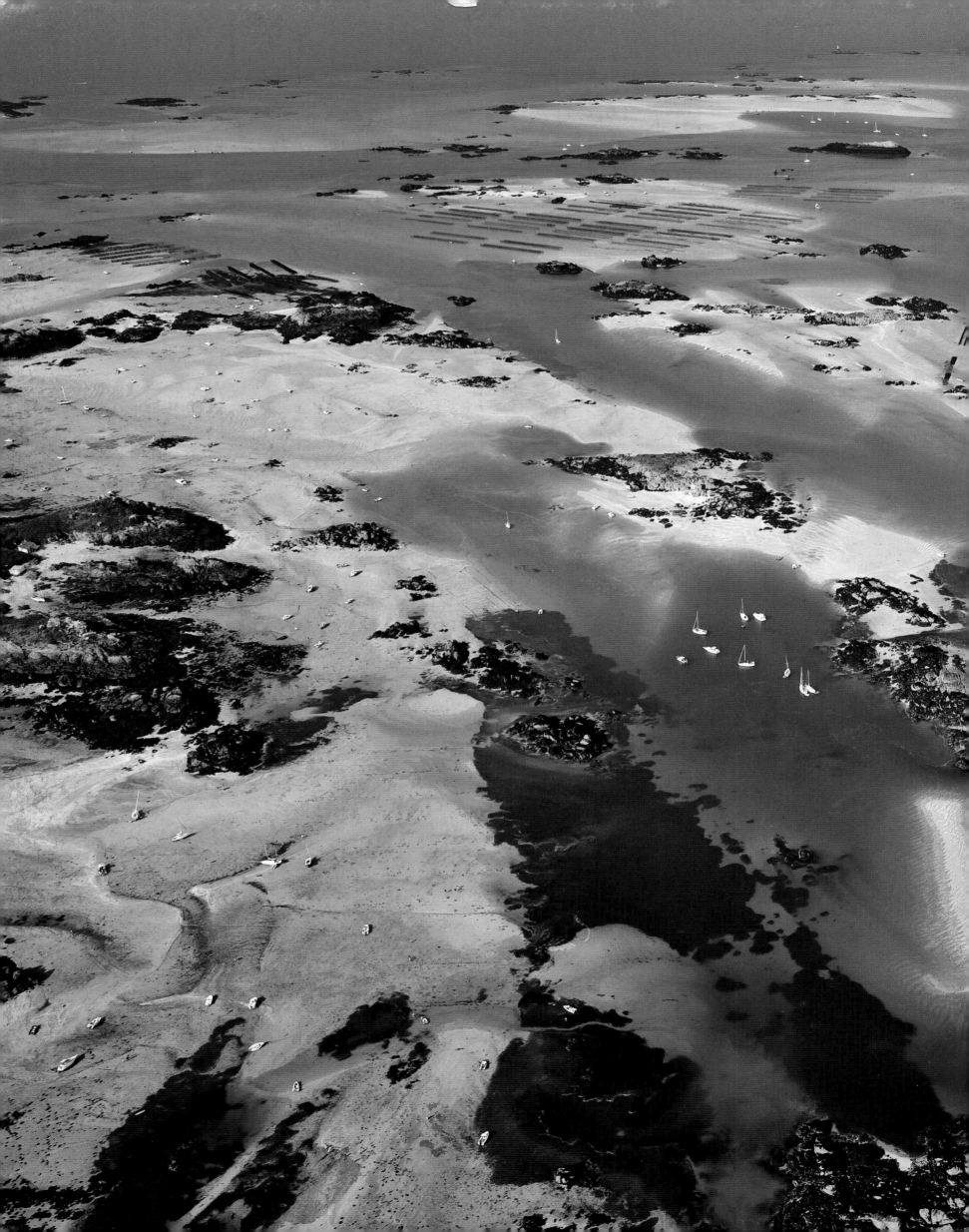

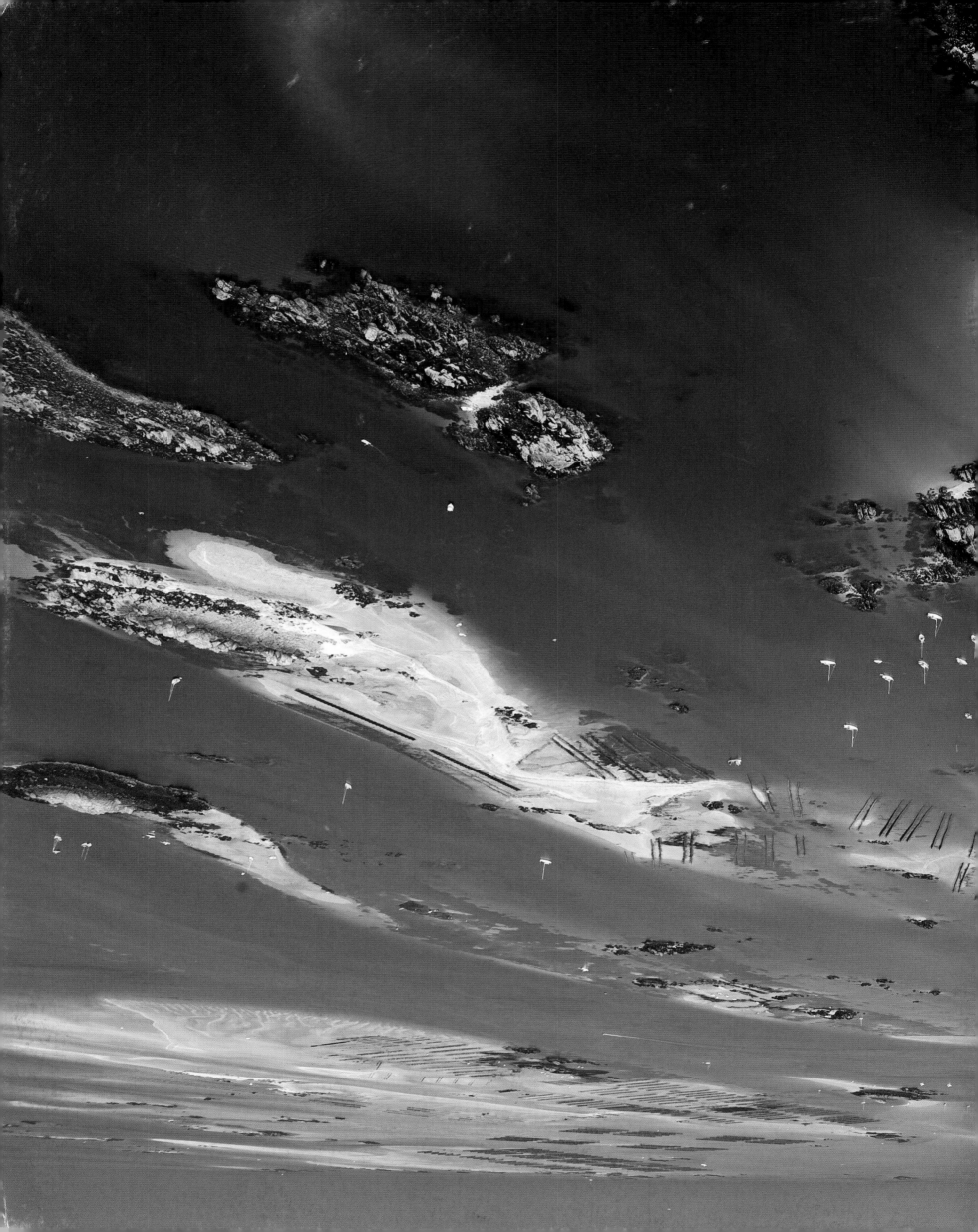

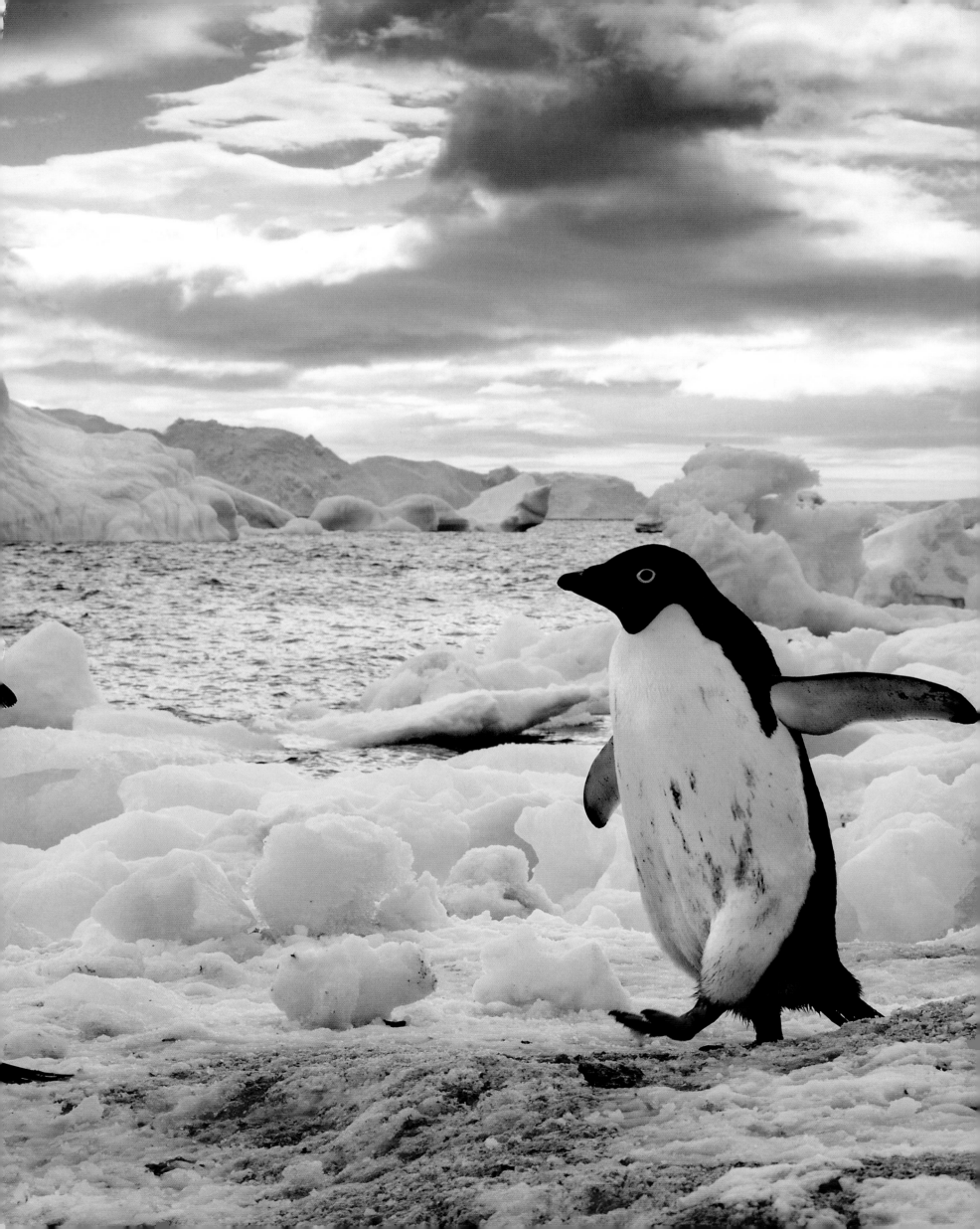

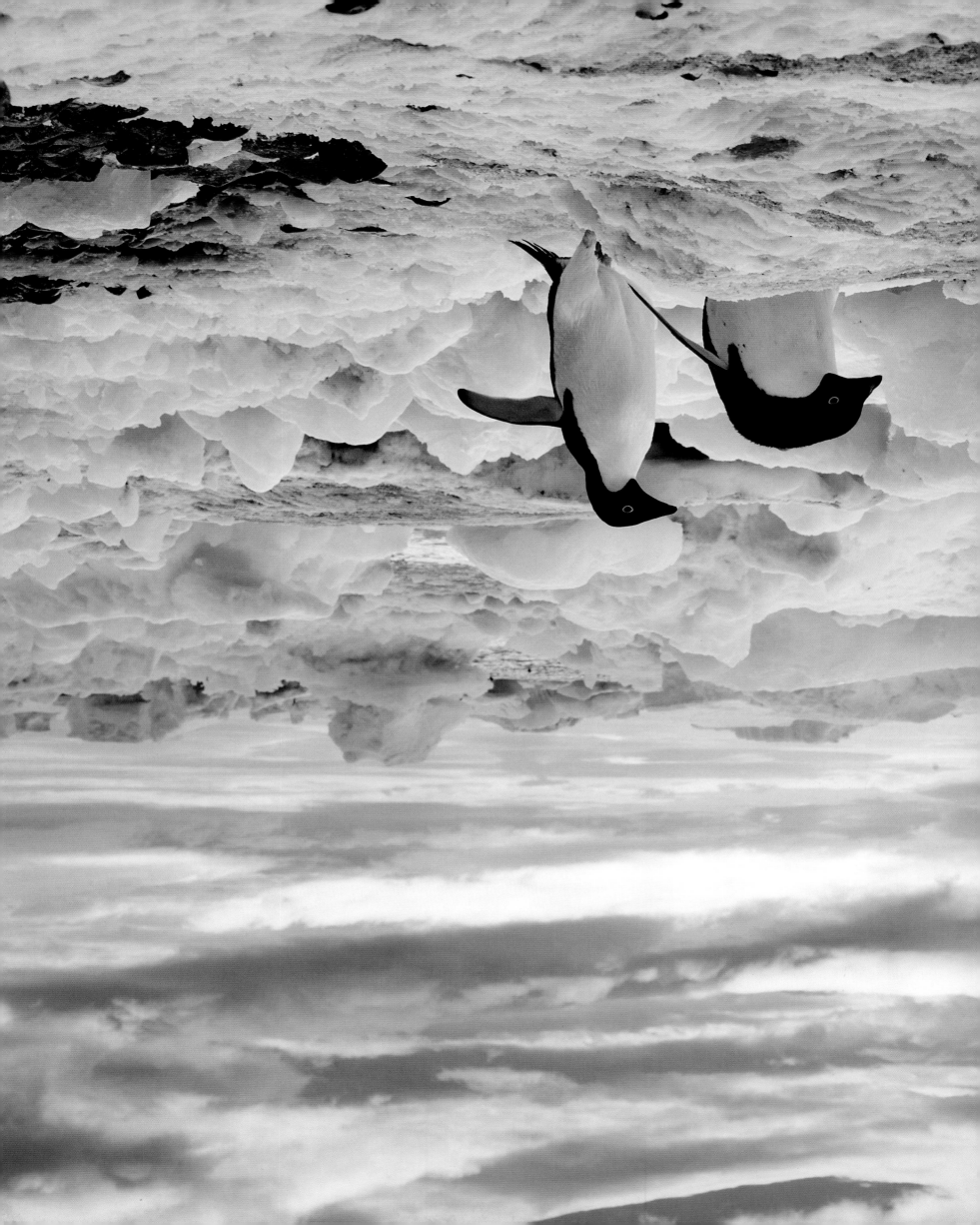

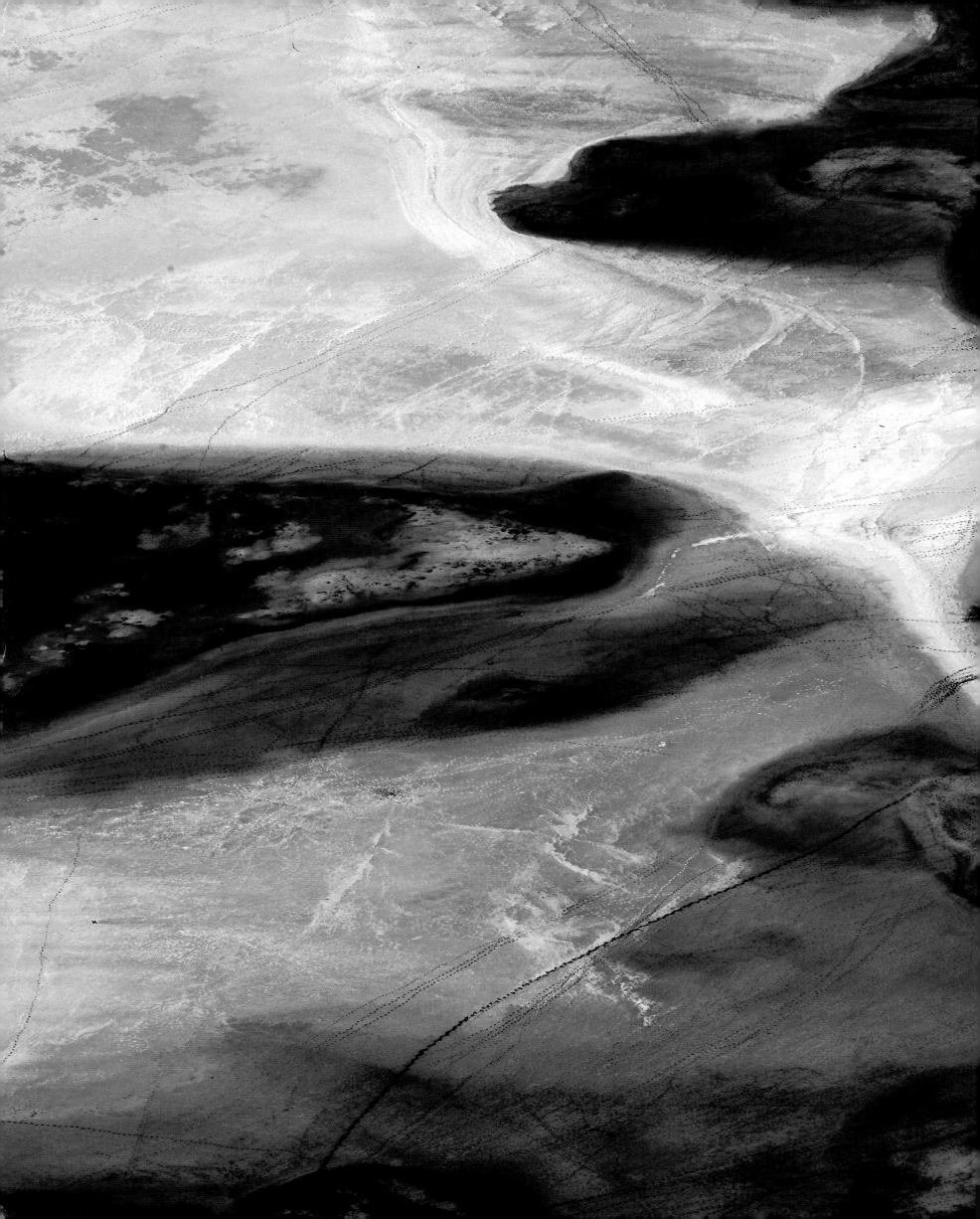

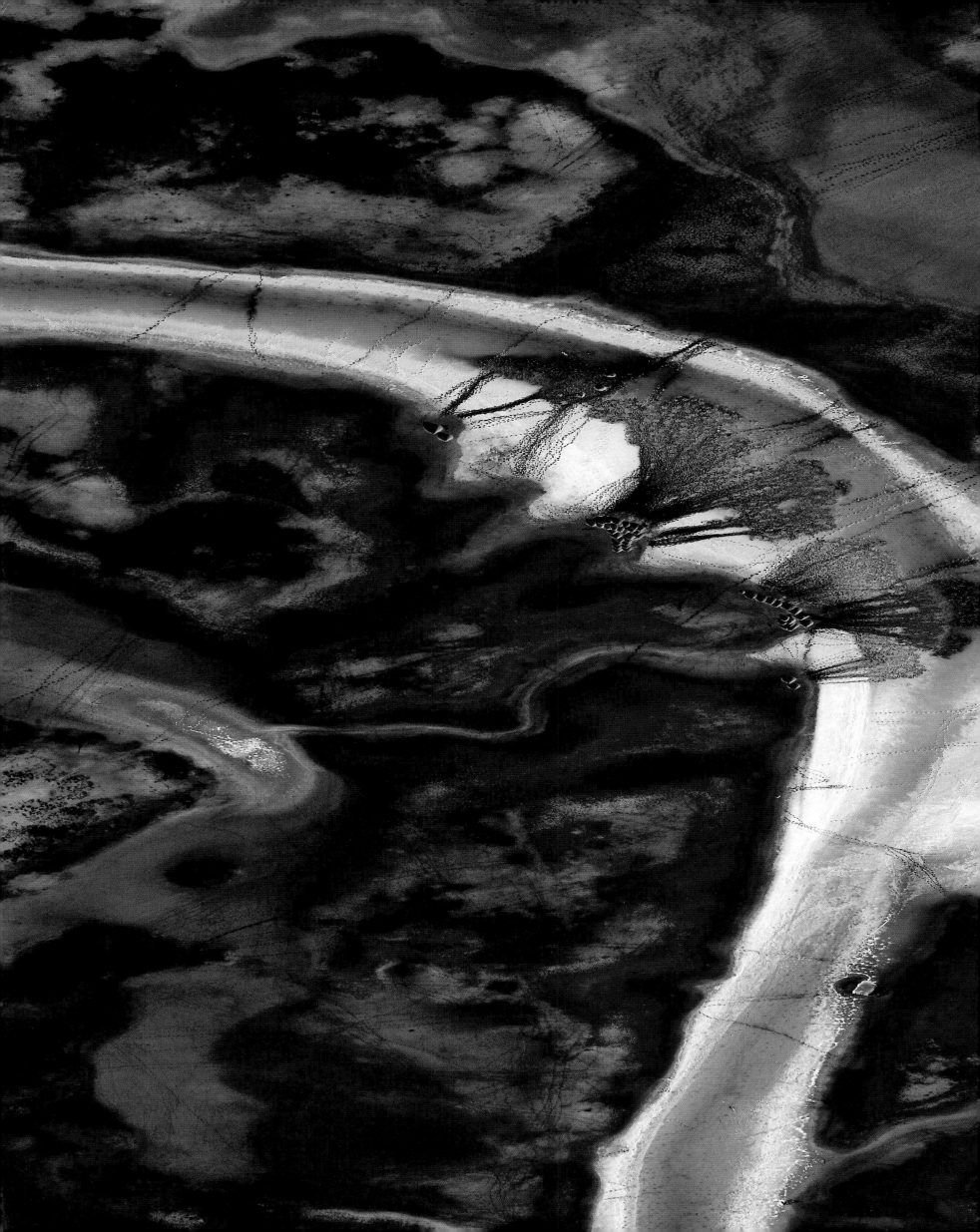

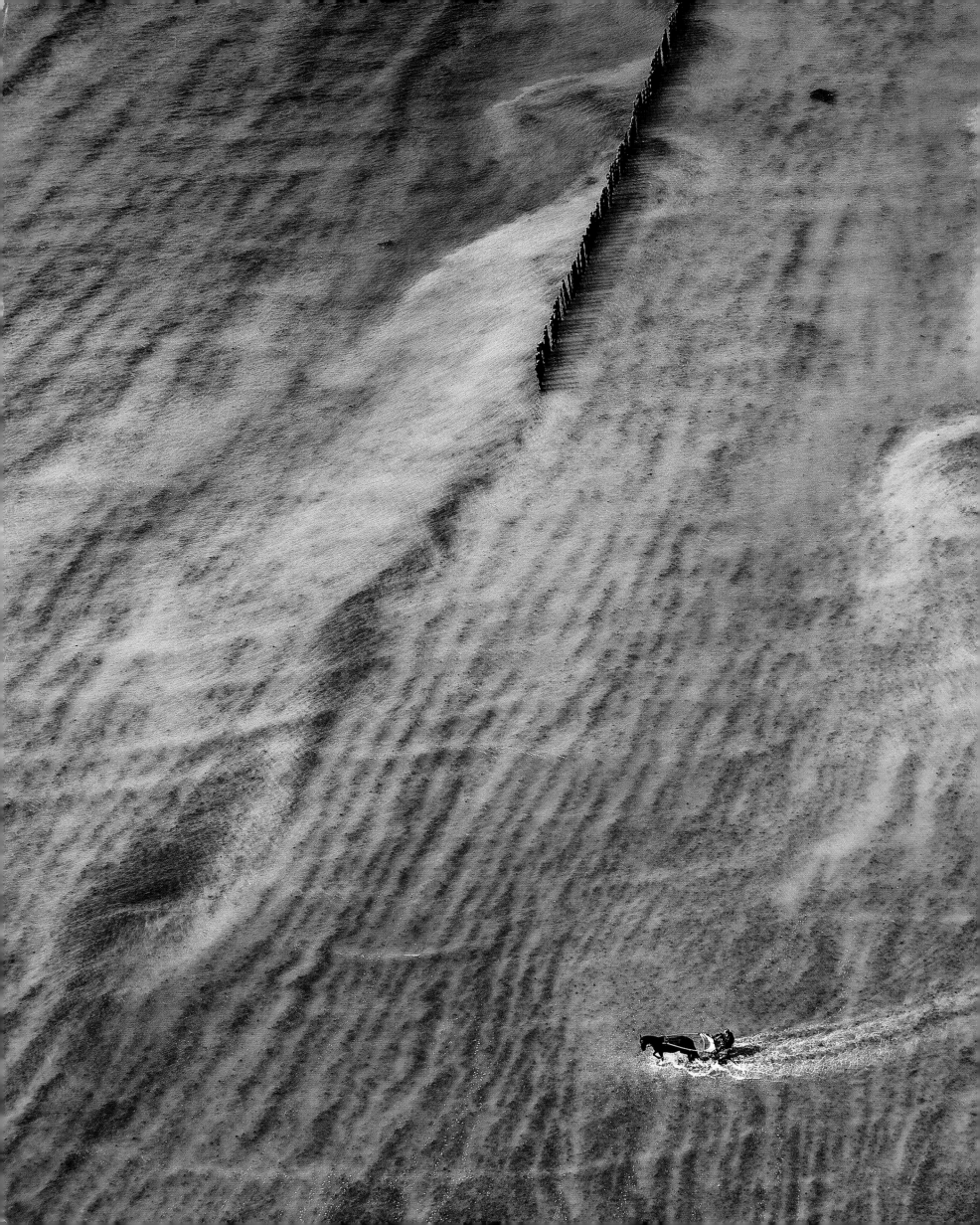

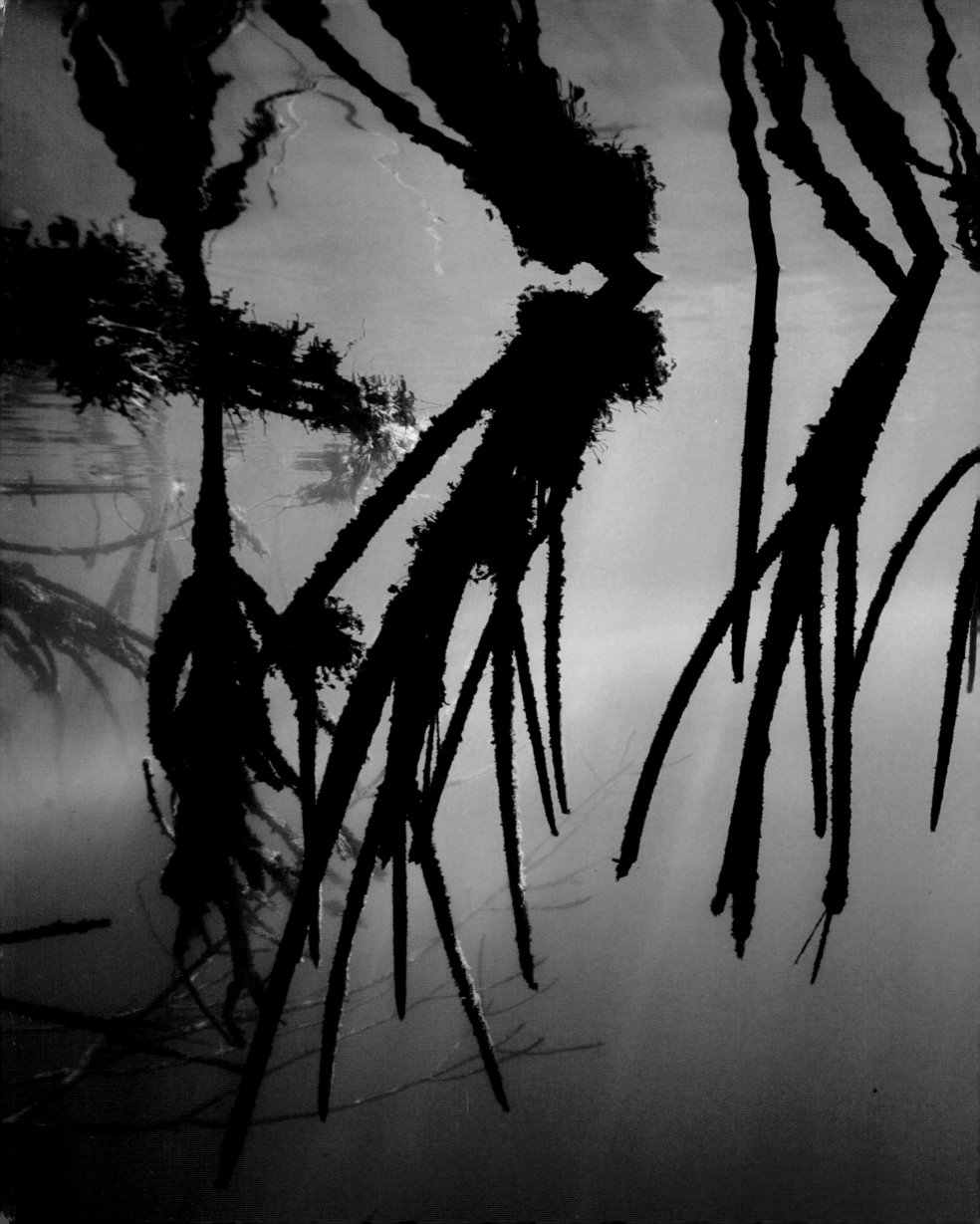

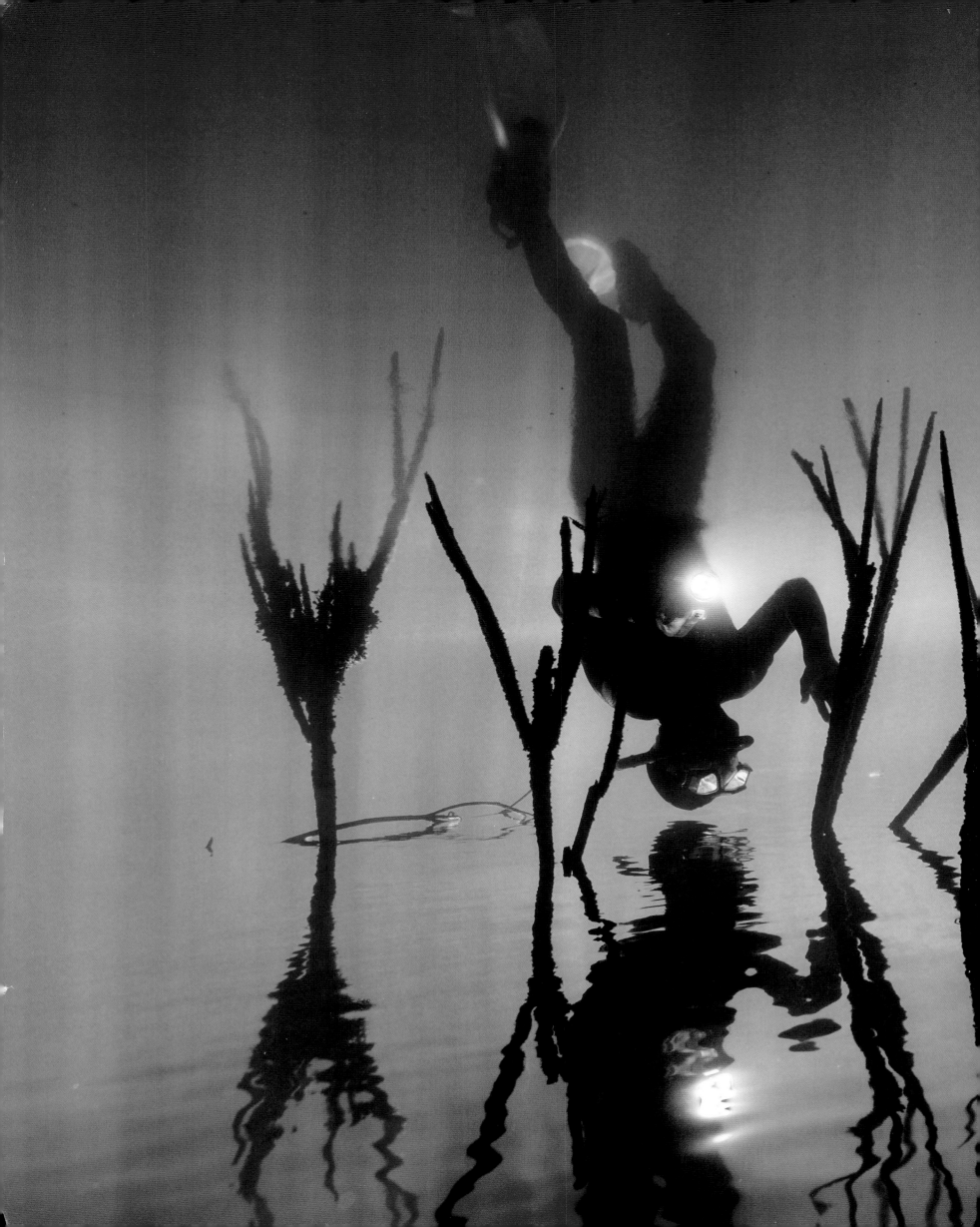

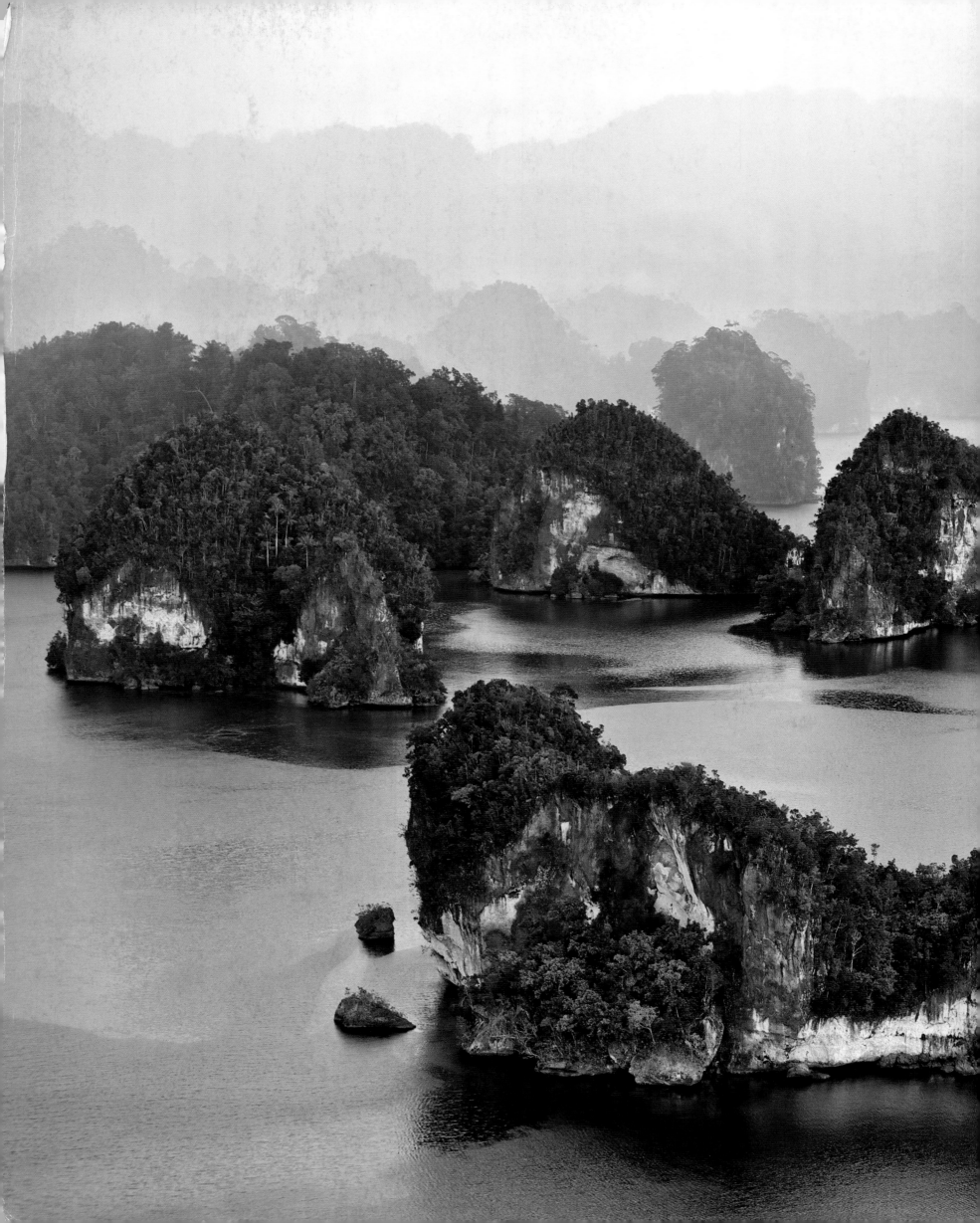

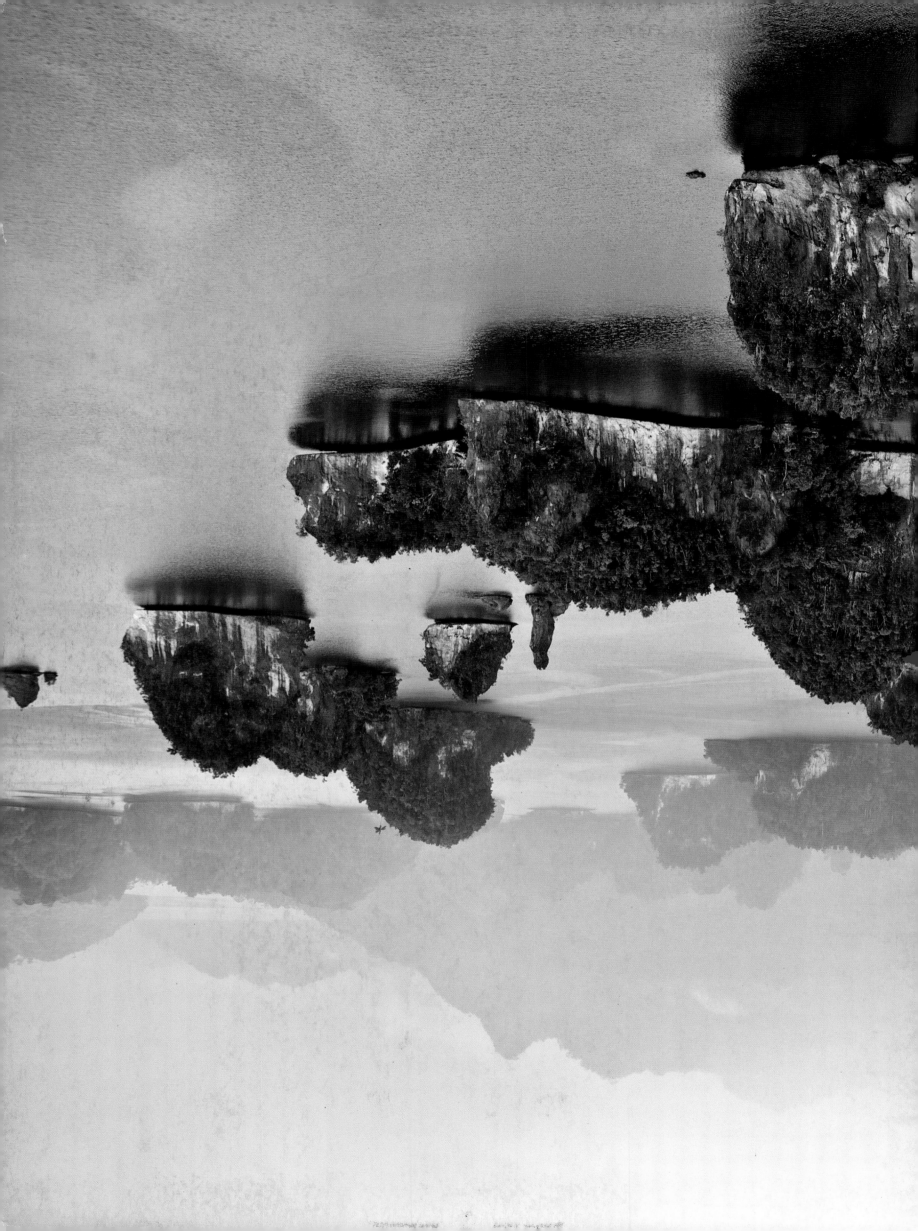

GoodPlanet Foundation

Editor in chief: Olivier Blond
Editors: Éric Boisteaux, Benjamin Grimont,
Cédric Javanaud, Julien Leprovost, Yves Sciama
Photo researcher: Françoise Jacquot

The entirety of royalties due to Yann Arthus-Bertrand and the editorial
staff will be donated to the GoodPlanet Foundation.

Discover and support the GoodPlanet Foundation's activities at
www.goodplanet.org. Keep up with news of the planet at www.goodplanet.info.
The GoodPlanet Foundation's editorial staff is supported by BNP Paribas.
The GoodPlanet Foundation's Océan program is supported by the OMEGA group.

The original French text of this book is under Creative Commons license
(BY – NC – SA). It can be reproduced (without layout and illustrations)
for noncommercial purposes so long as the source is cited.

GOODPLANET
FOUNDATION Ω **OMEGA**

Photography Credits

Aerial photographs: Yann Arthus-Bertrand
These images are displayed on the Altitude website:
www.altitude-photo.com
You can order signed prints on the gallery website:
www.yannarthusbertrandgalerie.com

Underwater photographs: Brian Skerry
To use a photograph or buy a Brian Skerry print, contact the National Geographic
Image Collection: www.nationalgeographicstock.com

With the exception of: page 27: Claire Nouvian/David Shale; page 51: NASA; page 53:
Christian Sardet CNRS/ Plankton Chronicles Project; page 97: Eva Ferrero; page 164:
Greenpeace/Pierre Gleizes; jacket flap: portrait of Yann Arthus-Bertrand: Thomas
Sorrentino; portrait of Brian Skerry: Mauricio Handler.
Some photos appear courtesy of Hope Productions.

Translation from the French: Nicholas Elliott

First published in the United Kingdom in 2013 by
Thames & Hudson Ltd, 181A High Holborn,
London WC1V 7QX

Original edition © 2012 Éditions de la Martinière, Paris
English translation © 2013 Harry N. Abrams, Inc., New York
and Thames & Hudson Ltd, London

All Rights Reserved. No part of this publication may be reproduced or transmitted
in any form or by any means, electronic or mechanical, including photocopy,
recording or any other information storage and retrieval system, without prior
permission in writing from the publisher.

British Library Cataloguing-in-Publication Data
A catalogue record for this book is available from the British Library

ISBN: 978-0-500-51690-4

Printed and bound in China

To find out about all our publications, please visit **www.thamesandhudson.com**.
There you can subscribe to our e-newsletter, browse or download our current
catalogue, and buy any titles that are in print.

**ABOVE RIGHT: Oarfish (*Regalecidae*),
Bahamas, Great Antilles**

Found in temperate and tropical waters,
oarfish are of the Regalecidae family and
can be over 30 feet (10 meters) long. It's
easy to see how oarfish that washed up
on the beach or floated close to shore
contributed to the legend of sea serpents.
Only 10 feet (3 meters) long, this specimen
is probably a young individual. Oarfish are
known for their ability to move vertically,
perpendicular to the surface of the water,
possibly in order to better distinguish their
prey as it stands out against the light.